. THE PATRON STATE

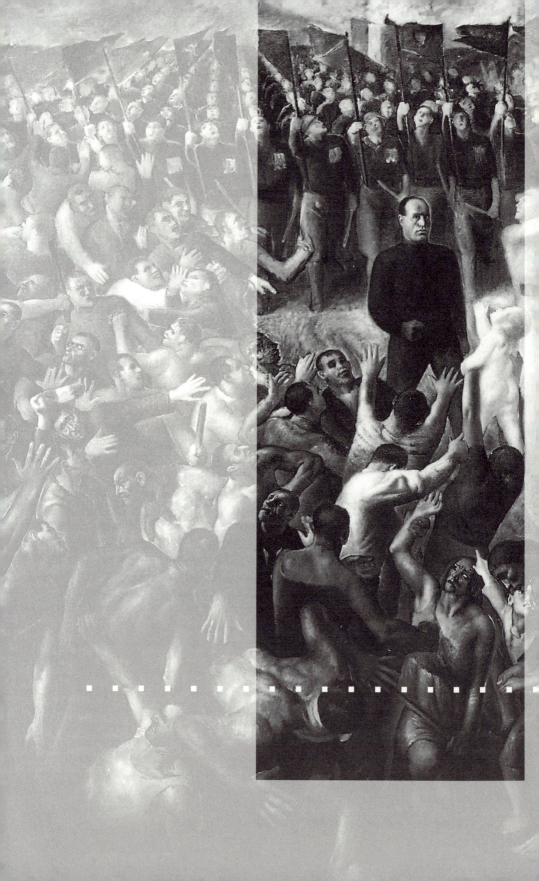

MARLA SUSAN STONE

THE PATRON STATE

CULTURE & POLITICS IN FASCIST ITALY

PRINCETON UNIVERSITY PRESS, PRINCETON, NEW JERSEY

Copyright © 1998 by Princeton University Press
Published by Princeton University Press, 41 William Street,
Princeton, New Jersey 08540
In the United Kingdom: Princeton University Press,
Chichester, West Sussex

Library of Congress Cataloging-in-Publication Data

Stone, Marla, 1960–
The patron state : culture and politics in fascist Italy / Marla Susan Stone.
p. cm.
Includes bibliographical references and index.
ISBN 0-691-02969-5 (cloth : alk. paper). — ISBN 0-691-05999-3 (pbk. : alk. paper)
1. Art and state—Italy. 2. Art patronage—Italy. 3. Italy—Cultural policy.
4. Fascism and art—Italy. I. Title.
NX750.I8S76 1998
700′.945′09043—dc21 98-9449 CIP

This book has been composed in Dante typefaces

Princeton University Press books are printed
on acid-free paper and meet the guidelines for
permanence and durability of the Committee on
Production Guidelines for Book Longevity
of the Council on Library Resources

http://pup.princeton.edu

Printed in the United States of America

1 2 3 4 5 6 7 8 9 10

(Pbk.)
1 2 3 4 5 6 7 8 9 10

■ ■ ■ ■ ■ *To My Parents*

NELSON STONE *and*

DOLORES STONE

CONTENTS

■ ■ ■ ■ ■ ILLUSTRATIONS

■ ■ ■ ■ ■ ■ *ACKNOWLEDGMENTS*

THIS BOOK has been a long time in the making, with many influences in the process. Over the years, teachers, mentors, colleagues, friends, and institutions have given this work and its author their aid, sustenance, time, and insight. I hope they will see their impact here.

I have been fortunate to receive extensive institutional and financial support for this project. At two pivotal junctures in the process (both the research and writing phases), the American Academy in Rome provided a rich environment for study and reflection. During my Rome Prize Fellowship year in 1995–96, the intellectual cross-fertilization at the American Academy pushed me to reconsider the disciplinary boundaries between history and art history and to strive for a synthesis. The Gladys Krieble Delmas Foundation generously funded two extended research trips to Venice during the summers of 1989 and 1991. As a visiting scholar at the Wolfsonian Foundation in Miami, Florida in 1995, I was able to work directly with the objects and artifacts of the era. The history departments at Princeton University and Occidental College funded research trips.

Archival searches brought me to a number of Italian archives and libraries where administrators and librarians kindly shared their knowledge of the sources and the subject. The staffs of the Archivio storico dell'arte contemporanea and the Querini stampalia in Venice and the Archivio centrale dello stato, the Biblioteca nazionale, and the Biblioteca di storia contemporanea in Rome went above and beyond the call of duty to help me find and reproduce materials. The Archivio storico dell'arte contemporanea and the Wolfsonian Foundation have generously granted the permissions to reprint the photographs found in the book. The Louis and Hermione Brown Humanities Support Fund at Occidental College helped to defray the costs of the illustration permissions. At Princeton University Press, I am pleased to thank Lauren Osborne, the history editor who acquired the project, and Brigitta van Rheinberg, who has seen it to completion.

It gives me great pleasure to thank and acknowledge those who have guided me and this project since its first incarnation as a dissertation at Princeton University. Marta Petrusewicz has been a constant and indispensable source of support, inspiration, and friendship. Arno Mayer has generously lent his keen historical and analytic insights through the many

stages of the manuscript. Victoria de Grazia provided critical readings of early versions of the text. I thank Harold James for his professional support. Alexander De Grand has repeatedly and enthusiastically shared his deep knowledge of the era in readings of the text. My colleagues in the history department at Occidental College have supported my work, reading portions of the manuscript, and giving me leave time at key moments in the writing process.

Colleagues and friends have graciously offered their support in readings of chapters. The following chapters have benefited from the careful consideration of scholars from a range of fields who each brought his or her own expertise to bear. Steven Aron, Elizabeth Castelli, Susan Crile, Lynn Dumenil, Kate Jansen, Laurie Nussdorfer, and Moshe Sluhovsky read chapters and gave suggestions which I have attempted to implement. During the course of this long process, Michael Berkowitz valiantly read the entire manuscript in a range of versions. Ann Munly and Marilyn Lavin lent their skills in the analysis of the some of the images.

Due to the creativity of a number of seminar participants, I was able to test the book's ideas and I thank the audiences at the Harvard University Italian Seminar, the Columbia Modern Italy Seminar, the Getty Center for the Visual Arts, the American Historical Association, the Social Science History Association, and the University of Turin for their insightful contributions.

In Italy, I owe a debt of gratitude to friends and colleagues who made two long stints of living, research and writing there also years of fun and exposure to contemporary Italian society and culture. Rosa Otranto, Anna Foa, Kenneth Stowe, Susan Filter, Terry Little, Joao Mateus, Claudia Papetti, Alfredo Granito all opened their homes and hearts to an American abroad.

The years of writing this book have been rich in friendship and I am glad to thank those who surrounded the project with companionship. In the East, Michael Berkowitz, Hilary Kunins, Joel Westheimer, Sally Gottesman, Rachelle Abrahami, Emily Liman, Photini Sinnis, Marc Schachter, and Larry Glickman enriched life in my home away from home. In the West, Amy Green, Steven Aron, Robin Berman, and Kristin Pankonin have convinced me that my new home is a home.

To my family, Nelson Stone, Dolores Stone, and Julian Stone, I owe a debt of gratitude for supporting me in this quest. This book is dedicated to them.

. THE PATRON STATE

■ ■ ■ ■ ■ CHAPTER ONE

Introduction

ART HAS ALWAYS BEEN ONE OF ITALY'S GREAT SPIRITUAL
FORCES, EVEN IN PERIODS OF POLITICAL DECADENCE,
EVEN IN ERAS DURING WHICH ITALY WAS A DIVIDED
NATION. TODAY, IN CONTRAST, ITALY IS A GREAT NATION.
IN SUCH CONDITIONS, I LIKE ART EVEN MORE BECAUSE IT
IS NOT TIED TO A PERIOD OF DECADENCE, BUT TO A TIME
OF POLITICAL AND MORAL ASCENDANCY.

Benito Mussolini[1]

THE twentieth century is littered with the debris of
regimes that recruited the arts to give representation to the new worlds
they promised. Adolf Hitler, the would-be landscape painter, imposed his
preference for hyperreal images of German soldiers, heroes, and maidens
upon National Socialist official culture. The aesthetic legacy of the Third
Reich, from Arno Breker's and Josef Thorak's bronze and marble Aryan
supermen ready for war to Adolf Ziegler's air-brushed blonde nudes,
when not denounced as a provocation to humanity, stand as monuments
to kitsch. Josef Stalin, once rid of the revolutionary avant-garde, promul-
gated a Soviet culture of stylized illustrationism easily read by (and ridi-
culed by) the masses. By now, these dictatorships can be identified by
their aesthetic choices—choices that in many ways have come to be a
shorthand for, or distillation of, the excesses they committed.

The dictatorships of the twentieth century all located aesthetics at the
core of their centralizing drives. Under fascism, the arts played a deter-
mining role in giving form to rhetoric and ideology. As Walter Benjamin
first argued, the aestheticization of political life was the "logical result" of
fascist mass politics.[2] Fascism's cult of beauty and its declared transfor-
mation of life into art gave it the spiritualism with which it proposed to

supersede the materialism of liberalism and communism.[3] As an ideology and a politics, Fascism proposed to "conceive of the entire space of life as the object of aesthetic experience."[4] As such, Fascism was a totalizing project steeped in aesthetics. Fascism's mythmaking, antirationalist, and aestheticized politics required a vast aesthetic overproduction to color its lived experience and to make good on the promise of a transcendent reality. Thus, artists, as aestheticians with the power to render the world "beautiful" and transcendent, held a special place in Fascist thought and practice.[5]

When looking at the cultural politics of the authoritarian and totalitarian regimes that dominated the European landscape in the period between the two world wars, Fascist Italy presents a paradox. The paradox of Fascist culture betrays available shorthands such as "Fascist realism" or "Mussolini modern." Twenty years of Fascist dictatorship left behind a body of artistic production that permits neither simple formulas nor easy judgments. No one style, school, or monument summarizes the patronage practices of the Fascist state. Rather, the official culture of Italian Fascism is best defined by its diversities, contradictions, and ambiguities. The cultural politics of the Fascist dictatorship followed neither the market-fueled pluralism of the liberal democracies nor the centralized antimodernism of totalitarianism. For the greater part of the Fascist era, the regime sought the cooperation and consent of artists, and the association between art and the state was one of mutual recognition and legitimation. The Mussolini dictatorship allowed artists to work and be supported without direct censorship (so long as they were not explicitly anti-Fascist). A large cross section of Italian artists and architects reciprocated by accepting the Fascist regime's patronage.

Italian Fascism with its futurist, syndicalist, and modernist origins offered little of the a priori aesthetic antimodernism and anti-avantgardism associated with Nazi Germany and the Soviet Union under Stalin.[6] Instead, arts patronage under Italian Fascism accommodated modernism and the avant-garde, adapting them to the Fascist cultural, political, and social context. The opposing aesthetics and legacies of the modern and the traditional, from futurism to neoclassicism to abstraction, all received state aid and support. Nondoctrinaire aid to the arts produced a state culture that simultaneously commissioned the glass and steel buildings of rationalist architecture and neo-Roman equestrian monuments. This pluralist approach arose out of Italian Fascism's decision to draw in, rather than alienate, artists and to encourage them to continue to produce art under the banner of Fascism. The regime's welcoming of a broad spectrum of artists and audiences produced a popular official culture, as the dictatorship balanced its interest in rhetorical propaganda with a desire

for critically acclaimed art and cultural programs that encouraged widespread participation.

It is the paradoxes, tensions, and inconsistencies that first confront the observer of the culture produced during the Fascist regime's twenty years' rule. A few such paradoxes open our journey into the particularity of the practices and choices that constituted official culture. For example, Armando Pizzinato, a painter from Venice, dedicated his life to abstract painting and the Italian Communist Party.[7] From September 1943 until the end of the war, he fought with the partisans and spent time in prison for his anti-Fascist activities. Yet for Pizzinato, who came of age alongside Emilio Vedova as an abstract painter in the late 1930s, the Italian Fascist dictatorship was "a decent patron" that "rarely discriminated."[8] He participated in the exhibitions of the Fascist artists' syndicates and found the Fascist bureaucrat who headed the Venice Biennale of International Art to be a "good fellow." As Nazi administrators purged the art of Metaphysical painter Giorgio De Chirico from public museums in 1936 and 1937, the Fascist government prized his work and located it at the center of its new state collections of contemporary art. In 1932, the exhibition promoted by the National Fascist Party to celebrate its tenth anniversary in power, the Mostra della rivoluzione fascista, commissioned artists of divergent aesthetic movements, among them futurist, rationalist and neoclassical artists; these artists, who held varying degrees of allegiance to the party, committed themselves to creating a modern, cutting-edge aesthetic for Fascism's anniversary celebration. Architects and designers executing Fascist-commissioned buildings proudly acknowledged the central inspiration of Soviet constructivists El Lissitzky and Konstantin Melnikov, as well as the modernist architects Le Corbusier and Walter Gropius.[9] In 1935, the Fascist-sponsored Venice Biennale film festival awarded prizes to Nazi, Soviet, and Palestinian-Zionist films. Max Reinhardt, the famous Weimar expressionist theater director, in forced exile from Nazi Germany since 1933, produced *The Merchant of Venice* under the auspices of the Fascist government at the 1934 Venice Biennale.

What do these facts tell us about the relationship between the Italian Fascist regime and culture? As a point of departure, they force a rejection of once fiercely held contentions that the culture of the Mussolini regime equaled an "art of the State" or that the regime promulgated a monolithic or consistent cultural vision. Rather, the seemingly inconsistent appearance of Fascist patronage reveals an evolving cultural politics shaped by conflicting factors. These factors were as varied as the search for critical and popular acclaim and the interest in the Fascistization and centralization of cultural production. What emerged out of the mix was a cultural policy of "aesthetic pluralism"—the Mussolini dictatorship's

practice of accepting and supporting a range of aesthetics. This Italian Fascist form of pluralism meant that multiple imageries and aesthetic formulations represented Fascism and were a part of its cultural system, its imaginary and its aesthetic universe.

This book confronts the distinctiveness and complexity of Italian Fascist arts patronage; it engages the conflicts attending the regime's use of culture in the search for consent and the simultaneous pursuit of a specifically Fascist rhetorical-aesthetic vision. The two impulses ran counter to one another, as an official policy of stylistic tolerance limited the production of a single "Fascist" style. Official culture (the culture bought or commissioned by the party or the government or displayed under its auspices) combined modern and avant-garde aesthetics, emerging mass cultural forms, and a discourse of national culture to produce, during the 1930s, many dynamic and vibrant products. These cultural products, and the institutions elevated by the party and government to promote them, such as exhibitions, expositions, and fairs, found a mass audience.

For artists, Italian Fascism's multivalenced approach to patronage translated into extensive funding free of stylistic directives. Whereas artists and architects could chose their styles, they could not pick their ideology or patron.[10] The regime offered cultural producers a Faustian bargain at seductively low interest: in exchange for state sanction, financial support, and a chance for stylistic experimentation, artists and architects accepted Fascism's role as patron, administrator, and arbiter. In the economic crisis of the 1930s, widespread state aid without stylistic contraints represented exciting possibilities for work that many artists found hard to reject. The era's various artistic movements—futurism, novecento, strapaese, scuola romana, among others—each accepted state patronage and each evolved its own response to the regime's rhetorical demands.

In its search for responsive publics, Fascism challenged the social boundaries of culture, introducing new social groups, such as the urban and rural lower-middle and working classes, to unfamiliar cultural experiences. State patronage also meant the centralization of cultural institutions, as the regime built national institutions, such as the Venice Biennale and the Roman Quadriennale, to replace the local and regional ones of Liberal Italy. For audiences, Fascism's eclectic approach to culture meant consumption of significant amounts of official rhetoric. But it also involved exposure to new and experimental cultural experiences. Fascist culture experimented with inherited cultural forms. It accepted recent and still controversial art forms, such as film, into high culture, and it expanded and diversified mass culture.

Between 1925 and 1943, the cultural politics of Italian Fascism replicated the dictatorship's political and ideological shifts as it moved from consol-

idation to stabilization to war. Fascist patronage had three distinct phases, each with differing priorities and strategies. After an initial period of bureaucratic overhaul and restructuring, the regime began a phase of cultural experimentation, and finally one of radicalization and a "battle for culture." In the period of stabilization (1925–30), the bureaucracies of the party and the government sought to appropriate the prestige and legitimacy represented by established institutions of high culture. This first phase comprised an initial period of bureaucratization and centralization, including the introduction of government and party personnel into cultural production and the creation of the Fascist artists' syndicates to regiment professional life.[11] In the second phase (1931–36), the regime intervened to shape the content and social bases of cultural institutions through a policy of incentive, patronage, and experimentation. The high point of aesthetic pluralism, this period was characterized by Fascism's goal of attracting large audiences and the support of cultural producers for official culture. During these years, Fascist culture reached a functioning equilibrium, boasting a broad spectrum of artists and catering to the cultural tastes of a significant portion of the population. The final phase (1937–43) witnessed the fragmentation of the Fascist aesthetic pluralist "moment" into cultural fiefdoms, each promoting its own cultural politics. Responding to pressures such as the war in Ethiopia, the alliance with Nazi Germany, and the growing power of a pro-Nazi faction within the Fascist Party hierarchy, the regime adopted a more coercive patronage style. In its final years, the dictatorship drew on imperial and National Socialist models, abandoning, to a large extent, the eclectic appropriation that had provided the cultural consensus it originally had sought.

While this book focuses on the practices and policies of official culture under Fascism, it also challenges reigning orthodoxies regarding the ways in which dictatorships in the twentieth century mobilized the arts. After World War II, the codings of abstract art versus representational art allocated aesthetic languages and artistic movements ex post facto moral characters. Due in part to its denigration at the hands of the Nazis, modernism was declared sacrosanct following the defeat of Nazism and Fascism and baptized as antithetical to dictatorship. Because of the horrors committed by regimes that had used monumental representational art to celebrate their ideologies, many in the cultural world of the postwar West declared monumentality and representation inherently totalitarian and its opposite, abstraction, necessarily democratic.

Modernism and its offshoots, from abstraction to neorealism, their postwar designations notwithstanding, were not genetically antifascist. As we will see, such styles were successfully enlisted into the authoritarian project by at least one fascist regime. In the Italian case, the symbiotic

relationship of fascism and elements of avant-garde culture continued well after the seizure of power. These expressions were fundamental to official cultural life, as the widespread use of futurism, constructivism, and functionalism in the official culture of Fascist Italy bears witness.

The regime posited this accommodation with modernism as a resolution of the tension between vanguardism and the state that characterized culture in many European nations between the wars. With a hybrid form of state patronage, Italian Fascism became the force able to rationalize contrary aesthetic languages—as well as opposing views of life. Fascist culture posited the notion that the distance that had evolved in the twentieth century between critical avant-garde art and the state could be collapsed in Italy within the confines of state structures. Of course, the strong vanguardist element of Fascist practice and theory reinforced its appropriation of vanguardist art. In fact, segments of the Fascist hierarchy celebrated the regime's unique ability to bring the cultural avant-garde into official culture.

Modernism and its practitioners were far more malleable than is generally assumed. Thus, an important corollary of this work is to assess critically the participation of modern movements and artists in Fascist culture. In its search for a representative aesthetic language, the regime, for a time, gave special sanction to a number of previously marginalized modernist and avant-garde movements (though always with the simultaneous presence of bombastic neoclassical and "Roman" styles). Because of the association of modernism with trans-European iconoclasm and antibourgeois movements, the union of Fascism and modernism has been ignored because it is uncomfortable. As this and other reevaluations of Italian Fascist culture reveal, Fascism accepted and, intermittently, appropriated modernist aesthetics in architecture, painting, design, and cinema.[12] Photomontage, constructivist design, futurist syntaxes, and International Style–influenced architecture contributed to Fascism one of its defining identities.

Fascism and variants of modernism worked together and mutually benefited from the relationship. Despite the undeniable contribution of many futurist artists and rationalist architects to Fascism, their role was ignored out of a postwar desire to maintain modernism's moral edge, to avoid ambiguity, and to create viable and strict categories of collaboration and resistance. Nonetheless, Marinetti and the futurists cannot be divided into a "good," authentically modern, early period (pre-1914 and non-Fascist) and a "bad" post-1922 period, and architects such as Giuseppe Terragni and Adalberto Libera must be located in a larger European modernist tradition.[13] Certainly, artists and architects working for the Fascist dictatorship produced a deracinated modernism, distanced from

its political and social origins. The Fascist modernists' qualifications as being genuinely avant-garde remain open to question, but their use of the forms and elements of modernism must be faced to understand modernism's own trajectory through the twentieth century.

Most of the art produced in Italy between the world wars occupied a space between concurrence with and rejection of Fascism's ideological and rhetorical imperatives. Given the flexibility of much Fascist patronage and the widespread participation of artists and architects, the established polarity of collaboration versus coercion fails to explain the process of cultural production. Affiliation and/or accommodation was the operative choice of the majority of Italian artists. A difficult and morally uncomfortable category to define, it was, in many instances, more passive than collaboration and entailed a more active commitment than that produced through coercion. The cultural bureaucracies of the party and the government—from the Ministry of National Education to that of Press and Propaganda—created an environment for the production of official culture in which the working conditions were too good and the obstacles too few. The trajectory from collaboration or accommodation to resistance was common among Italian artists and architects; the now well-known experiences of Giuseppe Pagano (1896–1945) and Renato Guttuso (1912–87) provide two prominent examples. Pagano spent the ventennium as Italy's most vocal proponent of rationalist architecture, urging the dictatorship to adopt it as an official style and celebrating it when it did. In 1943, Pagano, having completed his voyage through Fascism to anti-Fascism, was arrested by the Nazis for antifascist activities. He died in the Nazi concentration camp of Mauthausen in 1945. Guttuso, a generation younger than Pagano, trained under Fascism, accepted its patronage and evolved his Picasso-inspired social expressionism and his Communist politics in response to the regime's failings and collapse.

Recent scholarly work on daily life under totalitarian and authoritarian regimes dissolves the once rigid categories of collaboration or resistance, coercion or consent into much grayer conceptions. As James von Geldern writes about Soviet Russia, "the belief that the Soviet system rested solely on institutions of power and that its foundation was a systematic ideology has been shaken, allowing historians to reach a more layered and nuanced understanding. . . . Official culture used to be dismissed as political hackwork, yet under scrutiny it has yielded many insights into the society that produced it."[14] Herman Lebovics, assessing Vichy France, also rejects earlier divisions for nuance: "This simple moral trinity—collaborator, opportunist, resistant—cannot contain what we now are beginning to know about the elaborate and subtle scale of responses and initiatives—both structurally facilitated and individually essayed—which

made up public life under Vichy."[15] The manifold and diverse possibilities for accommodation and coexistence that were fundamental to the functioning of authoritarian and totalitarian societies must be assessed in order to confront the culture produced in their names.

Fascist Culture, or Culture under Fascism

Only as we begin to gain distance on the past four decades do we see the ways in which the cold war saturated all aspects of intellectual life. Not surprisingly, the study of fascism was among the most constrained by the pressures of bipolarity. The post–World War II political and moral settlement stood on a set of dichotomies: fascist and antifascist, totalitarian and democratic, and, in the sphere of the arts, reactionary representational aesthetics and modernist democratic abstraction. Imbedded in the settlement was an American and western European understanding that fascism had been a bacillus produced in the wake of World War I and destroyed on the battlefields of Europe and Asia. The necessities of cold war ideology allowed fascism no deep past, present, or future, no precedent or antecedent in Western culture.

The historiography of the immediate postwar decades labored to isolate the germ in the diseased National Fascist Party and the National Socialist Workers Party or in a particular class or clique. By the 1960s, this intellectual quarantine was no longer viable. The search for the causes of the rise and triumph of Fascism and Nazism then embraced the flawed paths to modernity or democracy or capitalism or psychic development on the parts of Italy and Germany. With the 1970s, it became possible to broaden our understanding to the complexities and contestations of fascism as a political ideology and a governing practice. Scholars introduced readers to the possibility that fascism represented a set of ideas and a political system consented to, and even desired, by many.[16] From diverse points on the political spectrum and with varied motivations, scholars reconceived postwar understandings of Fascism and Nazism. In Italy, Renzo de Felice analyzed the Mussolini dictatorship as having a viable ideology and political system, and by the 1980s revisionist German historians declared their intention to put Hitler in "historical context" and to "normalize" the Nazi era.[17] Others, such as Detlev Peukert, rejected the "utterly evil fascist and wholly good anti-fascist" divide, looking instead for the multivalenced anxieties unleashed in the "crisis of modernity."[18] Zev Sternhell pushed back fascism's ideological origins to the nineteenth century and moved its breeding ground west to France.[19]

The study of the relationship between Italian Fascism and culture fell under the larger epistemological rubric and adopted its contours. The earliest studies classified the cultural artifacts produced during Fascism as either the "hackwork" of regime propagandists, devoid of intrinsic aesthetic value, or as works of "pure art," isolated from political and social conditions.[20] For both of these groups, the regime's interest in culture was purely instrumental and functional, with official intervention in cultural affairs aimed at the singular goal of cementing an unwilling populace to the dictatorship. At first, then, debates over Fascism and culture rejected the notion of "Fascist culture," holding that the Italian Fascist regime was fundamentally anticulture in character, with its cultural directives used for the sole end of subordination.

Postwar interpretations of culture under Fascism reflected larger rifts dominating Italian attitudes toward the nation's recent past. Politicized and emotionalized debates over Fascism and culture of the immediate postwar decades argued across the Crocean-idealist and Marxist divide, with each side demonizing the dictatorship to an extent that precluded further examination.[21] For the Croceans, "true" culture created between 1922 and 1945 necessarily transcended political realities and responded to timeless aesthetic categories.[22] Remaining "uncontaminated," Italian culture waited in a holding pattern for the fall of the dictatorship in order to resume its authentic trajectory. This interpretation had the convenient corollary that "true culture," by definition, was estranged from the rhetorical propaganda that made up official culture; therefore, the cultural forms produced in the service of the regime or under its umbrella a priori could not be considered "art," nor could its practitioners be called "artists."

The immediate postwar Marxist position, intricately bound up in the partisan experience, saw Fascism's relationship to culture as it did its relationship to society—namely, as the superstructure over the base of a reactionary capitalist dictatorship. Here Fascist cultural policy directly replicated larger processes of domination and control; its official culture obfuscated reality and confused audiences with distorted perceptions. This perspective overlapped with that of the idealists in denying the relevance of the relationship between Fascism and culture and in using the term "Fascist culture" to refer to only the most base propaganda transmitted purely for the purpose of indoctrination and suppression.[23] Neither perspective allowed the cultural products of Fascism an existence beyond crude, propagandistic reflections of the dictatorship's political exigencies. Thus, Norberto Bobbio argued that "Fascist propaganda solidified very quickly. . . . They repeated the same formulas for almost twenty

years, combining in various ways not more than one hundred words."[24] The Marxist interpretation, because of its moral weight and association with partisan revolt and antifascist rebellion, dominated the Italian postwar intellectual climate.[25] The totalitarian school of the 1950s, which interpreted Fascist Italy as a failed totalitarian regime, also neglected to look beyond the repressive and terroristic force of Fascist culture.

Out of the tradition of Western Marxism came the first analyses to push beyond the reductionist dichotomy of art versus propaganda. Studies in the Gramscian tradition offered the initial insights into the superstructural components of Fascist hegemony and the regime's complex mechanics for binding diverse social classes and groups to its project. By the late 1960s, calls for moving beyond "certain suppositions that perhaps would be better called prejudices" began to dominate the field.[26] Nicola Tranfaglia, in one of the first of many such investigations, argued that the study of Fascism and intellectuals had been "paralyzed."[27] Given the fact that only 11 out of 1,200 Italian university professors refused to sign the Fascist oath in 1931–32, the issue of the accommodation between intellectuals and Fascism was an obvious first place to appraise the regime's mechanics of co-optation and consensus.[28]

But, even after scholars reconsidered the nature of the dictatorship and the means by which it bound intellectuals and other pivotal social sectors to it, the study of culture under Fascism remained crippled by a taboo against accepting the cultural products as viable, aesthetically pleasing, or critically successful—as though acknowledgment would lead to apology or resurgence. Reticence to face the ambiguities of cultural production in Fascist Italy led to an interpretive gap in the scholarship of culture under Fascism between "high" and "low" culture. Forms of low or mass culture, such as radio, newspapers, and cinema, seen as the primary loci of Fascist manipulation and exploitation, became fertile ground for analysis.

Nonetheless, high culture remained controversial territory. Art history, when it did confront Italian art of the 1930s, focused on elements of high culture considered untouched and untainted by Fascism. The work of the few artists interpreted to have remained isolated from Fascist patronage, such as Amadeo Modigliani, Giorgio De Chirico, and Giorgio Morandi, received particular attention.[29] Through the 1970s art historians neglected as tainted by Fascism and propaganda artists whose careers intersected more obviously with the dictatorship. As a result, they ignored the era's seminal artists and movements. As Guido Armellini noted, addressing the work of Carlo Carrà, Mario Sironi, and Ottone Rosai: "the connections between their work and the birth and triumph of Fascism are often wrapped in a veil of shame."[30] "For almost forty years," writes Raffaele De Grada, "the novecento movement was considered by

[Italians], and consequently abroad, as a reactionary artistic and cultural phenomenon, completely tied to Fascism."[31] Only in the 1970s and 1980s did art history resurrect and place in historical context central figures of twentieth-century Italian (and European) art such as Mario Sironi, Giuseppe Terragni, and Achille Funi and movements such as "second wave" futurism, rationalism, and the novecento.[32] Only in the last few years, artists such as Sironi (1993) and Terragni (1996) have received their first major national retrospectives.[33]

Reassessment of both the cultural bases of Fascism and social responses to it owes much to Renzo De Felice's reinterpretation of Italian Fascism begun in the late 1960s. De Felice's publication of *Le interpretazioni del Fascismo* (1969) and his multivolume study of the Mussolini dictatorship (1965–95) disputed the accepted canons on the regime.[34] De Felice argued that Fascism achieved tangible popular support, above and beyond the kinds of adhesion produced through coercion and domination. Because a form of "consensus," as De Felice termed it, emerged during a part of Fascism's rule, the dictatorship must be assessed seriously as a functioning political system. Rejecting the notion of Fascism as a "nonideology," De Felice countered with an interpretation of Mussolini as the leader of an authentically revolutionary movement.[35]

De Felice's reevaluation of the Mussolini dictatorship spurred scholars to rethink the regime's relationship to society and culture. The implications of De Felice's consensus theory and its concomitant disassociation of Italian Fascism from National Socialism provoked a broader scholarly revisitation of the period. While the first reappraisals came in the areas of ideology, education, and political organization, the Fascist regime's own declaration of "going out to the people" stimulated investigations beyond party and ideology and into the areas of cultural and social life.[36] Victoria de Grazia in *The Culture of Consent* analyzed the mechanics of the regime's mass working-class leisure organization, the Dopolavoro. She revealed that Fascism's mass organizations—the supposedly strongest nexus between the dictatorship and its publics—were shaped from below as well as from above and characterized by an essential condescension toward those very masses.[37] De Grazia exposed the limits of Fascist mass mobilization: limits imposed by the regime's interests; its appropriation of preexisting cultural forms and institutions, which precluded the formation of "total" Fascist identities; and the circumscribed level of mass engagement in the projects of the dictatorship. Above all, de Grazia's work highlighted the ambiguities, pluralities, and indecisions that made up Fascist culture. In the realm of the culture industries, David Forgacs developed further the negotiated character of Fascist cultural policy, reminding us that "there tends always to be a reciprocal play of interests

between cultural entrepreneurs and political forces. . . . in the Fascist period, despite the directive role which the state assumed during the thirties, relations between political forces and the private cultural industries continued to be negoitated relations, involving conflicts of interest and mutual support and not just a passive dependency of culture on the state."[38]

In the past two decades, the dichotomy of "art" versus "propaganda" under Fascism has been blown open and deconstructed in a range of disciplines—from history to art history to film and literary criticism.[39] Where scholars once saw Fascism's cultural policies as based on an unchanging rhetorical foundation or on a totalitarianizing mission, they now view the regime as maintaining a series of shifting goals and rhetorical priorities.[40] In addition, recent studies expose Fascism's variegated cultural roots and influences; Walter Adamson, Emilio Gentile, and others have detailed Fascism's hybrid cultural character and its ability to draw support and inspiration from a variety of cultural elites—from modernist to futurist to nationalist.[41]

Picking up where these works left off, *The Patron State* analyzes the process whereby Fascist culture, as an unstable and changing formulation, translated into an actual patronage practice. How did a regime with many different cultural influences and pressures from outside and inside the offices of the party and the government produce an official culture? What held it together and what pulled it apart? This book broaches an answer by analyzing the factions, visions, and motivations that drove cultural policy. It is my argument that Fascist cultural policy was forged from a range of forces—the regime (with its own composite character at the level of ideology and practice), cultural producers, the emergent cultural industries (such as film, radio, and mass publishing) and, last but not least, the public. The Fascist regime juggled competing cultural visions and worked with many cultural components and influences. The multiple aesthetics of Fascism circled around a core based on the nation and the leader and assimilated the shifting requirements of italianità, romanità, empire, and war.

The Patron State addresses the gaps in the study of cultural production and reception in Fascist Italy. The relationship between bourgeois high culture and Fascism has been neglected, despite the insights this relationship offers for the regime's consolidation and stabilization in the 1930s.[42] Further, the audiences for official fine arts culture and the ways in which the regime catered to diverse publics have been ignored. This book addresses the ways in which the regime pursued and co-opted bourgeois elites and a growing population of cultural consumers, as well as cultural

producers. This is not a study of a particular group of artists or movements or of a ministry, but a critical history of Fascist patronage.

The Fascist regime's eclectic arts policy arose out of its pursuit of consent, its hybrid cultural influences, and its nonmonolithic understanding of the possibilities for an aestheticized politics. Taking as a foundation Antonio Gramsci's distinction between "force" and "consent" in the construction of a hegemonic rule, this book explores an instance of Fascist dominance obtained through ideological and cultural means.[43] The consensual aspect of Fascist control has been given a multiplicity of readings, some of them rejecting Gramsci's functional construction, but accepting the proposition that Fascist stabilization grew out of consent. De Felice termed the middle 1930s the "years of consensus," meaning that, for a time, the majority of the population conceded to the rule of the dictatorship out of joint purpose, rather than fear.[44] For Victoria de Grazia, writing in reference to the Dopolavoro, the term "consent" refers to Fascism's changing attempts to "forge responsive constituencies" out of classes originally opposed to it and the dictatorship's acceptance of a complex formula of persuasion and intervention, instead of force, in its effort to govern in a period of economic dislocation.[45] These interpretations apply the term "consensus" to the equilibrium, stability, and neutralization of dissent experienced in Fascist Italy in the middle 1930s through means other than outright state repression. At the same time, the quality and character of this consensus must be considered in the light of abolished opposition parties and unions, special tribunals, a network of party organizations that coordinated all social strata, and a monopoly over the schools, the press, and the radio.[46]

For the purposes of this study, the term "consent" carries a different meaning when applied to cultural producers and cultural consumers. For the producers—that is, artists and architects—the regime measured consent by participation in Fascist-sponsored institutions such as artists' unions and exhibitions. Since the dictatorship failed to designate a stylistically uniform Fascist art, it focused on producing Fascist artists through professional regimentation—through participation in Fascist artists' unions and in Fascist-sponsored projects. Consent on the part of artists involved a dialectic of legitimation in which the dictatorship offered artists official commissions and a livelihood, often with few aesthetic constraints in exchange for artists lending their prestige and work to the state's projects. This process of mutual legitimation indebted artists economically and professionally to the dictatorship and tied the dictatorship to participating artists by habitualizing it to a level of prestigious and critically acclaimed art. Of course, the art created in this process was

mobilized into the vast propaganda apparatus from which the regime drew strength.

Clearly, not all consenting artists were tied equally to the Fascist project. Those who pursued government and party commissions accepted Fascism's rhetorical claims and aligned their careers with the regime, while artists who displayed their work in the Fascist-sponsored art exhibitions above all agreed to professional regimentation and dependence on a new patron with its own agenda. After 1936, when its willingness to secure the consent of artists conflicted with its intensifying propaganda demands, the dictatorship became a more coercive patron. As priorities shifted and Fascist culture demanded explicit representations of *italianità* (Italianness), *romanità* (Romanness), empire, war, and autarchy, artists still within the system had to adjust their work accordingly in exchange for official support.

For the audiences of official culture, consent presents a more difficult meaning to probe. Audience response is at once elusive and critical to an understanding of Fascist culture. The nature of the sources makes it difficult to measure audience reaction. The fact that the press was government controlled or monitored means that even art reviews must be read through the lens of official influence. Attendance figures for official events, the class composition of audiences, and the regime's interpretation of the audiences' experience all offer clues to the reception of Fascist culture. Cultural consumers attended Fascist-sponsored events in high numbers for a variety of reasons, not the least of which was official attention to cultural tastes. The offices of the party and the government measured success by attendance figures and pursued increased numbers through a redefinition of Italian culture and an expansion of the social bases of culture. As I demonstrate, by promoting national culture and mass culture, the dictatorship both responded to a number of preexisting cultural trends and encouraged new cultural habits and practices.

Exhibiting Culture

Exhibitions, as places of cultural exchange, together with the practices and institutions of patronage such as commissions, competitions, and artists' unions, were major locations for the unfolding of Fascist arts policy. Exhibitions constituted a central element of Fascist public culture and represented a meeting point for the dictatorship, the producers of culture, and the consumers of culture. Fascism's shifting cultural priorities are measurable in its relationship to exhibition artists and audiences.

Recent scholarly work in cultural studies and postmodern theory suggests that exhibitions are particularly revelatory forms by virtue of their ability to attest to shifting patterns of spectatorship, patronage, and cultural consumption. Historians, art historians, and cultural studies scholars have turned to national and international exhibitions as sites for the identification and deconstruction of cultural exchange and ideological transmission.[47] While Fascism experimented with the institution of the exhibition and put it to new uses, exhibitions had played a central role in Western national self-representation from the mid nineteenth century forward. With the expansion of the public sphere that accompanied the Industrial Revolution and the emergence of the Liberal state, many Western societies used exhibitions to represent political, social, and economic ideologies. In the wake of the highly successful British Crystal Palace exposition of 1851, governments from monarchies to parliamentary democracies to dictatorships devoted increasing amounts of money and attention to national and international industrial and art shows. From the American celebrations of westward expansion to the British glorifications of industry and empire, exhibitions introduced many people to the dominant narratives of their respective societies. In both Europe and the United States, the 1920s and 1930s were decades in which exhibitions played a central cultural and ideological function, as they offered messages of national unity and strength in a time of social, economic, and political crisis.[48] The Fascist regime organized an ever growing number of exhibitions during its rule. It celebrated its ability to promote a vast and varied exhibition culture. "During the regime's eighteen years," wrote art critic Arturo Lancelloti in 1940, "the party and other institutions . . . [have promoted] a level of art, historical, and industrial exhibitions, always extravagantly prepared, that have no equal in the world."[49] As early as 1933, one observer saw the flowering of a rich exhibition culture as proof of a Fascist cultural renaissance: "A series of regional exhibitions from 1926 until today—the Roman Quadriennale, the three magnificent editions of the Venice Biennale and the Mostra della rivoluzione fascista—are impressive affirmations of a revived faith and of the need for new and vibrant events."[50] The regime celebrated an official public culture of exhibitions, calling their proliferation the visible "accomplishments" and "reflections" of Fascist cultural intervention.[51]

Exhibitions, as they developed during Fascism, played a central role in its aestheticized politics; or, as Boris Groys has written of totalitarian culture in general, they were part of an "attempt to create a single, total visual space within which to efface the boundary separating art from life, the museum from practical life, contemplation from action."[52] Fascist exhibitions were designed to represent and define the cultural sphere.

Within this, exhibitions played a variety of purposes: (1) they were primary sites of state patronage; (2) they opened the social boundaries of culture to the mobilized masses; (3) they offered a location for the appropriation of the cultural identities and cultural capital of preexisting elites; and (4) they courted the participation of cultural producers. "Exhibitions could at once engage artists and large audiences," as Giuseppe Pagano declared in 1937, "one could make valuable and indisputable arguments to show how an exhibition, when directed by strict artistic criteria, educates the aesthetic sense of the masses and becomes a historic stage in the progress of contemporary art."[53]

As nationally publicized events, often held in Rome, exhibitions fit into the regime's project of creating a unifying national culture. As public cultural events, they were open to all. In this way, state sponsorship of exhibitions was connected to the larger struggle over public space and the public sphere. Through official culture, the regime worked to appropriate the public sphere as a site of Fascist representation and commemoration. Exhibitions are flexible forms—screens onto which a range of narratives can be projected—and they can be reconceived as political and cultural agendas shift. Fascist-sponsored exhibitions merged the core components of official culture—the arts, film, radio, tourism, entertainment, propaganda. Exhibitions responded to Fascism's essential publicness and the theatricality of its aestheticized politics. They also provided the regime with a tool with which to create a mass audience in a controlled and orchestrated manner and to coordinate crowds in a way that demonstrations could not. Like demonstrations, exhibitions introduced large crowds to ideas and ideologies in an emotional and public atmosphere. Also, as with demonstrations, exhibitions, in their development in the 1930s, provided movement, the rousing of passions, and an eventual epiphany.

The relationship between Fascism and exhibitions lay at the very origins of the movement. The aesthetics of Fascism, from the beginning, entailed public aesthetics—the aesthetics of the street, of the futurist living drama, of the D'Annunzian melodrama. Gabriele D'Annunzio's nationalist, romantic poetics joined futurist and modernist critiques of the decayed, static and materialist character of the culture of Liberal Italy to shape the spiritualized aesthetic underpinning of Italian Fascism.[54] As George Mosse and Emilio Gentile have detailed, public aesthetics, driven by nationalism and brought to life by Fascism, took form in the shape of myths, rites, symbols.[55] The Fascist government and party developed a series of vehicles, from mass demonstrations to festivals to exhibitions, for its public, national cult. A reviewer celebrating the Mostra aeronau-

tica of 1934 put it thusly: "the exhibition that is hoped for and wanted today is not a museum; there must be created around dead things a climate of life."[56]

From its theatrical inception in the streets of Milan, Fascism asserted the power of an aestheticized politics. The Fascist dichotomies of action/ stasis, violence/weakness led to a fetishization of action/emotion. D'Annunzian and futurist rhetorics gave Fascism inspiration in its blending of art and life. Yet, the assumption of power required that the cult of action and its aestheticized politics be choreographed, contained, and reconfigured into Fascist governance. Fascism's mobilization of the masses stimulated the channeling of politics into hierarchical expressions of theater and rite—in which many participated, but few acted.

In exhibition culture, more than in any other aspect of official culture, the regime incorporated aspects of futurism's violent rejection of the established institutions of Italian culture and its search for innovative and interactive forms. The futurists, led by F. T. Marinetti, were the first group to pledge its allegiance to the nascent Fascist movement in the months after World War I. They attended en masse the March 23, 1919 street demonstration where Mussolini announced the birth of the Fascist movement. For the futurists, Liberal Italy's ossified culture of museums and operas had to be destroyed as the remnants of a decayed society.[57] Claiming "we want to destroy the museums, the libraries, the academies of every type," the futurists declared war on the traditional institutions of Italian high culture.[58] As a replacement, futurism advocated temporary cultural forms and shocking new uses of spectacle and public space— culture had to move into the streets. The "futurist soirées" and "synthetic theater" made the public "a counterpart of the aesthetic operation, a reflection that was part and parcel of the operation itself."[59] The group spoke of placing the public "in the middle of the picture" and of elevating a new art-life relationship.[60] Exhibition culture under Fascism took up these challenges.

Chapter Overview

The Patron State combines sections on individual cultural institutions with larger discussions of Fascist cultural ideology, bureaucracy, and policy. Each of the next six chapters is organized both thematically and chronologically. Chapter 2, covering the years 1925 to 1930, focuses on early Fascist cultural politics and on the first articulations of Fascist cultural intervention. This section examines the initial tentative

search for a Fascist aesthetic and the application of corporatism to the art world in the form of the Fascist artists' unions. Although the regime never determined an "art of the state," the search for a uniquely Fascist aesthetic occupied the arts bureaucracies and many of the era's artists and critics. Some groups, such as the futurists and the rationalists, declared that their versions of European modernism were the only movements worthy of the title. Others, such as the novecento and the strapaese, called for the elevation of art tied to Italian and historical styles. A national debate ensued between modernists, traditionalists, futurists, and neoclassicists. This chapter lays out the debate over an "art of the state," its lack of resolution, and its impact on the delineation of Fascist cultural politics.

Chapters 3, 4, and 5 address the apex of Fascist aesthetic experimentation and Fascist modernism, the early and middle 1930s. Here the book assesses official patronage as measured by the volume and recipients of government-sponsored arts competitions, purchases, and commissions. These chapters provide case studies of Fascist high and mass culture and public responses to the expansion of official culture. Chapter 3, on the triumph of aesthetic pluralism, details the mechanics of state support for the arts during the early and middle 1930s and the strategies devised to attract artists and spectators—from official acquisitions and prizes to government and party-sponsored theme competitions.

Chapter 4 demonstrates the ways in which the Fascist Party and government pursued larger audiences by appealing to cultural tastes, by widening the social boundaries of culture and mobilizing new forms of spectacle and cultural consumption. The art exhibitions of the 1930s presented themselves as national events open to all responsive Italians. Unwilling to forgo the legitimacy offered by high culture's cultural capital, Fascist-sponsored art exhibitions negotiated a limited transformation in which some mass forms and larger audiences participated. In addition to focusing on the blurring of distinctions between high art and mass culture, this chapter debates the meanings of Fascism's elevation of various forms of public art—murals, mosaics, public sculpture—and the effect this had upon state patronage and the artist's role under Fascism.

Chapter 5 analyzes the construction and reception of Fascism's most successful and experimental propaganda exhibition—the Exhibition of the Fascist Revolution (Mostra della rivoluzione fascista) (1932). This multimedia celebration of the tenth anniversary of the assumption of power represented the regime's perfection of the mass culture exhibition. Here the Fascist Party reconceived the genre of the propaganda exhibition and located it at the center of its mass culture program, using it as an

orchestrated rally. Such events in the mid 1930s were based on a formula of modern aesthetics, emotionalized and mythmaking ritual, and crowd-pleasing entertainment. With the series of National Fascist Party extravaganzas, beginning with the Exhibition of the Fascist Revolution, Fascism offered a modernist *Gesamtkunstwerk*, blending rite, drama, art, propaganda, and entertainment into a total experience. The multidimensional exhibitions combined modern aesthetic developments and conceptions that sought to lift the spectator out of daily experience into constructed psychological environments. Taking inspiration from expressionist theater, avant-garde cinema, and constructivist design, these exhibitions blurred the space between viewer and object, producing the tension and ambiguity characteristic of modernist culture. After 1932, political exhibitions, new forms without past associations, became loci for regime-promoted cultural experimentation. In its popular and critical triumph, this exhibition reveals the dictatorship's success in creating an official culture that both met its political and propaganda interests and responded to the cultural tastes of a cross section of the population.

The final two chapters focus on the cultural impact of the Fascist alliance with Nazi Germany, the regime's political crisis, and World War II. Geopolitical factors, such as the invasion of Ethiopia, the declaration of empire, and, ultimately, the alliance with Nazi Germany, as well as an internal radicalization within the Fascist hierarchy, fueled a "battle for culture" between advocates of censorship in the arts and those supporting continued stylistic pluralism. These sections emphasize the changes in cultural forms and aesthetic choices brought about by ideological and political shifts internal and external to the dictatorship. Chapter 6 lays out the "culture wars" fought between the pluralist and antipluralist factions of the Fascist bureaucracies and the impact of bureaucratic discord on the making of official culture. This chapter centers on the collapse of the earlier consensus surrounding official culture and on the subsequent decline in the participation of cultural producers and consumers.

Chapter 7 examines the official theme exhibitions that followed the 1932 success of the Exhibition of the Fascist Revolution. Between 1934 and 1938, official arts policy replaced the tension and experimentalism of the mid 1930s with an increasingly spectacular, didactic, and rhetorical culture. In an effort to "sell" the coming world war and the alliance with the Nazi regime, official culture emphasized monumental and imperial art and architecture, stressing militarist and racial images. For its final acts of patronage and self-representation—the exhibitions of the Circus Maximus and the 1937 version of the Mostra della rivoluzione fascista—the Facist regime abandoned the formula of avant-garde aesthetics and mass

culture entertainment, which had served it so well in the early 1930s. The static and didactic exhibition format, devoid of the tensions and ambiguities implicit in the modernist/*Gesamtkunstwerk* type, failed to appeal to a mass audience. The sense of "event" ripe with possibility, which had coexisted with the more explicit propaganda of earlier official culture, disappeared after 1937.

Bureaucratization, State Intervention, and the Search for a Fascist Aesthetic

ITALIAN Fascism commenced its cultural politics with a challenge to the structures of cultural display and distribution. The cultural bureaucracies and administrators of the Fascist dictatorship turned first to institutional reform, rather than promote or celebrate particular aesthetics or genres. The beginning years of Fascist cultural intervention, 1922–30, focused on government and party involvement in preexisting institutions of high and mass culture, on the creation of new institutions where a lack was perceived, and on the professional organization of cultural producers. While the regime sought control over the means of representation, the style of representation remained open and an open question.

Fascist culture originated in a contest for control of the structures of representation. "The struggle," as Ivan Karp and Steven Lavine have written, "is not only over what is to be represented, but over who will control the means of representing."[1] In fact, the issue of "what" Fascism should represent was not broached until it resolved the "how" of artistic display. Official power over the means of representation meant access to display and exchange and, thus, was integral to a developing Fascist patronage style. "Who" is allowed to display art and "where" is the basis of the patron-client relationship. As powerful patrons before it, the Fascist dictatorship began by offering "access to the best places . . . places where everyone would see one's work."[2]

In this formative phase of state patronage, the 1920s, the Mussolini dictatorship transformed the organization and administration of artistic display. The party and government entered the cultural arena as organizer and arts administrator, redefining the system of display of the fine arts. Administrative reform laid the foundation for a powerful, wealthy state as patron with access to money, distribution, and visibility. The reconstitution of the structures of artistic display and cultural production

commenced in earnest after the Fascist consolidation of power in 1925–26, when the culture bureaucrats of the government and party considered the time appropriate for the regime to expand into previously neglected social and cultural realms.[3]

Fascism entered into the workings of a range of preexisting cultural institutions from the La Scala Opera in Milan to the Uffizi Gallery in Florence. Where the need was perceived, the Fascist regime built its own institutions.[4] The regime's intervention took place across the institutional spectrum, from high culture to low, from regional to national. Social organizations, libraries, and reading groups, which had previously come under local councils or organizations of the left, such as the *biblioteche popolari* (popular libraries), were consolidated and subsumed into party and government structures such as the Dopolavoro.[5] The First Congress of Fascist Culture was held in 1925, organized by Giovanni Gentile and attended by 250 intellectuals, including F. T. Marinetti, Ardengo Soffici, Luigi Pirandello, and Giuseppe Bottai. Later the same year, the regime founded the National Fascist Institute of Culture and, in 1926, the Italian Royal Academy. Giovanni Gentile founded the Fascist National Institute of Culture in 1925 to transmit Fascist culture and ideology on the local and regional level.[6] By 1931, there were eighty-eight branches in provincial capitals.[7]

The dictatorship gave a variety of reasons, from financial inefficiency to unqualified personnel, for the overhaul of earlier institutions. Nonetheless, the legacy of Fascism's initial intervention in cultural institutions, to which the case of art exhibitions attests, was bureaucratic streamlining and the creation of a centralized, national organization at the expense of the preexisting local or regional one. Fascism had come to power using the appropriated Risorgimento rhetoric of forging a unified and unifying Italian national culture; the creation of centralized, nationally based cultural institutions was designed to transform rhetoric into practice.

A simultaneous, two-pronged development characterized these years: the professional regimentation of artists and the creation of centralized systems of display. In addition, this first period of Fascist cultural politics (1922–29) hosted a debate over the constitution of, and need for, a "Fascist aesthetic" and the appearance of the cultural bureaucrats/impresarios who would later catalyze the creation of Fascist official culture.

The Syndical Organization of the Arts

THE FASCIST ETHIC HAS PENETRATED THE CONSCIENCE OF
ARTISTS AND HAS GIVEN THEM A SENSE OF DISCIPLINE AND
OBEDIENCE.—*Antonio Maraini, 1936* [8]

Initial official intervention in the fine arts produced
the regionally organized Fascist artists' syndicates or unions in the years
1925 through 1930. The Sindacato fascista delle belle arti (Fascist Syndicate
of the Fine Arts) regimented artists into eighteen provincially run syn-
dicates.[9] The national syndicate was composed of provincial member
syndicates, which joined the national organization at the time of constitu-
tion. A national secretary and a national directorate governed the mem-
bers and the national organization had "representatives on all the local
and national commissions for the fine arts," as well as on the National
Council of Corporations and in Parliament."[10] It "administered itself
under the control of" the Confederazione nazionale dei sindacati fascisti
dei professionisti e degli artisti (National Confederation of Fascist Syndi-
cates of Professionals and Artists).[11] This umbrella syndicate contained
twenty-one constituent syndicates, among them one each for architects
and engineers, writers, artists, and musicians.

Fascism declared that even the historically "free" profession of the art-
ist would join the corporate reorganization of society. The Fascist Syn-
dicate of the Fine Arts and the National Confederation of Fascist Syndi-
cates of Artists and Professionals, which governed it, were products of
Fascist syndicalism, the movement to organize labor and management
vertically within a structure of state-run corporations. Corporatism, as
promoted by Fascism, held that the economic life of the nation needed to
be structured vertically, with all members of a trade or profession, from
the factory floor to top management, belonging to the same corporation.
Interests would be represented by profession, rather than according to
class. This system of corporations, organized according to form of labor,
"negated and superseded the class struggle, creating class collaboration in
labor and with labor."[12] Fascist corporatism vowed to end the conflictual
relationship between labor, management, and the state. According to its
architect, Edmondo Rossoni, Fascist syndicalism represented "the recon-
ciliation of Labor with the Nation"; it was a system of "productive disci-
pline" which "perfects production and strengthens national productive
forces."[13]

In the arts, Fascist corporatism held out the promise of mutually pro-
ductive cooperation between cultural producers and the state. Artistic

production would be subsumed within state structures and aesthetic realization achieved through the state. In the context of the official corporatist discourse, state patronage resolved the past antagonistic relationship between state institutions and cultural producers.

Fascist syndicalism determined to recruit intellectual labor and make it a coherent influence within the Fascist state.[14] The 1927 Carta del lavoro (Charter of Labor), which laid the juridical foundation for the Fascist corporate state, articulated the need to make intellectual work a social duty and a part of national production. Fascist corporatism emphasized production and, at this stage, the mobilization of production and producers remained the primary goal.[15] Corporatism in the arts offered a designated and centralized system of display and production, but still had little to say about the content of "Fascist art."

The artists' syndicates presented themselves as a program of professional discipline and as the representatives of artists' corporate interests in the new Fascist state. "The profession's elevation within the framework of national life," declared the secretary of the fine arts syndicate, Antonio Maraini, was the ultimate aim of the artists' syndicates. Because the syndicates "desire neither uniformity of style nor form," the discourse of the regimentation of artists focused on using the "syndical order" to encourage dedication to Fascism through access to exhibitions, prizes, official purchases, and commissions.[16] Celebrating the changes, the 1930 Exhibition of the Venezia-Giulia Fascist Regional Syndicate of the Fine Arts boasted that it "represented the concrete realization of the new structural organization given to art exhibitions by the National Government."[17]

Corporate regimentation promoted a discourse of social usefulness, declaring that under the changed conditions the artist had an obligation to contribute to the whole as did the worker and the soldier. For the regime, the syndicates fulfilled a "moral, educative, and formative role."[18] "Today in the Fascist state" declared Mussolini, "those who work with their minds and their spirits must live ever more actively and with greater influence."[19] The regime intended corporate organization of artistic production to bring artists, previously laboring autonomously, into the structure of the state. This rhetoric attacked the bourgeois conception of the artist as a lone genius in a garret and condemned the self-indulgence of "art for art's sake." In the "new climate" of "artistic morality" and "professional collaboration," wrote Bruno Biagi in *Gerarchia*, "artists no longer need to distinguish themselves with such superficialities as wide-brimmed hats and fluttering ties."[20]

While promoting artists' obligations to the state and to Fascism, syndical organization offered artists something in exchange. Resurrecting a

guild vision of art's corporate and productive function, the regime promised official protection. State collaboration, declared some Fascist leaders, could free artists from the commericalizing (and vulgarizing) pressures of the market.[21] Fascist rhetoric held that, once sheltered from the corruption of the speculative art market, true creative forces would be unleashed—all to the greater glory of the patron who provided the preconditions for a cultural renaissance.

In addition to professional representation, moral purpose, and social imperative, the artists syndicates offered its members material assistance in the form of loans, relief payments, old-age pensions, and retirement homes. "The Syndicates are today the institutions," argued the journal of the National Confederation of Fascist Syndicates of Professionals and Artists in 1934, "that have secured all the means indispensable to the artist's functioning and protection."[22] According to the national syndicate's tabulations, between 1933 and 1939 the various regional syndicates assisted 462 artists with a total of 326,826 lire.[23]

The policy of professional regimentation and incentive succeeded, as many artists joined the syndicates and the numbers remained high through the 1930s. In 1933, the regime claimed 1,865 card-carrying members of the artists' syndicates and by 1939, it boasted 4,526 members.[24] Syndically sponsored events also celebrated consistently high attendance through the war years. However, adhesion at this level did not imply that the goals of Fascist cultural politics were achieved or that the interests of cultural producers and the regime coincided. The focus on professional rather than aesthetic regimentation encouraged artists who were not politically committed against the regime to join the syndicates. The corporate organization of artists revolved around a hierarchical system of display, with access determined by the syndicates. The syndicates promoted three levels of exhibitions: provincial, interprovincial, and national. The provincial shows, held in the provincial capital, permitted all members to show at least one work of art—each of Italy's eighteen regions held annual syndical exhibitions in their respective major cities. The interprovincial *mostre intersindacali* (intersyndical exhibitions) took place every four years. The provincial shows, explained a bureaucrat at the Ministry of Corporations, "represented . . . the first rung of the ladder on which rests the entire organization of the artists' syndicates."[25] An artist who "emerged distinguished" at the exhibition of his artists' syndicate would then show at the regional *mostra*.[26] At the apex of the pyramid stood the Quadriennale of National Art in Rome and the Biennale of International Art in Venice.

Participation in the local and regional shows, as well as access to government and party patronage, declared the regime, required membership

in the Fascist syndicates, although it did not require a Fascist Party card.[27] Membership in the artists' syndicates included free entrance to all official art exhibitions. The discourse of the syndicates' openness meant to imply that the only excluded artists were those who excluded themselves. Through the syndicates the regime hoped to create a system of artistic production that depended on the *tessera*—a membership card in the Fascist Syndicate of the Fine Arts.

The syndical leadership only inconsistently enforced membership as a requirement for participation in government-sponsored events. The regulations for the shows of the provincial syndicates varied in their position on syndical membership. Some regional syndicates only opened the means of display to adherents, whereas others accepted nonmembers as second-class participants. In 1933, for example, the Fourth Exhibition of the Fascist Syndicate of the Fine Arts of Sicily accepted entries from nonunion members but refused to cover the costs for transporting their work. In addition, when nonunion members sold artwork, they had to give the syndicate 15 percent of the total, as opposed to the 10 percent taken from syndicate members.[28] In 1932, the syndicate of the Marche gave artists a chance to join after they had received notice of their acceptance at the exhibition, at which point they could remit their fifteen-lire membership fee—roughly eighty cents in 1932 United States currency.[29] At the same time, the regulations stipulated that nonunion members must pay 5 percent more of the sale price to the syndicate than nonmembers, implying that the doors would not be shut to the recalcitrant. The membership requirement was intermittently applied, with the regions retaining some autonomy in enforcement. If the larger goal was to get artists to show up for officially sponsored events, then the system carried within it a certain flexibility.

In 1929, the government transferred control over nonnational art exhibitions to the Fascist Syndicate of the Fine Arts. Between 1927 and 1939, the artists' syndicates held more than 300 regional exhibitions.[30] The number of works shown annually at the local, regional, and interprovincial shows of the syndicates rose from 497 to 7,720 between 1927 and 1938.[31] Sales figures and prize monies also drastically increased as the government and party enlarged their presence: between 1930 and 1938 annual prize monies rose from 7,500 lire to 153,350 lire.[32] Syndical leadership consistently celebrated the amounts of art sold at the syndical exhibitions, which ranged from 546,975 lire in 1930 and 401,605 lire in 1933 to 832,309 lire in 1938. In its pursuit of artists' participation in the syndicates, the regime entered the art market, making significant purchases for the institutions of the government and party.

Centralizing Display

While the dictatorship used the syndicates to regiment artists, administrative reform and official patronage reconstituted the institutions of display. The connection between the syndicates and official cultural institutions was explicit: as the jewels in the crown of official high culture, the Venice Biennale and the newly instituted national Roman Quadriennale were run, respectively, by the secretary and the president of the fine arts syndicate. In order for professional coordination to succeed and for the culture bureaucracies of the regime to make good on their promises of the benefits of adhesion, the pre-Fascist fractured system of arts display, patronage, and consumption had to be rationalized and centralized.

Fascism had inherited an essentially regional arts culture. Attempts in the nineteenth century to use exhibitions as presentations of a national ideal failed in the face of regional rivalries, as did efforts to construct a national system of art exhibitions.[33] In the decades following the Risorgimento, undertakings on behalf of a fixed national exhibition seat "involved a thorny corollary to [national] administrative, economic, and organizational questions."[34] In the face of bitter regional splits that colored much of national life, the newly created Italian nation-state failed to build a unified system of artistic display. Fascism, with its program of national culture and commitment to "making Italians," vowed to fill this gap.

In nineteenth-century Italy, art exhibitions were central to elite, salon culture at the regional level. Beginning early in the century, large cities, particularly in northern Italy, commonly had private arts societies devoted to the task of promoting annual exhibitions. Milan's Società promotrice di belle arti (Society for the Patronage of the Fine Arts), modeled on the German and Swiss Kunstvereine, was founded in 1822 and Turin's Società amatori e cultori di belle arti (Society of Art Lovers and Enthusiasts) mounted its first exhibition in 1842.[35] The Kunstvereine, and their Italian counterparts, "performed a crucial function by organizing regular shows, in many cases creating their own collections and encouraging picture buying."[36] Membership consisted of arts patrons and artists interested in supporting local artists and endowing their municipality with an ambiance of cultural sophistication. The Florentine society, for example, financed its shows through dues and a lottery system, which awarded prizes in the form of works of art.[37] The shows of the private societies, often led by socially prominent citizens, exhibited primarily the

nineteenth-century genres of landscape and history painting. Such shows were less rigid than the academies and some innovative artists debuted at them, such as the *macchiaioli* who appeared in the Florentine society's exhibitions in the 1870s.[38]

Italian unification in the 1860s brought attempts at a national system of artistic display. One of the first cultural events of the newly formed Italian nation-state was the Esposizione nazionale del Regno d'Italia (National Exposition of the Kingdom of Italy), an agriculture-industry-art exposition held in Florence in September 1861, which ventured a vision of Italian nationality.[39] The achievement of nationhood encouraged the new Kingdom of Italy to compete with its neighbors to the north by using an exposition as a display of its accomplishments.[40] Another grand national display of Italian artistic culture took place in 1911, this time in the true national capital of Rome, in honor of the fiftieth anniversary of the unification.[41] The emergence of mass culture and an art market saw exhibitions become an increasingly popular cultural form in Italy. By the early twentieth century, a number of different institutions mounted art exhibitions, ranging from art dealers to museums, from government ministries to the artists themselves.

Fascist intervention into larger and nationally based art exhibitions took two forms. In some cases, as in the Venice Biennale and the Triennale of Monza (which, after 1929, became the Milan Triennale of the Decorative Arts), the government reshaped preexisting institutions to new uses.[42] In others, it founded new national institutions, such as the Roman Quadriennale of National Art, created in 1928 to remedy the Liberal government's failure to establish a fixed national exhibition of Italian art.

The regime promoted a vast network of official art exhibitions. The six editions of the Venice Biennale between 1930 and 1940, the four Milan Triennales, the three Roman Quadriennales, and the many shows of the provincial syndicates, interprovincial shows, and national shows of the syndicates testified to the scale of the regime's activities. State-run local, regional, and national art exhibitions grew steadily, from two provincial syndical shows in 1927 to thirteen in 1939, from four interprovincial shows in 1927 to eleven in 1939.[43] Total art exhibitions, including regime and privately sponsored shows, moved from 705 in 1935 to 887 in 1938 before slipping to 827 in 1940.[44]

The Fascist government coordinated previously local and regional art exhibitions into a pyramid-shaped national hierarchy, with the Venice Biennale of International Art at the top and the local shows of the Fascist Syndicate of the Fine Arts at the base. The exhibitions of the regional fine arts societies initially merged with those of the Fascist Syndicate in the

late 1920s, but the government soon thereafter subsumed them into the Fascist artists' syndicates. Fascism's shallow roots in civil society, owing in large part to the rapid assumption of power, encouraged it to appropriate and coexist with preexisting institutions. The coexistence with local arts societies also grew out of Fascism's hybrid cultural origins: its composite of Nationalist and Futurist cultural elites. "Joint sponsorship" of local art exhibitions continued through the late 1920s; for example, in 1928 and 1929 the Roman Società degli amatori e cultori delle belle arti cosponsored exhibitions with the Fascist Syndicate of the Fine Arts of Lazio and the Circolo di cultura belle arti di Trieste worked jointly with the Fascist Syndicate of Venezia-Giulia through 1930.[45] By initially grafting its artists' syndicates onto preexisting institutions, such as the societies for the fine arts, the regime maintained existing patronage networks and entered the cultural arena less disruptively than by making a radically new start.[46] This system permitted "a reciprocal action of legitimation" between Fascism and elite cultural institutions and provided for the slow transfer of personnel and allegiances.[47]

The regime had no master plan for the transformation of the means of artistic representation. Through the mid 1930s, loose supervision of art exhibitions took place at the Ministry of National Education, in particular in the office of the Direzione delle antichità e belle arti (Office of Antiquities and Fine Arts). This subdivision of the Ministry of National Education granted official permission and funding for art exhibitions. The Ministry of Commerce granted train fare discounts, which were central to the regime's program of enlarging exhibition audiences.[48] The government exempted specifically designated national exhibitions, such as the Venice Biennale, Roman Quadriennale, and Milan Triennale, from the ordinary review process and, in the early 1930s, reconstituted them as legally independent entities (*enti autonomi*), subject to national, rather than local, review and regulation.

In its first cultural interventions in the late 1920s, the government codified exhibition administration. A law of April 1927 acknowledged the "urgent and absolute necessity to issue regulations for the creation and organization of fairs, exhibitions, and expositions"; it ruled that all forms and types of exhibitions "must be authorized by Decree of the Head of State and seconded by the relevant ministries."[49] For the more prestigious exhibitions, the press announced official sanction.[50] The 1927 law further decreed that permission would not be granted to shows that failed "to demonstrate results in keeping with national noble artistic traditions."[51] In 1929, the government gave the Fascist Syndicate of the Fine Arts legal responsibility for mounting art exhibitions, except for the national shows—the Venice Biennale, the Roman Quadriennale, and the

Milan Triennale. By 1932, the proliferation of exhibitions of every variety by government ministries, local groups, and party organizations led to a law designed to regulate their authorization. A law of 1932 empowered the Ministry of Corporations to form of a committee to oversee all exhibitions not relating "to art, libraries, or agriculture."[52] The flurry of exhibition activity required that requests for permission to mount an exhibition be placed at least four months prior to the proposed inauguration.

In 1934, the government enacted a major rationalization of exhibition activities: all periodic exhibitions and fairs, such as the Fair of Milan, were juridically reorganized into independent entities with the president of the institution appointed by Mussolini and the secretary-general nominated by the Ministry of Corporations.[53] This law also required that budgets have the prior approval of the Ministry of Corporations. In an additional effort at refining the maze of international, national, and provincial fairs, exhibitions, and art shows, the government began to publish in 1934 an "Official Calendar of Fairs, Shows, and Exhibitions."[54]

Despite an impressive and growing array of art exhibitions under Fascist sponsorship, government and party intervention in the arts evolved slowly from the late 1920s, with administrative centralization preceding attempts at aesthetic regulation. As noted, the regime's limited inroads in civil society and lack of an articulated or unitary cultural or aesthetic agenda led it to begin with structural reform. The first structures it created were strongly centralized, allowing for official oversight over cultural production.[55] The government turned first to rationalization and centralization, which laid the foundation for broader government and party intervention in cultural production. Through control of the means of representation, the government and party opened the debate over the function and content of art under Fascism.

From the City of Venice to the State of Italy

At the national level, the Fascist regime oversaw two primary instances of reform of the system of artistic display. In the first it transformed the Venice Biennale of International Art into an official and nationally run event and, in the second, it founded a national exhibition of Italian art, the Roman Quadriennale. This locating of national artistic events in Venice and Rome, respectively, shaped the way Fascism used the two sites: Venice became Fascism's high-culture statement to the outside world and Rome the locus of domestic fine arts reception and consumption. The dictatorship coded the cultural uses of Rome and Ven-

ice and the creation of "appropriate" cultural institutions in each marked a first step in Fascist aesthetic politics and official patronage.

Government and party intervention in the administration of the Venice Biennale of International Art in the years 1928 to 1931 paralleled Fascism's larger involvement in institutions of high culture. The Venice Biennale, a biannual exhibition of international painting and sculpture, had been fin de siècle Venice's act of self-assertion. In the noble and nostalgic ambience of Venice, the exhibition brought together Europe's aristocrats and bourgeosie. Between 1928 and 1943, Fascism transformed this elite institution in accordance with its interests. The Mussolini dictatorship used the Venice Biennale for a number of its cultural policy goals, such as a the construction of centralized and nationwide cultural institutions, the regimentation of artists, the search for a "Fascist art," and the pursuit of cultural consensus.

Under the guidance of Antonio Maraini, artist and secretary-general of the Fascist Syndicate of the Fine Arts, the Biennale renounced its local Venetian sponsorship in favor of a national role. With the support of the minister of national education, Balbino Giuliano, Maraini revamped the Biennale and located it at the apex of a hierarchy of Fascist-sponsored exhibitions. In a February 1930 article, Maraini justified the government-underwritten changes. The Biennale, Maraini contended, had to be streamlined like a business in order to succeed in the modern Fascist world. "No longer," he wrote, can there be "casual improvisation nor simple agreements for the best; rather [what is needed is] disciplined and opportune planning and programming, logical coordination of every action, in a word, almost mechanical rationalization of administration, as in a large industrial and commercial venture."[56] Like a commercial enterprise, Fascism's Biennale had to cater to the market.

The Italian cultural marketplace by the late 1920s had expanded well beyond that of Liberal Italy. New cultural consumers coming from larger portions of the middle classes, as well as new cultural forms, such as film and radio, had altered the situation.[57] According to Maraini and other cultural functionaries who worked to bring the arts under the umbrella of the Fascist revolution, the display of the arts no longer could be done haphazardly and without coordination with other economic, social, and political exigencies. With the organization of the Fascist Syndicate of the Fine Arts and its promotion of a state-coordinated exhibition system, the most prestigious Italian art exhibition could not remain outside the new system.

By the 1920s, the Venice Biennale carried the reputation as a cultural event of the first order. It represented a location for cultural legitimacy and "symbolic capital" the regime was loathe to forgo. Appropriation of

this institution of European elite culture allowed Fascism an "opportunity for symbolic identification" with the upper classes and various associated class fractions.[58] The first Venice Biennale, inaugurated on April 30, 1895, commemorated the silver wedding anniversary of King Umberto of Savoy and Queen Margherita. The municipal government of Venice and Venetian business interests jointly promoted the exhibition. With the construction of a major new port at the Giudecca, late nineteenth-century Venice had witnessed economic growth for the first time in almost two hundred years. A regular exhibition of international art promised an additional economic boost through increased tourist revenues.[59] The Biennale's first president was Riccardo Selvatico, a poet, writer, and mayor of Venice, and Antonio Fradeletto, a prominent merchant, acted as the exhibition's first secretary-general. They organized the show with the help of a committee composed "half of citizens known for love of the arts and for a sense of business, and half of artists chosen among those residing in Venice."[60] The use of exclusively Venetian residents and artists as organizers guaranteed the show's Venetian character. The regional and city government, as well as municipal savings institutions, underwrote prizes.

During its first thirty years, the Biennale was an international salon and focal point for the established European art world. The exhibition, with its backdrop of grand balls and palazzi, attracted the attention of European aristocracy and haute bourgeoisie in the years before World War I. By 1914, it was a confirmed stop on the grand tours of an increasingly mobile bourgeoisie. While the exhibition's origins as a royal anniversary celebration linked it to other great European prestige exhibitions of the era such as the Crystal Palace Exhibition, the Biennale's location, regional elite sponsorship, and solely fine arts focus suggested its exclusivity.

The Biennale's founding charter of 1895 stated that the artists "most noted in Europe" would be invited to show their works.[61] The absence of a jury process promised a conservative outcome. Major exhibitors at the first eleven Biennales, such as Ettore Tito, Telemaco Signorini, and Pietro Fragiacomo, worked in conservative and salon styles. Venetian painting, "still solidly in the hands of the local arts academy," dominated the first exhibitions and, for some, the pre-1912 Biennales were "retrograde official salons."[62]

Although present from the outset, the Biennale's international underpinning grew in the years before World War I. At the inaugural show of 1895 fifteen nations participated by displaying art in the shared central pavilion. As of 1914, nineteen nations were represented and eight of them had constructed their own pavilions on the Biennale grounds— Belgium, Hungary, Great Britain, Germany, Russia, Holland, Sweden,

and France.[63] Between 1895 and 1928, foreign artists outnumbered Italian artists by almost two to one. Further, between 1895 and 1914, the sale of foreign works surpassed those of Italian works in seven of the eleven exhibitions held.[64]

The Biennales of the early 1920s continued to be elite events, insulated from the surrounding political and social upheaval. Despite a chronological convergence, the first showings of modern art at Venice in 1922 and 1924 and the rise and consolidation of the Fascist dictatorship were not directly related. Modernism broke into the mainstream world of fine arts consumption after World War I, and the Venice Biennale too felt the cultural shock waves emanating from Verdun and Ypres.[65] The man responsible for introducing modernism, Vittorio Pica, the secretary-general of the Biennale from years 1900 to 1926, had no affiliation with Fascism. Although Fascism changed the face of the Biennale, inaugurating centralized, national administration and regulating the show's content and bringing in new audiences in the 1930s, it did not introduce modern art to the Biennale. Impressionism and other European modernist movements made their first appearances in 1922, with showings of Degas, Cezanne, Modigliani, and Archipenko.[66] In addition, by 1924, members of the Italian postwar avant-garde movement known as the novecento regularly exhibited at the Biennale. The novecento was a loosely connected group of artists united in 1922 primarily in an attempt to find an aesthetic at once traditional, modern, and quintessentially Italian. Novecento artists declared themselves to be following the grand Italian tradition from primitivist to the Renaissance. The most notorious Italian avant-garde movement, futurism, arrived slowly at the Biennale and when it did in 1926, it was constrained to mount its exhibit in a building separate from the main pavilion.[67] While the major Italian modern movements appeared at the Biennale prior to Fascist intervention in 1928, they became defining elements only in the 1930s.

As with other cultural institutions, the first move toward integrating Fascism into the Venice Biennale involved personnel. In early 1927, the government pressured the Biennale administration to place Maraini, Margherita Sarfatti (Mussolini's mistress, cultural editor of *Il popolo d'Italia*, and patroness of the novecento), and C. E. Oppo (president of the Fascist Syndicate of the Fine Arts and secretary-general of the Quadriennale) on the exhibition's governing board.[68] Maraini grew quickly frustrated by the orthodoxy and parochialism of the Biennale's Venetian bureaucrats. In order to make the Biennale a national cultural center at the top of the hierarchy of state-sponsored exhibitions and to locate it within the cultural bureaucracy of the Fascist regime, Maraini met in November 1927 with Mussolini, Giuseppe Volpi di Misurata (minister of finance), and

Giovanni Giurati (then minister of public works and soon to be party secretary) to ask for a mandate to restructure the institution.

The Biennale's local, inbred Venetian character, declared Maraini, constrained it and prevented it from contributing to the "New Italy": "the Biennale can no longer be considered nor function as a simple municipal office of the City of Venice. . . . Italy has inherited a great artistic institution that will represent for the figurative arts what La Scala represents for opera."[69] The Italian cultural patrimony, which had been a loose collection of regional assets, had to be reconstructed and centralized in order to serve new national purposes. The program to liberate the Biennale from its local roots appealed to the growing trend against regionalism and toward centralization in Fascist policy. Maraini garnered support for his plans by coloring his critique of the existing Biennale in antiregionalist language. Bureaucratic reform would be part and parcel of the regime's quest for "Italians" and "Fascists" to replace local residents with regional allegiances.

The Biennale's evolution from a municipally and privately run exhibition to a major national cultural center at the pinnacle of a network of official art exhibitions comprised three stages between 1928 and 1931: legal reconstitution, personnel overhaul, and reform of the financial structure. In 1928, legislation established the permanency of the Venice Biennale and the newly created Roman Quadriennale of National Art. The second step, in 1930, legislated the governmental and party composition of the Biennale's administration. In 1931, a set of laws codified previous changes and presented the reformed charter of the Autonomous Institution of the Venice Biennale. A law of December 24, 1928, declared the Biennale permanent and guaranteed it perpetual rights to both customs exemptions and train discounts for spectators. Whereas other "expositions or art shows remain[ed] subordinate to the annual prior authorization of the Head of the Government," the Venice Biennale and the Roman Quadriennale were now autonomous fixtures in the cultural landscape.[70]

Not surprisingly, the appointment of Fascist figures with national reputations produced conflict in Venice. Within a year of his appointment as secretary-general of the Biennale, Maraini clashed with Pietro Orsi, the *podestà* of Venice, over their opposing visions of the institution's future. Orsi, believing he had been denied his rightful role in the selection of artists for the 1928 Biennale, asserted that the exhibition had been "a real and complete disaster" because of "the twentieth-century art which . . . is complete futurist eccentricity."[71] For Orsi, the Biennale functioned best as an "exhibition of Venetian painting," "art more respectful of the traditions . . . of the city."[72] The regime meant to end such a proscribed and nostalgic vision of Italian culture.

The dispute shed light on the regime's multifaceted interest in the Biennale: Fascist cultural bureaucrats desired to locate the institution within an emerging Fascist cultural politics, while they also pursued the social and cultural capital associated with it. Maraini brought his case to the minister of national education, threatening to resign. Taking Maraini's side and citing the conflict as just cause for severing the Biennale's Venetian dependence, Giuliano wrote Mussolini that the exhibition had a greater national "duty" than merely "to present to Venetian gentlemen and romantic dream chasers art forms inspired by the beautiful ghosts of the lagoon . . . nor must it remain behind the progress of other nations merely to continually repeat the same empty imitations of old harmonies." The Biennale, believed Giuliano, should welcome a broad range of aesthetic positions, not just Venetian "ghosts." Evoking the official policy of aesthetic pluralism, he added, "even the most uncommon art forms have the right to citizenship, provided they signify a type of consciousness."[73] The parochialism of Venetian administrators prevented the Biennale from becoming a vibrant artistic and tourist center and from reflecting the cultural allure desired by Fascism. For Maraini and Giuliano, the answer was to sever the Biennale from its Venetian roots. Maintenance of the Biennale's sleepy local character implied wasted cultural capital for which the regime had plans.

On January 13, 1930, a royal decree redefined the Biennale's administrative system, giving Maraini wide-reaching authority, including control over the show's installation and the composition of the special and personal retrospectives—essentially denying the curatorial influence of the Venetian staff. "The usual committees and councils are abolished" wrote Margherita Sarfatti, "this time the artistic direction of the exhibition turns on the direct and personal responsibility of Maraini."[74] The January decree also established the Biennale as an *ente autonomo*, nationalized the funding, and placed the administrative council directly under the sponsorship of Mussolini. The declaration of the Biennale as an autonomous entity made it legally independent; the regime often used creation of an *ente autonomo* as a means of removing an institution from local or private hands and regularizing its operations. Operating expenses would be covered by "fixed contributions of the State and the city of Venice and, if necessary, other institutions."[75] These fixed contributions ensured the central government's influence in the institution's internal workings. Furthermore, under the new law, the city of Venice ceded rights to the land and buildings of the Biennale to the *ente autonomo*. The reformed governing board consisted of five members appointed by Mussolini on the recommendation of various ministries: two proposed by the minister of national education, two by the minister of

corporations, and one by the minister of the interior in conjunction with the *podestà* of Venice. This Administrative Committee would govern for three exhibitions (1930, 1932, 1934), at which time Mussolini would make new nominations.

Clearly, the pinnacle of official high culture demanded the appropriate figure to preside over it. Mussolini appointed Conte Giuseppe Volpi di Misurata, at the time minister of finance, president of the Biennale in the spring of 1930. Volpi personified the regime's desire to appropriate the Biennale and give it a Fascist and national character. The office, an essentially honorific one, had been held in the past by prominent Venetian aristocrats or politicians, such as Riccardo Selvatico, the Biennale's first president in 1895 and mayor of Venice. Born into a lower-middle-class Venetian family, Volpi built an empire and a fortune from electrical, chemical, and iron industries in the Veneto and the Emilia-Romagna. From 1921 to 1925, Volpi served both Liberal and Fascist Italy as governor of Tripolitania. In 1925, Mussolini appointed him minister of finance and gave him the title of Conte di Misurata. While serving as president of the Biennale, Volpi also headed the Confindustria, the association of businessmen and industrialists, during the Fascist era (fig. 1).[76]

Volpi, in contrast to the Venetian aristocrats who had historically held the presidency, came from a new technocratic class rising to prominence under Fascism. Volpi's industrial and business background informed his attitude toward culture, which combined two conceptions, that of "Renaissance merchant-condottiero" and "Victorian empire builder."[77] His managerial and business experience led him to an awareness of the Biennale's potential as a commercially successful tourist center and the changes that would be required for the transformation.[78] The "Volpi era," which commenced in 1930, stressed the growth of a commercial tourist infrastructure with the Biennale at the center. Volpi represented a synthesis of Venice and Fascism, of local tradition and technocratic nationalism; he and the regime reshaped the Biennale into this mold.

A government-appointed administrative committee joined the new president and secretary. An executive decree of September 1930 nominated Beppe Ciardi, Marcello Piacentini, Ettore Zorzi, and Antonio Maraini as the remaining members of the governing board. Beppe Ciardi, a painter of still lifes and landscapes, had been active in the Biennale since 1924 and represented a point of continuity. Piacentini, responsible for the urban renewal of Rome, Brescia, Bergamo, Genoa, and the University City in Rome, was widely perceived as the official architect of the regime. As editor of *Architettura*, the official journal of the Fascist Syndicate of Architects, and as recipient of a vast number of state and party commissions, Piacentini wielded great power. He participated in the era's major

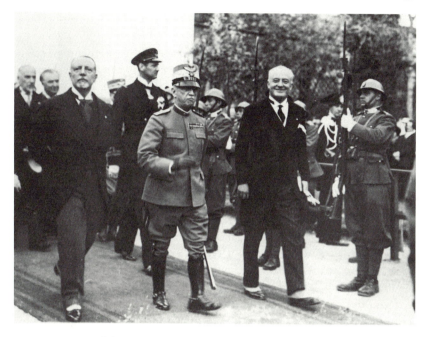

1. Inauguration of the 1934 Venice Biennale: *left to right*, Conte Giuseppe Volpi di Misurata, president of the Biennale; King Victor Emanuel; Antonio Maraini, secretary-general of the Biennale.

architectural debates and came to represent the traditionalist, monumentalizing wing of government-supported architecture. Ettore Zorzi, the new *podestà* of Venice, appointed by royal decree, represented the national government.[79]

National control required financial reform. Once firmly in control, the new governing board regularized the Biennale's financial structure and introduced government funding. Maraini had cited financial inefficiency as a reason for reforming the Biennale. In the spring of 1930, the city and the central government negotiated a system of state, regional, and city contributions. Estimating total annual contributions of 400,000 lire as the amount from national and local sources (this figure did not include revenues from admissions tickets, from the sale of art and catalogs, or the preexisting funds of the institution), the Ministry of National Education proposed to the minister of finance an annual government contribution of 150,000 lire, with the regional and municipal sources covering the 250,000 lire remainder.[80] Rejecting the proposal, the minister of finance, Antonio Mosconi, called the sum too high for a perpetual contribution. Instead, he suggested an annual national government contribution of 100,000 lire and contended that the city and regional government

of Venice should make up the 300,000 lire difference.[81] This proposal was returned to Venice for approval.

City, regional, and Biennale officials, defensive over state intervention, rejected the government proposal. If the government in Rome intended to usurp the local autonomy of the Biennale, it would have to pay for it. The prefect responded with a maximum of 150,000 lire from the city and 50,000 lire from the province.[82] This decision signified a major shift in funding patterns: previously the provincial government had contributed only 8,000 lire a year.[83] The reorganization increased the burden of the province and the central government, while decreasing that of the city. The resolution had the government assuming the heaviest financial burden: the Ministry of Education donated 200,000 lire, the city of Venice, 150,000 lire, and the province of Venice, 50,000 lire.[84]

The finanical reconstitution produced further national-local conflicts. In the summer of 1931, disputes between Venetian officials and the new Biennale staff arose over the completion of the final charter of the reorganized Biennale. The proposed charter divided the Biennale's patrimony in the event of its dissolution "between the financing institutions, in proportion to their contributions dating from 1930."[85] Given the new finanical arrangements, the government stood to inherit half the property. Shocked at the government's proposed seizure of the *comune's* property, the Venetian prefect responded: "It has always been only the City which sustained the expenses and covered the deficits of the exhibition."[86] Despite pleas from local officials, the minister of national education rejected the prefect's call for a revision: the Biennale remained in property and administration in the hands of the government in Rome.

A final dispute, indicative of conflicting visions and agendas, involved the resistance of the Biennale staff to the government-appointed accountants called in for the new charter. In a further move toward financial efficiency, the charter held that "the completed financial report of each exhibition must be remitted to the . . . Ministry of National Education" and that "the review of the accountants must be attached to the budgetary report."[87] With this order, all Biennale council meetings required the presence of the state-appointed accountants. The presence of professional accountants and financial "experts" at artistic and technical discussions offended the sensibilities of the older Biennale staff, who felt it compromised the exhibition's aesthetic integrity.[88] The final charter effected a compromise that, nevertheless, left the national government with the upper hand: the accountants would attend only those meetings at which the budget was discussed.[89]

In November 1934, Mussolini, as designated by law, made new appoint-

ments to the Biennale's Administrative Committee. Criticisms of the Biennale's progress had reached the Duce: the new committee had a broader national character than the previous one.[90] Volpi, Maraini, and Mario Alverà, the *podestà* of Venice, were joined by significant newcomers. Balbino Giuliano, the former minister of national education and consistent supporter of government intervention in the Biennale, joined the committee, as did Gianni Bianchetti, the administrative head of the Office of the Council of Ministers. The painter Felice Carena, a fixture of exhibition culture and government cultural programs and, after 1933, a member of the Accademia d'Italia, represented artists.[91] He participated in all the Biennales and Quadriennales from 1930 to 1940, with personal retrospectives at the 1936 and 1940 Biennales and with consistent government and party acquisitions of his work. Although associated with the novecento, Carena's work became increasingly monumental and classicized after 1936. Arturo Marpicati, the vice-secretary of the party, became the seventh member of the committee, on the proposal of the National Fascist Party. A prominent Fascist intellectual, Marpicati held numerous party posts during the 1930s, such as membership on the Grand Council and director of the National Institute of Fascist Culture. The Venetian influence that had survived the initial reorganization of 1930 in the person of Venetian painter Beppe Ciardi was now reduced to the token presence of the Rome-appointed *podestà* of the Veneto. The commission's increased national and party composition foreshadowed that the process of the Biennale's reconstitution had not ended. If the Biennale was to be truly a national cultural center, drawing artists and spectators from all of Italy, it had to be governed by individuals with national outlooks, reputations, and interests.

The reforms wrought upon the Biennale prefigured changes that the regime would soon impose on the whole exhibition system. In 1934, the government declared that national cultural institutions, exhibitions, and fairs be reconstituted as *enti autonomi*.[92] The same law designated that exhibition budgets be regularly reviewed by official accountants. In this way, the reform of the Biennale served as a test case, which, once successful, the government applied to the entire system.

Governed by a board of non-Venetian outsiders, financed by sources outside the Veneto, its property devolving mostly to the central government, the changes reduced the city's control over the Venice Biennale to the symbolic. Even the institution's name changed to stress its new national character. In early 1931, the Biennale's official title became Esposizione biennale internazionale d'arte (International Biennial Exhibition of Art), rather than Esposizione internazionale d'arte della città di Venezia (International Art Exhibition of the City of Venice).

The reconstitution of the Biennale as a national event extended from finances and administration to the selection of artists. According to the revised system and its coordination with the Fascist Syndicate of the Fine Arts, in order to be eligible for an invitation to the Biennale, and therefore for the selling of work at the exhibition, an artist would have to succeed at both the regional and national level. The 1928 Biennale catalog articulated the institutional hierarchy: "linking regional and national exhibitions to the Venice International in an organic system makes frequenting the former a necessity for participation in the latter."[93] The synchronization of the Biennale with the Quadriennale of National Art and with the shows of the syndicates was, by 1930, "in homage to the artistic organization which groups exhibitions into regional, national, and the International of Venice" . . . a "hierarchy of exhibitions."[94] In theory, after 1930, the path to the Biennale would be through participation in the network of officially sponsored exhibitions.

The Biennale reorganized its system of display to stress its integration into Fascist exhibition culture. The lowest level of the system, the provincial and interprovincial shows of the Fascist syndicates, had a regional organization; the Biennale echoed that classification in 1930.[95] While this organization ran counter to the regime's critique of regionalism, it reinforced the connection to the regionally structured corporate organization of the arts. The regional organization of display gave notice to artists and spectators. It made clear to artists the Biennale's connection to the rest of the shows in the system and it demonstrated to the public that the Biennale no longer had a particularly Venetian character that favored Venetian art.

As part of the regime's control over the means of representation, the Venice Biennale, in conjunction with the Fascist syndicates, participated in coordinating the professional life of artists.[96] In 1932, Maraini had successfully lobbied for the establishment of the Archivio storico dell'arte contemporanea (Historical Archive of Contemporary Art) under the auspices of the Biennale. Located in the same palace as the Biennale offices, the archive included both the Biennale and contemporary Italian art.[97] In 1934, it began publication of a monthly journal, which coordinated information on art shows throughout Italy. The journal, *Le mostre d'arte in Italia*, offered articles on shows ranging from the Biennale and the Quadriennale to the regional shows of the syndicates, as well as listings of private and public exibitions and competitions. The back of each issue listed *mostre* by city and carried a guide to articles from national publications pertaining to the shows.[98] By 1934, the Biennale had consolidated its institutional role as a centerpiece of official culture and presented itself as a clearinghouse for information on contemporary art in Italy.

The transformation of the Venice Biennale reveals the process by which the dictatorship appropriated access to display. In the first phase of its cultural politics, the regime depended upon structural reform. Between 1928 to 1931, Fascism created a nationally run, government-funded, and legally autonomous cultural institution. Administrative reform supplanted the Biennale's local character, and redefinition along administrative lines allowed the regime to become a patron of the arts, filling the spot formerly held by local elites. Unhinged from its original local and class identity, the Biennale now could be transformed in accordance with the preoccupations of its new sponsor.

The Aesthetic Climate

Against the backdrop of institutional reform and the professional regimentation of artists, the official cultural world of Fascist Italy waged a heated debate over which aesthetic forms, genres, and discourses should accompany official cultural intervention. Following the creation of a syndical and institutional hierarchy for the display of the arts, official patronage turned to the search for a "Fascist art." The debate engaged Fascist government and party officials, critics and artists who argued over whether and how fascism could promote new forms of visual expression.

However, as the practices of Fascist cultural patronage reveal, beyond a commitment to regiment artistic production, no consensus emerged. The culture bureaucracies of the government and the party "agreed to disagree" and no single style nor movement ever found official sanction. In the end, Fascism's decision to accommodate artists and allow itself to be represented by a range of aesthetic movements overrode any interest in imposing a single aesthetic vision. Aesthetic pluralism, as chapter 3 details, grew out of the dictatorship's decision to court the consent of artists through flexibility of taste and patronage.

In 1926 and 1927, Giuseppe Bottai, then minister of corporations, launched the debate in the pages of his *Critica fascista*, when he asked a number of artists and policy makers to describe the characteristics of "Fascist art."[99] This debate over the aesthetic future of Fascist Italy encompassed a range of political factions within the official hierarchy, which can be divided into conservatives, modernists, and intransigents. Cultural conservatives such as Maraini called for an art that employed traditional, classicizing aesthetic forms. Art, Maraini maintained, should be steeped in *italianità*, a concept that stressed forms evocative of the Italian character and inspired by Italian art. For these cultural

conservatives, many of whom came to politics out of the Nationalist movement, the appropriate aesthetic for the new Italy was classically inspired, "in the sense of a conception of the figurative arts produced from a profound sensitivity that engages the will, the mnemonic knowledge of truth."[100]

The conservatives pursued the elevation of a classicized, national aesthetic through the voluntary commitment of artists. For Maraini, Fascist culture must be open to all and new trends, but within a framework of nationalism and tradition: "one does not in the least intend to impose upon artists to follow a determined aesthetic program . . . but art is not a phenomenon isolated by individual caprice: it is a predestined and complex product of particular conditions intimately tied to the conditions of a given country." "Particular conditions" necessitated the commitment of artists to use their art to "give life to the aspirations and ideals of a historical moment."[101] Conservatives challenged artists to find "a spontaneous and healthy taste for beauty such as was dear to Raphael, of symmetry and proportion such as Michelangelo asserted, of expression and character such as Leonardo taught."[102] C. E. Oppo, another supporter of *italianità*-inspired art and secretary-general of the Roman Quadriennale, echoed Maraini when he wrote:

> Fascism . . . must have the courage to bear the weighty crown—not the chain, as the futurists have called it—of our great artistic heritage with the ease of an old gentleman wearing a monocle. . . . In Italy there can be no neoclassicism simply because classicism has never grown old. In Italy one is either a classicist or nothing.[103]

For this faction in the cultural bureaucracy, the Italian aesthetic patrimony was a ready-made and home-grown source of inspiration for art under Fascism. This celebration of a reinvigorated classicism, all within an Italian and Fascist context, combined an acceptance of aesthetic diversity with a commitment to *italianità*. The many former Nationalists and cultural conservatives who held influential positions in the Fascist cultural bureaucracy in the 1930s did not advocate a monolithic or exclusive aesthetic vision.

A second powerful faction within the Fascist hierarchy, variously represented by Giuseppe Bottai and Margherita Sarfatti (1883–1961), advocated an antirhetorical, modern art. Bottai, as minister of corporations and later as governor of Rome and minister of national education and as the editor of a number of journals during the period, was a constant presence in Fascist cultural politics. He called for the dictatorship to sanction an official modern art and to support its choice through expanded intervention.[104] Bottai, significant as promoter of a "revisionist" strand of

Fascism, championed activism, corporatism, and continual reform. His revisionism espoused an urban, technocratic Fascism, an end to intransigence, and the development of an enlightened managerial Fascist elite. As minister of national education, he mandated the purchase of large amounts of modern art from official exhibitions destined for the Galleria d'arte moderna in Rome. In recent years, he has been credited with the creation of a state patrimony of modern Italian art and has been praised for his nonsectarian taste. The memory of his advanced aesthetic sensibilities made Bottai the first Fascist *gerach* proposed by a postwar Italian government for a street named in his honor. Roman Mayor Francesco Rutelli's proposal to name the street in front of the Galleria d'art moderna after Bottai unleashed a virulent controversy, especially from the Roman Jewish community, in 1995. Rutelli eventually withdrew the proposal.

Sarfatti, patroness of the novecento and cultural critic for *Il popolo d'Italia*, also lobbied for an urban and contemporary aesthetic to represent Fascism.[105] The novecento movement she promoted claimed to combine modernity with *italianità* and was, thus, perfectly suited for official status. Sarfatti had many roles, though mostly unofficial ones: she shaped the cultural life of the era from a number of positions—as novecento organizer, art critic, and member of numerous exhibition juries and as Mussolini's mistress and confidant.[106] She celebrated contemporary aesthetic forms as a way out of a "passéist" lethargy which associated Italy with "brigands, mandolin players who dance and eat their pasta with their fingers; the sooner this lurid myth of false aestheticism ends, the better it will be for the true dignity and beauty of our sweet land."[107] She hailed the artists and architects of the novecento and rationalist movements, saying: "We have a noteworthy group of sculptors and painters; the most noted and accomplished of them gives one hope for and faith in [the state of] contemporary art."[108]

In contrast to the conservative Nationalists and Fascist modernists noted earlier, there emerged in the 1930s advocates of a rhetorical, celebratory, and idealizing-naturalist art that rejected European modernism. This group of intransigents excoriated what they saw as the self-indulgence of contemporary Italian art and agitated for a politicized aesthetic that would glorify the Fascist state with a monumental, nonambiguous vision of society. The antipluralist group, which included political figures and journalists such as Roberto Farinacci, Giuseppe Pensabene, Giovanni Preziosi, and Telesio Interlandi, as well as artists such as Pippo Rizzo and Ferruccio Ferrazzi, became increasingly vocal and powerful after 1935–36.[109] Giuseppe Pensabene and Telesio Interlandi's most zealous polemics against foreign and modern cultural influences took place in the late 1930s in Pensabene's *La razza e le arti figurative* and in Interlandi's *La condizione*

dell'arte and *Difesa della razza*. Roberto Farinacci, briefly secretary of the National Fascist Party (1925–26) and the party leader of Cremona, led the intransigent wing of the party. *Quadrivio*, founded in 1933 as a "great Roman literary weekly," was the locus of much of the antipluralist art and cultural criticism. It was published by Telesio Interlandi, Luigi Chiarini, and Giuseppe Pensabene, all known for their extremist and intransigent views in culture and politics.[110] In the mid 1930s, Interlandi's positions were to the right of the Mussolini dictatorship, although after 1936 he increasingly reflected the position of the regime, as it moved to the right. After 1937, Interlandi's views received their broadest exposure through the racist, pro-Nazi journal *Il Tevere*.

In 1934, *Quadrivio* launched an editorial campaign against state patronage and the state-run *mostre* that grew increasingly vituperative as the decade progressed. Farinacci used his Cremona newspaper, *Il regime fascista*, to vent his hatred of modern art. In 1935 he wrote that "the foreign-loving malaria, the deformist tuberculosis, the abstract bacteria, the Novecento germ are the four insidious microbes responsible for all the afflictions of Italian art."[111] For Farinacci and his supporters, modernism precluded the creation of an Italian Fascist art. They believed that the regime should, on the one hand, censor modern art and, on the other, provide the conditions for the development of truly celebratory works of art. This group denounced the regime as far too lax in its regimentation of culture and demanded that uncensored zones, in both high and mass culture, should be forbidden.[112]

Farinacci waged a bitter campaign against the novecento movement in 1932–33, accusing it of being overly "internationalist." He directed his attacks not only against the leaders of the novecento—Carrà, Sironi, De Chirico, Tosi—but also against overly lenient bureaucrats, such as Maraini and Oppo, who Farinacci blamed for "not closing the doors" of the Biennale and the fine arts syndicates to "internationalist corruptors of Italian youth."[113] For intransigents, the problem existed at the level of aesthetic production and organization, since exhibition organizers supported diversity at their institutions.

Alongside and integrated within the cultural factions of the government and the party worked the artistic movements that participated in and gave form to official culture. Some of these groups competed for the title of the "art of Fascism," positing their own solutions to the problem of "Fascist art."

The novecento most vociferously proclaimed its right to official recognition in the 1920s and early 1930s. Because of rhetoric about fusing modernity with tradition in a uniquely Italian context with a "clear pictorial language" and due to early and strident patronage by Mussolini

and Sarfatti, novecento artists were mainstays of official culture in the years 1926 to 1934.[114] For Sarfatti, "they demonstrate a living but ancient virtue, [while also] giving form to new representations of beauty."[115] Novecento artists worked in many styles, including primitivism, metaphysical painting, classicism, magic realism, and neorealism. Much of the novecento's popularity in official art circles focused on its measured critique of avant-garde Parisian models, while simultaneously not rejecting experimentation.

Novecento artists, who tended to work in blocky, solid forms, shared an interest in the architecturalism of painting and its formal values. They depended on common themes and images, such as women, landscapes, still lifes, and mythological scenes. Felice Casorati's (1886–1963) *La carità di S. Martino (The Charity of Saint Martin)* and *Lezione (Lesson)*, which were shown at the 1930 and 1934 Biennales, are exemplary of novecento formal experimentations (figs. 2 and 3). *The Charity of Saint Martin*, a depiction of the story of Saint Martin giving his cloak to a beggar, mobilizes various recent developments in painting. The space is tight and uncomfortable and the figures are collapsed into the picture frame. The front and back of the painting are collapsed, producing a claustrophobic sense. The elongation of the figures and the rendering of the flesh evoke some of Picasso's saltimbanque figures. Many of the novecento's most prominent members, such as Mario Sironi (1885–1961) and Carlo Carrà (1881–1966), shared a stylistic trajectory from futurism through metaphysical painting to monumentality and public art in the late 1930s.[116] Sironi's allegorical figures, seen in his paintings, drawings for *Il popolo d'Italia*, and in his many works of public art, combined a pre -Renaissance Italianate aesthetic with Picassoesque shadings and figuration. For example, *Pascolo*, exhibited at the 1930 Venice Biennale, presents a denuded, desolate and indeterminant landscape with shepherd and cow (fig. 4). The painting is monumental and classicizing in scale, but experiments with composition and use of forms.

In the years 1928 to 1934, the novecento movement generally received more government and party patronage than other groups.[117] Mussolini inaugurated its first collective exhibition in 1925. At every Biennale, Quadriennale, or show of the Fascist syndicates, the government and party purchased novecento works in large numbers. Figures such as Achille Funi, Anselmo Bucci, Massimo Campigli, Piero Marussig, Alberto Salietti, and Felice Casorati appeared repeatedly on the acquisitions lists for the 1930s. The group's cultural philosophy of a hybrid modernity meshed with the regime's own tendencies, encouraging the novecento's active participation in official culture. Yet, the movement's commitment to a variegated aesthetics contributed to its decline as Fascist cultural politics

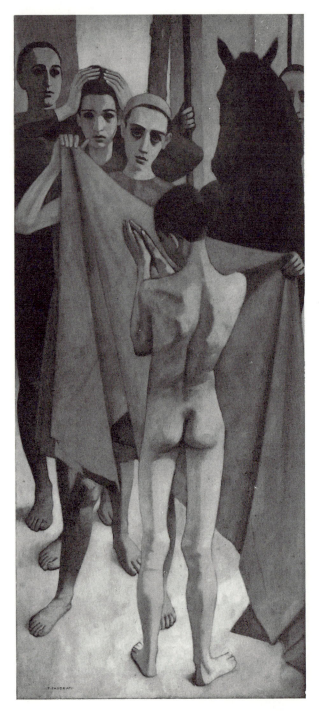

2. Felice Casorati, *La carità di S. Martino* (*The Charity of Saint Martin*), 1930 Venice Biennale.

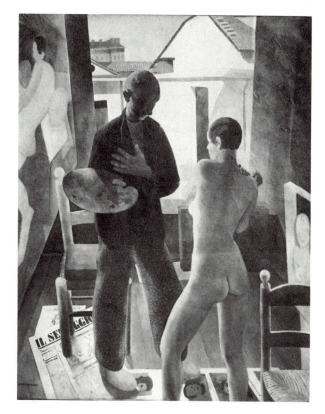

3. Felice Casorati, *Lezione (Lesson)*, 1930 Venice Biennale.

radicalized in the late 1930s. Many of the movement's members did adapt their art to a changed political climate. But even after the novecento's turn to public art and a language of tradition in the later 1930s, it rejected aesthetic regulation: "To be in keeping with the spirit of the Revolution, Fascist painting must be at once ancient and very new. One does not want in the least to advocate even a hypothetical agreement over a single formula for art. . . . We believe in the voluntary imposition of discipline in the arts."[118] Despite adjustments by some artists associated with the novecento, the movement began to fall out of favor after 1934, as anti-pluralists around Farinacci accused it of being "internationalist."[119]

The futurists, who as a group joined Mussolini and the National Fascist Party at its birth in 1919, also laid claim to the title of the "art of Fascism." This avant-garde movement, which had lost some its central figures in World War I, reconstituted itself in the 1920s under the banner of "second wave" futurism. F. T. Marinetti, futurism's founder and impresario from its 1912 inception, lobbied for these "second wave" futurists, who painted in an abstract geometric style called *aeropittura*. "Second wave" futurism expanded on the machine tropes of early futurism, abstracting these

4. Mario Sironi, *Pascolo* (*Pasture*), 1930 Venice Biennale.

forms and focusing on a distilled and spiritual representation of technology. *Aeropittura* posited the quintessentially modernist perspective offered from the air and depended upon biomorphic and geometric forms to represent aerial views; as Enrico Crispolti writes, this aesthetic consisted primarily of "plastic formulations" with some use of figuration, but "composed in a decidedly imaginative dimension, almost neo 'metaphysical' and in many aspects not far from surrealist works."[120] For the futurists, *aeropittura*, which Marinetti defined as "the celebration of an imagery of flight," captured the essence of the power of Fascist Italy.[121] In 1929, nine artists, including Enrico Prampolini, Fortunato Deprero, and Gerardo Dottori, signed the *Manifesto degli Aeropittori* (Manifesto of Airpainters) in which they hailed the force of this new aesthetic (fig. 5).[122]

5. Osvaldo Peruzzi, *Aeroarmonie (Aero-harmony)*, Room of Italian futurist *aeropittori*, 1934 Venice Biennale.

Because of early loyalty to Mussolini and Fascism and an ability to adapt their artwork to changing political conditions, the futurists remained a constant in official culture. With the wars in Ethiopia, Spain, and Europe, *aeropittura* embraced the task of representing contemporary combat and Fascist triumphs through geometric abstraction. Throughout the 1930s and early 1940s, government-sponsored exhibitions displayed, purchased, and prized the futurists, both as a group and indvidually: at every Biennale between 1932 and 1942, as well as at the Quadriennales of 1935, 1940, and 1943, they received a "special exhibition." Some artists and cultural functionaries resented futurism and Marinetti's special status, as an excerpt from 1931 Biennale administrative council deliberations reveals:

> SARFATTI: But, must there always be a futurist room?
> MARAINI: Marinetti has asked me this year for no less than four or five rooms. [laughter] It would be good to decide, once and for all, that the futurists must meet the same standards as all the others. . . .

OPPO: In Rome [at the Quadriennale] we were inspired by the same thoughts now inspiring Maraini, and we limited the number of futurists to three or four. But Marinetti wrote [Mussolini], who called me and told me to add an additional eight. . . . It is blackmail.[123]

Futurism's protected status continued throughout the Fascist era. Even after National Socialist antimodernism and the Nazi aesthetic purges influenced Fascist cultural policy, the futurists and Marinetti remained central players in state-sponsored culture.

Futurism's relationship to Fascism has provoked a heated historical debate. In the years after World War II, scholars frequently disassociated early futurism from its later manifestations, in an attempt to "protect" it (and, hence, the historical avant-gardes) from Fascist associations. "True" futurism, in this reading, dated from 1909 to 1915 and the movement of the 1920s and 1930s was avant-garde in name only and the producer of art and literature unworthy of serious consideration. However, recent work rejects the construction of a cordon sanitaire around the movement's phases, stressing instead the continuities between futurism's two generations and the overall significant contribution of futurist cosmology and aesthetics to Fascist ideology.[124] Futurist syntaxes and aestheticized politics, in their pre– and post–World War I guises, were fundamental to and constitutive of the Fascist project and deeply imbedded within it.

Other artistic movements also participated in official culture, albeit in lesser degrees than the novecento and the futurists. The scuola romana,

6. Scipione, *Cardinale Decano* (*Cardinal Decano*), 1930 Venice Biennale.

led by painters such as Mario Mafai (1902–65) and Scipione (Gino Bonichi) (1904–33), rejected the novecento's language of *italianità* and turned to an expressionism that focused on experimentation with color (fig. 6).[125] The work of the scuola romana tended toward angst-ridden urban and domestic scenes. Beginning in the early 1930s, the expressionists of the scuola romana entered into polemics with the artists of the novecento, accusing them of "cold academicism" and "relative classicism."[126]

A group of abstract painters, known as *concretisti*, came of age in the early 1930s. This group, centered around the Galleria Milione in Milan, included painters and sculptors such as Lucio Fontana, Fausto Melotti, and Atanasio Soldati, and later Osvaldo Licini and Renato Guttuso (fig. 7).[127] While this group eventually opposed the dictatorship, it did,

7. Osvaldo Licini, *Castelli nell'aria* (*Castles in the Air*), 1932.

when offered, accept Fascist patronage at the Quadriennales, Biennales, and syndical exhibitions of the 1930s.[128] Though seriously and increasingly neglected by official circles, the abstract movement saw itself as posing a possible avant-garde alternative to the neotraditionalism of the novecento and the machine aesthetic of futurism.

Fascist cultural politics and the stylistically hybrid choices of state patronage that evolved after 1925 grew out of the debate over the appropriate aesthetic content and form for representing Fascist Italy. The disagreement among bureaucrats, critics, and cultural producers gave shape to the complex and unstable compromise that was art under Fascism.

The Impresario Bureaucrat

The particularities of Fascist cultural politics necessitated and facilitated the rise of a new profession: the state cultural impresario. This was a bureaucrat who utilized entrepreneurial and cultural skills in the management of government and party-sponsored cultural institutions. Created by and central to Fascist culture, they served as middlemen between the regime, artists, and spectators. The dictatorship's goal of a centralized national culture made mediating individuals, able to recruit artists and coordinate institutional change, essential. Italian Fascism's search for institutions and events that met propaganda goals while achieving popular and critical acclaim, together with the growth of the culture market and mass culture in Italy, gave birth to a new and modern genre of bureaucrat.

The men who built careers at the core of Fascist institutions joined commerce, culture, and ideology and mediated between the demands of official culture's constituent parts—the government and party apparatus, cultural producers, and consumers. The most prominent and powerful of this species successfully blended innovative methods, attention to public tastes, awareness of the regime's agenda, and attacks on established cultural practices. The type appeared in both high and low culture. Most were tied to the Fascist syndical system and held positions within it. Although from various political backgrounds and often with differing visions of the appropriate content of Fascist culture, they shared a commitment to its expansion and development. By and large, these figures were committed to a Fascist culture that mobilized a range of aesthetic languages.

Fascist cultural impresarios were a savvy and experimental breed. The most visible cases were ambitious men who used official cultural politics as a springboard to nationally prominent careers in the Fascist hierarchy.

Antonio Maraini and C. E. Oppo carved out cultural fiefdoms and built major careers on their successes. Because the regime came to power without a blueprint for a cultural *gleichschaltung*, more often than not initiative fell to the tenacious and ambitious. Three figures in particular molded the primary sites of state arts patronage: Antonio Maraini, Cipriano Effisio Oppo, and Dino Alfieri. These cultural impresarios saw themselves as an intimate part of the Fascist project, but they shaped the project as much as they were shaped by it.

The cultural impresarios who ran the major national institutions must be distinguished from bureaucrats who sat in government and party offices. The impresarios implemented policy at the level of specific institutions and gave it tangible form. Their role must also be seen in distinction to critics, such as Margherita Sarfatti or Ugo Ojetti, who, while powerful, remained outside an institutional framework. Figures such as the Biennale's Antonio Maraini and the Quadriennale's C. E. Oppo acted as a nexus between the regime and artists, as did Dino Alfieri at the Mostra della rivoluzione fascista. Such cultural impresarios saw exhibitions in the late 1920s as a cultural form ready for development and expansion, as well as prime territory for the bases of personal careers.

In societies where nationwide networks of mass culture existed earlier, cultural impresarios emerged from the private sphere. In the late nineteenth century, America's P. T. Barnum and England's Imre Kiralfy introduced new publics to new forms of entertainment and cultural spectacle.[129] Like his later Italian counterparts, Kiralfy combined promotional savvy, nationalism, and a sensitivity to public tastes.[130] In Italy, mass culture and national culture took root under the auspices of the Fascist state and were tied to its interests, thus producing cultural entrepreneurs from within the official apparatus, as well as from outside it. The dictatorship's interest in mass mobilization and in expanding the social boundaries of official culture encouraged the development of broad-based events and gave space to state-sponsored promoters.

Many of the leading cultural figures chosen by the regime to run national exhibitions, such as Maraini, Oppo, and Alfieri, came to Fascism from the Nationalist movement. They were influenced by Nationalist cultural philosophies that stressed renewal through the elevation of Italian traditions. These bureaucrats (also practicing artists in the cases of Maraini and Oppo) had been active in the Italian Nationalist Association prior to 1922 and continued to represent the monarchist, traditionalist wing of Fascism.[131] This Nationalist contribution helped to impede the Nazification of Fascist culture in the later 1930s: the Nationalist outlook implied a latent commitment to elements of pre-Fascist liberalism in conservative circles. When Fascist culture fragmented into factions for and

against censorship, key ex-nationalists stayed close to Giuseppe Bottai, the leader of the pluralist faction.

The fact that individual directors of the regional artists syndicates, of the Quadriennale, and of the Biennale exercised a significant degree of autonomy in regulating policy created considerable administrative inconsistency. More often than not, proponents of change in the organization of official culture came from the margins of the Fascist hierarchy. The dictatorship's underdeveloped cultural ideology and composite cultural origins left space for individual initiative. In many cases, individuals lobbied the government in support of their proposals and proffered the specific terms of cultural reorganization.

As the preceding analysis of the transformation of the Venice Biennale detailed, the immediate impetus for its Fascistization came from Antonio Maraini. He mobilized, lobbied, and organized relentlessly in the years 1927 to 1930 to convince the minister of education and Mussolini of the Biennale's potential. Already prominent as an activist in the Nationalist Party and a sculptor of classicizing, traditional, and, often, religious works, Maraini joined the Biennale Administrative Council in 1927.[132] A native Roman with a degree in law, Maraini first entered the national art scene in 1910, when he won a silver medal for sculpture at the Brussels International Exposition. After serving as an officer in the air corps in World War I, Maraini joined nationalist and right-wing politics.[133] In 1925, he organized in Florence the first branch of the Fascist Syndicate of the Fine Arts.[134] Maraini remained committed to the organization of the arts through the syndicates throughout his career, founding in the years 1925 to 1930 nine sections of the Fascist Syndicate of the Fine Arts. He also frequently contributed art criticism to the daily newspapers *La tribuna* and *Corriere della sera*.[135]

Maraini's coming-of-age in Nationalist politics left him with conservative cultural values and the view that much of avant-garde art was frivolous. His own work and his political origins led him, by his rise to national prominence in the late 1920s, to support an aesthetic position based on a "return to order" in aesthetics and a commitment to *italianità*. For Maraini the regimentation of artists into syndicates that represented their corporate interests through the active patronage of exhibitions and purchasing was the optimum method for the flowering of *italianità*.[136] His vision, founded on notions of balance, form, and Italian-based inspiration, drew on very different sources than the subsequent promoters of a fully politicized "Fascist art."

Maraini had multiple motivations for transforming the Biennale. The Venetian exhibition presented him with an opportunity to implement his political-artistic vision and to advance his own career. His experience

organizing the fine arts syndicates led him to view artists as a recalcitrant, yet valuable and untapped resource for the regime.[137] Artists, Maraini believed, were uniquely qualified to contribute to national renewal. In 1932, he was promoted from member of the National Directorate of the Fascist Syndicate of the Fine Arts to its secretary-general. At the age of forty-two, Maraini was secretary-general both of Fascist Italy's most prestigious art exhibition and of its national union of fine arts. The announcement of Maraini's appointment in the trade journal of the National Syndicate of the Confederation of Fascist Professionals and Artists highlighted his qualifications: "his past as a scholar, syndicalist, and artist has given him the right to just recognition."[138] Maraini had made his name in the foundation of the artists' syndicates and he brought this experience to Fascist culture at the national level.

A deluge of unsolicited correspondence from Maraini to the administrative head of the Council of Ministers and to Mussolini in 1927 began the process of exhibition reorganization in Fascist Italy. With the government's first moves toward declaring the Biennale an independent institution, in February and March of 1928, Maraini intensified his personal campaign.[139] On February 18, 1928, Maraini, in a characteristically officious tone, wrote Guido Beer requesting an audience with Mussolini in order to "present to His Excellency the information [he] had gathered on the state of the arts and artists in [his] travels around Italy."[140] Maraini knew that organization of the arts remained unmined territory; his experiences organizing the artists' syndicates allowed him to present himself as the most willing and able candidate to restructure the official system of artistic display.

Some considered Maraini a "corrupt, incapable party hack" and a "tyrannical" head of the artists' syndicate—as illustrated by a 1933 movement of artists against him.[141] However, his commitment to the syndical system and to the regime's evolving vision of a centralized national culture kept him at the center of Fascist cultural politics. Vittorio Fagone, finding Maraini's influence crucial, calls him "the authoritarian executor of a centralizing drive" and "a true deus ex machina" for policy in the arts during the years 1928 to 1943.[142] Throughout the Fascist ventennium, Maraini jealously guarded his overlapping positions as czar of the artists' syndicates and as the government's man at the Biennale.

Even more visible than Maraini, Cipriano Effisio Oppo could make or break a cultural event in Fascist Italy. With great skill, he combined a career as artist, critic, arts administrator, and parliamentary deputy. Like Alfieri and Maraini, Oppo came to Fascism through the Nationalist movement. He had actively supported a return to Italian aesthetic values in his reviews for the nationalist newspaper *La tribuna* (the same news-

paper for which Maraini had written) in the years prior to Fascism. His many visible positions during Fascism included president of the Fascist Syndicate of the Fine Arts (1927–32), Fascist parliamentary deputy (1929–34), and president of the Quadriennale (1931, 1935, 1939) and of the Shows of the Lazio Syndicate of the Fine Arts. Active also in Fascist mass culture, Oppo served as artistic director for the regime's opening salvo at a national event of self-representation—the Mostra della rivoluzione fascista.[143] At the end of the decade, he oversaw the construction of a rotating exhibition center in the Circus Maximus.

Committed to *italianità* and a philosophy of the solid values of art, Oppo nevertheless approached culture under Fascism with a vision of aesthetic pluralism. The curator of Oppo's papers, Fabio Benzi, celebrates Oppo's "unique breadth of vision" and commitment to independent artistic expression. "He contributed significantly to allowing artistic events, despite the existence of a dictatorial regime," writes Benzi, "to enjoy a liberty and richness of expression restrained only episodically by the central government, at least until the war."[144] Artists and architects, such as Giuseppe Pagano, praised Oppo for "giving a modern stamp" to the official exhibitions under his jurisdiction.[145] In the late 1930s, Oppo rejected the rising tide of academic neoclassicism and calls for an "imperial art." "The old cannot be copied," wrote Oppo in 1927. "Those who see Fascism as a good vehicle for a new imperial art (with Roman attributes) should remember the result of such artistic assumptions under Napoleon: academies, false grandeur, rhetoric, stylization two to three times removed."[146] In an early article for *Critica fascista*, Oppo defined "Fascist art" simply as "that which is done and will be done during the Fascist era."[147] As director of the Quadriennale, Oppo made fewer compromises to the antipluralists' call for a marginalization of modern art in the later 1930s than did Maraini at the Biennale.[148] Oppo's direction of the artists at the Mostra della rivoluzione fascista ultimately shaped the exhibition's acclaimed outcome, as he executed his job with a commitment to aesthetic diversity and experimentation. Overall, Oppo's sustained participation in Fascist official culture contributed to its eclecticism and expansion.

A "cultural impresario" like Antonio Maraini and C. E. Oppo, Dino Odoardo Alfieri (1886–1966) demonstrated an entrepreneurial promotional capacity and a facility with mass culture. Alfieri organized and directed the first, most successful, and prototypical of the Fascist mass culture exhibitions. Recruiting artists, using modern art and design, and offering advertising and tourist incentives, Alfieri turned an original idea for a commemorative anniversary celebration into the innovative centerpiece of Fascist culture.

The Mostra della rivoluzione fascista, like the reorganization and expansion of the Venice Biennale, originated as the brainchild of a single promoter. In 1928, while serving as president of the Istituto nazionale fascista di cultura (National Fascist Institute of Culture) in Milan, Dino Alfieri conceived of an exhibition in celebration of the decennial of the founding of the first *fascio di combattimento* to be held on March 23, 1929.[149] After a series of solicitations to Mussolini's office, Alfieri secured a meeting with the dictator on March 23, 1928.[150] Following a positive response on the part of Mussolini and the Fascist Party, Alfieri devoted the bulk of his attention for the next six years to the Mostra della rivoluzione fascista and to its expansion and publicity.

Like Maraini and Oppo, Alfieri came to Fascism through involvement in the Nationalist movement, having organized a Milanese nationalist group and joined the Nationalist Party in 1910.[151] Alfieri, who entered the movement for Italian intervention in World War I in 1914, was wounded in action and decorated for his contributions at the front.[152] Like other Nationalist latecomers to the Fascist movement, Alfieri falsely claimed early membership in the party. As of 1933, his résumé maintained that he had joined the Fascist Party in 1919 with a party card numbered 83,517 of the fascio di Milano.[153] A letter written in support of Alfieri's nomination to the Fascist Grand Council in 1942 declared that "at a very young age he entered the political struggle against [Communist] subversion and was a participating squadrista at the March on Rome."[154] However, it is hard to consider him a "Fascist of the First Hour," since he "decidedly opposed" fusion of the Nationalist Party with the Fascist Party in March 1923 and did not participate in the March on Rome.[155]

Given his role as architect of the Mostra della rivoluzione and his overall influential position in the formulation of Fascist cultural politics, Alfieri's late adhesion to Fascism personifies the negotiated, hybrid, and evolutionary character of Fascist policy. It also suggests the significant contribution and influence of figures shaped by the Nationalist Party. Alfieri's conversion and reinvention as a "Fascist of the First Hour" served him well: the Mostra's success carried Alfieri into the inner sanctum of Fascist power and formed the basis of a career at the pinnacle of the Fascist hierarchy. Alfieri served as a Fascist deputy in the parliaments of 1924–28 and was undersecretary of corporations from November 1929 until July 1932. In August 1935, Mussolini appointed him assistant secretary of press and propaganda and in June 1936, when Galeazzo Ciano became foreign minister, Alfieri ascended to the position of minister of popular culture, which he held until late 1939.[156] In his last post, Alfieri served as ambassador to Berlin; his final and highest promotion took place in 1942 with nomination to the Fascist Grand Council.

Maraini, Oppo, and Alfieri all saw themselves as cultural producers, as well as middlemen: Maraini had some success as a sculptor, Oppo painted and wrote art criticism, and Alfieri was a writer.[157] This self-conception allowed them, more or less successfully, to present themselves as artists' advocates. These three state cultural impresarios had significant levels of autonomy and room for experimentation within their cultural spheres. Maraini transformed the Venice Biennale into a major international art exhibition at the center of a vast tourist spectacle. He introduced film and decorative arts into the Venice Biennale between 1930 and 1932; and when these attractions found a popular following, he moved them to the center of the exhibition's program. Under Maraini's tenure, the Biennale recruited contemporary advertising and offered incentive programs to entice audiences, and the Biennale became a multifaceted attraction that combined the fine arts and mass culture. Oppo helped to turn Rome into a national arts center and he mediated between the regime and the nation's most prominent modern artists. He successfully challenged Milan's hegemony as the only focus of modern Italian artistic life. Alfieri directed what became Fascist official culture's most popular and most modern event, the Mostra della rivoluzione fascista, and coordinated its elevation to national and permanent status.

Their administration of cultural events, their self-understanding as artists, and their autonomy within their given spheres made these figures new breeds in the cultural landscape. These men oiled the gears of official culture and gave form to Fascist cultural patronage. Indispensible to the workings of Fascist culture, they were products of larger changing cultural conditions, as well as Fascist cultural centralization and the regime's initial focus on form over content.

Aesthetic Pluralism Triumphant: The State as Patron, 1931–1936

THE REGIME HAS COME TO REPLACE THE COURTS,
THE GREAT FAMILIES, THE CHURCH, AND THE
CONFRATERNITIES.

Giuseppe Pensabene, 1934[1]

THE Italian Fascist government in 1932 commissioned a new facade for the main pavilion at the Venice Biennale of International Art. The regime's choice of facade offers a physical representation of the style of arts patronage characteristic of Italian Fascism. The Venice Biennale facade and the simultaneous renovations to the interior presented a mix of concurrent messages—ones of hybridity and heterodoxy emblematic of Fascist arts patronage. The changes simultaneously pursued modernity and classicism, simplicity and monumentality. The blend of classical and functionalist elements, of historicism and contemporaneity projected a decision to mix and combine rather than exclude. The Biennale facade provides revealing insights into Fascist cultural politics, because, as the most well known international art event on Italian soil, the regime paid close attention to the exhibition and treated it as the linchpin of its arts patronage program. The extensive attention and funding directed to the Biennale by the offices and functionaries of both the government and the party between 1928 and 1942 made it the primary site of evolving Fascist arts patronage strategies.

The Fascist-commissioned Biennale facade of 1932 replaced the one built in 1914. The earlier facade stood in a heavily ornamented neo-Renaissance style which utilized classical orders, decorative marble motifs, and two towers. It was composed of four modified-Corinthian

pilasters surrounding a door, above which stood the words "pro arte" (for art) and a large brass relief of the lion of Saint Mark, Venice's patron saint and symbol (fig. 8).

In contrast, the new rationalist facade, designed by Dullio Torres, replaced the detailed portico with simple, clean lines. Ornamentation disappeared, reduced to linear form, as in the cornice and archway (fig. 9). This facade, declared the government architecture journal, is "modern and synthesizes a motif of classical flavor."[2] It has four simple columns under a linear, nonornamental pediment, supporting an inscription. The word "Italia," in large marble sans serif lettering, substituted for the earlier "pro arte". The winged Lion of Saint Mark now shared the facade with the Fascist symbol, the imperial eagle grasping a *fascio littorio* (lictor's fasces). The central theme of the facade thus became Italy, neither *arte* nor Venice. Aesthetically and iconographically, the old facade had spoken to pre-Fascist elites through historically loaded symbols. The signs of the new facade read the nation and the party.

The new facade in a functionalist, rationalist style conveyed an openness to new aesthetic forms, as well as to expanded audiences bringing with them different forms of cultural literacy. Antonio Maraini, secretary-general of the Biennale, explained the relationship between the new facade and the new Biennale: "The sober and clear harmony of the new facade declares the intentions pursued by the Biennale with its XVII Exhibition . . . the same will to avoid and abolish the superfluous, in order to tend only to the essential."[3] The interiors of the pinnacle of official culture were also reworked at the architect's drafting table. The redesigned interiors evoked Fascism's desire to be represented not only by a new and modern aesthetic, but by a plurality of modern aesthetics. Architect Gio Ponti reconstructed the pavilion's rotunda in a streamlined art deco classicism that limited ornamentation while depending upon stripped-down classical elements (fig. 10). Marcello Piacentini brought his interest in *romanità*-influenced architecture to the rebuilding of the main salon.[4]

Keenly attuned to the messages implied in the design of public spaces and interested in appropriating those spaces, the regime worked to redefine them to its own advantage. Exhibition architecture is a useful point of entry into official culture because "it stands metaphorically as well as physically for the structures that define the boundaries between 'inside' and 'outside.'"[5] In order to announce its arrival and the changed cultural conditions, Fascism replaced ornate nineteenth-century beaux arts exhibition design with characteristically rationalist facades and modern, nonornamental interiors with classical references. Internally and externally, the new patron reshaped the Venice Biennale's physical space to announce its transformation to even the most unsuspecting visitor.

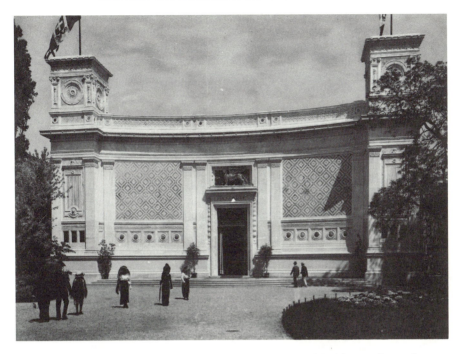

8. The facade of the Venice Biennale Italia pavilion modified by Guido Cirilli in 1914.

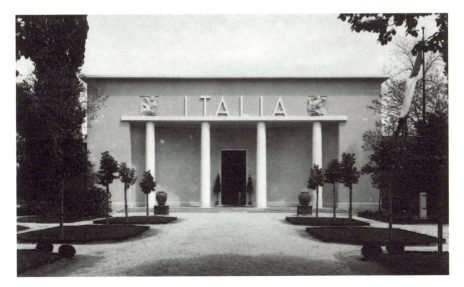

9. The 1932 facade of the Italia pavilion designed by Dullio Torres.

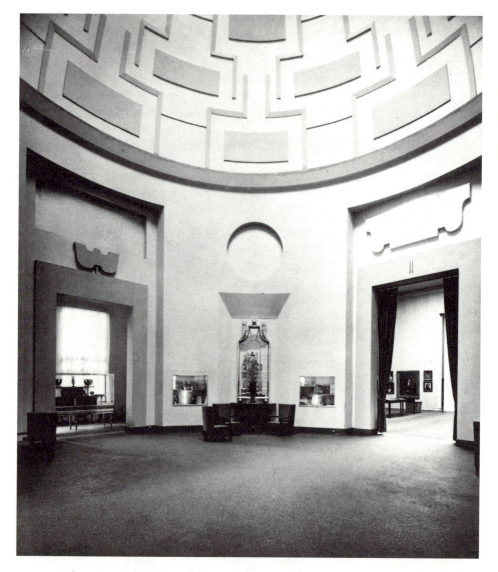

10. The renovated interior of the Italia pavilion: Sala della rotonda (Room of the Rotunda) by Gio Ponti, 1932.

Once the pavilion had been readied for the new patron, what did the new men of the government and party select to display in it? This chapter details the character and function of official arts patronage between 1930 and 1937 and lays out the practice of aesthetic pluralism and the patronage patterns that it engendered. The regime's patronage strategies are clues

to the elaborate role played by art and artists in the Fascist state and Fascism's successful mobilization of a range of modern and traditional aesthetic languages.

The Theory of Aesthetic Pluralism

With a patronage system composed, in varying degrees, of incentive, flexibility, and coercion, the Mussolini dictatorship came to artists and audiences as a patron in search of support. The need for mass support led to the enshrining of aesthetic pluralism in the early and mid 1930s and encouraged the promotion of hegemonic pluralism—a Gramscian-informed notion describing the semblance of pluralism that coexists within and gives legitimacy to a repressive regime.[6] Hegemonic pluralism was the acceptance, appropriation, and mobilization of a variety of aesthetic languages in the pursuit of consent and legitimation and in the search for a representational language evocative of the Fascist new era.

Within a hegemonic political structure, the dictatorship balanced a need for rhetorical propaganda with an interest in critically acclaimed art and cultural programs that encouraged widespread participation. This patronage system based on a plurality of expressions took potentially oppositional discourses and aesthetic languages and integrated them into a ruling structure. A heterodox approach to patronage preempted the creation of an artistic underground and with it the regime appropriated the "intellectual and moral leadership" of the artist class to win the consent of other groups.[7] For artists, this translated into extensive funding without aesthetic directives. It also produced the conditions under which artists and architects performed formal experimentation within the confines of state structures. For audiences, it meant experimentation with inherited cultural forms and the expansion of and experimentation with mass culture.

This chapter traces the trajectory and meanings of hegemonic pluralism as a form of state patronage. Through 1937, a majority of artists and cultural functionaries assented to the dictatorship's role as enabler of cultural production. A dominant discourse of pluralism held the system in place and validated an eclectic approach to state patronage. As conflicting visions of the state's role in cultural production destroyed the compromise, the hegemonic system collapsed, with the regime's leading role lost, challenged by counterdiscourses and alternative, radically centralized, and univocal understandings of the relationship between art and the state.

While hegemonic pluralism functioned as a legitimizing and consent-building technique, Fascist cultural bureaucrats and Mussolini himself understood and explained the policy in cultural and aesthetic terms, hailing it as the path to a Fascist-led cultural renaissance. Italian cultural traditions and Fascist spiritual, antimaterialist goals precluded aesthetic regulation, according to supporters of a pluralist state patronage. Mussolini articulated an inclusive cultural politics when, at the Roman Quadriennale of 1931, he declared it was not "an exhibition of a particular tendency, of a particular group, of a particular coterie." Rather, he added, referring to this first national exhibition of Italian art, "there is everyone: from old timers to the very young, and also unknown [artists]."[8]

Members of the party and the government reiterated this self-conscious rhetoric of inclusion throughout the 1930s and institutionalized it in the regulations of official art exhibitions. In 1933, the program of the Fourth Exhibition of the Fascist Syndicate of the Fine Arts of Sicily declared it intended to "welcome with the broadest vision every possible artistic expression and to accept all inspirations and techniques."[9] That same year the syndicate of the Emilia-Romagna articulated a similar formulation saying that "the Exhibition welcomes without prejudice all tendencies, schools, and techniques of any chosen artistic expression."[10] The syndicate of the Marche, for its first exhibition, declared even more emphatically "the utmost objectivity regarding tendencies and schools."[11]

Many of those running the culture ministries in the 1930s celebrated the pluralist climate in which new, national, and Fascist forms would be nurtured under official care. Such an approach, they added, would create a national patrimony of modern art—a modern art that testified to the healthy, creative air of Fascism. The dominant voices of Fascist cultural politics repeatedly enunciated a refusal to discriminate based on aesthetic choices. They described this approach as quintessentially "Fascist" and as the way to ensure aesthetic quality. As Giuseppe Bottai, minister of corporations and national education during the ventennium, declared, "Fascism does not promulgate aesthetics. . . . Fascism does not want an art of the State."[12] Even Ugo Ojetti, the conservative cultural critic who would advocate an evermore classical aesthetic as the 1930s progressed, held that Italian cultural traditions precluded aesthetic regulation. "In twenty-five or twenty-six centuries of its art history, Italy had respect for clarity, beauty, and humanity and offered so many great and glorious examples [of it] that it cannot today, under Mussolini, fix limits and set up barriers."[13] In the journal *Gerarchia*, often seen as reflective of the Duce's own opinion, Bruno Biagi celebrated a climate of aesthetic debate, saying "in the syndicates there must be and it is good that there are struggles between and disagreements over tendencies and schools; but the admin-

istrators must pay attention not to become upholders of a single style nor defenders of a single school."[14]

Pluralist state patronage arose from a combination of the possible, a belief that the arts did not require the level of coordination that other realms did, and a dominant discourse that only a multiplicity of expressions produced good art. For many Fascist officials, aesthetic debate within an Italian and Fascist context would lead to cultural regeneration and a replacement of the desiccated bourgeois culture of the nineteenth century. Conceptions of cultural degeneracy and modernism as a corrosive force that drove Nazi cultural politics toward "a program of aesthetic eugenics" found little root in either the theory or praxis of Italian Fascist cultural politics.[15]

Additional reasons for aesthetically pluralist patronage are manifold. To begin, given Fascism's low level of penetration of state and society in the late 1920s, stylistic pluralism was a viable way to make its presence felt in culture. Second, many Fascist officials regarded the arts as removed from the political functioning of the dictatorship and, therefore, less in need of regimentation. Third, inclusivity bred consent and discouraged the creation of an artistic underground: a level of pluralism took potentially oppositional discourses, aesthetic languages, and celebrated artists and integrated them into Fascism. It bound artists to the regime and proved to culture-going elites that the regime would not challenge the prestige of high culture. Finally, a deep-running discourse of the historical exuberance of Italian culture subverted counterdiscourses favoring an "art of the state."

By elevating a patronage strategy based on support for a multiplicity of aesthetic languages, the regime achieved legitimacy, visibility, and cultural authority. Arts patrons and critics received continuity and the acknowledgment of their expertise, and artists gained access to display and material support. A system of triangular legitimation evolved: artists and audiences participated in party and government cultural institutions and acknowledged the regime's leading cultural role, and in return the dictatorship conferred status and material rewards upon cultural producers and consumers. As Howard Becker writes, this symbiosis is a common feature of efficient patronage systems, in which "the patrons provid[e] support and direction, the artists creativity and execution."[16]

High culture, in the form of the fine arts of easel painting and ornamental sculpture, received particular attention from the dictatorship. The accumulated prestige of established high art offered the consolidating regime essential cultural capital. As Pierre Bourdieu has detailed in his work on the creation of "cultural tastes" and "status," in European societies high culture is freighted with cultural authority that can be

appropriated or used by those with access to it.[17] The cultural capital imbedded in the arts "transforms the elementary power of wealth into acceptable forms of social dominance and class standing and lends legitimacy to economic, social, and political power."[18] As of the middle 1920s, Fascism had political clout, but its relationship to prestige, culture, and status remained indeterminant.

In the years after 1925, with the Fascist assumption of power recent and the declaration of dictatorship new, Fascism's reputation for thuggery and vulgarity concerned established elites; arts patronage gave the bureaucracies and individuals of the government and the party an opportunity to declare their cultural authority within existing networks and discourses. While Fascism came to power coded by preexisting elites as "outsider" and as dangerous, messages of cultural continuity and respect for the "classics" drew the dictatorship closer to Nationalist and bourgeois elites who continued to harbor anxieties. Many of the figures in the regime's culture bureaucracies had come to Fascism from the Nationalist movement and they moved slowly toward cultural transformation. The dictatorship's selective appropriation of inherited high culture strengthened elite consolidation and helped glue together a reconstituted hegemonic bloc. The Italian royal family's appearance at all the major exhibition inaugurations and closings of the era testifies to the regime's interest in mobilizing cultural capital. Some emulation of the patronage styles of the bourgeois and aristocratic elites of Liberal Italy gave the emergent regime cultural legitimacy and strengthened class alliances.

Yet Fascism's fine arts patronage was far more than a replication of the tastes and practices of the urban bourgeoisie which had set the cultural tone for Liberal Italy. Given Fascism's original antibourgeois mass politics, which had launched it as a movement in the heady days of 1919–20 and continued to sustain it, arts patronage could not be a simple emulation of a previous cultural system or bloc of elites. Fascist arts patronage was founded on the simultaneous appropriation and reconstitution of cultural authority. The most significant initial challenges to cultural authority, in the form of challenges to the social practices and forms of culture, took place in mass culture. Even in the realm of high culture, the patronage style that evolved by the middle 1930s represented the product of negotiation between the interests of the regime (and its unstable cultural compromise between culture bureaucrats drawn from a Nationalist past and those from a futurist-modernist present), cultural producers, and cultural consumers.

The Mussolini dictatorship required the cultural capital associated with elite culture, artists demanded financial support and access to the institutions of cultural display, and the consumers of high culture sought contin-

ued access to that culture. In this way, the fine arts represented a "glue" between the regime and elites, functioning similarly as mass culture did between the dictatorship and other segments of the population. By addressing cultural interests, and partially reconstituting them in accordance with Fascism, the regime could both lead and follow. The dictatorship sought simultaneously to inherit the hierarchical categories of cultural capital and to restructure them to allow entrance to the new agencies of the government and the party and the, as yet unarticulated, discourses and narratives of Fascism.

Taste played a central role in the construction of Fascist patronage. Taste "functions as a marker of class" and "classifies the classified." The right choices confer rank and, as Howard Becker writes, "the ability to pick the best artists and commission the best work shows the nobility of spirit and character the powerful and wealthy think they possess, so that being a good patron supports the claim to high rank."[19] Seeking an image of continuity and change, Fascist taste in the fine arts was an amalgam of traditional, bourgeois, and high modernist tastes. Fascist choices in the arts took a form conditioned by the "complex relationship between wealth, knowledge, taste, patterns of support for artists, and the kind of work produced."[20]

Fascist taste was shaped by changing class alignments and by the regime's interest in cultivating certain groups. As studies on consumption and arts patronage in other eras have demonstrated, new elites can "distinguish themselves" through taste.[21] The historical and social specificity of taste shapes the relationship between cultural consumption and production; as new tastes evolve, production patterns adapt, and consumption, in turn, colors production. Official taste under Fascism favored the neoimpressionism and neoclassicism of the return-to-order movement and the *italianità*-modernism of the novecento, together with a long-standing commitment to futurism. The plurality of aesthetic tastes saw official acquisition of landscapes, still lifes, portraits, and some political theme works. The nineteenth-century favorite of history painting found little favor among the new official patrons, and overornamentation and sentimentality were also in low esteem.[22] Generally, official taste ran to a hybrid and heterodox modernism with a strong current of neoclassicism.

While hegemonic pluralism describes the contours of the relationship between art and the state under Italian Fascism, Fascist arts patronage was not a static system. Over twenty years of rule, the regime's goals and interests as a patron were contested and reformulated as differing aesthetic styles, forms, and genres received official attention. Fascist cultural functionaries experimented with patronage strategies as social, political,

and economic priorities changed. As discussed in chapter 2, in the period of political stabilization (1925–30), the dictatorship focused on administrative and bureaucratic control of the arts by regimenting artists into Fascist-run syndicates and placing the institutions of cultural display under official control. The middle years of Fascist arts patronage (1930–36) simultaneously stressed the creation of a visible, modernist official culture and the formation of a cultural consensus around Fascism. In the years 1937–43, the dictatorship turned to imperial and militarist imagery and to National Socialist models of patronage, deemphasizing the eclectic appropriation that had provided the consensus it originally had sought.

Buying Art

High levels of government and party patronage served the regime as a propaganda and consensus-building technique, as well as being part of a less definable commitment to culture on the part of many Fascist officials. For artists, official purchases meant money and prestige. Acceptance in official exhibitions brought display; government and party commissions carried visibility and reputation. In the middle 1930s, the regime began to emulate the patronage patterns of the church and earlier wealthy patrons. As in other epochs, "the connections between artists and a wealthy elite have made artistic development possible while at the same time have bestowed prestige on elites, thereby legitimizing their powerful roles."[23] High levels of patronage without a specific aesthetic directive tied artists to the regime and encouraged them to see the dictatorship as a benefactor. By participating in a Fascist-sponsored exhibition, an artist empowered the regime; by patronizing the shows, the regime acknowledged and supported the arts. As of 1930, the Fascist dictatorship presented itself as a benevolent patron with an open purse.

The still emergent commercial art market and the depression of 1929–34 influenced the character of the symbiosis between the regime and the artist class. The Fascist dictatorship entered the patronage business at the moment when the private art market was both taking root and in financial crisis. The economic crisis, which struck as the regime first invested significant sums into the consumption of art, left many artists dependent on state support—support the offices of the Fascist Party and government were reluctant to withhold on a number of counts, among them, fear of alienating the culturally powerful, interest in underwriting a cultural renaissance, desire to make good on promises implied in syndi-

cal organization, and interest in preempting the creation of an artistic underground.

The government and the Fascist Party promoted, through a vast network of exhibitions, competitions, commissions, prizes, and purchases, an active fine arts culture, successfully attracting large numbers of artists and spectators. By the late 1920s, the growing culture bureaucracies of the Fascist regime began to look for more than artists' membership in official artists' syndicates, and the relationship between artists and the dictatorship shifted, as the regime turned to active patronage as a way of influencing the content of cultural production. Fascist patronage did more than open the doors of the institutions of display to artists with varying aesthetic inclinations; it hailed them by buying, commissioning, and prizing a range of artists, aesthetic schools, and genres. Official patronage depended on a multiplicity of methods for attracting artists and spectators. The regime reinforced the first level, that of determining access, with active purchasing and, then, with prizes, competitions, and commissions. Essentially, state patronage was based upon trial and error: when one form of patronage failed or when the regime perceived new interests, it implemented new programs.

After 1930, government and party patronage in the form of acquisitions became a widespread and visible method used to attract artists, gain their consent for government and party intervention in the arts, and introduce Fascism as a force and a discourse into the visual arts. From 1930 until its collapse in 1943, the Fascist dictatorship consistently allocated funds for the purchase of paintings, drawings, and sculpture from the international, national, and regional exhibitions under its sponsorship. The organs of the party and the government made acquisitions at every Venice Biennale between 1930 and 1942, at the Roman Quadriennales of 1931, 1935, and 1939, as well as at the many provincial and interprovincial shows of the Fascist Syndicate of the Fine Arts. Widespread official buying was supplemented by significant private purchasing by Fascist officials. This strategy of eclectic and numerous acquisitions cemented the official cultural system and created a national patrimony of modern art.

The regime designated the Venice Biennale, because of its international character and available, convertible cultural capital, to be the showcase of official culture. This biannual exhibition of international art, first held in Venice in 1895 under royal sponsorship, represented the testing ground and first recipient of Fascism's developing patronage style. Beginning in 1930, government and party purchases at the Venice Biennale remained fairly steady ranging between 25 and 32 percent of total sales and increased to 37 percent in the early 1940s.[24]

In 1930, at the first Venice Biennale with major Fascist government and party presence, overall sales amounted to 1,407,892 lire for 462 works of painting, sculpture, and drawing.[25] Government offices, local agencies, and party organizations together spent 291,700 lire (one lire was roughly equivalent to five cents in 1930 United States dollars).[26] The largest official buyer, the Ministry of National Education, spent 130,000 lire on 35 paintings and sculpture destined for the new Galleria d'arte moderna in Rome.[27] The government was also represented by the Roman municipal administration, the Ministry of Corporations, and the Undersecretariat for the Fine Arts. The National Fascist Party, and some of its affiliated organizations, such as the National Fascist Confederation of Professionals and Artists, bought 54,000 lire worth of art.[28]

Active purchasing encouraged more spending. Government and party purchases increased at the 1932 Biennale. The Ministry of National Education, again to stock the new Galleria d'arte moderna, requested "extraordinary funds" in the amount of 130,000 lire from the Ministry of Finance. Initially, Finance Minister Mosconi rejected the request, citing the economic depression.[29] However, Minister of National Education Giuliano pressed the issue, stressing the necessity of government support:

> Given the international importance of the Venice Biennale—importance which is both artistic and political—it is impossible for the State not to be morally and materially present. . . . A possible absence could not help but be commented upon in Italy and abroad, in artistic and intellectual circles, as well as in political ones.[30]

Giuliano recognized the importance of state arts patronage for the international status of this new political culture.

Of the total of 1,154,675 lire spent on art purchases at the 1932 Venice Biennale, state and local government and party organizations expended 375,403 lire.[31] Out of 516 works of art sold, the government and party purchased 159. With the 130,000 lire granted to it, the Ministry of National Education purchased 55 pieces, varying in price from 500 to 10,000 lire.[32] The Ministry of National Education and the Ministry of Corporations further showed their commitment to the fine arts by spending the unawarded prize monies of 1932 on art to adorn the ministries' offices. In its consent to spend over 200,000 lire (combining the purchases for the Galleria d'arte moderna with those for the ministry buildings), the regime further encouraged artists to depend upon government and party support.

The government was not alone in its patronage of the 1932 Venice Biennale. At the Biennale held during Fascism's tenth anniversary, the Decennale, the member organizations of the National Fascist Party again

actively purchased artwork. Purchases by the National Fascist Confederation of Professionals and Artists, the Fascist General Confederation of Italian Industry, and the National Balilla Organization totaled 58,000 lire.[33] The party, though not the decisive patron that the central government was, made its presence felt.

The deepening of the economic crisis slowed arts consumption after 1933. Yet, the government and party continued their active purchasing policy. While total sales at the 1934 Biennale declined, the percentage contributed by the government and party remained steady. Out of a total of 915,185 lire, government and party acquisitions amounted to 184,800 lire, and from a pool of 600 pieces of art sold, the government and party bought 140.[34] Major government ministries buying art changed in 1934: the Ministry of National Education continued its role as supplier for the Galleria d'arte moderna, spending 80,000 lire for the museum and 7,500 lire on art to decorate the ministry offices. The Ministry of Corporations, reducing its commitment, bought a single piece for 2,000 lire. The Ministry of Foreign Affairs appeared for the first time as a patron, also spending only 2,000 lire, but setting a precedent for intervention in the Biennale and other national exhibitions.[35] Party acquisitions for the 1934 Biennale, adding up to 37,800 lire, were made by a variety of groups, ranging from the the Fascist Confederation Agricultural Syndicates to the National Fascist Confederation of Professionals and Artists.

The government and party replicated ambitious official arts spending across the now centralized exhibition system. At the newly founded Roman Quadriennale of National Art in 1931, the Ministry of National Education purchased 130,000 lire worth of Italian art designated for the Galleria d'arte moderna.[36] Official expenditures increased at the 1935 Roman Quadriennale. The Ministry of National Education returned for more works of art, this time spending 200,000 lire, a 70,000 lire increase over its 1931 presence.[37]

For all these acquisitions, aesthetic pluralism remained the practice and theory of state patronage. The government and party acted as an eclectic patron, purchasing art without specific aesthetic requirements for patronage. The purchases of the years 1930–35, overwhelmingly of Italian artists, favored the novecento but included contributions from futurists, members of the Italian "return to order," Tuscan naturalists, strapaese artists, and abstract painters.[38] The Ministry of National Education bought paintings by Antonio Donghi, Alberto Salietti, Marino Marini, and Enrico Prampolini, among others.[39] For example, the ministry paid 5,000 lire for a sculpture by Marini entitled *Donna dormiente* (*Sleeping Woman*); this expressionist depiction of a reclining woman is rendered roughly and emotionally and conveys through its technique a timeless

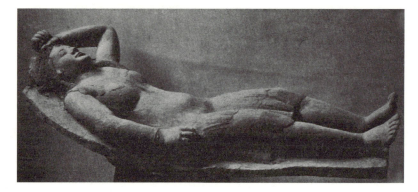

11. Marino Marini, *Donna dormiente* (*Sleeping Woman*), 1930, purchase of the Ministry of National Education.

weariness (fig.11). In the same set of purchases, the Ministry of National Education acquired Enrico Prampolini's futurist landscape, *Paesaggio femminile* (*Feminine Landscape*). Here Prampolini uses abstraction and color to convey a "female" form. The painting is a swirl of curved strokes combined into the outline of a woman (fig. 12). Both works are imbedded in the modernist sensibility, as they are dependent on color and form to convey emotion.

12. Enrico Prampolini, *Paesaggio femminile* (*Feminine Landscape*), 1930, purchase of the Ministry of National Education.

At the first Roman Quadriennale in 1931, the Ministry of National Education's thirty-one works of painting, sculpture, and incision replicated the aesthetic pluralism of the regime's general tastes: the works were a mixture of the novecento school, for example, *Fiori* (*Flowers*) by Felice Carena; "return to order," such as Filipo De Pisis's *Natura Morta* (*Still Life*); and futurism, such as Gino Severini's *Gruppo di Case* (*Group of Houses*).[40] The Ministry of National Education also purchased the expressionists of the scuola romana. The novecento school and its celebrities, represented the core of official acquisitions: Mario Sironi's *Famiglia* (*Family*) (6,000 lire), Achille Funi's *Trieste* (4,000 lire), Felice Casorati's *Mele* (*Apples*) (5,000 lire), and Gisberto Ceracchini's *Riposo* (*Rest*) (5,000 lire) were among the more expensive acquisitions.[41] Overall, prices ranged from 1,000 to 5,000 lire for paintings, 2,000 to 14,000 lire for sculpture, and 200 to 500 lire for drawings.[42]

At the Venice Biennale of 1934, once again, the works bought failed to show bias toward a particular aesthetic school. The novecento and the futurists turned up repeatedly on the acquisitions lists of the government and party, with the names Achille Funi, Felice Carena, Tato, and Enrico Prampolini appearing frequently. The aesthetic tastes of party organizations deviated little from those of government ministries: all the prominent schools from the futurists through the metaphysicals found government and party purchasers.[43]

Works of overt political content appear rarely in these middle years of Fascist patronage. The catalog for the 1930 Exhibition of the Fascist Syndicate of the Fine Arts of Venezia-Giulia reproduced thirty-two works of art: four landscapes, two still lifes, thirteen nudes and portraits, three city scenes, four country scenes, two religious themes, and four sculpted figures.[44] In 1932, of the thirty-two reproductions, three have explicit political themes, with three landscapes, ten portraits, nine city and country scenes, three abstract works, and four figurative sculptures.[45] While the catalog for the 1933 Third Exhibition of the Siennese Fascist Syndicate of the Fine Arts had a cover with a drawing of the Duce, not one of the reproductions inside presented a directly Fascist theme.[46] By the time of the second Roman Quadriennale in 1935, Fascist themes had increased slightly: of 130 reproductions, 9 depicted Fascist scenes.[47] The tastes of the Fascist Party, which represented a small fraction of official purchases, did show stronger interest in works with explicitly political themes. At the 1930 Biennale, the Fascist Party's two selections, Plinio Romellini's *La rivoluzione fascista* (*The Fascist Revolution*) and Orazio Amato's *La prima ora* (*The First Hour*), represented Fascist events or scenes.

Official purchases at the 1935 Roman Quadriennale sent a variety of modern-leaning schools to the Galleria d'arte moderna, but official taste

had changed. Government purchases deemphasized the novecento celeb-
rities. Younger artists who had risen through the official network of the
local, regional shows of the Fascist syndicates and those who had worked
on government commissions made a first appearance.[48] For example,
Arnaldo Carpanetti, who had designed part of the Mostra della rivolu-
zione fascista and had won a prize at the Venice Biennale in 1932, replaced
figures such as Mario Sironi on the 1935 acquisitions list. The language of
the committee charged with selecting the Ministry of National Educa-
tion's purchases reveals this new focus. They wrote to the minister of
national education to explain their "cordial openess to all tendencies and
techniques which are not facile or capricious, [but] a *preference* for those
paintings which seem animated by an Italian humanity and free from
cerebral and cold abstraction."[49] Aesthetic pluralism prevailed, but was
delimited by an attention to *italianità* and classicism. This discursive
change reflected the larger debate over Fascist aesthetics and the ques-
tion of whether pluralism could produce a sufficiently "fascist" cultural
environment.

Private purchases by prominent Fascists, and their widespread publica-
tion, underscored the regime's interest in appearing cultured and its ap-
propriation of traditional definitions of cultural sophistication. Fascist
officials, from Giuseppe Bottai to Achille Starace, the secretary of the
Fascist Party, demonstrated their support through private purchases of
art. These officials, many of them newcomers to high culture, aped the
behavior of earlier elites, seeking the cultural legitimation offered by the
fine arts. Like the ministries and organizations they represented, Fascist
officials had eclectic taste. Unlike their Nazi counterparts, who also
amassed fine arts collections, the private tastes of Fascist officialdom
tended toward "return to order" modernism and the patronage of prom-
inent Italian contemporary artists. Where the Nazis preferred master-
pieces of Renaissance and baroque European painting and middle-brow
nineteenth-century art, high-ranking Blackshirts took home the work of
Sironi, De Chirico, and Modigliani.

Well-publicized official patronage bolstered Fascism and Mussolini's
image vis-à-vis the art-going public. The dictatorship directed its arts pa-
tronage at audiences, as well as artists. To project an image of Fascism as
cultured and to respond to critiques of Fascists as philistine ruffians,
official and personal purchases by Mussolini and his gerarchs received
extensive press coverage, with announcements running in journals,
newspapers, and the Agenzia Stefani, the Italian Fascist news wire ser-
vice.[50] The Biennale press office released daily notices of purchases by
prominent officials, celebrities, members of the royal family and foreign
dignitaries.[51] Media coverage, in the press and in official newsreels, of

acquisitions played a role as important as the purchases themselves. The essential theatricality of Fascist politics and culture necessitated the continual representation of events in order to guarantee that a wide and varied public was apprised of them.

In 1934, Mussolini's office, the president of the Council of Ministers, patronized the arts for the first time with purchases worth 43,000 lire; these purchases, made in Mussolini's name and under his orders, marked the Duce's first intervention as a direct patron.[52] Entreated since 1928 by Maraini, Mussolini in 1934 finally authorized his office to spend 30,000 lire on Italian art and 10,000 lire on foreign art.[53] Domestic purchases included contributions from a variety of the predominant aesthetic schools: from Felice Casorati, associated with the novecento, to Ottone Rosai, prominent in the Tuscan naturalist school, to Tato, a futurist.[54]

Arts purchases served a number of purposes for Mussolini. The Biennale of 1934 was the first after Hitler's rise to power in Germany. Mussolini, committed to his position as leader and inspiration of international fascism, grew concerned at increased German influence in neighboring nations. Consistent with his image as protector of Austrian independence, Mussolini gave an explicit order to purchase "predominantly" Austrian art.[55] In a challenge to Nazi Germany, Mussolini bought *Portrait of Engelbert Dolfuss* and presented it as a gift to the widow of the right-wing dictator, only two months after his murder by Austrian Nazis.[56]

By 1934, state patronage constituted a defining aspect of officially sponsored exhibitions. The regime, artists, and critics all noted the centrality of government and party acquisitions. Giuseppe Pensabene, a strident critic of pluralist patronage, regretted that "each show always closes with a notable number of acquisitions and . . . the vast majority of these goes not to private patrons, but to state institutions."[57] Artists could participate in official exhibition culture with the confidence that a branch of the government and/or party would purchase their work. Antonio Maraini, acknowledged the dependence upon official support which Fascism had cultivated, saying in 1932 that, "given the difficult times which artists are experiencing, it would be painful to cut them off from resources which they have come to rely upon by now."[58] According to Maraini and the syndical system he represented, Fascism had the responsibility to aid artists and use exhibitions as the locus of exchange. The syndical leadership was conscious of the role played by acquisitions. In 1932, the head of the fine arts syndicate of the Marche extracted "a formal promise" from the prefect to encourage "personally" buying on the part of government offices and party organizations; the regional syndical official hoped this would ensure that "the exhibition closes with the full satisfaction of participating artists."[59] As such expectations reveal, the dictatorship had

created a situation in which artists and administrators understood participation in official culture to mean material reward.

Artists, particularly prominent ones, found Fascist patronage sufficiently flexible as to venture negotiation. Three of the thirty-one artists whose work was purchased at the 1931 Roman Quadriennale expressed displeasure with the regime's offer: according to a government report, Arturo Martini requested "a least 15,000 lire instead of the 8,000 offered" for his sculpture, Gino Severini "wanted 6,000 lire rather than the 5,000 lire offered," and Ercole Drei "refused [the offer] in an altogether rude manner."[60]

Artists assented to the state as patron, as evidenced by high levels of participation at government-sponsored exhibitions. At the 1930 Biennale, artists entered 1,767 works into competition for general display, of which the jury chose 17 percent.[61] The regional shows of the Fascist syndicates were also well attended. The larger regional syndicates, such as that of Lazio in 1936, could boast upward of 700 works submitted and 291 shown.[62] At the 1930 show of the Fascist syndicate of Venezia-Giulia, seventy-six artists submitted 204 works of art. The jury accepted 90 works by fifty-five artists; the next year, artists presented 236 works, with 75 selected for display.[63] The Exhibition of the Fascist Syndicate of the Fine Arts of Venezia-Tridentina in 1933 chose 133 of 211 submitted works and invited nineteen artists.[64]

Fascism built an arts policy based on professional, corporate regimentation. The Fascist syndicates told artists that participation in official culture would lead to material assistance. By continually increasing its financial presence at the Venice Biennale, the Roman Quadriennale, and the rest of the shows in the exhibition network, the regime achieved its goal of widespread participation. The vast number of official shows (300 shows of the syndicates alone took place over the course of the dictatorship) institutionalized eclectic patronage and made it nearly impossible for Fascist cultural bureaucrats to change course. By buying a significant percentage of the art shown at official exhibitions and evidencing variegated tastes, the regime demonstrated its commitment to an aesthetically pluralist culture.

Nonetheless, the system bred discontent. Critics disparaged the central role played by acquisitions and the regime's flexibility in matters aesthetic. In 1934, Giuseppe Pensabene complained that the regime had replaced "the courts, the great families, the church, and the confraternities" as primary patron.[65] For Pensabene and the cultural antipluralists he came to represent, in allowing financial dependence without demanding political and aesthetic adherence, the dictatorship wasted its resources, coddled artists, and failed to create what he considered a truly Fascist

cultural environment. This faction also blamed flexible patronage for the modernist and "internationalist" character of much official culture—it maintained that a more coercive system could rid Fascist culture of corrosive influences. By the later 1930s, this group couched its cultural critiques in a racist and imperialist language that declared international modernism a Bolshevik hoax—a formulation borrowed from National Socialism.

Shaping Art: Competitions

In the middle years of Fascist arts patronage—the high point of aesthetic pluralism—the dictatorship mobilized multiple strategies for the introduction of Fascism to the display and production of the fine arts. Prizes, competitions, and commissions, the regime's other patronage methods, acted as potentially more coercive forms than purchases, as they encouraged the adoption of designated narratives and discourses, if not formal languages. Some culture bureaucrats hailed competitions as forces driving the creation of a Fascist aesthetic. Officially promoted theme competitions, initiated in 1930, became a mainstay of Fascist official culture. Government offices—such as the Ministries of Corporations and National Education; party organizations, from the Balilla to Gruppi universitari fascisti (Fascist University Groups); and Mussolini, in the form of the Premi del Duce (the Duce's Prize)—all sponsored competitions. These competitions marked Fascism's first attempt to underwrite a particular rhetorical, pictorial, and discursive content. Well-funded competitions highlighted the advantages of joining the official system of cultural production.

Official prize competitions first appeared in 1930. At the 1930 Venice Biennale, the offices of the government and the party promoted a series of nineteen prizes worth a total of 331,000 lire. The Fascist Party and the Ministry of National Education put forward the most prestigious and lucrative prizes: the latter offered 50,000 lire for a statue "that exalts the physical and spiritual vigor of the race" and the former presented 50,000 lire for "a painting inspired by a person or event from the founding of the *fasci di combattimento*."[66] The Biennale's new backers offered no prizes to foreigners, constructing instead "a purely internal system of benefits."[67] The goal, as publicly articulated by Maraini, was to offer "practical assistance and comfort" to Italian artists.[68]

Reality, however, fell far short of expectations. Despite the fact that adminstrators opened the competitions to any artist belonging to the Fascist syndicates, the project met with a poor response. In late June 1930, after the due date for the submission of entries, Maraini, in an effort to

round up additional participants, mailed more than sixty postcards, personally soliciting the participation of artists who had shown at previous Biennales.[69]

A jury composed of government bureaucrats, arts administrators, and artists with varying cultural philosophies—from neoclassical or traditionalist to modernist—awarded the 1930 prizes.[70] The jury's concluding report expressed grave disappointment with the quality and quantity of the competing works.[71] "Not all the competitions," the report noted, "reached an outcome worthy of much faith." Indeed, some artists "contented themselves to follow the themes of the competition by the application of an improvised title to a work previously conceived and begun." For three competitions of 1930, the jury awarded no prize at all; for five categories, the jury reduced the prizes or shared them among several artists. The Ministry of National Education withdrew its prize, claiming that "it should have and could have found a more fortuitous response."[72] A 25,000-lire prize offered by the Fascist General Confederation of Industry for a painting dedicated to "the poetry of work" drew thirteen contestants, but the jury did not award it because none of the works addressed the theme. The prize of the National Fascist Confederation of Merchants offered for a work "inspired by the works of Commerce," found only two aspirants.[73] Neither won.

A mere twelve artists competed for the 50,000-lire prize of the National Fascist Party in 1930. Arnaldo Carpanetti won 40,000 lire for *Incipit novus ordo*, with the commentary that his painting, despite "all its defects," "best approached the assigned theme."[74] Carpanetti, an artist who skillfully used the Fascist patronage system to his own advantage, anticipated the jury's desires by attaching an explanation of the canvas to his entry.[75] In it, he narrated his "attempt to interpret the formative phase of Fascism":

> The Blackshirts, baptized by the war, advance in a disciplined and relentless march commanded by Benito Mussolini, creator of the new Italian order. . . . Into the chaos of postwar Italy . . . [in which] many insulted the flag and men were discouraged by sectarian and demagogic passions, the Blackshirts inevitably enter and return the people to their best sentiments: here, a mother offers the newborn baby, a future *balilla*, to the Duce.[76]

Carpanetti recruited a baroque-influenced aesthetic and composition for his allegory of the Fascist assumption of power (fig. 13). Led by a solitary Mussolini, the new black-shirted order sweeps away the forces of chaos and disorder. The baroque technique of figures overlapping and breaking the frame and strong diagonals gave the painting its tension. Carpanetti alluded to a Last Judgment genre, with the Mussolini/savior figure

13. Arnaldo Carpanetti, *Incipit novus ordo*, 1930 Venice Biennale, winner in the competition sponsored by National Fascist Party.

dominating the upper register of the painting. The Duce emits a glow or an aura, implying his otherworldliness. The Mussolini figure drives away the debris of the past—the damned, the grotesques, the tortured who writhe at the bottom of the canvas. In contrast to the biblically damned of the Last Judgment, these figures are condemned to the purgatory of history. The converts turn back to the approaching new order. The new order, depicted by the marching Fascist *squadristi*, move forward as a bloc. This new redemptive elite wave the flag of Italy, together with flags bearing the skull and crossbones of the Fascist squads. Their chests bear medals of World War I. Carpanetti depicted Mussolini as the

transfigurative agent separating chaos-damnation from order-redemption. Through Mussolini and Fascism, declared Carpanetti's painting, the anarchic masses were given form and purpose.

Although the competition called for a painting based on "a person or event from the founding of Fascism," Carpanetti's allegory, according to the jury, "best" reached the assigned theme. Despite the shortcomings of Carpanetti's entry, his energy and will to please were well rewarded: in addition to the Biennale honors, in 1932 he received a commission from Dino Alfieri to help design the prestigious Mostra della rivoluzione fascista.[77]

Two years later the regime cautiously ventured another competition series, in coordination with the national mobilization of 1932 in honor of the tenth anniversary of the Fascist assumption of power. The organizers added pomp and circumstance to draw attention to the theme competitions: prizes were to be given in a grand ceremony on the date of the Decennale (Decennial), October 28, 1932. As in 1930, participation required only membership in the Fascist Syndicate of the Fine Arts. Hoping to draw a larger showing than for the 1930 competitions, Maraini ran announcements in all national, local, and trade journals, well in advance of the entry deadline.[78] This time, total money fell to 150,000 lire from the 330,000 lire of 1930, reflecting disillusionment with the outcome of the earlier competitions. It was divided among seven prizes: 50,000 lire each from the Ministry of National Education and the Ministry of Corporations and 10,000 lire each from the City of Venice, the Opera nazionale balilla, President Volpi, the Consiglio provinciale dell'economia corporativa di Venezia, and the Rotary Club.[79]

The prescribed themes, all tied to the Decennale celebrations, ranged from "The Victory of Fascism" to "The Pact of Labor" to "A Personality Who in These Ten Years Has Well Served the Fascist Revolution" to "Year X."[80] Maraini designated that the ten best works from each competition would be displayed in a separate section of the Biennale to be entitled "Exhibition of Art of the Decennale." Again artists showed minimal interest: a total of 213 artists participated in the seven competitions.[81] The lucrative 50,000-lire prizes of the Ministry of National Education and the Ministry of Corporations attracted forty-seven and sixty-one artists respectively, and the remaining five found approximately fifteen contenders each.[82]

The preliminary jury, appointed to choose ten works to be displayed from each competition, lamented artists' continued lack of enthusiasm:

> Considering that the Biennale's idea of offering celebratory prizes for the Fascist Decennial was in itself generous, the outcome has shown

the artists ill-prepared to elevate themselves to the level required by the civic and historic allegory requested of them. . . . this deficiency is reflected in the outcome of the competition itself: the works unfortunately fail to reach the heights of the assigned themes.[83]

The jury failed to locate even ten pieces from each competition worthy of public display. For the prize underwritten by the city of Venice for a depiction of "The Victory of Fascism" and for that offered by President Volpi for a medallion commemorating the March on Rome, the jury found only eight presentable pieces. Given the mediocre showing on the part of artists, Maraini deemphasized the competitions and the Exhibition of the Art of the Decennale opened with "neither ceremony nor formality" on September 11, 1932.[84]

By offering alternative means of support, the regime's policy of aesthetic pluralism inadvertently encouraged the failure of the theme competitions at the Biennales of 1930 and 1932. Prizes, unlike acquisitions, aimed to reward a particular outcome. In general, low participation can be attributed to artists' reluctance to follow preordained themes. At the 1930 Biennale, the competitions that called for specific thematic responses fared far worse than those with broader, more malleable themes. For example, the two competitions that found no respondents asked for (1) "a series of four xylographs that grasp the educative and sporting activity of the Opera nazionale balilla"; and (2) "a bronze plaque that depicts the collaboration of citizens with the structure of the state."[85] The competition asking for a bronze medallion of Mussolini attracted four contestants and that for a work inspired by the "Accomplishments of Commerce" found two aspirants.[86] Yet, broadly defined competitions received more aspirants; for example, the one promoted by the National Confederation of Fascist Syndicates of Professionals and Artists for a "Composition with Figures" attracted fifty-four entries. The competition of the city of Venice calling for a depiction of maternity attracted sixty-three responses.[87]

The 1932 prize-winning works, though greeted with disappointment by the jury, reflected the eclectic aesthetic atmosphere of the moment. The pieces ranged from the solid architecturalism of the novecento to the frenetic geometry of second stage futurism to the naturalism of the Italian "return to order." The Ministry of Corporations granted 4,000 lire of its 50,000 lire prize to the futurist Gerardo Dottori for an *aeropittura* painting entitled *Anno X* (fig. 14). For *L'illustrazione italiana*, the popular illustrated weekly, the canvas depicted "a swarm of airplanes, agricultural machines, and cities around the annals of the Decennial which are superimposed in the shape of steps to form an Assyrian and Babylonian pyramid."[88] This futurist-inspired piece represented, through a combination

14. Gerardo Dottori, *Anno X* (*Year Ten*), 1932 Venice Biennale, winner in the competition sponsored by the Ministry of Corporations.

of abstraction and representation, the achievements of ten years of Fascist rule: Dottori painted the products of the aeronautics industry, shipping industry, industrial ports, and farm machinery. In addition to the futurist interest in sequential motion, there is some similarity to contemporary Soviet work, particularly in the attention to technology and production. As in much of the artistic production of the era, the references are at once contemporary (the Giacomo Balla–inspired swarm of airplanes) and historical (the stone blocks bearing Roman numerals at the center of the work).

Tommaso Cascella and Alfredo Paolo Graziani also each received 3,000 lire from the Ministry of Corporations for their submissions to the "Victory of Fascism" competition. Working in heavy forms influenced by the novecento, Cascella presented a painting of a mother flanked by the frenetic workers of the new Italy and protected overhead by the airborne spirits of those who died for the Fascist revolution. Graziani won for a depiction of *squadristi* in formation.[89]

A medallion by Publio Morbiducci celebrating Italo Balbo's transatlantic flight won in the medallion competition for 1932. This art deco allegory of flight represented victory in the air with a female triumphant bust. Morbiducci's "Victory" medallion focuses upon a stylized classicism with the clean and minimal lines of art deco (fig. 15). His entry was one of eight and was not on the assigned subject.

Artists resisted the competitions, despite the explicit rewards. In an economy where a kilogram of flour cost 1.60 lire and where the hourly wage of industrial workers averaged 1.98 lire, 50,000 lire represented a windfall.[90] The dictatorship's patronage style led artists to believe that government and party support could be obtained without having to adapt their art.[91] Fascism had already declared its intention not to dictate aesthetics. In the light of an official rhetoric on the arts and artists that focused on "professional regimentation" and "aesthetic liberty," rather than on an "art of the state," the call for specific responses fell on deaf ears. One artist, Antonio Discovolo, refused to participate in the 1930 competitions. "I did not," he wrote Maraini, "fill out the application form for participation in one of the prize competitions. . . . I hope that my displayed painting can have the fortune of being purchased, given the fact that this is a time of financial crisis for me."[92] Despite economic difficulties, artists opted instead for the greater freedom they perceived to be available in the acquisitions policy and in the rewards implied in syndical membership. While many artists happily accepted the Fascist state as organizer and buyer, they rejected patronage that regulated pictorial content. This was, in many ways, the double-edged sword of aesthetic pluralism: as long as the regime offered consent-building techniques that

15. Publio Morbiducci, *Victory*, 1932 Venice Biennale, winner in the medallion competition.

stressed flexibility concurrently with more coercive ones, the restrictive ones found few adherents.

The composite character of the prize juries reflected the contradictions inherent in aesthetic pluralism as the official ethos of state culture. Aesthetic pluralism produced frustration when administrators and juries sought forms evocative of Fascism. Composed of dissonant voices, the prize juries lacked consistent, shared-upon aesthetic and thematic criteria, agreeing only on the state's role as cultural organizer. Consensus on the state's hegemonic function, created a situation where the Fascist regime worked well as an organizer and purchaser, but failed as arbiter of aesthetic choices.

In 1932, the Venice Biennale jury consisted of representatives from diverse viewpoints. To safeguard the interest of the futurists, Marinetti had himself appointed to the jury. Marinetti had written to Volpi in May 1932 to assert his role as the representative of the Italian avant-garde. "My presence on the jury," he explained, "is indispensable to guarantee the rights of younger artistic movements and especially the numerous groups

of futurists who otherwise would be constrained not to participate."[93] Cornelio Di Marzio represented the pluralist position of bringing various aesthetic tendencies under the Fascist umbrella. Originally active in nationalist politics and a consistent supporter of cultural flexibility, Di Marzio in 1932 headed the National Fascist Confederation of Professionals and Artists.[94] The director of the Office of Antiquities and Fine Arts, a department of the Ministry of National Education, Roberto Paribeni, an archaeologist and classical scholar, defended a more conservative and traditional aesthetic. The remainder of the jury consisted of five artists from a range of schools: Felice Carena and Arturo Tosi belonged to the novecento; Arturo Dazzi sculpted in the static, classicizing style associated with the "return to order" movement; Italico Brass painted Venetian landscapes; and Edoardo Rubino sculpted nudes in a naturalistic style.

The report of the 1932 jury concluded that the competitions had again not lived up to expectations. Though the judges may not have agreed upon an aesthetic standard, they did concur that the competitions failed to produce art at once celebratory of Fascism and of acceptable quality. Of the works selected for prizes, the jury report stated, "not one is worthy of the entire allotted amount of any of the prizes."[95] Moreover, where the commission conferred even a portion of the prize money, it acknowledged effort, not talent: "Thus, even where the committee has indicated those works to receive a fraction of the prize money as recognition, it desired to award the effort demonstrated by the artist, more than the level of the art he delivered."[96] Although the committee members did not agree on a single aesthetic standard, they agreed on what failed to meet any standard.

Despite Maraini's deemphasis of the outcome of the competitions, critics reviewed the 1932 event with disappointment. In the journal of the Department of the Fine Arts, *Rassegna dell'istruzione artistica*, Alberto Neppi used the experience of the Biennale competitions to highlight the success of the artwork at the Mostra della rivoluzione fascista. Where the work of artists at the Roman Mostra della rivoluzione fascista represented "without a doubt an artistic event of tremendous significance," the "recent Venetian competitions" produced a "poor outcome."[97] Neppi accused the Biennale competitions held in honor of the decennial of lacking purpose and of providing artists with no direction. The Mostra della rivoluzione fascista succeeded because it offered artists "the opportunity to develop very well defined themes, which compose the figurative dialogue" of the exhibition.[98] The artists who worked on the Mostra della rivoluzione fascista had been hired to create exhibits dedicated to specific historical events. These artists participated in the creation of "public art," such as murals, displays, and mosaics, which by

its very nature was meant to be utilized by large audiences and had a social function. Given the lack of a Fascist aesthetic per se, only projects with a specific function could visibly demonstrate artists' adhesion to the dictatorship.

Critical responses, such as Neppi's, to the 1932 Biennale competitions reflected an emergent discourse over the social function of art. Many critics claimed that the art of Fascist Italy had to have a social-public function in form, rather than, or in addition to, content. As noted earlier, members of the novecento movement had begun to experiment with mosaics, frescoes, and exhibition design in the middle 1930s. The reaction against easel painting as associated with the culture of Liberal Italy and as too removed from "the people" came from the left, the pluralists, and the right, the antipluralists. The antipluralists claimed that the social function of art should be to transmit unambiguous images accessible to the untrained eye, regardless of form. The novecento and futurist experimentations with public art more closely paralleled debates taking places among European avant-gardes over the accessibility of traditional art forms in a changed, modern environment.[99]

The regime used competitions as a strategy for introducing Fascism to the content of the fine arts at various locations in the network of official exhibitions. The provincial and interprovincial exhibitions of the Fascist artists' syndicates began a series of competitions in 1930. In the first series, the syndicate of Venezia-Giulia promoted 5,000 lire worth of prizes and the Campania syndicate, 2,500 lire. The 1931 regional syndical exhibition of Venezia-Giulia promoted a combination of monetary awards and medals, and various regional municipalities and local Fascist organizations gave gold, silver, and bronze medals based on quality. Syndical groups offered prizes of 5,000 lire and 1,000 lire, respectively, for "a painting that expresses and exalts the Fascist revolution and the achievements of the regime" and for "a young painter from Friuli disadvantaged by economic conditions."[100] In 1932, Venezia-Tridentina offered 2,500 lire, Venezia-Giulia, 2,000 lire, and Tuscany, 6,500 lire. Overall, syndical prize offerings rose steadily with 28,500 lire in prize monies in 1933, 55,750 in 1934, 90,350 in 1935, and up to 153,350 in 1938.[101]

With the Venice Biennale of 1934, patronage patterns began to change. The competitions program, so enthusiastically launched in 1930, lost most of its government and party support. In 1934, the Biennale promulgated just two prize competitions: one by the National Fascist Party for 10,000 lire and one by the Florentine Academy of Fine Arts for two gold medals.[102] The striking decline in the number of lucrative government and party competitions resulted in part from the failures of the 1930 and 1932 competitions and the economic depression then burdening Italy.[103] But,

above all, the unenthusiastic response of artists, and the embarrassment this caused, led the regime to reconsider its patronage style and, for the time being, to discontinue the prize competitions.

Although aesthetic pluralism at the 1934 Biennale can be seen in the exhibition itself and in government and party patronage, hints of the tensions implicit in the regime's patronage style emerged. Some of the tensions registered in the patronage patterns themselves: the novecento school, although still purchased, had lost its primary position. Many art historians consider 1934 the point when the novecento lost the battle for aesthetic primacy in Fascist Italy and was "definitely defeated," in part due to the polemics of cultural antipluralists such as Farinacci and Interlandi.[104] An exhibition of nineteenth-century portraiture constituted a central element of the 1934 Biennale and received a significant amount of attention from promoters and critics. The emphasis on a retrospective of portraiture, historically among the most conservative of art forms, reflected an ascendant conservatism.[105] The "Retrospective of Nineteenth-Century Portraiture," organized by Volpi and Maraini in conjunction with an international committee of art historians, occupied the first ten out of fifty rooms in the main pavilion.[106]

Policing the Boundaries of Fascist Taste:
Critical Reactions to the First Fascist Biennales

By the close of the 1934 Venice Biennale, the system of state patronage that I call aesthetic pluralism had completed its first phase. How did the constituent elements of the era's cultural establishment react to it? Reviews reveal the boundaries of Fascist taste and many of the gaps and contradictions repressed in the decision to focus on structure over content. Exhibition reviews in the predominant state and private arts journals in the 1930s provide clues to the possibilities available to Fascist culture and how it was constantly mediated by conflicting visions inside and outside of the official hierarchy. Fascist patronage was shaped by those who give "symbolic production" to works of art— "artistic mediators (publishers, critics, agents, dealers, academies, and so forth) as producers of the meaning and value of the work."[107] As Andrew Ross writes in reference to the United States, critics play the role of gatekeepers, who "patrol the ever-shifting borders of popular and legitimate taste."[108] In the case of Fascist Italy, critics inside and outside the Fascist establishment monitored the conflicting and shifting borders of official taste, as well as the elusive search for an aesthetic expressive of the new era.

The apparent consensus over official strategies of patronage masked discontent within and around official culture. The patronage system that had emerged by 1934 had a conflicted status among bureaucrats, administrators, artists, and critics. Hegemonic pluralism carried within it the seeds of its own collapse, as it sought to be simultaneously unitary and multiple. The experiences of 1930–34 raised questions, both inside and outside of the offices of the government and the party, over whether the regime's cultural interests could be met through stylistic inclusivity, hybridity, and heterogeniety.

Reactions to the 1932 and 1934 Biennales reveal the currents and countercurrents of opinion on the appropriate role of the state in art in Fascist Italy. By the mid 1930s, critics of flexible and multivalenced state patronage began to express the gaps and contradictions in the dominant discourse. Moderates and extremists, political leaders and government functionaries, as well as the artists themselves, all discussed the "recovery of art, the return to humanity and normality at the XIX Biennale."[109] Where some critics hailed Maraini's promotion of an atmosphere leading to an Italian "return to order," others found that a wide program of official patronage failed to create a "Fascist climate." The divide between "conservatives," celebrating an elevation of "solid" plastic values and intransigent ideologues rejecting internationally inspired modern art and advocating a rhetorically politicized aesthetic, is obvious in critical responses to the 1932 and 1934 Biennales.

Margherita Sarfatti, the high priestess of the novecento, hailed the 1932 Venice Biennale as the culmination of an artistic rebirth represented by the novecento exhibitions, the Roman Quadrennale, and the various syndical exhibitions.[110] For Sarfatti, the Italian pavilion's display of De Chirico, Carrà, Sironi, Carena, Funi, and other celebrities proved Italian art's "temperament of vivid originality," while she cited expressionist Oskar Kokoschka, French fauve André Derain, and Russian constructivist Zadkine as the strongest aspects of the foreign pavilions.[111]

The 1934 Biennale reviews of Balbino Giuliano and Francesco Sapori offered the verdicts of two cultural hierarchies in Fascist Italy: government cultural functionaries and the artists' syndicates, both of which supported aesthetic pluralism within a proregime context. In his review of the 1934 Biennale for the monthly of the National Fascist Confederation of Professionals and Artists, *Bibliografia fascista*, Balbino Giuliano, the former minister of education (1929–32), senator, and professor of philosophy at the University of Rome, expressed the position of the moderate conservatives who came to culture with a nationalist critique. As a former nationalist and follower of Giovanni Gentile, Giuliano believed in an aes-

thetic of tradition and *italianità*; through support for these two elements, he hoped artists would move, of their own accord, toward a dedication to Fascism.

Giuliano called for aesthetic standards, but believed they ought not be imposed, or pursued too rapidly. At the same time, he advocated an end to the hegemonic influence of modernist movements such as the futurists and the novecento: "Futurist works stand alone almost like an appendix to be accepted in homage to the past: and to look at the general composition of the show one quickly comes to ask himself if, by chance, Carrà and Sironi were not already to be considered men of the past."[112] Giuliano simultaneously celebrated a "return to order" and sought a reconciliation between modernity and tradition: "while foreigners remain entangled in the exasperating search for daily novelty, Italian art decisively rises to the conquest of an effective originality through an ideal order which resolves the tension between the value of tradition and the perennial need for renovation."[113] While the art of other nations mortgaged the past to a constant search for innovation, Fascist Italy's art should balance traditional with contemporary aesthetic developments. The *mostre* of Fascist Italy, for Giuliano, should encourage artists to work in styles and forms tied to Italian traditions, without rejecting the idea of aesthetic diversity.

Francesco Sapori, artist and art critic, reviewed the 1934 Biennale in the journal of the Department of the Fine Arts, *Rassegna dell'istruzione artistica*. Finding greater evidence of a "return to order" than Giuliano had, he celebrated Italian art for its "healthy return to fundamental aesthetic values: respect for the form, a sense of space, research in colors, preparation of designs ... the triumph of primary laws and traditional graces.[114] For Sapori, the evidence of a return to aesthetic values lay in the diminished presence of abstract and cubist art. "Cubist motifs and futurist abstractions," he noted, "have vanished in order to cede the camp to plastic expressions, which are also spiritual creations."[115] Where modern art tended toward "specious color analysis," "return to order" currents bore an authentic and spiritual character appropriate to artistic regeneration.

Sapori's position, however, while celebratory of government attempts to encourage an aesthetic of *italianità* also shied away from advocating either censorship or an "art of the state." Like Giuliano, Sapori ruled out a return to the past through an unmediated elevation of the nineteenth-century aesthetic values. Arguing with the radical, antipluralist contention that representational or idealized naturalist forms of the past were the only appropriate models, Sapori (writing in a government journal)

stated that "we consider absurd the supposition of possible comparisons between the art exhibited by living artists and that of their predecessors.[116] While artists needed guidance and tradition, Sapori asserted as untenable a wholesale harkening back to the past. He supported the commitment of artists to the regime, but on a voluntary basis. Sapori and Giuliano agreed, however, that the aesthetic future of Fascist Italy did not lay in embracing European avant-garde developments of the previous twenty years. Where the rising hard-line wing of the Fascist Party advocated compelling artists to produce thematically "Fascist" and formally representational art, Sapori and Guiliano welcomed a spirit of change that would lead artists to commit themselves freely to work within a range of tradition-based aesthetic languages.

The strongest condemnation of the state of the arts came from the emerging antipluralist camp. The attack was best articulated by *Quadrivio*, founded in 1933 as a "great Roman literary weekly," and published by Telesio Interlandi, Luigi Chiarini, and Giuseppe Pensabene, all known for their extremist and intransigent views in culture and politics.[117] In 1934, *Quadrivio* launched an editorial campaign against the state-run *mostre* that grew increasingly strident as the decade progressed. In the journal's first review of a Biennale, Pippo Rizzo, painter, former leader of the Sicilian futurist movement, and activist in the syndical movement, articulated *Quadrivio*'s criticism, focusing on the regime's failure to produce a monumental, political art and on artists' rejection of the mission offered to them.[118]

According to Rizzo, the Biennale in particular, and official exhibition policy in general, had failed because they had not been midwives to a rebirth of great art capable of transcending fashion and educating the masses. "Painting today," according to Rizzo, "tends toward the 'chic.' It is too subtle; where yesterday painters concerned themselves with great and dramatic compositions, today they present refined decorations. . . . Many of them worry only about pleasing and conquering the public."[119] For the advocates of an "art of the state," attention to public taste and the marketplace and the regime's encouragement of this by indiscriminate patronage had produced a self-indulgent art world. This group of hardliners rejected the aesthetic pluralism practiced by the dictatorship and asserted that Fascism should command more from artists than mere consent.

For the faction demanding aesthetic regulation, the Fascist government and party wasted their influence and moral duty through random purchasing methods. Instead, the dictatorship should use patronage as a tool to guide artists. According to these cultural extremists, art in Fascist Italy needed to conform to a "national and unitary vision" that precluded

the type of aesthetic diversity practiced in the Biennales of 1928 through 1932.[120] Critics such as Pensabene and Farinacci believed that the regime's decision to act as pre-Fascist bourgeois patrons showed weakness and sloth on its part: the cultural hard-liners found no risk in the possibility of alienating artists and spectators who might have rejected conditional patronage.

Quadrivio hailed past examples of arts supportive of existing power structures, such as nineteenth-century hagiographic portraiture, and said to artists: "Here, you need to paint like this to be admired."[121] Art, for Rizzo, had to be clearly celebratory. He cited the Soviet pavilion at the 1934 Biennale as a positive example of "the work of artists who live as part of their *patria*. Each of these artists has his own hallmark and all of them have that of their *patria*."[122] The Soviet pavilion's contents consisted of monumental and idealized allegories of the workers and peasants of the Soviet Union. In the Soviet Union under Stalin, the extremists found an artistic community willing (or coerced) to dedicate itself to a singular goal: celebration of the state and its policies.

Fascism had failed to answer the question of a "Fascist art." Rather, it allowed the competing cultural factions to debate the issue and hoped an equilibrium would be maintained between them. The system's eclecticism allowed for multiple readings: Sarfatti saw the ascendancy of an internationally influenced but Italian-inspired aesthetic, Sapori read a "return to order" in progress, and Rizzo denounced official culture as dependent on bastardized foreign imports. The questioning of the policy of aesthetic openness at the Biennales of 1932 and 1934 demonstrated a level of dissatisfaction with the regime's patronage style. Sapori and Giuliano, writing in government and party journals, fundamentally supported the noncensorship policies of the government, but they also backed Maraini's encouragement of an Italian "return to order" and a deemphasis of modernist movements. The intransigent position of *Quadrivio*, first articulated in 1934, thereafter became increasingly vocal and influential.

If the dominant discourse regarding state patronage focused on "welcoming, without prejudice, every tendency, school, and technique of a chosen work of art,"[123] heterodox cultural politics bred discontent from within Fascist circles. As aesthetic pluralism became entrenched as the modus operandi of state patronage, a faction of Fascist officials and intellectuals launched a campaign against it. For the antipluralists, the authoritarian coordination of state and society necessary to Fascism was not being reproduced in the cultural field. These critics of aesthetic pluralism challenged the cultural system in production, decrying it as weakness, as something that must change in order for the Fascist revolution to succeed. For this group, tolerance of multiple aesthetic formulations, from

the traditional to the most contemporary, smelled of both liberalism and Socialist internationalism. In the next phase of Fascist patronage, the later 1930s, the antipluralists increasingly would couch their critiques in racial and imperialist language and would declare war on modernism—Fascist or not.

Challenging the Social
Boundaries of Culture

Excitement ran high on the Lido in Venice on the night of August 3, 1932. The glamorous crowd on the terrace of the Excelsior Hotel awaited the anticipated arrival of Greta Garbo and Lionel Barrymore. For the closing festivities of the first Venice Biennale International Film Festival, "the Super Colossal *Grand Hotel*," presided over by "M.G.M.'s principal artists," was screened for an audience of film stars, dignitaries, Fascist officials, European rich, and summer tourists.[1] The conclusion to a Fascist cultural experiment, the Venice Biennale film festival was a carefully choreographed Hollywood-style extravaganza that stressed fantasy, spectacle, and romance. The government-appointed Venice Biennale administrators celebrated a cultural triumph and innovation. The secretary-general of the Biennale, Antonio Maraini, boasted that the Biennale was "the first to place cinema alongside the other major arts."[2] "The world's greatest exhibition of contemporary art," wrote the press, "has received and consecrated among its arts even cinematography."[3] Mass culture met elite culture on the terrace of the Excelsior Hotel and the Fascist government and party had arranged the match.

The cultural politics of Italian Fascism opened the social and formal boundaries of European elite culture. As part of its project to integrate Italians into official cultural institutions and as a product of broader Western sociocultural shifts, Fascist sponsorship transformed the presentation and cultural role of the fine arts in Italy. The regime simultaneously appropriated and adapted elite culture by using its available legitimacy, while also expanding its content and by enlarging its audiences. Fascist intervention advanced certain preexisting trends, such as the commercialization of the fine arts, begun in the nineteenth century, and introduced new ones, such as the mixing and blending of cultural forms within an elite context.

This chapter explores the ways in which the Fascist regime, economic crisis, and an emergent mass culture industry expanded the fine arts in Italy beyond a network of galleries and museums into the world of broad-

based cultural consumption. By the very nature of the mass mobilization which characterized Fascist politics, together with a founding battle cry for a postclass society and an antibourgeois culture, the regime was driven to reassess the existing "social practices of culture."[4] The pursuit of large numbers of people for the dictatorship's cultural projects implied that cultural institutions had to incorporate, at least to a certain extent, previously neglected social groups. Fascist cultural institutions also promoted diverse patterns of cultural consumption and adapted to changes in popular taste. The regime accommodated to changing patterns of cultural consumption and shifts in cultural tastes in the hope that such consumption would take place within the institutions of the state.

The Venice Biennale of International Art, then and now the most prestigious art exhibition on Italian soil, exemplified the intersection of Fascist cultural politics and the fine arts. The Fascist government replaced local Venetian elites as the promoter of the Biennale and brought with it a new agenda and relationship to inherited European elite culture. With the dictatorship's vision of the Venice Biennale as the pinnacle of a centralized network of national arts institutions and "a great festival of cultural tourism," the shift in patron meant the opening up of the institution to larger and more diverse audiences, as well as to new cultural forms and aesthetic languages.[5]

This chapter depends on terminology of common, but often slippery usage. For our purposes, the categories "high culture" and "elite culture" refer to cultural forms created by dominant social groups and then mobilized into a system of social stratification. High culture, as it emerged by the nineteenth century, required knowledge of and expertise in the classical tradition. It provided European elites with "cultural capital" used to bolster a position of economic and social dominance. As Pierre Bourdieu has detailed in his work on the creation of "cultural tastes" in European societies, high culture is freighted with symbolic capital, which can be used by those with knowledge of it and access to it.[6] Historians and sociologists, such as Lawrence Levine and Paul DiMaggio, have revealed how, in the course of the nineteenth century, bourgeois elites appropriated cultural forms such as classical music and drama away from more popular realms and reconfigured them as the exclusive terrain of high culture.[7]

Italian culture by the late nineteenth century was hierachical and segregated. As David Forgacs writes of the theater, "in the eighteenth century and for most of the nineteenth an acute sense of hierarchy ... ran through the Italian theater. There was no single meeting-place and no single mixture of classes. On the contrary, there was a well-understood

hierarchy of theaters, of areas within the theater, of audiences, of seasons, of genres."[8] The art world also was based on social segregation. The Venice Biennale in its pre-Fascist existence stressed the separation of the fine arts from the pressures of mass society. Academic painting prevailed, with the impressionists and postimpressionists generally excluded until the years just before World War I. Elevating the cult of the master and the masterpiece, this institution in its pre-Fascist incarnation was based on a limited number of genres, styles, artists, and social classes. During its first thirty years, it served primarily as a meeting place for the established European art world. The exhibition, with its backdrop of grand balls and palazzi, attracted the attention of European aristocracy and haute bourgeosie in the years before World War I. The Biennale's location, regional elite sponsorship, and solely fine arts focus suggested its exclusivity.

Under Fascism, the biannual international art exhibition's aristocratic and bourgeois character was repackaged to attract the new professional and white-collar middle classes. The rise in numbers of urban professionals and middle-class white-collar and clerical workers in the early twentieth century represented a potential untapped audience for the Biennale and for Fascist-sponsored high culture. The years 1900 to 1925 had witnessed rapid urbanization in Italy; by the 1920s the urban middle classes and petite bourgeoisie had expanded significantly to include three-quarters of a million salaried personnel.[9] Moreover, in the course of the 1930s, the number of public employees alone rose from 500,000 to 1 million.[10]

Fascist cultural bureaucrats employed several strategies for widening a previously limited cultural institution. Shifts in the boundaries of high culture fell into two categories: broadening the content and actively cultivating the attendance of new social groups and class fractions. The first strategy, changing accepted notions of high culture, involved the inclusion of new cultural forms and genres, from popular to mass culture. It also translated into the welcoming of a greater variety of aesthetic schools and styles. Between 1930 and 1936, the Fascist dictatorship moved certain manifestations of popular and mass culture—film, popular drama and music, the decorative arts, and public art—to the center of the institution, displacing the dominance of easel painting and sculpture. From the Hollywood musicals and situation comedies of the film festival to the glass vases of the decorative arts pavilion, each previously excluded form threatened the isolation of the fine arts.

The second strategy focused on familiarizing new groups to a formerly exclusive cultural practice. Using techniques developed by advertising

and mass tourism industries, the regime sought to reshape cultural habits and practices. Some of the phenomena of consumer capitalism, such as advertising and the culture industry, coincided with the dictatorship's goals of economic expansion, as well as with Venetian interest in the same. Fascist bureaucrats targeted travel discounts and hotel packages at the new urban middle classes, which might have felt excluded from the Biennale or which might have chosen to travel elsewhere. Government-subsidized train fare discounts of up to 70 percent worked with hotel and restaurant promotions to transform the Venice Biennale into a consumption and leisure experience.

Nonetheless, the Venice Biennale's reconstitution was negotiated and hybrid: rather than abandon elite culture, the regime promoted an amalgamated cultural institution. The mass and popular culture introduced at the Biennale in the 1930s retained an identification with the aristocracy and a flavor of cultural elitism. Fascist defiance of the borders of elite culture was contradictory: the dictatorship at once pursued the legitimacy and continuity it found in elite culture and the cultural consensus possible in a successful mobilization of mass culture.

In opening high culture and adapting it to Fascism's perceived interests, the dictatorship underwrote the transformation of the Biennale's visitors from arts connoisseurs to cultural consumers. Thus, those attending official art exhibitions moved from the narrower category of connoisseur, with accumulated knowledge and expertise in European high culture, to consumer, the partaker of a commodity based on its accessibility and diversity, which carried fewer rites of initiation. Where the connoisseur would "judge critically because of thorough knowledge," the consumer came to assimilate and experience.[11]

In addition to Fascism's goal of expanding the audiences for official culture, the reconceptualization of the Venice Biennale was driven by domestic political and economic interests and national and international cultural and economic trends. The blurring of the lines between high and low, elite and mass, connoisseurship and consumption came out, as well, of an Italian and European avant-garde critique of elite culture: from the futurists to the constructivists, cultural avant-gardes, both before and after World War I, broke down inherited categories and declared the bankruptcy of established bourgeois and elite culture. The challenges to cultural segregation came in large part from the growth of mass culture industries such as film, radio, and publishing in the 1930s. The officially coordinated changes in the Venice Biennale, thus, reveal the transformation of fine arts (re)presentation in the face of Fascism and consumer capitalism.

The Social Boundaries of Culture

Fascist-sponsored cultural events and institutions, with their celebration of the widespread adhesion of cultural producers, required that the dictatorship's leading role be seconded by audiences. And, as the dictatorship increased its cultural presence after 1930 and searched for a set of cultural forms and aesthetic languages evocative of its ideology, it sought broader segments of the population to acknowledge its accomplishments.

Without significant expansion of the culture-going public, the regime could not make good on its promises of a cultural renaissance and financial support to artists, could not be a successful and visible patron, and could not recruit high culture in its search for consent. Spectators were the pivotal spoke in the wheel of Fascist state patronage. A number of factors, based in Fascist ideology and governing practices, coalesced in the expansion of a government-supported fine arts culture. Interest in being seen as the force behind cultural renewal and as the enablers of the new and the revolutionary drove the move, together with the desire to mobilize the population within controlled conditions. Furthermore, Fascist patronage embraced a revision of high culture, in keeping with its original antibourgeois, populist, and modernist discourses.

In 1931, Mussolini announced the decision to "move toward the people."[12] He called upon the agencies of the party and the government to draw Italians into the party and the state and have Fascism touch the lives of those still not mobilized into the organs, institutions, and events of the regime. In the early 1930s, official journals debated the depth of Fascist influence upon Italian state and society, discussing methods for its expansion. Among the strategies proposed to make the party more populous and populist was the expansion of Fascist mass culture and a resurgence of populist discourse in official high culture. The party and the government created programs and policies for bringing Fascism into as yet untouched corners of Italian society. The mass organizations multiplied and differentiated their tasks according to social group.[13] The Gruppi universitari fascisti (Fascist University Groups), Gioventù fascista del littorio (Fascist Youth of the Lictor), and the Fasci femminili (Women's Fasci) targeted youth and women.[14] The Opera nazionale Dopolavoro (National Afterwork Organization) expanded into new workplaces.

Urban middle- and upper-middle class adults, social groups accustomed to autonomy and, by the 1930s, with an individualist, noncorporate understanding of their social role, were harder to coordinate.[15] One

solution was an officially organized and expanded sphere of high culture. As Simonetta Lux has explained, the need "to involve a broader public . . . was often resolved by a plan to control the major organizational and exhibiting structures of art."[16] The Fascist regime targeted this adapted high culture specifically at groups such as the new urban and professional middle classes.

The New Forms

Fascism's eclectic patronage style and its use of culture in the search for responsive publics encouraged Antonio Maraini—both secretary-general of the Biennale and head of the Fascist artists' syndicates—and Count Giuseppe Volpi di Misurata, president of the Biennale, to experiment with the exhibition. The government-appointed Biennale administration, in place by 1930 and presided over by Volpi, evolved a vision of a major national institution. Between 1930 and 1936, the Fascist administration added a series of diverse attractions to the fine arts exhibition. The film festival, music festival, drama festival, poetry competition, and the introduction of the decorative and public arts all represented challenges to dominant notions of high culture. The new attractions determined perceptual shifts and brought the Biennale closer to contemporary cultural forms, such as department stores, arcades, and world fairs. The viewer's gaze moved from the conspiratorial and knowing gaze of the initiate to that of the modern consumer, "looking at" and consuming a range of phenomena. These entertainment-oriented festivals pursued social groups less trained in the language and manners of European high culture. Held in theaters, halls, and open-air auditoriums, they were available to a numerically larger audience than the traditional painting and sculpture exhibition and bestowed potentially greater profit upon organizers.

The first innovation, while hardly revolutionary, paved the way for further experimentation. In 1930, the music festival debuted with a program of international classical music.[17] Its organizers welcomed it as pathbreaking, because "it not only signals an important development, but opens wide horizons for new and fertile expansions."[18] Mirroring the organization of the figurative arts exhibition, the music festival offered separate "national" and "international" concerts.[19] It presented a varied fare, selecting from European classical music and including "soloists performing recent classical music" and "classical dance pieces."[20] The 1934 program emphasized well-known music by Mozart, Richard Strauss, and Verdi. That same year, in a move to blend mass and elite culture, the

music festival organized a competition for music "suitable for radio broadcasting."[21] Scheduled with an eye toward keeping a steady flow of visitors to the Biennale, the second music festival in 1932 ran the first two weeks in September, when the summer crowds traditionally thinned out. In contrast to the art exhibition which ran at a deficit throughout the 1930s, the music festival showed a modest profit.[22]

The music festival catered to new cultural consumers who looked for more accessible forms. With its eclectic programs and open-air theater, it mixed musical genres and challenged notions of elite experience. Spectators consumed the program simultaneously in large numbers and it took place at night, when the fine arts exhibition was closed. The music festival redefined the Biennale's itinerary, replacing the formal evening banquets of the Biennale's earlier participants with reasonably priced entertainment. The physical mixing and crowding of an amphiteater or hall confronted elite notions of the private and isolated assimilation of culture, which had previously characterized the Biennale.

The music festival's popularity encouraged Maraini to launch theater and poetry festivals which fulfilled similar functions. The theater festival stressed a Venetian theme with Goldoni productions and other plays written by Venetians or set in Venice. Again, in an effort at accessibility, Goldoni's *La bottega del caffe* was performed in "modern prose."[23] This opening up included formal experimentation, as when in 1934 the theater festival welcomed modernist direction and staging with the exiled Weimar theater director Max Reinhardt's *The Merchant of Venice*.[24]

The addition of an array of evening activities was tied to the expanded tourist packaging of the Biennale. After 1932, on any given evening, visitors could partake of a variety of attractions, including folkloric festivals and regattas on the Venetian canals. The diversified Biennale stressed the consumption of the "Venetian experience," in the form of a surfeit of Venetian imagery and references, from the Goldoni productions of the theater festival to the gondolas and masks of the promotional literature. Of course, these images were in symbiosis with the inexpensive and readily available souvenirs carrying the same ones.

On the heels of the music festival, the Biennale administration introduced an event that quickly became its most popular new feature and fundamentally confronted the hegemony of the fine arts at the exhibition. In the summer of 1932, the Biennale inaugurated the international film festival, projecting forty films from nine nations and attracting 25,000 spectators.[25] The film festival showed two films per night for twenty nights, with "the projections [taking] place on the seaside terrace of the Excelsior Hotel."[26] To view the films, well-dressed spectators sat in wicker chairs on the Chez Vous terrace of the Excelsior Hotel (fig. 16).

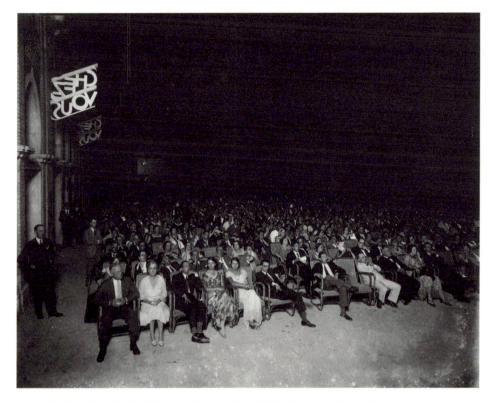

16. The first Venice Biennale International Film Festival: Chez Vous outdoor theater on the terrace of the Excelsior Hotel, Lido, Venice, 1932.

Locating the spectacle in the primary hotel on the Lido furthered the Biennale's identity as a site of consumption, tourism, and leisure. The film festival was situated snugly among the hotels and restaurants of the Venetian beach resort. A visitor-consumer could dine on the terrace of the Excelsior, watch a film, and sleep peacefully at the Hotel des bains.

The second edition of the film festival in 1934 established it as a permanent fixture: seventeen nations participated with fifty-eight production companies showing films to 41,000 people.[27] The success of this festival quickly led Mussolini to decree it an annual event, thus giving it a more visible and regular cultural presence than the fine arts exhibition itself, which took place every two years.[28] From the start, the film festival stressed variety and entertainment, especially multiplicity of genre and nationality. At the 1932 debut, showings included E. Goulding's *Grand Hotel*, Leni Riefenstahl's *Blue Light*, Dziga Vertov's *Towards Life*, and René Claire's *A nous la liberté*.[29] American films predominated: the inau-

gural event screened *Doctor Jekyll and Mr. Hyde, The Champion, Franken-stein, The Cry of the Crowd, Forbidden, Grand Hotel* and *The Man I Killed*, among others. The goal of a large and diverse audience and the market-ing of a ground-breaking event gave the film festival a smorgasbord char-acter and an explicit connection to new forms of consumption and lei-sure. In addition to a range of melodramas, historical dramas, musicals, situation comedies, documentaries, and animated shorts, the program "include[d] films of unusual character: avant-garde, surrealist, musical light symphonies."[30]

Along with the stress on variety and diversity, much of the transforma-tion of the Biennale depended upon the promotion of prizes and awards. Each of the separate festivals mounted competitions and awarded prizes. The music festival, for example, promoted a competition for music suit-able for radio broadcasting; the theater festival launched one for "four new comedies"; and the poetry festival ran a competition for "young poets."[31]

At the film festival prizes and awards played an especially determina-tive function in drawing in new audiences. The spectacle surrounding the designation of prizes at the film festival for production, direction, and performance tied the event to shopping and commerce. The numerous categories of prizes, including an audience referendum with monetary awards for the winners underlined the commercial rather than intellec-tual aspects of artistic production.[32] For example, at the 1934 film festival, Mussolini, the Biennale, the city of Venice, the Istituto luce, the Ministry of Corporations, the Fascist Performing Arts Association, and the Minis-try of National Education, among other organizations, promoted twenty-three prizes for categories ranging from "best foreign film" to "best di-rection" to "best animated cartoon."[33] In 1936, Walt Disney won "Best Animated Cartoon" for *Three Orphaned Cats*; the honors included a me-dallion depicting Mickey Mouse astride a *fascio-* ornamented gondola, with the Venetian cityscape in the background (figs. 17 and 18).[34] Blend-ing the diverse signs of elite culture (Venice), mass culture (Mickey Mouse), and Fascism (the *fascio*), the medallion manifests the film festi-val's attempted cultural synthesis.

Disney cartoons and comic strips illustrate a particularly complex epi-sode of culture under Fascism. Like Hollywood feature films, they found a vast following in 1930s Italy.[35] The regime responded ambivalently to Mickey's Italian success: on the one hand, it pursued the support of the culture industries that imported the comic—the Mondadori publishing house in this case—and wanted to cater to popular tastes; but, on the other hand, as the decade progressed, Disney products became associated with the foreign cultural products that squeezed out domestic offerings

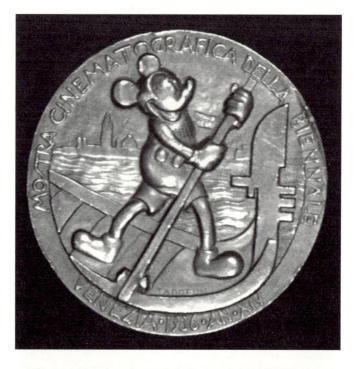

17. Obverse of medallion awarded to the Disney Studios for "Best Animated Cartoon" at the Venice Biennale film festival in 1936.

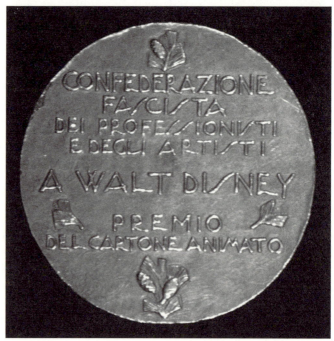

18. Reverse of medallion.

and ran blatantly counter to calls for cultural autarchy. A 1938 Ministry of Popular Culture directive supressing foreign cartoon strips exempted Disney cartoons because of their popularity. Yet, with World War II, cultural nationalism superseded considerations of public taste: the ministry revoked the exemption in 1941.[36]

The vast and varied prizes of the film festival courted as many types of film and filmmakers as possible. In distinction to the competitions for the figurative arts, these prizes were not based on thematic categories. They were awarded for "quality" and "popularity" and were conferred by an international jury. The "audience referendum," a key innovation of the film festival from its start, provided the element of popular choice and selection central to consumer culture. The questions of the audience referendum reveal a connection between the film festival and the emergent discourse of Hollywood film culture. The seven categories of the audience referendum, from Best Actress and Actor to Best Film, very closely resembled those of the recently begun Academy Awards.[37] In 1932, Americans won in four of the audience referendum categories, with Helen Hayes and Frederick March taking best-performance honors.

That year the audience referendum prize for "best film" went to Nicolas Ekk's *Towards Life*, a socialist-realist depiction of the rehabilitation of Russian civil war orphans by the Soviet government.[38] *Il gazzettino*, the Venetian daily, hailed the screening of the Soviet film as "very noteworthy because Russian cinematography is little known to the Italian public."[39] The film dealt with "the possibility of the rehabilitation of the young generation of Russian youth through the healing power of work." The reviewer concluded by saying that "whatever the political orientation of the producers, the film will be considered, without a doubt, one of the most important works of world cinema."[40] This public and critical respect for and interest in the artwork of the avowed ideological enemy bespeaks more than aesthetic tolerance; in the early 1930s Soviet film offered models for an experimenting Italian film industry. Filmmakers searching for a way to depict Fascism as revolutionary often appropriated Soviet cinematic realism and montage techniques. One contemporary scholar has argued American and Soviet films constituted the "dominant models" for the Italian film industry during this period and that until the mid 1930s "there existed a keen interest" in Soviet culture.[41] The film festival, in search of international critical acclaim and designed to appeal to as wide a cross section of cultural consumers and producers as possible, drew on all available cinematic styles and forms.

The Fascist transformation of elite culture is striking in the film festival's use of Hollywood spectacle for the presentation of the films. The film festival merged a number of spectacular elements, such as nighttime

19. The Cinema Palace, the Lido in Venice, inaugurated in 1937 to host the Venice Biennale International Film Festival.

film premiers, the romantic ambience of Venice, dramatic appearances of "stars," and the titillating excitement of treating cinema as a fine art. The regime eagerly cultivated the drama and "hype" available in the film festival. Prizes were awarded in tense and staged ceremonies, openings and closings were carefully orchestrated and the whole of the event was tied to the glamour and fantasy of Hollywood. The brochure for the 1934 film festival summoned advertising's language of innovation. It boasted the "First Presentation of New Films" and that "The Best-Known Artists of the Screen Will Be Present."[42] The promise of "the first" and "the best" represented the influence of consumerism upon culture. In July 1937, the minister of popular culture, in a much-touted ceremony, inaugurated a new and permanent "Cinema Palace" on the Lido. The term "palace" mobilizes Hollywood language of the new aristocracy of film and of the fantasy of film: it was not called the "Film Pavilion," which would have been in keeping with the Biennale's other buildings (fig. 19).[43] With this turn to spectacle and fantasy, the film festival involved the new kind of viewing implied in cinema spectatorship. The participant in the film festival was a "spectator-shopper [who] tries on different identities," identities of fantasy, mobility, and romance.[44]

The inclusion of popularly acclaimed and commercially successful films in the context of the Biennale both leveled and reconfigured cultural categories. The Venice Biennale film festival bestowed respectability on the relatively new and still controversial art form of cinema. The festival allowed previously excluded spectators to partake of mass culture experiences within the elite context of the Biennale. The Biennale, the quintessential high-culture institution, adapted itself and produced a "mixed" cultural event: though film was a mass art form, the film festival attracted a primarily middle- and upper-class audience by virtue of its location on the Lido and its association with the Biennale. The pricing of film festival tickets further reveals the regime's middle-class, rather than working-class, focus: tickets cost five lire, twice the normal movie ticket price. At the same time, the promotion and advertising of the event incorporated the language of mass film culture, such as the stress on "stars" and "the appearance of the most admired artists of the silver screen."[45]

The film festival's promoters also had the honor of hosting the first international film festival in Europe. There was profit in defying convention, which the Biennale administration self-consciously celebrated: Maraini declared that his "precise goal . . . in founding and organizing this exposition" was "to put cinema on the level of painting, sculpture, music, and drama—all arts already promoted by the Biennale."[46] Its promoters recognized that the elevation of film to acceptable high culture accounted for the film festival's attraction: "What are the reasons for such success? It is very simple. First, put cinema on par with all the pure arts—painting, sculpture, music, poetry, architecture."[47]

The economy also drove the contours of cultural change. The state-sponsored film festival offered practical aid to an embattled national film industry. At the time of the first film festival, annual domestic film production in Italy had fallen to less than a dozen films from a pre–World War I high of 500 features.[48] A well-attended, critically acclaimed and highly publicized international film competition promoted by Italy suggested lucrative possibilities to Italian filmmakers squeezed by the popularity and visibility of Hollywood productions. To offer exposure to Italian productions and to highlight official support of the film industry, the first night of the 1933 film festival was "devoted exclusively to Italian productions" and began with "a great propaganda film edited by LUCE and designed to illustrate the greatest works of Fascism achieved in the last two years and in the process of completion."[49] In 1934, in an effort to coordinate and stimulate national production (as well as get as much publicity as possible out of a successful event), the film festival became annual. In recognition of the growing importance of film to Fascism's

propaganda efforts, that same year an Undersecretariat for Cinematography was opened in the Ministry of Popular Culture. Thus, the inauguration of the film festival anticipated by just over a year the regime's first active intervention in film production and its establishment of the permanent undersecretariat to regulate both the private and state production and distribution of feature films.[50] The Biennale mounted the film festival with the aid of the L'unione cinematografica educativa (Istituto Luce), the film studio established by the Fascist government in 1924 and, after 1934, administered by the Undersecretariat for Cinematography.[51] The Biennale staff coordinated the technical aspects of the show, while, after 1936, the Ministry of Popular Culture organized and promoted the festival.[52]

The film festival acquired a popular following, with attendance figures rising continually through the 1930s. In 1935, 38,500 people attended; in 1936 the event boasted 50,000 spectators; and the 1937 version counted 56,000 viewers.[53] By way of comparison, attendance for the 1934 and 1936 Biennales totaled 361,917 and 194,702, respectively. Thus, by 1936, slightly more than one-quarter of Biennale visitors paid a separate fee to watch at least one film. By the time of the 1935 film festival, Maraini celebrated the profitability of the enterprise, which had "brought in 250,000 lire, rather than the 180,000 predicted."[54]

The popular and critical success of the film festival notwithstanding, by the middle 1930s conflicts began to emerge among its promoters. As in all areas of official culture, demands arose from hard-line factions within the Fascist hierarchy for a more measurably "Fascist culture" and for a balance which weighed more heavily toward politically coherent content, even if at the expense of crowd-pleasing entertainment. As is discussed in detail in chapter 6, the pressures of war and radicalization moved concepts such as cultural autarchy and cultural nationalism to the center of Fascist culture, forcing a redefinition of the regime's relationship to cultural producers and consumers. In a memo of September 3, 1935, Maraini wrote that the encouragement of "pure diversion" must also be accompanied by the Biennale's support for "the orientation of the cinematographic art toward investigations into the great political and social problems which today excite the souls of the people."[55] Despite such pressure, the total politicization of the film festival came slowly. The jury that awarded prizes at the 1935 film festival consisted of four foreigners and four Italians. They honored films as aesthetically and thematically diverse as Germany's *Triumph of the Will*, America's *Becky Sharp*, and Jewish Palestine's *Promised Land*.[56]

As the 1930s progressed, the content of the film festival mirrored larger alterations in the regime's attitude toward culture. After 1935, Fascism's

foregrounding of the rhetoric of empire as a way of conveying messages about the nation and race was reflected in the prizes awarded: in this period the Biennale introduced a prize for "Best Colonial Film," and films of bombastic propaganda began to receive the bulk of the prizes. Two of the most celebrated propaganda films of the Fascist era won the "Duce Cup for Best Italian Film" at the film festivals of 1937 and 1938. *Scipione l'Africano* (Scipio, the African) reinvented the conflict between Rome and Carthage as the battle of authoritarianism against democracy, as action against debate and irresolution. This 1937 film by Carmine Gallone stressed an emergent racialized politics, depicting the Carthaginians as uncivilized and "semitic."[57] *Luciano Serra Pilota (Luciano Serra, Pilot)* by Goffredo Alessandrini won the 1938 prize for its celebration of soldiers fighting in the Abyssinian War.[58] This film emphasized the qualities of the Fascist "new man"—heroism, love of risk, adventure, and male comrade-ship. Yet, the inconsistencies and pluralities of Fascist cultural patronage remained: in 1937 the film festival also prized Jean Renior's great pacifist film, *Grand Illusion*.

By 1938, political exigencies came to overshadow aesthetic or audience-attracting concerns and the "relative autonomy of the juries, up until then respected," waned.[59] After 1937, the prize for "Best Foreign Film" went without exception to Nazi Germany. Leni Riefenstahl's documentary of the 1936 Berlin Olympics, *Olympia*, took the 1938 honors. Following the screening, Fascist Minster of Popular Culture Dino Alfieri and the head of the Nazi delegation cabled Mussolini to celebrate the film's "brilliant first showing."[60] One of the signs of the cultural coordination of the two fascist regimes and of the integration of the film festival into the regime's propaganda apparatus is that the Nazi anti-Semitic film *Jüde Süss* by Viet Harlan had its world premiere at the Venice Film Festival in 1940. World War II and the film festival's connection to the Ministry of Popular Culture encouraged its full appropriation by the regime's propaganda machine. For pro-Nazis at the Ministry of Popular Culture, who had witnessed the Nazi cultural *Gleichschaltung*, a propaganda weapon as powerful as the film festival could not be left outside the direct war effort.

The growth of the film festival, its obvious propaganda value, and Fascism's revised patronage style led to the show's legal and organizational redefinition after 1936. As part of its growing control over the creation and dissemination of films, the Ministry of Popular Culture under Dino Alfieri expanded the ministry's role in the festival. A law of February 13, 1936, severed the film festival from the Biennale and decreed it an *ente autonomo*—an equivalent and autonomous legal status to the Biennale.[61] As would happen to the Biennale itself within a year, the film festival was now run by committees of appointed party and government

officials. The head of the Department of Cinema of the Ministry of Popular Culture, the president of the LUCE, and the president of the Fascist National Federation of Entertainment Industries held government-appointed posts at the film festival.[62] A law determining annual financial contributions to the newly independent institution followed: the Biennale contributed 10,000 lire; the city of Venice, 20,000 lire; and the Ministry of Popular Culture, 30,000 lire.[63]

In 1940 the film festival was reconstituted as the Manifestazione cinematografica italo-germanica (Italian-German Film Festival).[64] For what proved to be the film festival's final appearance of the Fascist era, in August 1942, Josef Goebbels, the Nazi minister of public enlightenment, officially opened the festivities.[65] The following day, September 1, 1942, Goebbels and his Italian counterpart, Fascist Minister of Popular Culture Alessandro Pavolini, inaugurated the Italian German Association Center in Venice.[66] As late as June 1943, Mussolini's office authorized plans for another film festival, also organized with Goebbels's collaboration.[67]

The music festival, the drama show, and the film festival together gave the Biennale a multifaceted character, offering a new set of itineraries and ways of consuming culture. After 1932, visitors could make extended trips, partake of a range of activities, select, choose, and consume plays, music, film, and the fine arts. Each of these attractions mobilized the consumptive possibilities of culture and of Venice itself by being situated in various parts of the city and requiring that the spectator move through the city to attend them. The 1934 Biennale brochure underlined the limitless attractions of the event: the brochure was divided into seven promotional sections: film, fine arts, decorative arts, music, theater, "traditional feasts and sports competitions," and "exceptional railway reductions."[68] The Biennale now had an itinerary similar to shopping: the art exhibition's pavilions themselves resembled shops and the act of moving among a variety of attractions located throughout the city deepened Venice's transformation into an extended arcade or theme park. The connection to broader trends in consumption and leisure can also be seen in the stress on the quantity of new attractions, as opposed to an earlier emphasis upon the quality and exclusivity of the Biennale. By creating the atmosphere of a supermarket of events and exhibitions, Maraini and the other Fascist-appointed administrators had altered the context of the viewing of the fine arts. The changed context, by shaking up the experience of viewing art, challenged the social imbeddedness of taste and, to a certain extent, the social boundaries of culture.

The fine arts pavilion, the core of the Venice Biennale, was not immune from the search for expanded publics and the challenges to cultural

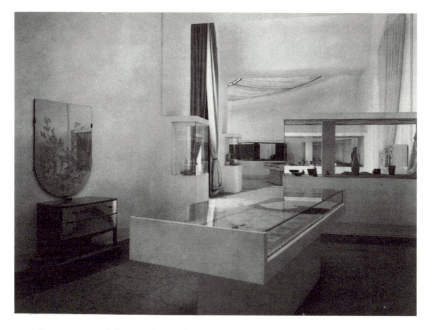

20. The interior of the Pavilion of the Decorative Arts, Venice, 1942.

categories. The Biennale inaugurated in 1932 a Venezia pavilion alongside the main Italia building in which the painting and sculpture were housed.[69] This new pavilion housed decorative arts displays. Previously, the art of the Biennale had been restricted to painting, sculpture, and drawings—all art forms rooted in long-standing European elite culture traditions. These art forms required knowledge of and familiarity with high culture and were too expensive for the noncollector. After 1932, however, new forms arrived: glassware, textiles, lacework, gold smelting, enamel work, and brass work all became central to the Biennales of 1934 to 1942.[70] In 1934, seventy-three decorative arts exhibitors presented 422 objects. Modern glass designs by famous Venetian producers such as Venini and Saviati shared the Venezia pavilion with traditional lacework (fig. 20).

The new middle classes had been distanced from arts acquisitions by the costs, as well as by the barriers of cultural habit and practice. Paintings and sculpture at the Biennale had been too expensive for the noncollector or nonelite. In 1932 and 1934 painting prices ranged from 1,000 to 5,000 lire, while glassware and other decorative art pieces cost between 100 and 300 lire.[71] A visitor of middling means could attend the Biennale after 1932, purchase a Venetian glass vase for 125 lire, and consider himself a patron of the arts. Artwork produced in volume and at a lower cost

allowed patrons of the arts to come—as president of the Biennale, Volpi, claimed—from "a vaster public of smaller means."[72]

Blurring the lines between high and low, elite and popular came in many forms and played many functions. In some cases, it came through patronage of mechanical reproduction—film—and in others it took the form of defending craft against the machine. The introduction of the decorative arts at Venice had an economic and ideological function. On the one hand, it opened arts consumption to new classes, as the accountant from Turin now could take home a Venetian glass vase from the Biennale. The decorative arts confronted the segregation of high art, which had excluded design objects because of their "distasteful entanglement with commerce."[73] On the other hand, as Michele Cone writes referring to Vichy France, official patronage of the decorative arts also "imaginatively reproduced the patron/artist relationship of the old aristocracy and the craftspeople they commissioned."[74] So, while the decorative arts allowed more people to purchase objets d'art, they remained somewhat elitist, in that they embodied preindustrial social hierarchies. The decorative arts of Venice, fine blown glass and handworked lace, still evoked images of luxury associated with aristocracy. The location of the decorative arts at the center of the Biennale simultaneously revealed a challenge to convention and anxiety about change.[75]

As in the case of the film festival, official patronage of cultural change incorporated financial support for an embattled sector. Government and party support of the decorative arts meant aid to an endangered crafts industry. The Venetian lace-making and glass-blowing islands of Murano, Burano, and Torcello had suffered greatly under the competition of the cheap goods of mechanized production. The 1934 Biennale catalog stressed the relationship between the economic crisis and patronage of the decorative arts, claiming that "times [have] fatally harmed the decorative arts."[76] Official interest in sustaining the decorative arts was also tied to official anxieties over unemployment among the skilled artisanal working class.[77]

Fascism's interest in *italianità*—authentically Italian cultural forms— brought renewed significance to indigenous art forms. The celebration of the decorative arts meshed with a larger debate over popular and traditional arts. As part of the resurrection of indigenous art forms, the regime founded the Italian National Committee for the Popular Arts in 1930 which later became part of the Dopolavoro, the Fascist after-work organization. In the realm of the syndical organizations, the National Fascist Confederation of Professionals and Artists maintained a special section devoted to representing the interests of artisans and encouraging "collaboration between artisans and distributors."[78] At the level of the display

and distribution of the decorative arts, the Triennale internazionale delle arte decorative e industriali moderne (International Triennial of the Decorative and Industrial Arts) became an increasingly important and visible institution during the course of the Fascist era. The Triennale moved from Monza to Milan in 1931 and the regime declared it a legally independent institution (*ente autonomo*) the same year. As national culture, free from foreign inspiration, became more central to Fascist culture, the once marginalized crafts and decorative arts, at times associated with peasantry and function (as opposed to aesthetics), became opportunities for *italianità*, larger-scale consumption, and aesthetic development.

The Triumph of Public Art

By the middle of the 1930s, the challenges to the formal and class boundaries of official fine arts culture accelerated to confront the figurative arts exhibition itself. The next step in Fascist cultural experimentation involved attacks on the canon of the fine arts and a reconceptualization of what it meant to be a patron of the arts. In a move that joined rhetoric concerning the social role of the artist under Fascism to a critique of private, bourgeois patronage, Fascist cultural bureaucrats made public art a central component of the production and display of the fine arts in Fascist Italy in general and at the Venice Biennale in particular.

Public art emerged in Italy in the early 1930s as the answer to the problem posed by artists, officials, and critics looking for a new and Fascist art dissociated from the private, academic work of the nineteenth century. Figures inside and outside of the Fascist hierarchy seized on public art as the way to make art more accessible to the masses and to reorient artistic production in the name of Fascism. The Fascist syndical organization hailed public art as a way to "valorize the role of the artist and to affirm in ever greater and better ways his integration into the life of the nation."[79] Fascist populist discourses and a depressed art market (and later demands for cultural autarchy), together with artists' own experiments with genre and explorations for more socially effective forms, led to the production and consumption of vast numbers of frescoes, murals, mosaics, and public statuary by the government and the party. Increasingly from 1930 on, such public forms constituted a central element of state patronage.

Fascist Italy's embrace of public art was hardly unique. The intersection of public art and state patronage occurred on an international level, with the crisis of the 1930s witnessing a reconsideration of the social role of the arts and of artists.[80] The 1930s were characterized across Europe

and America as a decade of the politicization of culture in which artists and governments searched for responsive forms. Public art, especially frescoes, murals, and monumental statuary, represented a diffused form of international 1930s culture. Diego Rivera and Clemente Orozco stand as the most prominent examples of a renaissance of grand-scale public forms. Public art had a cross-political cultural appeal which can be accounted for on a number of levels. First, governments in the years between the world wars integrated public art into the search for a national culture and the representation of national myths and identities. Second, mass politics and socioeconomic crisis had rendered official support for isolated or elite culture illegitimate. Public art fit firmly within the discourse which saw bourgeois culture as indulgent and antithetical to "honest production." Third, in a time of economic crisis, public arts projects provided employment to a potentially unruly but useful social class. Various governments between the wars from New Deal America to France of the Popular Front to the Soviet Union under Stalin recruited the artist class for the production of art with a social and public function.

Domestic and international ideological and cultural developments drove Italy's turn to large-scale public art forms in the 1930s. The inconclusive search for an aesthetic representative of Fascism drove the rise of public art. Murals, mosaics, and bas-reliefs coincided with Fascist patronage agendas in both form and content: they were all long-standing types of public art that combined Italian traditions dating from antiquity with Fascism's interest in opening the social composition and rhetorical possibilities of cultural production and reception. Patronage of murals, mosaics, and bas-reliefs also represented great statements of *romanità*; such forms reinforced the regime's connection to ancient Rome and allowed it to explicitly emulate the great Roman imperial patrons, thereby providing an alternative model to more recent bourgeois elites. The Roman-inspired frescoes, mosaics, and bas-reliefs bore a classical aura that buttressed the message of the regime's longevity and historical rootedness. Some Fascist bureaucrats believed that frescoes, mosaics, and bas-reliefs strengthened the authority of the state in ways that more contemporary forms could not. Murals and mosaics were also a home-grown response to the growing hegemony of mass culture.

In the mid 1930s, factions within the regime questioned the emphasis on bourgeois patronage with its elevation of artistic celebrities, its belief in the autonomy of artist, and its dependence upon easel painting and nonmonumental sculpture. Public arts projects opened the ranks to younger and nonconsecrated artists.[81] The Fascist syndical organization created subsections within its professional organization for frescoes. The

Ministry of National Education devised the famous 1938 Two Percent Law, which declared that "in all public works projects, 2 percent of the costs will be devoted to decoration."[82] For Maraini, state patronage "out of social, aesthetic, and economic reasons to which Fascism cannot remain indifferent . . . [must] return to a place of honor grand-scale wall decorations, as they are tied to the new political reality created by Fascism."[83]

The debate over the designation of a Fascist art had split, by the middle 1930s, into one between form and content. The novecento, the futurists, and the "return to order" movements searched for new forms expressive of Fascism, while the antipluralists elevated an art of content dedicated to representationally depicting Fascism. The call to make art more useful and visible was, perhaps, the only element of Fascist culture agreed upon by the various bureaucratic factions and artistic movements vying for official recognition.

A number of art and architecture movements in Fascist Italy explored the public function of art. The modernist groups located the turn to public art within a critique of easel painting and nonmonumental sculpture as suffocated by tradition and history and, therefore, inappropriate for the modernity of the Fascist reality. As chapters 5 and 7 demonstrate, many of Italy's avant-garde artists and architects resolved their aesthetic experiments on public projects. Architects used government commissions for post offices, stadiums, and summer camps as places to experiment, as did artists on the mosaics, frescoes, and bas-reliefs that adorned these buildings.

Each major Italian artistic movement active in the interwar period promoted its own brand of public art. The public art produced in Fascist Italy generally shared (with the exception of that of the futurists) an aesthetic that blended avant-garde elements with populist, historical, and monumental ones. Out of both an internal development and in response to critics, the Novecento painters evolved a style of public art after 1934 called *pittura murale* (mural painting). In addition to celebrating the use of murals and mosaics, *pittura murale* drew on resurrected pre-Renaissance Italian pictorial traditions, such as the Etruscan and Romanesque. The *Manifesto della pittura murale* (Manifesto of mural painting), published by Massimo Campigli, Achille Funi, Carlo Carrà, and Mario Sironi in December 1933, declared that "in the Fascist state art must have a social function: an educational function."[84] These novecento artists proposed the creation of a truly Fascist, Italian, and modern style through mural painting. "Mural painting," they asserted, "is social art, par excellence."[85] They stressed the combined public and collective character of the mural's

production and reception. For them, mural painting "committed the artist to a decided and virile execution which the technique of mural painting itself requires."

Mario Sironi, a leader of the novecento and an active participant in all aspects of official culture, was among the first artists to advocate for public art. For Sironi, *pittura murale* was a solution to the search for an authentic Italian art available to a large public and an art form suited to "this epic of great myths and giant upheavals." "The return to mural painting means a return to Italian examples and to our own tradition," he wrote in 1932.[86] For Sironi, *pittura murale* was more than "the simple enlargement over large surfaces of paintings that we are accustomed already to seeing." Rather, it offered "new challenges—challenges in the uses of space, form, expression, [challenges] of lyrical or epic or dramatic content; the renewal of rhythms, of balances, and of a constructive spirit."[87]

The futurists promoted their own provocative brand of public art in the form of three-dimensional, predominantly abstract wall displays, called *plastica murale* (plastic walls), which they brought to a number of building projects and exhibitions in the 1930s. According to the futurists, *plastica murale* with its geometric forms, abstraction, and tactile character had the distinct advantage of being the only truly avant-garde and *modernolatria* (modernity worshiping) strand of public art.[88] Posited as "polymaterial," *plastica murale* had the goal of "plastic emotion" and "could be constructed from as many as twenty diverse materials ... including: glass, wood, paper, iron, cement, leather, electric light, etc."[89] Marinetti and Prampolini, among others, launched *plastica murale* as a way to "liberate the artist from the outdated and detached-from-life practice of easel painting and to render the world of things into a direct projection of the life of the spirit."[91] The futurists celebrated *plastica murale* as a vibrant response to what they considered the passéism of the novecento's frescoes and murals: "*plastica murale* supercedes and abolishes the old-fashioned murals and frescoes in order to give space to numerous expressive and illustrative possibilities offered by *polimetri* and by plastic–documentary–free word simultaneity, through the use of all materials and all techniques."[91] The use of *plastica murale* at the Mostra della rivoluzione fascista was, for the futurists, its debut and apotheosis. They called for the application of *plastica murale* in "every type of Fascist edifice," because such constructions were "original-virile-optimistic plastic syntheses that brought together the study, festival, military force, and glory the Fascist revolution nourishes."[92] Rather than look to the past for the decorative inspiration for Fascist building programs and public art, one, shouted the futurists, must "launch a style/movement in continual

motion which rips men from admiration of the past and projects them into an enthusiastic desire for the future."[93]

The debate over public art launched a dialogue between art forms. Murals and mosaics encouraged a relationship between art and architecture and opened the possibilities for the exchanges between art forms dear to interwar modernists. The integration of painting, sculpture, and architecture, reminiscent of Bauhaus and De Stijl explorations, would forge new and daring visual styles, declared its promoters.[94] Murals and mosaics became loci of aesthetic development and debate: most of the celebrities of Fascist culture produced large-scale projects for government and party buildings and exhibitions. Early appearances of the form included the murals at the 1930 Monza Triennale: Achille Funi and architect Giuseppe Pizzigoni painted a cycle illustrating scenes from the life of Dido, and a collective of eight painters executed murals for the first floor of the exhibition. During the 1930s, the Milan Triennale, as the national centerpiece for the design arts, hosted much of the critically acclaimed public art produced. The 1933 Milan Triennale opened with a grand statement on the new centrality of public art: Campigli, Funi, Severini, Martini, and Carrà covered the walls of the Palazzo dell'arte in murals. De Chirico contributed a mural called *La cultura italiana* (*Italian Culture*) and Carlo Carrà painted one entitled *L'Italia Romana* (*Roman Italy*).[95]

At official fine arts exhibitions, the regime struggled with various art forms and patronage patterns, only to move a critique of bourgeois patronage and an espousal of public art to center stage after 1936. The private art of the easel, destined for the salon or drawing room, as opposed to public buildings or gardens, was seen as overly removed from the daily realities of Fascism. Public art promised to carry art out of the ivory tower and into public view. The emphasis on public art at a fine arts institution suggests Fascism's transformation of the very character of arts patronage.

Where the pre-Fascist Biennale had been based on private patrons buying art to decorate private spaces, the Biennale after 1936 elevated grandscale forms such as mosaics and murals to be enjoyed by the public and purchased by the state. Public art and the question of appropriate art forms for Fascist Italy, in distinction to appropriate content, represented a point of intersection between the two genres of Fascist-promoted exhibitions. At political exhibitions, Fascist patronage focused from the start on public art and on commissioning artists to create works with a broad function. Fascism's experience at mass-based exhibitions resonated back to fine arts exhibitions.

In 1936 public art came to the Venice Biennale in full force. That year, prize competitions wove together a number of newly emphasized

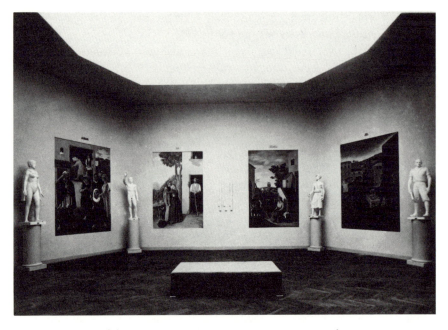

21. The Room of the Fresco Competition, 1936 Venice Biennale.

ideological strands. Government and party-sponsored competitions were divided into two sections: one for "seven frescoes" and one for "eight statues to decorate a central hall chosen for this purpose."[96] These competitions replaced earlier ones asking for easel paintings and ornamental sculpture. Two years later in 1938, the public art focus expanded to include competitions for frescoes, bas-reliefs, portraits, and commemorative medals. In an effort to open high culture at the level of production, these competitions specified who could participate: in 1936 restrictions of age and experience required that contributing artists be less than thirty-five years of age, members of the Fascist syndicates, and from among those not invited to the Biennale.[97]

In a bold challenge to the private patron and to "the artist as celebrity," the Biennale administration filled the main halls of the 1936–42 exhibitions with the products of the public art competitions. In 1938, to emphasize a more regimented and more public form of patronage, the works of the competition winners occupied the first five rooms of the main exhibition hall of the Italia pavilion. The much publicized winning frescoes and bas-reliefs met audiences in the entrance and the "grand central hall" (fig. 21).[98] Now, the visitor would first see the collective, large-scale works of public destination.

The placement of works destined for public or official uses at the center of the Venice Biennale reconfigured patronage. The spectator in the galleries of the pavilion now viewed the art for the experience and for the message implied in the work, not to acquire it. The "lessons" of the frescoes and statuary—from the glories of the war in Ethiopia to the Battle for Grain—were for consumption, not the objects themselves. This consumption was to go on in public, either the public space of the more open Biennale or the public space of the work's final destination. The removal of the private market from the main halls of the 1938 to 1942 Biennales declared the event less intimidating and more open to those without the means to purchase artwork. Moreover, the location of rhetorically Fascist public art at the front of the Biennale announced the unequivocal authority of the state.

With the addition of public art to the Biennale, the dictatorship changed the hierarchies of cultural production and reception. Most of the participants in the public art competitions were young and nonconsecrated artists, given access by the regime, like the new audiences. The frescoes, mosaics, and monumental statuary inside the Italia pavilion forced a meeting between an elite space and a public form. The promotion of public art with a prescribed theme pleased the antipluralists because of its content and the Fascist modernists because of its socially engaged form. In addition to being public art, frescoes, mosaics, and murals all harkened back to historical Italian traditions and, thus, fit snuggly into Fascism's intensifying rhetoric of cultural autarchy.

Conservative art critic Ugo Ojetti hailed the celebration of these Italianate forms of public art. "The word fresco," Ojetti wrote, "corresponds to something definite, lasting, sacred, and consecrated for centuries."[99] "Frescoes and mosaics," announced a supporter of cultural antipluralism in 1939, "have already assumed the social function of celebrating historic events and national glories."[100] In the absence of a single Fascist aesthetic, public art, particularly if expressive of some element of Fascist rhetoric, became the one agreed-upon criterion for Fascist artists. After 1936, official exhibitions moved public art and art with a prescribed theme to the center of their activities. The 1936 and 1938 Biennale competitions demonstrated the special attention given to frescoes, bas-reliefs, celebratory portraiture, and commemorative medals—all art forms both accessible to an untutored public and receptive to didacticism.

The breaking down of cultural hierarchies and reconsideration of the function of the arts took place across the official cultural landscape. The regional shows of the Fascist Syndicate of the Fine Arts also introduced new forms to art exhibitions in the 1930s. In 1932, the first exhibition of the

Fascist Syndicate of the Fine Arts of the Marche opened in conjunction with "a series of cultural and sporting events."[101] This trend accelerated with the growing confrontation with bourgeois patronage: the 1936 exhibition of the fine arts syndicate of Lazio was merged with the First National Poster Exhibition and the First National Exhibition of Sports Art. "This juxaposition is not by chance," wrote the show's organizers, "[but] has the goal of bringing artists and the public ever closer to both the practical needs of our age and to present forms closer to the masses."[102]

Enticing the Audience

Advertising and tourist incentive comprised the third strategy for opening Italian elite culture and integrating it into a larger burgeoning leisure and consumer economy. The European expositions of the middle and late nineteenth century had initiated the connection between travel, commerce, and the art market. By the early twentieth century, "a symbiotic relationship had developed between central European tourism and the visual arts."[103] The Biennale's Fascist organizers wanted to extend the institution's share of this commercial market. The broadening of culture-going audiences at fine arts exhibitions meant economic development for the tourist industry, especially hotels, restaurants, and shops.[104]

By the end of the decade, the Biennale had become a central focus point of a Fascist-promoted tourism. In addition to the structural changes and the reconsideration of patronage styles, Maraini and Volpi recruited promotional and publicity techniques to attract audiences. Organized by both the Biennale press office and the government tourist agency, the publicity initiative encouraged Italians to travel to Venice and partake of an Italian and Fascist cultural experience. Maraini expanded and modernized the Biennale press office with the regular publication of information, schedules, prizes, and discounts in the local, national, and international press.[105] By 1934, Biennale news and advertisements ran in sixty-two national newspapers and fifteen European and American dailies.

Beginning in 1930, thousands of posters detailing available train discounts hung in train cars throughout Italy. The posters' placement reveals targeted audiences: in 1930 announcements were split evenly between first- and second-class train cars, with none for the third-class cars.[106] While not renouncing its commitment to long-standing elite audiences, the Biennale now pursued middle-class audiences with equal fervor. By 1932, the balance swung in favor of middle-class patrons, with the orders for announcements showing twice as many allotted to second-

class train cars as to first-class cars.[107] The selection of locale for railway station advertisements also demonstrated the geography of the targeted audiences. Large wall-size posters adorned thirty-three Italian central municipal railroad stations in 1930, with 85 percent in northern industrial cities.[108] By 1932, the number of participating railway stations rose to fifty-five, but the overwhelming emphasis remained in the industrial North.[109] Advertising went into 40,000 telephone directories.[110] Biennale marketing consciously targeted urban middle-classes, those who owned phones and took second-class train cars. The Biennale also published pamphlets in six languages for tourist offices and resort hotels. The publicity program was coordinated with Italian and foreign tourist agencies, such as Italy's ENIT or Britain's *Bradshaw's Continental Guide*.[111]

Maraini made travel discounts the cornerstone of the incentive program. The train fare discount policy benefited both the regime and the consumer: the Ministry of Communications granted each exhibition the right to a certain number of weeks of discounted train tickets. The ticket holder would, upon reaching the Biennale, have his or her ticket stamped in proof of attendance. The *bollo* or validation cost between five and fifteen lire, which was divided between the Biennale and the Ministry of Communications.[112] For the 1930 Biennale, which ran from May 2 until November 4, 50 percent discounts were available May 2–11, July 18–27, September 7–27, and October 26–November 4, and 30 percent discounts were offered May 12–July 17, July 28–September 6, and September 22–October 25. The discounted tickets were valid for eight days, if issued in the Veneto, fifteen days if issued in other Italian train stations, and twenty days for those coming from abroad.[113]

By 1934, the expansion of the Biennale, the birth of the collateral events, and the attention to developing the audience all led to greater travel discounts. The 1934 Biennale, which ran from May 1 until October 15, offered 70 percent train fare discounts from May 1–20 and July 1–September 15 and 50 percent discounts from May 21–June 30 and September 16–October 15. Honeymooners were eligible for 80 percent discounts.[114] Both the train fare program and the entry tickets were priced to attract large crowds for the Biennale's central events: Biennale administrators further reduced train fares for inaugurations and closings and on the closing day of the 1934 Biennale, a press release announced that "the entrance ticket for this final day is reduced without exceptions to one lire".[115]

While the Biennale pursued primarily the middle classes, it made growing gestures toward working-class attendance during the course of the 1930s. Fascist rhetoric spoke of the need to create an Italian culture open to all citizens and even the Biennale opened its doors to "the

people"—but only certain deserving groups or on special days.[116] Maraini declared Sunday, October 6, 1934, "Sunday's Day of the People," with entrance tickets reduced to half price.[117] At a normal price of five lire, the Biennale was too expensive for a working-class Italian, who could attend a movie for half that amount. Because the dictatorship did not want to unhinge the Biennale from its prestigious identifications, entrance tickets at the show remained higher in this period than tickets to the mass-based political exhibitions, such as the Mostra della rivoluzione fascista, which cost two lire. Attendance figures attested to the success of the "People's Day": Saturday (a work day), October 5, drew 1,816 visitors, while the "People's Sunday" the following day attracted 3,081 spectators.[118] Organizers consciously worked to create a context for attendance that would minimize working people's discomfort: the long opening hours on Sunday, "People's Days," and discounted tickets were part of that effort. For the 1936 Biennale, Dopolavoro members entered the Biennale for 2.50 lire, half the regular entry fee, and riders on the "popular trains" visited for 1.50 lire.

As the 1930s progressed, the regime grew increasingly committed to exposing working-class audiences to official art exhibitions. So, it simultaneously cut back middle-class incentives and expanded popular ones. This shift took a toll on programs such as the travel discounts. For example, in 1935, the Ministry of Commerce set train discounts for those attending national exhibitions at a maximum of 50 percent for periods not more than four months.[119] This marked a decrease from the early 1930s when discounts of 70 percent were not uncommon. By 1940, the amount of travel time allowed with the discounted fares fell to five to 10 days, from an earlier peak length of fifteen days.[120] At the same time, the Biennale began, as requested by the regime's tourism ministry, a program offering Dopolavoro members and travelers on the regime's "popular trains" significant entrance discounts.[121]

While travel and entrance discounts were designed to bring in a socially mixed audience, the Biennale's publicity materials continued to stress the elite ambience of the event. The institution's first clientele remained a crucial part of its self-conception and one of the institution's "selling points" under Fascism. The pageantry and pomp of the Biennale inaugurations and ceremonies highlighted the continued participation of the Italian and European upper classes. Fascism wanted to appropriate the prestige of the Biennale; this required the participation of the exhibition's original constituency. Elites had been the mainstay of the pre-Fascist Biennale and gave it its distinctive aura; Maraini worked hard not to lose their support as the institution moved in new directions. For all the inaugurations of 1928 through 1942, the House of Savoy was well

represented. In 1932, 1934, 1936, 1938, and 1942, King Victor Emanuel III opened the Biennale, together with the current minister of national education. In 1934, the Biennale press office mailed 1,596 invitations for the inauguration ceremonies and festivities which included banquets and fancy dress balls.[122] This number included 461 senators, 400 deputies, 200 "various personalities," fifteen ambassadors, eight members of the Italian Academy, and ten directors of galleries and museums.[123] Biennale press releases always included lists of dignitaries, aristocrats, and celebrities in attendance at the Biennale. Advertising in "the great Italian and foreign hotels" and "foreign luxury magazines" persisted throughout the period.[124]

By 1934, the Fascist-administered Biennale pursued large-scale and socially diverse tourism. As Maraini celebrated, "The International Biennale of Art ... [has] produced interest from all over the world and [has] brought a tremendous boost to Venetian tourism—doubling the number of visitors since the last exhibition."[125] The search for evidence of ever expanding audiences led to special attention to the compilation of attendance figures and the continual sending of tallies to Mussolini's office and the Ministry of National Education.[126] By the close of the 1932 Biennale, Maraini claimed success: in 1932 attendance reached 250,000 spectators, as compared with 193,000 in 1930 and 172,000 in 1928.[127] For the Biennale of 1934, the Biennale adminstration celebrated a jump in attendence to 450,000 visitors.[128] These increases by 1934 mirrored the success of newly established programs, such as the music, drama and film festivals, better publicity, and increased train discounts.

Exposure was central in the "selling" of the Biennale in particular and of official culture in general. The exhibition figured prominently in government-produced, LUCE newsreels.[129] Images of the May 1930 Biennale, inaugurated by the duke of Bergamo, made up the longest story in the week's newsreel and provided glimpses of the opening ceremonies and the Italian and foreign pavilions.[130] Another May 1930 newsreel depicted the visits of "artists and journalists to the Biennale prior to the opening."[131] The film festival, with its spectacular inaugurations and attending stars, received particular attention in the newsreels. Biennale inaugurations, closings, and special events, featured many times in government newsreels between 1930 and 1940, exposed Italians to the Biennale and projected an image of the exhibition as fun and Fascist.[132]

Official press attention to the Venice Biennale was one example of larger official coverage of government- and party-sponsored cultural events. Newsreel coverage represented a key way of diffusing official culture beyond those actually present. The government-produced newsreels, the LUCE *cinegiornali*, obligatorily carried at least one image of the

opening, closing, or famous visit to an exhibition. Press attention to exhibitions drew audiences into Fascist-sponsored culture and reminded them of the regime's cultural interventions. Images of an activist dictatorship were reinforced by depictions of government and party officials cutting inaugural ribbons. Further, the repeated representations of members of the House of Savoy participating in exhibition activities reminded the viewer that Fascism had brought in old elites and had become the voice of the entire nation. The regime created public spaces beyond the piazza and made them appealing to the mass audience of the newsreels. Of 210 newsreels produced in 1930 and of 195 produced in 1931, 25 and 24 respectively had segments dealing with exhibitions.[133] In 1932, the number amounted to 34 of 136 sound newsreels.[134] Stories involving exhibitions appeared in over a quarter of all newsreels between 1937 and 1939, with 53 to 56 appearances in approximately 208 yearly newsreels.[135]

On July 21, 1938, a law, a year in the making, gave the Biennale the final administrative and financial form it would have under Fascism. In response to calls for greater regimentation and efficiency of cultural production, the central government again intensified its part in the workings of the Venice Biennale. The addition of supplementary events in the mid 1930s, such as the film, theater, and music festivals, had confused administration and placed a growing financial burden on the *ente*. The outreach to new audiences, embodied in the new attractions and Maraini's development of the art exhibition, brought added responsibility and required more money. The expansion of the years 1930–37 and the Biennale's new multidimensional character had produced a confused system of government supervision: the Ministry of National Education supervised the figurative arts section of the Biennale; the Ministry of Popular Culture oversaw the film festival and the international exhibitions; and the provincial government of the Venice administered the theater festival.

Legislation of 1938 established an executive committee and a series of subcommittees designed to streamline the administration of the various Biennale events. These new committees drew directly, for the first time, on government and party personnel: the law declared that the executive committee, in addition to five Biennale personnel, would include the *direttore generale per le antichità e belle arti* (undersecretary for antiquities and fine arts), a subministry at the Ministry of National Education; and the *direttore generale per il turismo* (undersecretary for tourism) and the *direttore generale del commercio* (undersecretary for commerce), both undersecretariats at the Ministry of Corporations.[136] In addition, the law authorized three subcommittees to oversee the primary Biennale events:

one each for the figurative arts exhibition, the film show, and the music and theater shows. By law, each of the subcommittees was composed of representatives of the government and party apparatus.

While reorganizing the administrative structure, the 1938 law left intact the legal and juridical organization of the International Exhibition of the Figurative Arts, as stipulated by the earlier Fascist-sponsored law of 1930. The film festival remained under the supervision of the Ministry of Popular Culture, as set out in its charter of 1936. The theater and music festivals were to be run jointly by the city of Venice and the Ministry of Popular Culture.[137] The clarification of government supervision over events was accompanied by a new Biennale administrative council composed of the following members:

> A person of clear fame, living in Venice, designated by the Office of the Council of Ministers, decreed by Mussolini to act as president
> The *podestà* of Venice
> A representative of the Fascist Party appointed by the secretary of the party
> A representative of the Ministry of National Education
> A representative of the Ministry of Corporations
> A representative of the Ministry of Popular Culture
> The *preside* of the province of Venice
> The president of the Fascist National Confederation of Professionals and Artists[138]

Where the 1930 law setting the composition of the council called for the appointment of five members by Mussolini on the proposal of the Ministry of National Education and Ministry of Corporations, this 1938 law required eight specific government and party officials. The 1930 law left the council without representatives from the party, while the 1938 law called for the appointment of a Fascist Party representative and the president of the Fascist National Confederation of Professionals and Artists.

The Ministry of Popular Culture, between its role in the film and theater festivals and the Administrative Council, came away with marked influence. Created in 1937 out of the former Undersecretariat of the Ministry of Press and Propaganda, the Ministry of Popular Culture became the locus for the shifting propaganda priorities of the regime. The ministry's power grew commensurately with the regime's interest in expanding its propaganda apparatus and in competing with the National Socialist propaganda machine in the later 1930s.[139]

A law reorganizing and vastly increasing the finances of the Biennale quickly followed in November 1938.[140] The government's contribution to annual funds for the general operating expenses of the institution rose

from 250,000 lire to 400,000 lire. The law divided the financial burden between the Ministry of Popular Culture and the Ministry of National Education.[141] With the new decree, each of the component events of the Biennale separately received government financial support. The 200,000 lire a year alloted to the Esposizione internazionale d'arte figurativa (International Exhibition of Figurative Arts) from the budget of the Ministry of National Education supplemented the 250,000 lire a year from the city of Venice and 50,000 lire from the province of Venice. The film festival collected an annual budget of 50,000 lire a year from the Ministry of Popular Culture and 20,000 lire from the city of Venice. The Ministry of Popular Culture and the city of Venice also divided the expenses of the music and drama shows, with 300,000 a year from the former and 200,000 from the latter.[142] Overall, the annual financial presence of the central government rose dramatically from 200,000 to 850,000 lire, with 450,000 lire coming from the Ministry of Popular Culture and 400,000 lire from the Ministry of National Education.[143]

The reorganization highlighted the interpenetration of the state, culture, and commerce. "The qualified organs created by the regime," wrote Maraini, "in the various fields of art and tourism will participate directly in the new life [of the Biennale]."[144] The structural reorganization of 1938 acknowledged that the cultural reality had changed. It also mirrored the larger centralization of cultural institutions under government and party control. Fascist patronage made isolated institutions devoted to the social reproduction of a single class and art form no longer viable. Maraini welcomed the changes, explaining that more active national adminstration was needed because the Biennale had "developed so significantly as to become a center of undertakings which include all the arts."[145]

For Maraini, the adminstrative overhaul highlighted the Biennale's central position in national cultural life. He welcomed the direct intervention of government personnel as a necessary outcome of the exhibition's growth and adaptation to Fascism. Maraini congratulated himself for the Biennale's national stature and concluded that "What is important to note is how such a growth of activity aims to make Venice the center of all the arts . . . during the summer season. [This] was undertaken by the Biennale with only the means provided by the government for its figurative arts exhibition."[146]

The expansion and centralized national administration of the Venice Biennale had reduced its Venetian character to tourism. "La Serenissima" offered a pleasant and attractive backdrop for a national cultural institution and the uniqueness of the Venetian artistic patrimony remained an

essential element of Biennale advertising; but the form and content of the exhibition was determined and organized at the national level.

The former focus and raison d'être of the Biennale—the figurative arts exhibition—had, by 1938 descended to an equal footing with the other events of the Biennale. The regime first came to the Biennale emulating traditional patrons of European high culture. But in its desire to bring in new audiences, it transformed the exhibition. The very genre of the art exhibition had been reconceived by Fascism's decision to expand the social bases of culture. The traditional high arts of painting and sculpture and the static format they required failed to fulfill the goals of Fascism's cultural intervention.

Fascist elite culture moved in numerous directions in its search for enlarged constituencies. Official support for diverse forms within an elite context challenged the canonical power of bourgeois patronage. By 1938, the regime had transformed the genre of the art exhibition. To attract new audiences, it sponsored experimentation and accommodated film, popular music, drama, and the decorative and public arts. Fascism's interest in mass entertainment and national culture had percolated up to the Biennale, which could no longer cater predominantly to arts connoisseurs and a haute-bourgeois clientele.

Much of the pushing of the social composition of culture involved shifting the viewing gaze and bringing the spectators' gaze in line with a new set of cultural imperatives. Some of the new imperatives were particular to Fascism, while others were the product of a general 1930s Western turn to cultural populism. In many locations, artists and cultural functionaries pursued new cultural forms able to engage the masses. Mass movements and societies in flux incorporated new constituencies into high culture. This was done in an array of settings from New Deal America to the Soviet Union. A set of powerfully revolutionary cultural forces coincided with Fascism, from the growth of a culture industry to technological revolutions in mass culture.

The reconfigured Venice Biennale offered a multitude of possibilities to the visitor. By 1936, a menu of cultural choices greeted the engineer from Turin and his family. From the Mickey Mouse cartoons of the film festival to the Goldoni plays of the theater festival to the Venini vases of the decorative arts pavilion, the Biennale was now a cornucopia of forms and entertainments. Fascist goals of commercial development, popular success, and cultural innovation and legitimation coincided to reconfigure high culture in Italy.

■ ■ ■ ■ ■ ■ CHAPTER FIVE

Fascist Mass Culture and the

Exhibition of the Fascist Revolution

ONE MUST CONSIDER THE EXHIBITION AS A TYPE OF
APPLIED STRATEGY FOR ARCHITECTURE: A BATTLE WITH
ART IN WHICH THE FACTORS TIME, IMAGINATION,
COURAGE, AND DETERMINATION COUNT FOR MUCH.

Giuseppe Pagano, 1934[1]

EXHIBITION TECHNOLOGY HAS ASSUMED A NEW
CHARACTER. POLITICAL REPRESENTATIONS ACT AS WELL-
CHOSEN CUES FOR ARTISTS; THE POSSIBILITIES FOR
REALIZATIONS ARE INFINITE AND [THE EXHIBITION'S]
EDUCATIONAL EFFECTIVENESS HAS BEEN ESTABLISHED AS
SOLID AND PRACTICAL. WE ARE IN AN ERA IN WHICH
CINEMATOGRAPHY HAS DISPENSED WITH THE READING OF
NOVELS, IN WHICH THE RADIO BRINGS MUSIC INTO THE
HOME. . . . THE DESIRE NOT TO TIRE IN ORDER TO
KNOW AND TO UNDERSTAND . . . [SUCH] THINGS GIVE OUR
"JOURNALISTIC" CIVILIZATION A MORALITY ALL ITS OWN:
THE FASHION OF THE EXHIBITION IS A TYPICALLY
TWENTIETH-CENTURY ONE.

P. M. Bardi, 1932[2]

EXHIBITIONS: LET'S BUILD OUR OWN SYSTEM FOR
ESTABLISHING THEM. THERE IS ART, POETRY, AND
MORALITY TO BE MADE.

P. M. Bardi, 1932[3]

Fascist Political Exhibitions

Fascist patronage at mass exhibitions with a po-
litical, social, or economic theme differed considerably from that at fine
arts exhibitions. While a variety of styles prevailed in both forms, the
dictatorship encouraged greater experimentation with the form of theme
exhibition. The links between art exhibitions and preexisting elites and

art forms limited Fascism's ability and desire to alter them, as the regime sought to appropriate aspects of elite culture. As Fascist intervention in the Venice Biennale reveals, only in the late 1930s, when it rejected inherited patronage styles, did the dictatorship move public art to the center of official art exhibitions. In contrast, political exhibitions, as recently developed forms, offered the government and the party an opportunity to create a uniquely Fascist intersection of art and propaganda.

While Fascist Italy did not invent the theme or political exhibition, it adopted it readily, taking the form in new directions and giving it its most diffused exposure to date. The design aspects of the political exhibition had been developed by the European interwar avant-gardes in the process of experimenting with industrial design and advertising. German designers at the Bauhaus and Soviet constructivists experimented in the late 1920s with the possibilities of bringing "new spatial and technical solutions" to exhibition design.[4] Walter Gropius and Gustav Moholy-Nagy at the Bauhaus and El Lissitzky and Konstantin Melnikov in Moscow evolved techniques of "spatial interpenetration," using photomontage and constructivist symbolism to give exhibition design a modern, tactile character.[5] The larger European (and Italian) art world came into contact with avant-garde exhibition design at a number of trade and industrial exhibitions in the late 1920s, especially Lissitzky's "Press Pavilion" at the 1928 Cologne Exhibition, and Gropius's and Breuer's *Werkbund* section at the 1930 Paris Decorative Arts Exposition.[6]

The Fascist regime celebrated its anniversary of ten years in power with a massive exhibition: the Mostra della rivoluzione fascista, an official interpretation of the March on Rome and the history preceding it. The success of the 1932 exhibition launched a range of similar shows that focused on political, social, or economic issues. In the course of the 1930s, the autarchy policy, the League of Nations Sanctions against Italy, the Nazi-Fascist Alliance, and the Racial Laws all found expression in exhibitions.[7]

While political developments catalyzed the most extravagant shows, the regime also expressed its social and economic policies through mass exhibitions. The Mostra dell'istruzione tecnica (Exhibition of Technical Education) (1936) celebrated Fascism's advances and plans for further growth.[8] The demographic campaign of the 1930s reappeared in a national exhibition on infant health care, the Mostra delle colonie estive e assistenza all'infanzia (Exhibition of Summer Camps and Assistance to Children) (1937).[9] Theme exhibitions also reinforced the dictatorship's relationship with industry at various moments during the 1930s. For example, the joint interest of government and business in expanding the aeronautics industry led to the promotion of the Mostra aeronautica

(Aeronautics Exhibition) in Milan in 1934.[10] Official support for the na-
scent Italian fashion industry stimulated the birth of the annual Mostra
della moda (Fashion Exhibition), while government and business interest
in the development of radio technology catalyzed the establishment of an
annual Mostra della radio (Exhibition of the Radio); the regime's promo-
tion of an Italian-led Mediterranean economic sphere underwrote the
expansion of the Fiera del Levante (Fair of the Levant) after 1930.

Thus, during the 1930s, with all these topics providing a wide variety of
occasions for official cultural events, the Fascist regime patronized and
advanced a successful mass exhibition formula. This formula attracted
the talents of many of the nation's best artists and architects. These exhi-
bitions were complicated texts, blending propaganda with entertainment,
didactic and reductive narratives with more ambiguous and complex
ones. The exhibitions were part of Fascism's intermittent rejection of pre-
existing cultural standards, its attempt to transform the cultural institu-
tions of Liberal Italy and its search for forms it could declare uniquely
Fascist. In its inheritance of the futurist antipathy toward museums, Fas-
cism sought an active, temporary, and innovative exhibition format and
a new kind of visual communication.

The mass, theme exhibitions shared formal commonalities that al-
lowed specifically Fascist characteristics and innovations to emerge. The
Fascist political or theme exhibition genre can be defined by six charac-
teristics: (1) the use of art to aestheticize politics; (2) the application of spe-
cifically avant-garde art, architecture, and design; (3) the collapsing of the
space between the spectator, the artifact/document, and the art; (4) the
employment of a repeated exhibition itinerary or dramatic path; (5) a
volatile combination of entertainment, tourism, and propaganda; and
(6) a discourse of Italian national identity and culture and its conflation
with Fascism. The sum total of these parts was a Fascist *Gesamtkunstwerk*
of art, drama, propaganda, and entertainment.

For most of the 1930s, political exhibitions commis-
sioned a modern art that partook of elements of twentieth-century avant-
garde culture, from photomontage and constructivist design to function-
alist architecture, expressionist theater, and experimental film. Fascism
enlisted new, untainted aesthetic languages in its theme exhibitions and
asserted that the aesthetics of the twentieth century must be mass aes-
thetics. The political exhibitions embraced the new syntaxes supplied by
modernist culture. Artists constructing the shows found modernist design
a ready container for the regime's rhetoric. The functionalist architecture
characteristic of Fascist exhibition facades, for example, provided easily
imprinted and visually exciting surfaces, such as the six-meter-tall metal

abstracted fasci of the Mostra della rivoluzione fascista. The photomontage commonly used, with the cutting, pasting, and disassociation of images from their contexts, assisted in the creation of myths by suggesting new visual experiences and perspectives.

Mass exhibitions also drew on the syntaxes of film and expressionist theater: there was little attempt to hide the ephemeral quality of the constructions, as though the ephemerality contributed to the electricity of the event. The scaffolding and supports of installations were often visible to the spectators. Fascist exhibition design readily borrowed from the constructivist scaffolding and platforms that had been characteristic of early Soviet theater design.[11]

The mass exhibitions disoriented the viewer with unfamiliar visual and spatial experiences. They mobilized avant-garde forms of visual communication and merged the space between spectator and object, as well as between objects and art work. Taking a further technique from trans-European modernist culture, Fascist culture mixed "high and low, formalism and populism, museum culture and everyday life through the progressive fusion of text and image."[12] By rejecting a documentary format that appealed to the viewer's reason, these shows recruited the emotions and the spirit to convey information. A further defining quality of the genre under Fascism, then, was the mingling of art and document and art and life. Modernist techniques of photomontage and "spatial interpenetration" disoriented and roused the spectator. These exhibitions appropriated the avant-garde project of "break[ing] down the conventional space between actors and audiences."[13] As in film, the viewer was placed in the middle of the scene, not outside it. Where film "erased differences and conflicts between actors and spectator," these exhibitions blurred the distinction between viewer and object, and thus "generated identification" between the two.[14] This mix of representation and life and the creation of identification between viewer and display meant to replicate the mobilization and emotionalism of mass rallies, but within a controlled environment.

The use of art to house and translate the display objects, declared one observer, separated these shows from past cultural forms: "Tens and tens of rooms with thousands of rare documents can, in fact, instantly become a stagnant museum, if not for the fact that in every corner, even the most hidden, political necessity and artistic reasoning [are] intimately connected."[15] The intermingling of art and historical object reversed the nineteenth-century trend toward separation and scientific distinction.[16]

Further, forming a typology, the shows shared a liturgy or dramatic cycle. The exhibition path took the spectator from ignorance to realization to epiphany. Each show combined informative rooms with spiritual

rooms and usually concluded with a secular chapel or sacristy, such as the Mostra della rivoluzione fascista's Chapel to the Martyrs or the Mostra aeronautica's (Aeronautics Exhibition) Room of Icarus—a chapel dedicated to the martyrs of flight. The itineraries of Fascist theme exhibitions relied upon an intensifying emotional register as the spectator moved through the exhibition. The narrative unfolded and then achieved resolution in a calm, quiet "chapel"-like room. In this way, propaganda became spiritualized and the spectator was party to an emotional and transformative experience.

An additional defining component of the Fascist exhibition formula was the merging of tourist, propaganda, and entertainment motives. By linking mass culture entertainments such as film festivals, fashion shows, and sports competitions with travel incentives, such as discounted train fares, to more overt forms of propaganda, these shows offered the spectator an opportunity to be fun loving, traveling, and Fascist all at once.

The evocation of the shows as events of Italian national culture constituted a final aspect. From the Mostra della rivoluzione fascista of 1932 forward, the exhibitions mobilized a rhetoric and symbolism of a unifying national culture. The exhibitions shared a symbolism that merged the symbols of the Italian nation-state with newer Fascist symbols. With this historical, rhetorical, and semiotic load, the exhibitions claimed to speak to all Italians, regardless of class or region. Held in Rome, the shows drew crowds to the national capital. For many of those whom the regime bused, trained, or trucked to Rome, the political exhibitions represented their first introduction to the Italian nation.

Whereas official art exhibitions focused on the support of artists and an expanded art-going public, the political exhibitions targeted mass audiences without distinction. Fascism sought to channel those who might or might not attend rallies and demonstrations into the political exhibitions, thereby transferring the energy of mass politics into Fascist-organized culture. As the scale of the constructions and the numbers they held attested, these events existed to be experienced by large crowds.

Notwithstanding the centrality of the audience, the regime's program of political exhibitions depended on the participation of vast numbers of artists, designers, and architects. As discussed further on, many of interwar Italy's most prominent and avant-garde artists and architects resolved their aesthetic questions on government commissions, particularly exhibition sites. Exhibitions comprised a temporary (and thus perhaps even more experimental) equivalent to the post offices, summer camps, and official buildings that the regime commissioned architects to design and artists to decorate. The patronage of modernists gave the dictatorship the support of prominent artists and architects and tied them

to the dictatorship—a patron willing to risk patronage of new and modern forms. As Giuseppe Pagano said in defense of official use of rationalist architecture, "the so-called 'rationalists,' free from stylistic constraints and enthusiasts of a new aesthetic creed have shown themselves most capable.... Exhibitions permit them to express opinions and precepts otherwise difficult to realize in experimental situations."[17] Theme exhibitions thus represented an especially well located and central aspect of Fascism's program of public architecture and official culture.

Fascist Self-Representation

WHERE IT ASSERTS THAT "THE MOSTRA ... EXCITES THE IMAGINATION, RECREATES THE SPIRIT," THE GUIDEBOOK IS GUILTY OF MODESTY. HERE ONE LEARNS, ONE REASONS; HERE ONE THINKS, CORRECTS PRECONCEPTIONS, AND REAFFIRMS CONVICTIONS.—*Guelfo Andalo, 1934*[18]

On the morning of October 28, 1932, the tenth anniversary of the Fascist assumption of power, Benito Mussolini inaugurated the most enduring cultural event of the Fascist dictatorship. As the Duce reviewed the assembled honor guards and passed the cheering crowds to open the doors of the Mostra della rivoluzione fascista (Exhibition of the Fascist Revolution), Fascism invited Italians and foreigners alike to experience and participate in the regime's act of self-representation.[19] The Mostra della rivoluzione fascista recreated through a mélange of art, documentation, relics, and historical simulations the years 1914 to 1922, as interpreted by Fascism after ten years in power. The exhibition's twenty-three rooms focused on each year from the beginning of World War I until October 1922 and crescendoed in the Sala del Duce (Room of the Duce) and the Sacrario dei martiri (Chapel of the Martyrs).

While the show's text was the past—1914 to 1922—the context was the future. The Mostra's celebration and evocation of the history and rise to power of Fascism took place on the decennial of that takeover. As discussed in chapters 2 and 3, the regime became increasingly involved after 1929 in cultural production and institutions. These years witnessed Fascism's consensus-building programs, such as the draining of the Pontine marshes, the construction of the Fascist "new towns," the wars on tuberculosis and infant mortality. The year 1932 also marked the beginning of Achille Starace's tenure as secretary of the National Fascist Party. Starace vastly opened up party membership and expanded the party's mass organizations. In this context, the Mostra della rivoluzione fascista

constituted a referendum on Fascism to date. The regime, in presenting its own story and exposing as many citizens as possible to it, sought validation for its rule as it entered a second decade in power.

The popular and critical success of the Mostra della rivoluzione fascista and its continued presence throughout the Fascist era furnishes a case study for shifts in Fascist culture and clues to an understanding of public responses to that culture. How did the National Fascist Party organize a propaganda event that both met its interest in political legitimation and responded to the cultural tastes of a broad cross section of the Italian public? The answer discloses itself in layers: (1) the iconographic and aesthetic, (2) the discursive, and (3) the promotional. Examination of the mechanism of aesthetics, an open-ended nationalist-Italianist discourse, and mass culture reveals the ways in which Fascism produced a propaganda exhibition that pleased spectators and critics alike, while also giving the regime the popular consensus it sought.

The Mostra's triumph signified the birth of a genre that the regime would expand during the remainder of the decade. This Fascist-developed mass exhibition genre, as noted in the preceding section, blended aesthetics and artifacts. Through the transformation of documents into works of art, Fascism spiritualized history and politics, providing spectators with intensely emotionalized propaganda. The Mostra della rivoluzione fascista, soon after its opening, became a multimedia event and a de rigueur cultural experience. With a sophisticated use of aesthetics and mass cultural organization, the regime filled a gap left by the Liberal parliamentary governments and offered Italians an event of national proportions.

Assessment of the multifaceted dynamic of mass culture, aesthetics, and Fascist rhetoric and symbolism is best approached through analysis of the creation, reading, and the organization of spectatorship at the exhibition. As the cultural event chosen to depict Fascism's self-understanding and to render visually its present and future, the Mostra della rivoluzione fascista is central to an understanding of the cultural formula advanced by Fascism in the early 1930s and abandoned by it at the end of the decade.

MAKING THE EXHIBITION

The proposal of a single low-level bureaucrat evolved into the most important propaganda and artistic–mass culture event of the Fascist era. The Mostra della rivoluzione fascista, like the reorganization and expansion of the Venice Biennale, originated as the brainchild of an individual promoter. In 1928, while serving as president of the Istituto nazionale fascista di cultura (National Fascist Institute of Culture) of Milan, Dino

Alfieri conceived of an exhibition to celebrate the decennial of the founding of the first *fascio di combattimento* to be held on March 23, 1929.[20] After a series of solicitations to Mussolini's office, Alfieri secured a meeting with the Duce on March 23, 1928.[21] The first meeting designated a committee composed of "the Duce, the quadrimviri of the March on Rome, the secretary of the party, the administrative secretary of the party, the director of *Il popolo d'Italia*, and the federal secretary of Milan." To support the project's development, the Fascist Party donated 500,000 lire toward production.

Under Alfieri's direction, the Milan Istituto nazionale fascista di cultura composed an outline of the Mostra del Fascismo, to open in Milan on March 23, 1929, and to close one month later. The "general plan" presented the exhibition's five topics:

1. Interventionism and neutrality (1914–15)
2. War (1915–18)
3. The dawn of Fascism and its struggle for the salvation of the nation (1918–22)
4. The March on Rome (July–November 1922)
5. The regeneration of Italy created by Fascism (1922–29)

The "general plan" projected the events of 1914–22 through the lens of a crisis-ridden Italy rescued from total disintegration by Fascism. For example, one of the third topic's primary themes was "the nation in extreme danger," which included subsections on "public disservices," "affronts to patriotic values: the victory, the flag, the soldiers, and wounded."[22] The show's ideological core was a recreation of the crisis of 1914–20 and presentation of Fascism as the force responsible for both solving it and for producing social, political, and economic harmony. The largest, final, and most detailed section of this first plan for the Mostra del Fascismo concerned the regeneration of a "new Italy" under Fascism. After descending into the despair of total war and postwar crisis, the viewer would rise again upon seeing the "moral values," "public works," "agricultural resurgence," and the "new spirit" forged in the years 1922 to 1929.[23]

Work on the Mostra del Fascismo progressed in late 1928 but soon ran aground.[24] After six months of preparation, the project collapsed over the issue of an appropriate locale. In December 1928, the National Fascist Party directorate concluded that Rome, rather than Milan, should host such an important event.[25] With the expansion of the project and the accelerating interest of government and party officials, the show had "assumed a decisively national character" or, as one journalist reported, "Rome was justly preferred."[26] The project's elevation to national status required the use of the national and historical capital.

Roma and *romanità* were central components of Fascist ideology and rhetoric. The Fascist conceptualization of Rome and Romanness stressed the past greatness of Italy under Rome's leadership and its future glory under Fascism. *Romanità*, in its capacity as a trope of Fascist culture, focused on the creation of an Italian identity free from foreign inspiration and steeped in idealized notions of the glory of imperial Rome.[27] Margherita Sarfatti described Rome's role as a unifying force, thusly: "one [of Fascism's] goals," she wrote, "is to abolish communal and regional particularism, in order to tie all of Italy solidly to Rome."[28] Given the growing role of "Rome" in Fascist doctrine and culture, the city of Rome was the only viable site for a cultural event designed to transcend regional allegiances and bring the nation's inhabitants together as Italians and Fascists.

In the midst of location debates, the designated opening day of March 23, 1929, came and went. While the tenth anniversary of the founding of the first *fascio* passed, a far more portenuous commemoration loomed. "With the approach of the regime's decennial," wrote *Il popolo d'Italia*, "[the exhibition] was restarted with a total reinforcement of means and funding."[29] The affirmation of the assumption of power in 1922 rather than the celebration of the birth of the Fascist movement, promised wider participation and supplied a more receptive anniversary for the creation of a mass-based myth. Whereas the founding of the first *fasci di combattimento* in 1919 involved a few individuals, the March on Rome and the imposition of Fascism touched the lives of all Italians. Fascist rhetoric, as it had evolved between 1922 and 1932, articulated the March on Rome as the event that saved Italian society from dissolution and civil war. Further, in the shift from movement to regime, Fascism embraced a rhetoric of responsibility to Italy as a national whole. This decision followed a historical pattern, as founding myths and their celebration are often based on the anniversary of the shift in power, rather than on the initial acts of rebellion. The United States of America, for example, celebrates July 4, 1776, and the Declaration of Independence, instead of the Boston Tea Party or the first shot of the Revolutionary War at Lexington Green.

With the Roman location and the new anniversary, preparations began in earnest. In early 1932, Alfieri and his team established headquarters in the Palazzo delle esposizioni (Palace of Exhibitions), on the Via nazionale, one of Rome's central arteries. The Via nazionale traverses the city from the main train station to the Piazza venezia, the large plaza located below Mussolini's office and adjacent to the Roman Forum. The Palazzo delle esposizioni is also located on a centuries' old pilgrimage route, leading across the city to the Vatican. The regime's construction of its auto-celebration within sight of the Vatican represented a physical declaration

of its challenge to the papacy. This location, as one critic noted, "in the heart of Urbe," placed the Mostra del fascismo and Fascism at the core of the nation's capital.[30] It also paved the way for the later choreography between the Mostra and the city.

As an outgrowth of the decision to present the exhibition as a national work-in-progress, the Mostra's directorate announced a nationwide call for artifacts and objects to be put in the displays. While the open collection policy may have been bureaucratically unwieldy, its ideological utility was unmistakable: it allowed the organizers to present the Mostra as a "people's" depiction of its own history.[31] The senator or a local Fascist leader who sent in a clipping or a photograph personally contributed to the regime's self-commemoration and was, therefore, an active participant in the construction of Fascism and Italy.

From his command post in the Palazzo delle esposizioni, Alfieri coordinated the "collection of the most important and significant relics, photographs, pamphlets, autographs, artifacts, newspapers, and publications."[32] To secure the aid of local and regional party organizations, the Roman party secretary circulated an announcement to be "posted in all the offices of local groups and in the district and provincial *fasci*." By March 1932, thirty-two provincial Fascist federations had "responded to the call, sending various material of tremendous interest."[33] Private citizens and organizations, such as the Società nazionale per la storia del risorgimento (National Society for the History of the Risorgimento), rallied to the call and mailed in clippings, photos, and mementoes. In September 1932, for example, the exhibition offices received a fragment of the bridge where "the martyr Giovanni Berta, with his hands grasping the sides of the bridge in a desperate attempt at salvation, was beaten and crushed by the savage fury of subversives."[34] The offices of the Mostra received many more common and less emotional artifacts, such as the 1915 "membership card" to the Nationalist Association of Trento-Trieste forwarded by Professor Fracassi.[35]

While ideologically functional as an example of Fascist populism, the open collection system had its limitations. Repetitive materials flooded the Via nazionale offices and many objects central to the exhibition's narrative had to be solicited.[36] There was an "overabundance of red and black flags, pennants, clubs, relics of subversives, and a shortage of exemplary Fascist documents, historical pamphlets, and important newspapers."[37] Materials, celebrated the official press, came from a vast array of sources, including "ministers, prefects, federal secretaries, secretaries of Fasci, *podestà*, leaders of all the Fascist political and syndical organizations, museums, libraries, private citizens, authorities from Quadrimviri to ministers, from senators to deputies to ambassadors."[38] At the "closing

of acceptances" in late September 1932, Alfieri announced the receipt of 18,400 artifacts through the mail.[39]

The change of the Mostra del fascismo's focus from the anniversary of the founding of Fascism in 1919 to the March on Rome in 1922 drastically shifted its narrative. In its 1932 manifestation, the show addressed only the years leading to the assumption of power and the March on Rome itself, rather than, as earlier envisioned, the entire period of Fascism to date. Foregrounding the seizure of power created a dramatic path and a master narrative: the escalating crises of 1914 through 1922, years of war and social strife, achieved denouement in the Fascist takeover. Or as *Il popolo d'Italia* phrased it:

> The reevocation of the Fascist revolution's episodes of magnificent action . . . will awaken the Italian people to the reality of the sacrifices of the pioneers and the Black Shirts, as [the Mostra portrays the cycles of redemption, liberation, and the moral, spiritual, national, and political unification of Italy and Italians.[40]

Severing the post-takeover period of 1922 to 1929 from the exhibition located the narrative squarely and undistractedly upon Mussolini and the Fascist movement as the saviors of a nation in crisis. This choice wedged a space between past and present, making the past mythic. The party also changed the show's title to Mostra della rivoluzione fascista, thus stressing the revolutionary narrative while also separating it from the present.

The show's importance escalated, as, on July 14, 1931, the Fascist Party directorate in the presence of Mussolini approved a final plan.[41] The exhibition, declared the plan, will not "take historical reevocation as a goal in itself." An excited official press raised expectations further, announcing, the Mostra will not be a "simple exhibition" or "show," but something which "will be deeply felt by the people in their souls, thirsting for light, love, and drama."[42] In April 1932, Alfieri together with Luigi Freddi published a final synopsis of the exhibition's projected content, entitled "Historical-political Outline for the Mostra del fascismo."[43] Reflecting the Mostra's growing significance, *Il popolo d'Italia* reprinted this abstract.[44] The official press worked closely with organizers to forge an atmosphere of expectation and anticipation.

With only five months remaining until opening day, Alfieri and the assistant directors—Luigi Freddi, C. E. Oppo, and Alessandro Melchiori—coordinated the scholars and artists assigned to oversee each section.[45] Luigi Freddi, Alfieri's primary lieutenant, as head of the Historical Office, oversaw the activities relating to the exhibition's documentary side. Freddi, an early Fascist, boasted an impressive pedigree: he numbered among Marinetti's first followers in the interventionist struggles and was

arrested in a prowar demonstration against Austria in 1914. After serving in World War I, Freddi participated in the founding meeting of the *fasci di combattimento* in 1919 and then in the D'Annunzian actions against Fiume.[46] Soon after the March on Rome, Freddi was appointed press secretary of the National Fascist Party and, in 1927, he took up the post of vice-secretary of the Fasci italiani all'estero (Fasci-Organizations Abroad). Freddi's work as a journalist had him accompany Italo Balbo's two transatlantic publicity flights in the early 1930s. Freddi, thus, came to the Mostra della rivoluzione fascista with two major qualifications: a long and high-profile career in the Fascist Party and training in journalism and public relations.

Like many Fascist bureaucrats associated with successful institutions or events, Freddi's experience at the Mostra paved the way for a future career at the center of Fascist culture. With the exhibition's close in 1934, he was to assume the newly created position of director general of cinematography, a suboffice of the Ministry of Press and Propaganda.[47] Freddi's influence over Fascist film policies and the coordination of Italian cinema with the regime was so significant that the period has come to be known as the "Freddi era."[48] Freddi brought to the film world the same awareness of popular tastes and attention to entertainment that he had encouraged at the Mostra. Further, the openness to foreign inspiration and models, which supplied the aesthetics of the Mostra their vibrancy, gave Italian cinema during Freddi's tenure its openness to experimentation.

Like Freddi, Alessandro Melchiori, who served as Fascist Party liaison, came to the exhibition with the credentials of a "Fascist of the First Order." In 1919, he founded the *fascio di combattimento* of Brescia and joined the D'Annunzian expedition to Fiume the following year. After three years as a correspondent for *Il popolo d'Italia*, he was appointed by Mussolini as vice-secretary of the party in 1924. Like a number of Fascist officials, such as Freddi and Mussolini himself, Melchiori's experience in journalism gave him a special gift for translating Fascist priorities for a mass public. Melchiori's attachment to acts of Fascist self-representation would endure, as he later directed the second edition of the Mostra in 1937, after Alfieri and Freddi had moved on to higher-ranking government posts.

Alfieri successfully recruited Cipriano Efisio Oppo to direct the exhibition's artistic side.[49] Oppo, who has already figured prominently in this story of Fascist official culture, combined a career as artist, critic, arts administrator, and parliamentary deputy. As noted in chapter 2, he vigorously supported a return to "Italian" aesthetic values tied to the embrace of modernism. He spent the Fascist era in the thick of the cultural

bureaucracy, holding a series of high-level positions, including secretary-general of the Fascist Syndicate of the Fine Arts (1927–32), Fascist parliamentary deputy (1929–34), and president of the Quadriennale (1931, 1935, 1939 and 1943) and of the Exhibitions of the Fascist Syndicate of the Fine Arts of Lazio.[50]

Teams composed of a "historian" and an artist shared responsibility for the execution of each room. The historians and artists came from very different sources: the historians, "a group of comrades from the old guard," came "exclusively" from the ranks of the Fascist Party, especially deserving early adherents to Fascism.[51] *Il popolo d'Italia* acknowledged the contrasting requirements for artists and historians, saying "if from the historians we could reconstruct a *squadra di azione*, among the artists not all were fascists."[52] The party demanded Fascist pedigrees from those who would choose the historical artifacts that the regime sought to infuse with gravity and sacredness. For the artists who would interpret and house those objects, it did not.

Assignment as a historian on the Mostra della rivoluzione fascista came as recognition for service to the party. Luigi Freddi prepared Rooms A and B, entitled "From the outbreak of the European conflagration to the founding of *Il popolo d'Italia* 1914" and "From the foundation of the *fasci d'azione rivoluzionaria* to Italian intervention." Alessandro Melchiori organized Room N, "Year 1921." Thus, three ideologically central rooms were from the start under the control of exhibition staff. The historians' credentials reveal their provenance. Riccardo Gigante was *podestà* of Fiume, senator, former director of the Fascio of Fiume; he had been the leader of Fiumian Irredentism from 1908 until 1914 and president of Young Fiume.[53] Dante Dini, journalist and *sancepolcrista* (participant in Fascism's founding rally), directed the Organizzazione nazionale balilla and frequently contributed to *Il popolo d'Italia*.[54] The exhibition catalog listed Giovanni Capodivaca, Gigi Maino, and Piero Parini as *sancepolcristi* and *diciannovisti* (one who joined Fascism in 1919).[55]

The artists of the Mostra della rivoluzione fascista were cut from a very different cloth. Rather than commendation for service to the Fascist Party, Alfieri selected the artists based on their national and international reputations for provocative work. Alfieri and his assistants chose artistic collaborators by the same principle that had determined patronage patterns at official art exhibitions: consensus through diversity, vitality through the appropriation of multiple aesthetic possibilities. In addition to pursuing the participation of artists from a range of movements, Alfieri hired the most prominent artists he could attract. Margherita Sarfatti congratulated him on his foresight, saying "for his part, he knew to trust the

most assailed and controversial artists, because they are the best artists in Italy. And he knew how to stand by and support them in the face of the usual cowardly old criticisms."[56]

Mussolini had ordered the Mostra della rivoluzione fascista to be "something of today, extremely modern . . . and audacious, without melancholy recollections of past decorative styles."[57] Accepting the gauntlet, Oppo and Alfieri courted the most prominent figures in the Italian art world. In the end, the artists included "architects, painters, sculptors, all coming from diverse artistic schools. . . ."[58] The party newspaper proudly described them as "an array of artists of the avant-garde."[59] Edoardo Persico, himself one of main exponents of modernist architecture in Italy, called them "an exceedingly happy selection of artists of the most modern tendencies."[60] The desire to forge a cultural and propaganda experience aesthetically disassociated with earlier epochs and one that had a revolutionary narrative and aesthetic drove the dictatorship to offer its autocommemoration in a mixed but overall avant-garde style.

When Alfieri invited artists to work on the Mostra della rivoluzione fascista, he challenged them to breathe life into the artifacts of Fascism, to take them and reincarnate them into relics, spiritual objects, and inspirational touchstones. Artists from a range of schools and histories were stirred by the possibility.[61] All the Italian movements were represented: futurism by Enrico Prampolini, Gerardo Dottori, Arnaldo Carpanetti; novecento by Mario Sironi, Achille Funi, and Domenico Rambelli; rationalism by Giuseppe Terragni, Adalberto Libera, Mario De Renzi, and Antonio Valente; "return to order" and strapaese by Mino Maccari and Leo Longanesi. Artists who associated themselves with modernism but without strict allegiances to a particular movement also participated. In addition, Alfieri gave assignments at the Mostra to the young and unestablished, but ready and willing, such as Antonio Santagata. Others received assignment based on success in the Fascist-coordinated exhibition system. For example, Arnaldo Carpanetti had won the 1930 Biennale competition sponsored by the National Fascist Party and then received the commission to design the Room of 1918–March 1919.[62] Despite an attempt to include younger artists and newcomers worthy of official recognition, the overall list of contributors read like a roll call of prominent interwar Italian artists.

Much of the Mostra's ultimate success and its visual uniqueness lay in the fact that artists from varied movements shared a common and innovative approach to exhibition construction. The Mostra depended on repeated, simple architectonic forms such as triangles and circles, photomontage, extracted slogans, and enlarged photographs, as well as

repeated use of bold and striking coloration—mostly red, black, and white. The artists shared a faith in the malleability of the artifacts and the possibility of using modernist artistic construction such as collage and photomontage to make the objects bespeak a number of messages and to transport the viewer. "Photomontage," declared one reviewer, "gave the entire collection [of objects] its most exquisite and indisputable visual character."[63] The show appropriated the futurist innovation of *plastica murale*—the use of three-dimensional design and multimedia projections that rendered the walls "plastic" and moving. *Plastica murale* was able to present a range of expressive and illustrative possibilities through the use of plastics, sounds, and three-dimensional installations.[64] For Enrico Prampolini, one of the contributors to Mostra, *plastica murale* provided a new "semantic functionalism"—a three-dimensional visual language. A common interest in stretching the boundaries between "art" and "objects" permitted the artists' varied styles to fuse and produce a coherent whole. The blurring of "art" and "artifacts" gave the show its spiritualized character and its shape as a total experience, a Fascist *Gesamtkunstwerk*.

SEEING THE EXHIBITION

The exhibition played out a cycle of crisis, redemption, and resolution. Its itinerary carried the visitor around the side rooms of the palace and then down the grand central halls. The first fourteen rooms, circling the edges of the palace, traced Italian intervention in World War I, the postwar crisis, the rise of Fascism, and the Fascist victory. After the representation of the Fascist triumph, the exhibition abandoned a chronological format and the rooms in the center of the building—the Salon of Honor, the Gallery of Fasci, and the Chapel of the Martyrs—were thematic, rather than chronological. Since the Fascist coup symbolized the end of history and a resolution of all national conflicts, the rooms that followed its depiction suspended time. Six elements emerged as the most evocative: the facade, the Room of 1922, the Room of the March on Rome, the Salon of Honor, the Gallery of Fasci, and the Chapel of the Martyrs.

These six spaces with their complicated texts and dynamic visual forms articulated the show's narrative core. The facade, as the beckoning image, drew in spectators with its imposing specter of power and modernity. The Room of 1922 roused passions of anger and allegiance by manipulating images of the crisis leading to the March on Rome. The rooms memorializing the Fascist takeover offered a moment of resolution and epiphany. Finally, the show's core cycle ended in the silent and mystic Chapel of the Martyrs.

The Facade: "You Are Grasped, as if into the Mouth of an
Immense Machine"

The facade, the visitor's first glimpse of the Mostra della rivoluzione fascista, startled and overawed. Rationalist architects Adalberto Libera and Mario De Renzi completely recovered the nineteenth-century beaux arts face of the Palazzo delle esposizioni, hiding the heavily ornamented facade of 1882 behind a rationalist metal mantle. Over the thirty-eight-meter long Pompeian-red metal archway, rose the words "Mostra Della Rivoluzione Fascista" in red capital letters, above which towered four metal stylized fasci. These imposing fasci ascended twenty-five meters and were made of oxidized and polished copper sheets, stretched over a scaffolding of steel.[65] On either side of the building stood two, six-meter-tall X's, also constructed from sheet metals. The rectangular archway entered into an atrium surrounded by arches, which swept the visitor into the exhibition. The facade inscribed Fascism onto the urban Roman landscape (fig. 22).

The facade contained a variety of available readings. The long rectangular arch over a bank of doors beckoned to be entered. At the same time, the immense fasci dominating skyline of the crowded Roman shopping street humbled and minimized the spectator. The contrast between the jumbled, urban commercial surroundings and the stark metal simplicity of the facade boldly announced the regime's power. The bare, machinelike fasci advertised the dictatorship's decision to represent itself as modern, while the reconstruction of a triumphal arch out of the four columnlike fasci stressed its identification with the past. Moreover, the facade's primary iconographic elements, the fasci and the Roman numeral X, harkened back to imperial Rome, yet the stark, stylized fasci evoked images of modernity, of smokestacks and naval warships. The facade contained a symbolic universe: the eye first caught the metal fasci proclaiming the power of the state, then the X, which announced the state's temporal reign, and finally the title of the event, heralding its founding myth.

The facade's audacity represented a starting point for discussions of the Mostra della rivoluzione fascista. The official guidebook celebrated it as a hymn to modernity and as "a moment in the cycle of the creation and definition of new expressions."[66] "You are constrained by a superior force which convinces you that there has been a revolution in Italy," gasped Roberto Papini.[67] For Ottavio Dinale, writing in the weekly magazine of *Il popolo d'Italia*, the facade reflected "the enormous weight of Fascism, which throws itself on the paths of history to influence all."[68] Calling it

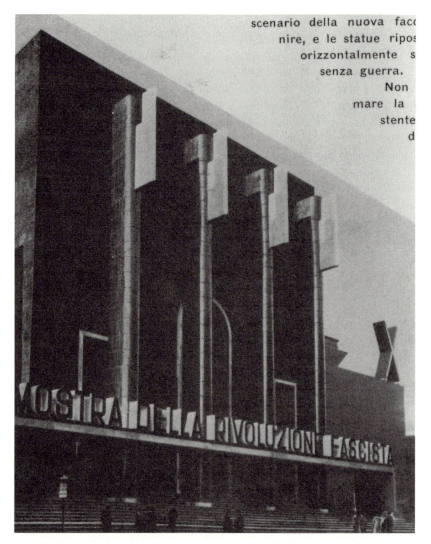

scenario della nuova facc
nire, e le statue ripos
orizzontalmente s
senza guerra.
Non
mare la
stente
d

22. Adalberto Libera and Mario De Renzi, facade of the Exhibition of the Fascist Revolution (Mostra della rivoluzione fascista), 1932.

"perfect," another observer compared the facade's fasci to "huge, ancient, and proto-Roman towers."[69] For Margherita Sarfatti, the entrance embodied her own view of Fascism, "with its clean vertical lines of ascension and action, of domination, audacity, and empire."[70]

Alfieri and Oppo had taken a risk in choosing Adalberto Libera to design the facade and the Chapel of the Martyrs. By 1932, Libera, together with Giuseppe Terragni, was the most visible member of the Italian ra-

tionalist movement in architecture. He had been a motivating force behind the creation of the Movimento italiano per l'architettura razionale (Italian Movement for Rationalist Architecture), which held its first exhibition in Rome in March 1928.[71] Libera also led the Gruppo 7 which included Luigi Figini, Guido Frette, Sebastiano Larco, Gino Pollini, Carlo Rava, and Terragni. This group of architects, all of whom had come of age after World War I, defined itself in distinction to the other two Italian modern movements in architecture, futurism and novecento.[72] The rationalists, who claimed to have moved beyond both futurism's dependence on the individual creative act and the novecento's emphasis on tradition and ornamentation, celebrated functionalism and the new materials brought by technology, such as concrete and reinforced steel.[73] As the Mostra's facade demonstrated, the rationalists applied the lessons and materials of industrial design to an Italian and Fascist context. The rationalists unabashedly located Le Corbusier's *Vers un architecture* and Walter Gropius's *International Architecture* at their inspirational core. Libera based his career on explorations in modernist "public" architecture. His legacy includes an array of experimental pavilions and facades: the Italian Pavilions at the Chicago World's Fair (1933) and the Brussels International Exposition (1935); the main pavilion of the Mostra nazionale delle colonie estive e dell'assistenza all'infanzia (National Exhibition of Summer Camps and Assistance to Children) (1937), the Palazzo dei congressi (Congress Hall) (1940), and participation at the Mostra della Razza (Exhibition of the Race) (1942).[74] For Libera, monumentality and contemporaneity coexisted unproblematically. In fact, this union gave architecture renewed potential as "a great container of symbolic messages, as a monumental envelope and organizer of basic iconographic material, objects, and significant ideas."[75]

Terragni and the Triumph of Fascism

In the Room of 1922, the spectator traveled from the depictions of chaos and disintegration that dominated the first exhibition rooms to ones of hopefulness, possibility, and continued struggle. This room dramatized the critical months prior to the Fascist takeover in late 1922 and was, thus, central to maintaining the show's pace. Cut diagonally by a wall and surrounded by semicircles of display cases, the visitor walked into a room divided into a frenetic mass of interconnecting photomontages, collages, cutouts, all moving at diagonal angles. The room offered a semiotic overload by utilizing repeated dynamic and asymmetrical symbolic forms that exploded the expository space.[76]

Rationalist architect Giuseppe Terragni executed this room detailing the period from the beginning of 1922 until the March on Rome. His

themes ranged from the continued martyrdoms of Fascist squad members in their battles against the left to accelerating parliamentary crises to the birth of the first Fascist parastate organizations. Looking up, the visitor saw a canvas-draped ceiling, adorned with an enormous X, for Year Ten: "This model is completely covered in socialist and anarchist flags, placed in semidarkness. These flags are nailed to the frame by daggers illuminated by reflectors—demonstrating that all the real effective force of the subversive parties ended in 1922."[77] This technique, inspired by expressionist stage design, gave tactile form to the representation of the Fascist repression of the left. One side of the diagonal wall narrated the Fascist punitive actions of 1922 with clippings and artifacts. Above the display hung a series of merging profiles in which Mussolini's black profile fused with the silver outline of Italy, all framed by the words "Organization of the Forces of the Young." This collage symbolized the emergence of the institutions of the nascent Fascist state out of the internecine strife of 1919–22 and created the iconographic conflation of "Italy-Mussolini-Fascism." Another segment of the wall bore Mussolini's slogan, "The Last May 1st!" supported by a cutout figure pushing away the crutch of socialism. In the adjacent corner stood a ceiling-high figure composed of a prison-suit of metal strips entitled, "The Worker Ensnared by Strike Mania."

Antisocialism and anticommunism and the demonization of these movements supplied the transitional trope between chaos and calm: the destruction of the enemy allowed for the social-national peace that reigned in the coming rooms. The violent purge of the enemy took agitprop form in Terragni's photomontage of the burning of the headquarters of the Socialist newspaper, *Avanti*. Here he blended photomontage with cubist-futurist overlaps and transparencies of flames to aestheticize the Fascists' suppression by fire.

The Room of 1922 climaxed in a wall construction entitled *Adunate* (Mass Meetings). The lower section bore three-dimensional airplane propellers built from photographs of mass rallies. These propellers faced diagonally up toward hundreds of plaster hands, all pointing toward the sky in a disembodied Roman salute (fig. 23). The *Adunate* wall, the room's last wall, celebrated the dynamism of the masses and recreated the mass rally through art. Here the spectator flowed into "the sea of hands tensed for the oath and the Roman salute representing the rising tide of Fascism."[78]

Terragni's agitprop of the hope and unity of Fascism after the chaos of 1920–21 stirred the passions of reviewers and spectators alike. Reviewers were overcome by the force of his constructions which "gave . . . a flaming impression to whomever . . . crossed the threshold of [the Room of]

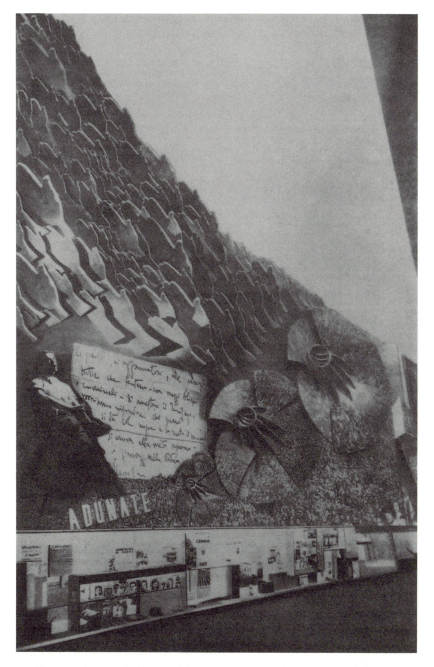

23. Giuseppe Terragni, *Adunate* (*Mass Meetings*), panel, Room O, Exhibition of the Fascist Revolution (Mostra della rivoluzione fascista), 1932.

1922."[79] "The innumerable daily events of those months that preceded the March on Rome," wrote one overwhelmed critic, "chase after and superimpose one after another to the detriment, at times, of clarity."[80] Terragni swirled events, images, facts into a tornado that excited but also confused the spectator.

Terragni's influences were an amalgam of futurism, from which he took his dynamism, the international avant-garde, which gave him his abstraction, and the novecento, which supplied Italian decorative and symbolic references.[81] His abstraction played on an Italian visual repertoire and his symbolism drew on Italian and international sources. The Mostra, for Terragni, was "a revolutionary act" and "violently antiacademic."[82] His exhibition design employed graphic and set design devices drawn from Russian constructivism, especially from Konstantin Melnikov. Much of Terragni's career focused on government commissions and public architecture, such as war memorials and exhibition pavilions. The triumph of his career, and perhaps of rationalist architecture as a whole, came in 1936 with the completion of the Casa del fascio in Como.[83] This three-story building, built as an "open container," with its clean, functional lines and reformulation of de Stijl and Corbusian architecture, has been termed one of the most important buildings of the modern movement.[84] Terragni also won the competitions for the never constructed Palazzo littorio (1934) and the completed Palazzo dei congressi (Congress Hall) (1940) for the planned Esposizione universale di Roma (Universal Exposition of Rome). He tirelessly defended modernism and rationalism against the monumentalizing and Romanizing, Piacentinian wing of government-patronized architecture. With an identity that scholars in the past have been reticent to accept, Terragni considered himself both a committed Fascist and an executor of the modern style. He found nothing contradictory in the combination.[85]

Contemporary critics have stressed Terragni's avant-garde international influences and his ability to apply the agitational techniques of the European avant-garde to the reactionary authoritarianism of Fascism. Much of the photomontage on which Terragni based his work came from German dadaism and he borrowed as well from Melnikov and El Lissitzky, the Soviet futurist-constructivists.[86] In fact, the "collective sea of affirming hands" in Terragni's *Adunate* panel closely paralleled a poster by Soviet constructivist, Gustav Klutsis, for the 1927 Soviet elections: Klutsis's poster showed a mass of hands against a red background, moving in a diagonal tide toward the top of the space, all raised in collective affirmation. In both works, the disembodied hands moved in common patterns against similar red backgrounds (fig. 24). As discussed further on,

the use of common symbolism and techniques such as photomontage to illustrate the collective life of the postrevolutionary Soviet Union and the Fascist dictatorship of Mussolini indicates the malleability of the modernist aesthetic and the inability to assume political positions based on form or style.

Terragni's rooms were the ideological core of the show: they created the distinction between the "us" who belonged to Fascism and the "them" (the subversives) who would have destroyed the national community—if not for "us." The rooms that followed, constructed by Mario Sironi, evaporated the "us" versus "them" distinction and created a national Fascist cult. With the triumph of Fascism, all Italians had become "us."

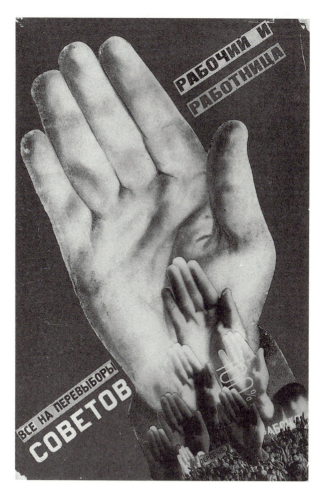

24. Gustav Klutsis, study for poster, *Workers, Everyone Must Vote in the Election of Soviets,* 1930.

Sironi at the Mostra della rivoluzione fascista

From the frenzy of Fascism's seizure of power, the visitor entered the strength and stability of the new order. The show's emotional tone shifted drastically with the transition to rooms dedicated to the March on Rome, the Arrival of Fascism, the Salon of Honor, and the Gallery of Fasci. The spectator, by now anxious and disturbed by the semiotic over-stimulation of the earlier rooms, was made tranquil by large monumental spaces and orderly perspectives. For these postcrisis rooms, security and continuity replaced disintegration and chaos as the dominant narratives. Mario Sironi expressed the shift in narrative by opening up the expository spaces, a monumental scale, a lack of photomontage, and a different iconographical language.

While rationalists such as Terragni and Libera executed ideologically important elements of the show, to Sironi went the exhibition's most emotionally potent rooms, those concluding the show's chronological order. The first of these rooms, the Room of the March on Rome, consisted of two sections. The first focused on the National Fascist Party congresses prior to October 28, 1922, and the second on the March on Rome itself. Sironi merged the symbols of Fascism with those of the Italian nation-state. The ceiling was tricolor, as was the color scheme of the entire room. Three images met the visitor upon entering: (1) white letters with red borders, declaring "La Marcia su Roma," below (2) a bas-relief of a stylized eagle in flight which supported (3) a relief of the national flag adorned with the cross of the House of Savoy. Together, the shapes of the flag and the eagle produced the silhoutte of a fascio. This three-dimensionial trilogy of "Fascism–imperial eagle–Italian flag" projected the assimilation of the old into the new and advanced a message of stability and consolidation. The head of the eagle projected off the wall and into the exhibition "as a premonition of destiny's imminent arrival" (fig. 25).[87] On the floor below this *plastica murale* stood a machine gun (symbolizing both the national struggle of the Great War and the battle against the left). According to the official guidebook, "the victory has by now relegated [the machine gun] to a purely decorative function."[88]

Bare except for two images, the opposing wall concisely translated Fascism's great act of self-assertion: a three-dimensional, wall-length Roman dagger, engraved with the intersecting words "Dux/Italia," shattered the red chain of Socialism, which hung in jagged fragments from the wall. The Roman dagger, the symbol of Italy united to its Duce in a resurrection of Roman glory, had smashed the stranglehold of socialism. *Il popolo d'Italia* hailed the "bloody chain," which had to be cut as a "prelude to the flight of the eagle."[89] The room's immense, overpowering, yet

25. Mario Sironi, Room of the March on Rome, Exhibition of the Fascist Revolution (Mostra della rivoluzione fascista), 1932.

minimal images brought the viewer an austere respite, an opportunity to savor the unifying and restorative powers of Fascism.

From the Room of the March on Rome, the spectator progressed to the "grave and silent" Salon of Honor. The Salon of Honor and the Gallery of Fasci that followed it were detached, self-sustaining environments designed to evoke a reverential mood. The Salon of Honor was a crypt—an exedra dominated by a statue of Mussolini bursting out of the wall. This militant statue of a solid and armed Duce stood guard over the room, as the nation's warrior-protector. Below the statue ran the enormous san serif letters DUX. The side walls of the exedra were squares with projecting rectangles, thereby producing "roughly made fasci." The statue-DUX combination guarded the "den," the "severe cell of the first seat of *Il popolo d'Italia*," the room's real focus.

Alone inside the bare crypt stood a simple, square building, which housed a re-creation of Mussolini's office from 1914 until 1920. The building's only ornamentation comprised plain pillars wrapped in reproductions of *Il popolo d'Italia* and a simple doorway through which spectators observed the relics. The reconstituted office bestowed a voyueristic look

into Fascism in its radical movement phase: Mussolini's paper-covered desk was strewn with hand grenades and a carelessly placed revolver, and behind the desk hung a black flag with skull and crossbones. The disordered room, claimed the catalog, was "a living documentation of the den from which came the orders of the insurrection."[90] The Salon of Honor's dual focus on (1) the image and word of Mussolini as authoritarian consolidator and (2) an environmental recreation of Mussolini as radical revolutionary leader gave the cult of Mussolini a mythology.

The Salon of Honor drastically reoriented the spectator's gaze. While in the preceding rooms the visitor was an undifferentiated historical participant, rising with Fascism's triumph, the view into the Duce's office was an individual's look into the leader's private space. The voyeuristic gaze, exaggerated by the limited access of the small doorway, into the relics of Mussolini's revolutionary den connected the spectator to the Duce as an individual. One at a time, the visitors gazed into one man's private den: with this, history and the historical subject were suspended and personalized for a moment. With the democracy of "looking in," the spectator's subjectivity was altered as the exhibition placed leader and follower on the same plane for an instant. This private moment between the (representation of) leader and the follower produced an identification more individual and personal than that forged in the other rooms.

From the Salon of Honor followed the Gallery of Fasci, where Sironi again reshaped the preexisting architecture in order to produce a "total environment." This long hallway was bordered by two rows of rough-hewn ceiling-high fasci dedicated to the various *fasci di combattimento* of Italy (fig. 26). The triumphal hall created by the columnlike fasci exuded an ambience of "Roman greatness" and closed in upon a monumental and classicizing bas-relief of a horse and rider, which symbolized Italy "in liberated and victorious procession."[91] The hall's monumental proportions inscribed the strength of Fascism and connected it to an earlier imperial age. Here viewers could gather themselves together before entering the emotional Chapel of the Martyrs.

While Terragni prepared the spectator for the Fascist seizure of power, Sironi fashioned the iconography of the new regime and reconstituted preexisting symbols of the patria to new uses. Sironi combined the novecento's solid architecturalism and rejection of ornamentation with constructional elements taken from the international avant-garde. From El Lissitsky, Sironi appropriated the notion of creating an internal, self-enclosed environment. Sironi acknowledged his debt to the Soviet constructivist, citing the Soviet pavilion at the 1928 Cologne exhibition as his primary source for the formal organization of the Mostra della rivoluzione fascista.[92]

26. Mario Sironi, Gallery of Fasci, Exhibition of the Fascist Revolution (Mostra della rivoluzione fascista), 1932.

Sironi's aesthetic with its repeated emphasis on volume, rough cuts, and monumental scale, had an "archaeological" dimension. The rough-hewn Roman sword, the chiseled DUX, and the hall of fasci all harkened back to a time of myth. The grand scale and "archaeological" texture

gave Sironi's rooms a timeless authority, one connected to a mythologized Italian past. Sironi built the "cell" to house Mussolini's office in a blocky (Etruscan) pre-Roman style, implying that the Duce was not associated with a particular historical period, but belonged, rather, to all time.

As the catalog acknowledged, Sironi's stature as leader of the novecento and long-standing illustrator for *Il popolo d'Italia* led to his assignment of the "most imposing" elements of the show.[93] Sironi began his career as a futurist, studying under Giacomo Balla, signing his first futurist manifesto in 1915 and serving alongside the futurists in the Lombard Cyclist Battalion during World War I.[94] His early work and urban landscapes of the 1910s and 1920s bore a futurist imprint, which he later fused with metaphysical inspirations. Together with Margherita Sarfatti, Sironi organized the novecento movement in the years 1922–26. Following the decline of the novecento after 1933, Sironi turned the bulk of his energies to public art, such as exhibition design, frescoes, and mosaics and encouraged his novecento colleagues to do the same. Sironi's high profile, his unwavering commitment to the regime and his evolving style throughout the Fascist period have led some scholars to see him as the paradigmatic Fascist artist.[95]

Sironi's influence on the show's aesthetics, and those of the Fascist mass exhibitions to follow it, was central and defining. For Margherita Sarfatti, "it is above all to Sironi that one owes the overall artistic imprint of the show." Sironi, she wrote, "gave his austere, religious, and tragic soul, not only to the rooms that he constructed himself, but he permeated [the whole], with the imprint and example of his genius."[96]

The Chapel of the Martyrs: "For the Immortal Fatherland"

The Chapel of the Martyrs concluded the exhibition's liturgical cycle. Here the viewer's experience coalesced in mourning and tribute to the Fascist martyrs, now become the nation's martyrs. The minimalist circular room, designed by rationalist architects Adalberto Libera and Antonio Valente, centered on a simple, large cross inscribed with the words "Per la patria immortale" (For the immortal fatherland). Lit from above with theatrical and ritual emphasis, the metal cross stood on a blood-red pedestal (fig. 27). The entire room glowed in a muted red light. In response to the inscription on the cross, the walls repeated the word "presente," referring to the living memory of the fallen. The Fascist anthem "Giovenezza" was broadcast softly into the room, as a disembodied chorus of the dead.

In the chapel's charged ceremonial space, the viewer released the pent-up passions aroused in the earlier rooms. This was the moment in which the conversion took place and the spectator was fully subsumed into

PER LA PATRIA
IMMORTALE!

27. Adalberto Libera and Antonio Valente, Chapel of the Martyrs, Exhibition of the Fascist Revolution (Mostra della rivoluzione fascista), 1932.

the national-Fascist community. In the rooms addressing the Great War and rise of Fascism, the Mostra created identifications between the viewer and Fascism. In Sironi's rooms the Fascist cult became the national cult, and both of these flowed into the cult of the Duce. In the sacristy, these elements fused to produce a multivalenced identification

between Fascism-Italy and the individual-collective subject. The spectator joined the visual and aural chorus represented by the repeated "presente" of the walls and the song. This technique of disembodied voices evoked by text was a common one, which replicated the responsive crowd of the mass rally, as well as the incantations of the Catholic mass.[97]

The chapel proposed a physical location for the "cult of sacrifice and death," a central tenet of Fascist ideology. The bloody shirts and relics of the Fascist martyrs had figured prominently in the display rooms: the Chapel of the Martyrs provided the spectator with a moment of prayer and release for the anger produced by the soiled relics. The exhibition constructed the violence and bloody martyrdoms of the seizure of power as cleansing and redemptive. The violence had passed, declared the narrative, but must be commemorated as the necessary purification of the body politic, which had prepared the nation for the Fascist redemption and triumph.

READING FASCIST MODERNISM

Mussolini had proclaimed that the Mostra della rivoluzione fascista be "without precedent, very new, very modern, very Fascist."[98] With this, the Mostra's challenge became the articulation of a Fascist modernism. As we have seen, the vibrant, modern, and evocative aesthetics of the 1932 Mostra incorporated and reconfigured a vast mélange of aesthetic developments, both contemporary and traditional. This synthesis of modernist-inspired imageries rearticulated to materialize Fascist ideology and rhetoric produced, in fact, a new representational language and a new kind of visual communication.

The Mostra was a critical moment in the relationship between the Fascist regime and artists. Since its first cultural interventions in the late 1920s, the Fascist dictatorship had shown itself to be a tolerant patron without a singular vision of an "art of the state" or an "art of Fascism." As discussed in reference to fine arts exhibitions, the regime gave artistic expression, as long as it did not conflict with the work of the dictatorship, room for experimentation and diversity. However, as the Mostra was the Fascist Party's act of self-representation, the artists selected to produce it had the power to determine the nature of that self-representation. Given this pressure, official patronage had an expectant quality based in the need to produce more than artists' participation—a recognizably Fascist art.

While official patronage at the Mostra operated within the parameters of aesthetic pluralism, the outcome was very different than that at art exhibitions. State patronage of the fine arts had produced exhibitions that

displayed a range of schools, styles, and forms alongside one another and which were purchased simultaneously. But at the Mostra, the various aesthetic styles mingled and merged to produce a coherent whole— something close to a paradigmatic Fascist aesthetic.

The dictatorship's autocommemoration in a modernist-influenced aesthetic has produced a debate among postwar and contemporary scholars of culture during Fascism. What motivated the regime to give such visible commissions to the most modern movements in the Italian art and architecture worlds? What did the decision to represent itself in a futurist–avant-garde aesthetic imply about the regime? About Fascism's relationship to the arts? There are many readings of the choices for the construction of the Mostra. However, a reading that associates the varied choices with the larger environment of aesthetic pluralism and with the wide net cast in the search for a Fascist art reveals the way in which the regime encouraged the broad participation of "the best" and "the brightest" and inverted commonly held assumptions about modernism.

At the time of the exhibition, F. T. Marinetti, the leader of the futurist movement, cited the use of futurist exhibition construction as proof of futurist ascendancy. He called the Mostra "a triumph of futurist style," declaring that "this new aesthetic of the machine and of speed, typically Italian and Fascist, can be found in all the rooms of the Mostra della rivoluzione."[99] Marinetti took the futurist imprint of the Mostra to imply the centrality of futurist aesthetics to Fascism and as an unofficial proclamation of futurism as the art of Fascism. For some art historians, such as Enrico Crispolti and Guido Armellini, the Mostra della rivoluzione fascista did symbolize the victory of futurism.[100] In fact, Armellini concludes, "in its general conception, the Mostra was inspired by futurist plastic and chromatic dynamism—clear signs of futurist hegemony."[101] Futurist *plastica murale* shaped the entire show especially "in the sense of recurring imaginative tensions, which made this episode a true instance of breaking with the past."[102] In another interpretation, Diane Ghirardo finds the Mostra della rivoluzione fascista a "showcase" for the rationalists.[103] Certainly, the assignment of the facade, the Room of 1922, and the Chapel of Martyrs to prominent rationalist architects attested to the regime's faith in the power of this aesthetic.

While various movements claimed victory based on a perceived special status at the Mostra della rivoluzione fascista, the regime ultimately refused predominance to a single group, encouraging instead the participation of many and the integration of multiple aesthetic languages into a single rhetorical identity. As Giorgio Ciucci asserts, the regime "fished" for a representative language at the exhibition. Fascism took component parts from various movements: it used the "vehemence" of the futurists,

the "spirituality" of the rationalists, the "order" of the novecento, and the "simplicity" of the strapaese.[104] By picking and choosing aesthetic elements, the regime resolved the problem of having to present a single identity. A mixed aesthetic identity became a strength, rather than a weakness. Here Fascism projected a malleable, flexible self-image, which could be read as simultaneously revolutionary and authoritarian, changing and stable, urban and popular.

The art of the Mostra indicated, above all, the regime's successful integration of modern and avant-garde aesthetics and modern artists into official culture. Fascism's support for a significant cross section of the art world created a situation whereby many avant-garde artists contributed their services to the state and worked out their aesthetic theories on government- and party-commissioned projects. The ease with which the dictatorship attracted the allegiance of prominent modernists confirmed the mutual legitimation implicit in the relations between Fascism and the arts. While artists legitimated the dictatorship by working on its projects, Fascism lent artists wrestling with questions of grand-scale and public applications of their experimental aesthetics the opportunity to realize them.

The regime encouraged artists to use forms, such as constructivist exhibition design, which were originally created to break down social hierarchies in the construction of Fascism's self-representation. The Bauhaus's shocking use of typography, photomontage, and advertising techniques in exhibition design and the constructivist re-creations of environments were first designed to herald a new social order and to destabilize preexisting views of the world. The regime's patronage of elements of avant-garde culture (nearly always with the simultaneous presence of more traditional and classical aesthetics) involved the detachment of forms from their original ideological context. In this way, the exhibition represented an "episode of the exploitation and inversion of the avant-garde and the modern aesthetic language."[105] The signs and the media conceived at the beginning of the century for a critical and spiritual liberation of modern man were readapted to celebrate the Fascist state. In their use in official culture these forms materialized Fascist hierarchies and the rhetorics of nationalism, authority, and antidemocracy, among others. Fascist modernism stripped forms initially tied to a utopian project of their inflammatory properties; the regime recruited the excitement surrounding the new aesthetics and their transgressive qualities to interpret the Fascist counterrevolution. By patronizing and commissioning the "new volumes" and "vanguard communication structures" of futurism and constructivism, the regime adapted them to exalt "predetermined propaganda messages."[106]

For some of the artists of the Mostra della rivoluzione fascista, Fascism's patronage of new and experimental art furnished modernism with a rare opportunity for official legitimation. As of 1930, very few governments had offered official support to the European avant-gardes, with the inconsistent exception of the Soviet Union in the 1920s and certain local governments under the Weimar Republic.[107] As Edoardo Persico emphasized in *Casabella*, the publication of avant-garde architecture:

> The support of the national government for the forms of the avant-garde is another sign of the exceptional atmosphere that is developing in Italy: all other so-called official art which the other governments of the world adopt . . . for events of this type are usually as retrograde and bourgeois as can possibly be imagined.[108]

With its visible patronage of contemporary aesthetics, especially in architecture, the Mussolini dictatorship became one of the first national governments to extend official sanction, commissions, and space to promote to modern avant-garde artists and architects.

The regime posited this accommodation with modernism as a resolution of the tension between vanguardism and the state, which characterized culture in many European nations between the wars. With a hybrid form of state patronage, Fascism became the force able to rationalize contrary aesthetic languages—as well as opposing views of life. Fascist patronage posited the notion that the distance that had evolved in the twentieth century between critical avant-garde art and the state could be collapsed in Italy within the confines of state structures. Of course, the strong vanguardist element of Fascist practice and theory reinforced its appropriation of vanguardist art.

Some artists, such as Sironi and Terragni, committed themselves in the 1930s to the evolution of an experimental Fascist art. Sironi's *pittura murale* and Terragni's exhibition design expanded and updated public art and applied the vocabulary of constructivism to it. In his championing of modern mural painting and bas-reliefs, Sironi sought an art that could be socially functional, modern, national, and Fascist. Sironi and Terragni hailed the compatibility between modernism and Fascism and spent large periods of their respective careers searching for formulas adequately modern and Fascist.

Thus, the regime's selection of a nonaligned modern aesthetic for its self-representation proved fruitful: this choice (1) attracted prominent artists and architects and (2) found widespread resonance among critics and the public. The dynamism, experimentation, and novelty drew viewers into the event, made them privy to a daring experience, and presented Fascism as unafraid to cut new ground. Audiences seconded

the regime's decision to mobilize the new aesthetics, which they read as
Fascist innovations.

Members of the government and party cultural hierarchy, a wide range
of critics, and a broad cross section of artists agreed on the positive value
of Fascism's support for the art of the Mostra and success of the artistic
products themselves. How do we account for the success of this strand
of aesthetic pluralism–state patronage and the failure of government and
party competitions at the state art exhibitions of 1930–35? Artists failed to
muster the same enthusiasm for official competitions, and critics and
sponsors found the few works produced in this context unworthy. No
Fascist aesthetic or innovation had emerged from fine arts patronage,
and critics lamented the absence of an identifiable Fascist art at state-
sponsored fine arts exhibitions.

In contrast, the Mostra was celebrated as having broken new ground
and as having created a form of expression intimately tied to and expres-
sive of the Fascist era. The Mostra was, above all, an act of public art and,
in that way, responded to the debate raging among artists and Fascist
intellectuals over the social role of art in the Fascist state. Alberto Neppi
compared the Mostra and the Venice Biennale competitions, concluding
that the Mostra's essential "publicness" gave artists a purpose unavailable
in the Biennale competitions. For Neppi, the Mostra della rivoluzione
fascista lent artists "the occasion to give form to well-defined themes,
which act as figurative commentaries [to the art]."[109] Another critic attrib-
uted the success of the aesthetics presented at the Mostra to their ability
to be "read," like "the newspaper, the poster, the matchbox" by the
masses.[110]

Alfieri's failed attempt at a commemorative medal competition in
honor of the decennial supports Neppi's assertion and reveals the limits
of pluralistic state patronage. On August 1, 1932, Alfieri announced a com-
memorative coin competition.[111] One side of the coin was to depict the
decennial and the other, an effigy of the Duce. By the end of September,
Alfieri canceled the program, declaring that "a negative outcome has
closed the competition."[112] As with the Biennale competitions of 1930 and
1932, artists had failed to respond. By 1932, the regime had mobilized
through aesthetic pluralism those artists interested in partaking of the
regime's largesse or those committed to its rhetorical priorities without
drawing in the remainder.

While a bricolage of aesthetic elements from constructivist and futurist
to neoclassical gave the Mostra its form, they also embodied its narra-
tives. The exhibition postulated a series of simultaneous and, at times,
conflicting narratives. A master narrative of Fascism's legitimating gene-
alogy bound together the subnarratives. Fascism, read the Mostra, had

rescued a nation on the brink of social, political, economic, and spiritual disintegration. The interpretation of the events of 1914 to 1922 portrayed an Italy besieged on all sides by internal and external enemies bent on national destruction. The rooms covering the years 1914 to 1922 depicted wolflike parlimentarians, backstabbing allies, insidious Soviets, and evil socialists. Fascism, asserted the Mostra, had prevailed over a desiccated and ineffectual political and social system and had replaced "an Italy whose national parliament, populated by foxes devoid of all spirituality, dragged the nation for months and months through the shame of their neutralist calculations."[113]

In this Fascist teleology, history became myth as all events preceding the March on Rome predestined the Fascist victory. The rooms addressing World War I glorified Italy's war experience as its moment of national regeneration and self-assertion. The show idealized trench warfare and the community of self-sufficient soldier-heroes it forged; this was the external battle that preceded and necessitated the domestic one. The anti-"nation" and anti-"history" forces inhered in a demonized enemy—all the political parties of the left and center that had resisted the rebirth through war and the inevitable Fascist victory the Great War had foreshadowed. The parlimentarians were decrepit and ineffectual, the socialists and Communists devilish seducers of the workers and betrayers of the nation. Room B offered a roughhewn, monumental sculpture of a worker crushed under the weight of the volumes of Marx, Engels, and Bebel.[114] Fascism alone, declared the exhibition, had redeemed Italy from the ravages of class conflict and replaced it with a harmonious national community.[115]

The simultaneity and timelessness of most of the displays that mythologized the history depicted reinforced the dominant narrative of Fascism as savior and repository of the nation, the people, and the state. The displays confused past and present, as history became an explosion of images, relics, and symbols. Chronology fell prey to the trajectory of national fulfillment. Nationhood, declared the Mostra, would be forged from the swirling images of the past. The Risorgimento imperative flowed into the D'Annunzian cult to climax in the victory of Fascism. The king became the re-soldato (the king-soldier), a vitalist participant in the nation's destiny.[116] The Mostra inverted the narratives of the nineteenth and early twentieth centuries to convert them into precursors to Fascism. The fixed point amid this swirling history was Mussolini, the fulfillment of the national past.

According to the Mostra's idealist presumptions, history was a spiritual force—felt rather than reasoned. An essential antipositivism existed in the conflation of the historical artifacts and the artwork that encased them.

For example, an anti-Bolshevik display in Room E blended photographic fragments, sculpture, and prose.[117] Photographs of Italian Communists mingled with scenes of famine, alongside an enlarged *Il popolo d'Italia* headline, "Contro la bestia ritornante" (Against the Recurring Beast). The entire construction burned in a fire-red glow. Such displays disoriented. Were the photographs documentary evidence or part of the artwork? Were they to be taken more or less seriously than the howling monster next to them? "War," "Nation," "Victory," read the exhibition, were concepts redefined and rematerialized under Fascism.

While the exhibition proffered a mythologized past and a demonized enemy, the future remained ambiguous and contradictory. The Mostra's text left the viewer in tension: it imparted simultaneous images of revolution and consolidation, celebrating Fascism in its movement phase while elevating the cult of Mussolini. The contradiction between authority-order and evolution-change pervaded the show. The stark monumentality of the facade, the Salon of Honor, the Chapel of the Martyrs, and all the stairways, halls, and corridors implied stasis and order; the frenetic photomontages, diagonal walls, and three-dimensional constructions emphasized confusion and struggle. The enemy—liberals, socialists, and communists—were depicted as defeated, but the repetition of their frightening appearance in the rooms hinted that vigilance could not be abandoned. The relics of the Fascist martyrs and the "captured" mementos of the enemy reminded that "this is a past that has not concluded."[118] The spectator exited the Mostra della rivoluzione fascista rekindled and "as ready as before to defend the revolution and its leader, even with bloodshed."[119]

Parallel to the theme of national regeneration ran that of the regenerator: the Duce. In fact, some scholars locate the Mostra as the birthplace of the "Cult of the Duce."[120] From the show's entryway, which bore Mussolini's prescription of "the book and the rifle," through each room, the leader's words drove the historical narration. The emergence and triumph of Mussolini, both actor in and representative of the national struggle, wove together the exhibition's plot. The show canonized Mussolini's early years by isolating and enlarging the photographs and artifacts of his movement days. Each room devoted a wall to the words of the Duce. The Duce's words provided a "driving thread," since they were "dominant and decisive in all the events that took place from the struggle for intervention to the March on Rome."[121] The focus on *Il popolo d'Italia* cemented the cult of Mussolini: he was a man of word and action, and the newspaper he founded became a barometer of the people's passions. The catalog itself focused, above all, on the leader: the minimalist cover bore

the repeated syllables DU-CE DU-CE with a bust of Mussolini as the only other image—the signified of the disembodied chants (fig. 28).

A series of subnarratives flowed into the dominant ones. The show's populist imagery, in keeping with the brand of populism generally touted by the dictatorship, stressed a unified, idealized view of "the people." "The people" were essential in their role as the masses who paved the way for the triumph of the Duce. Yet, beyond the Duce, Fascist martyrs,

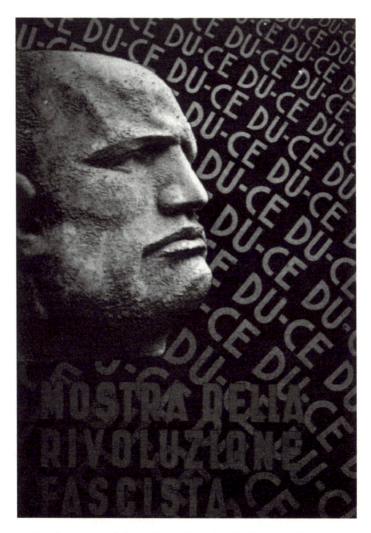

28. Catalog cover of the guidebook to the Exhibition of the Fascist Revolution (Mostra della rivoluzione fascista), 1932.

and a few Fascist leaders, the people were an undifferentiated mass. The Mostra contained repeated images of mass rallies, from the prointerventionist rallies of 1914–15 to those which welcomed Mussolini to Rome on October 29, 1922. The masses, read the show, were most relevant to history in that they embraced Fascism, thereby allowing the engine of history to move forward. Representations of the interventionist movement in 1915 and of the Fascist rallies depicted the masses as a malleable, volatile force waiting to be formed by the leader. The exhibition celebrated the piazza as a locus of political change, but without images of the masses actually participating in the process of change. The exhibition represented the masses through crowd scenes; or it referred to them as a missing presence, as in the case of the DU-CE, DU-CE chant of the catalog cover. The presence and assent of the masses was essential, but it was a symbol participation. The catalog and reviewers mirrored the show's ambivalent, top-down populism. The Mostra, wrote *Bibliografia fascista*, was "done *for* the people, *for* the masses of the people."[122] *Capitolium* called it a "gift to the people."[123]

Above the central narratives rode a series of tensions and ambiguities, the irresolution of which played an essential function in the show's success. The confusion of imageries and narratives allowed the viewer to feel as if he himself made a choice, when, in fact, the disorientation precluded intellectual choice. The confusion implied that a transformation had taken place; the exhibition spiritualized and emotionalized the past to an extent that led the spectator to believe it a fundamental experience. As one supporter asked after repeated visits, "I do not know if here you finish the pilgrimage or if here you begin the truest and purest ascent of the soul. I do not know if this is the destination or the beginning of the life of the future."[124]

In its desire to forge new cultural identifications and elevate a new symbolism, the Mostra, in particular, and Fascist culture, in general, sought the resolution of elements of the national cult left incomplete by the Liberal state. Fascism, as Victoria de Grazia has argued, appropriated the Risorgimento discourse of "making Italians." "Coming to power with all the rhetoric of an unfulfilled Risorgimento tradition," writes de Grazia, "Fascist and Nationalist ideologues continuously paid homage to the idea of a unified and unifying national culture."[125] The construction of the Mostra as an event of a shared national culture with deep historical roots fit into Fascism's "artificial creation of a sense of overriding national identity."[126] Emilio Gentile carries this idea further, stressing the Fascistization of incomplete elements of the national cult, "which meant the reconsecration of the cult of the nation and the regeneration

of the [Italian] people in order to transform them into a community of strength and unity."[127] With this appropriation of a preexisting discourse, Fascism found responsive audiences, ready to have "Italianness" imposed on them. The willingness of many spectators to read themselves into the recomposed history of the Mostra testifies to the regime's identification of cultural gaps and attempts to fill them.

The textual responses to the exhibition tapped into this anxiety over the composition and stability of the national community. "The visitors," declared one observer, "were a mass of people from all sectors, all ages . . . all classes and all the regions of Italy."[128] The exhibition "captured the soul of the worker, the aristocrat, the professional, the student, the adult, and the young," echoed Francesco Barone.[129] In a deeply divided Italy in which a range of often conflicting identities had impeded the creation of a stable or shared national identity, Fascism constructed its self-representation as open-ended and fluid enough to include most Italians. One former expatriate thanked the exhibition for his rekindled patriotism. He dedicated his pamphlet on his conversion to nationalism and Fascism to "You who can return from lives far away—finally made Italians by the Duce."[130] He himself had been "re-Italianized."[131] The regime promoted a visit to the Mostra as a pilgrimage to the core of the nation. "The Mostra," wrote Giovanni Biadene, ". . . has offered Italians of all backgrounds, even the most modest, the opportunity to know Rome in its various old and new aspects."[132]

The Mostra proposed a Fascist teleology and genealogy through the integration of art, text, and ritual. The exhibition borrowed freely from the secular rituals of the French Revolution and the religious ones of Catholicism. For Emilio Gentile, the Mostra was the apotheosis of the Fascist secular religion of the nation-state—"the cult of *littorio*."[133] There is a strong argument to be made for the show's theological character: the rhythm of the show—crisis, epiphany, redemption—paralleled the Catholic liturgy. The celebration of the "glorious dead" combined a Catholic reverence for martyrdom with the nationalist celebration of allegiance to the patria.[134] The exhibition was celebrated repeatedly in language such as, "an act of faith and homage to the Fallen" and "an exaltation of even the most anonymous sacrifices."[135] Religious mysticism informed assertions such as "every visit transforms itself into a pilgrimage."[136] *Il popolo d'Italia* hymned that, for the people, "it is a solemn rite, exalting the spirit of the Revolution and the sacrifice of the Martyrs, who died for them."[137]

As most clearly demonstrated by the Chapel of the Martyrs, Fascism borrowed from D'Annunzio's political rite the technique of linking secular symbols such as the flame to those of Christianity.[138] D'Annunzio had

used Christian symbols alongside their secular counterparts at the nationalist festivals at Fiume in 1920. At the Mostra, the flame and the metal cross of the chapel constructed a national liturgy with a Christian iconography. Reviewers responded to the Chapel of the Martyrs with great feeling, and they emphasized the religious catharsis it invited. In *Il popolo d'Italia*, Ottavio Dinale composed a hymn to the room:

> In the Sacristy is the mysticism of the Revolution.
> In the Sacristy is the inextinguishable flame.
> In the Sacristy is the heart of the Nation.
> In the Sacristy are the roots that locate Mussolini and Fascism in time and space.[139]

"The heart beats faster," wrote one critic, "and tears come to the eyes in the chapel."[140] This comingling of national and Catholic symbolism supplied the viewer with a familiar symbolic universe and a prexisting repertoire of responses to draw upon. Audiences responded with learned religious rituals: one visitor fell on bended knees and prayed in the Chapel of the Martyrs.[141]

The Mostra wove elements of Catholic liturgy into the fabric of the Fascist imaginary. The deep red or scarlet color that lent a glow and holiness to the exhibition gave the interiors a churchlike feel. The objects relating to the Fascist martyrs were often housed as relics. The incantations of the Chapel of the Martyrs mirrored the response-repeat of the Catholic mass; the enclosed den of Duce in the Salon of Honor served as a national confessional.

While it drew on preexisting religious rituals, Fascism also conflated the national cult with the Fascist cult. The Mostra fused the national symbols of the tricolor and the cross of Savoy with the fascio and images of Mussolini. This fusion implied Fascism's organic national origins. This symbolic world merged with Fascism's reinterpretation of the past. Modern revolutions have generally asserted either a wholly new symbology and civic religion or reconfigured elements of the preexisting one. In contrast to the French Revolution or the Russian Revolution, the Fascist counterrevolution consciously sought an amalgam of past and present, asserting its own iconography while subsuming elements of the preexisting Liberal, Risorgimento cosmology.

While Fascism urged its connection to "history" as ancient and recent, it recognized the importance of a rupture or demarcation. October 28, 1922, became the cordon sanitaire between a troubled past and a glorious future—the Fascist equivalent of July 14, 1789. Using the French example, the regime retroactively restarted the calendar in 1927, designating Octo-

ber 28, 1922 the first day of the first year of the new calendar—I. I. I. The decennial year, Year X, thus, represented an opportunity for the celebration of Fascist identities and traditions. The Roman numeral X appeared repeatedly in the exhibition's displays and promotional material. The dictatorship declared it would replace old allegiances and create new Italians with a new (common) collective history.

The ritualization of Italian history by Fascism mobilized forces identified by George Mosse as "the nationalization of the masses."[142] The Mostra's massification of the March on Rome aspired to turn the Fascist assumption of power into a shared "public cult." The Mostra della rivoluzione fascista proposed a transcendence similar to that of the nineteenth-century German public festivals described by Mosse as "extraordinary occasions which lifted man above the isolation of daily life."[143] The ideologies of the twentieth-century all embraced secular festivals; the ability of events, from the festivals of the Soviet Union to the rallies of Nazi Germany, celebrating the nation to provide "respite from the alienation of modern life" was central.[144] Cornelio Di Marzio, Fascist writer and intellectual, believed that the Mostra could elevate the participant from alienation into a collective experience. "From the most distant homes," he wrote, "will arrive this sign of collective participation in a movement which, between the poles of authority and sacrifice, has offered its martyrs and its Duce."[145]

Techniques derived from other cultural forms, such as theater and film, supported the Mostra's text and art. As a controlled street demonstration or mass rally, the show had an improvised aspect, as though the act of looking brought it to life and as though the spectator were also participant. Beginning with the sheet-metal facade built as stage front over the preexisting facade, the show had a theatrical ephemerality. The wall projections utilized many of the same materials as stage sets, such as canvas and plaster of Paris. The artists made little attempt to conceal the temporary nature of the installations. The fragility of the displays was essential to the tension they produced. Antonio Valente, a futurist artist who built the Chapel of the Martyrs with Adalberto Libera, had apprenticed with European and Russian design experts and had designed traveling theaters for the Dopolavoro.

The theater as an inspiration lay at the very core of the exhibition. It was divided into three acts, as in a play: The War, The Postwar Crisis, The Victory of Fascism. The narrative concluded with the resolution of conflicts set out in the first act. The second act presented the possibility of failure and loss, with the threatening forces not decisively defeated until the final act.

ORCHESTRATING THE MOSTRA

Official mass culture, like state-sponsored high culture, depended upon and targeted cultural consumers. As the regime's great act of autocommemoration, the Mostra was accompanied by a vast and innovative campaign of publicity and audience-incentive. This campaign coalesced and furthered the intersection of art, tourism, commerce, and official culture upon which much of Fascist culture depended.

With vivid pomp and circumstance, the Mostra opened on October 28, 1932. Making Rome a great stage set, Mussolini simultaneously inaugurated the Via dell'impero and the Mostra della rivoluzione fascista. National preparations transformed the decennial into a festival day from which no one was to remain immune. The Ministry of National Education closed the schools from October 24 until November 5, "so that teachers and students can participate in the ceremonies taking place on the historic occasion."[146] The capital received a face-lift: the reconstruction of the Piazza Venezia, the reopening of the Theater of Marcellus, and the inauguration of the first Rome-Viterbo electric railway all anticipated the momentous event.[147] Emulating past rulers, Mussolini released 423 political prisoners in honor of the anniversary and dedicated new public buildings, including seven post offices.[148] "It was a feast of celebrations, parades, displays of jubilation," remembered Ruggero Zangrandi, ". . . for one who was then fifteen years old, it truly seemed that a great national event was taking place, consecrating unity and harmony."[149]

Mussolini inaugurated the Mostra della rivoluzione fascista at eleven o'clock in the morning in a finely choreographed ceremony. The party secretary ordered that the inauguration was to have "a simple, almost military character, with 150 people."[150] Accompanied by quadrimviri, the director of the party, and Alfieri, Mussolini reviewed a 180-member honor guard outside the exhibition. In the atrium, a group of Giovanni Avanguardisti and Balilla recited the Fascist decalogue for the Duce. A collection of special guests consisting of sancepolcristi (those present at the founding meeting of Fascism), federal secretaries, members of the Fascist Grand Council, and government officials greeted the Duce in the Salon of Honor, where Starace refrained from a speech because the Mostra "speaks eloquently for itself."[151] Alfieri reserved the first afternoon from noon until five o'clock for special guests, such as senators, deputies, party officials, and "personalities of the political and art world."[152] In addition to luminaries of the Fascist political hierarchy, members of the royal family, the Royal Academy, and a large contingent of journalists attended the first afternoon. For this reserved opening afternoon, Alfieri's office distributed 23,784 tickets.[153]

An anxious crowd gathered outside the exhibition waiting for the doors to open to the public at five o'clock, after which the influx of visitors remained uninterrupted until past midnight.[154] This stream flowed unabated throughout the Mostra's two-year run.[155] The exhibition remained open to the public every day of the year, including Christmas and New Year's Day. In response to the crowds, the Mostra often closed as late as half past eleven. Such relentless crowds took exhibition organizers by surprise and facilities proved inadequate to meet the needs of visitors. One disgruntled visitor wrote Starace in May 1933 protesting the lack of bathrooms and noting that he had heard "foreigners and Romans alike complaining."[156]

Popular response to the Mostra della rivoluzione fascista exceeded the Fascist Party's forecasts and anticipations. Attendance steadily increased and remained so intense through the exhibition's planned six-month run that the closing date had to be extended from April 21, 1933 to July 31, 1933 and, finally, to October 28, 1934.[157] Attendance figures supported assertions of widespread interest: in the first seven months (October 29, 1932–May 23, 1933), 1,236,151 visitors attended the exhibition and by the closing date of October 28, 1934, 3,854,927 spectators had passed through the twenty-five-meter-tall metal fasci that constituted the entrance to the Mostra della rivoluzione fascista.[158] During the Mostra's first year alone, 87,972 employees of *enti pubblici* (public institutions) attended.[159] Between opening day in October 1932 and November 1933, the exhibition showed a profit of 15,410,151 lire.[160]

The dictatorship courted spectators through incentives, which included travel discounts, organized group excursions, and rotating honor guards. During its two years on the Via nazionale, the Mostra offered 70 percent train fare discounts to any visitor who had his or her train ticket validated at the exhibition's ticket office. The Ministry of Communications approved "exceptional reductions," owing to the importance of the event.[161] As the closing date of the Mostra was extended, so were the discounts.[162] The discounted tickets were valid for thirty days for those coming from abroad; twenty days for those arriving from stations farther than 400 kilometers; ten days for those within 151 to 400 kilometers; and five days for those within 150 kilometers of Rome.[163] In addition, sixteen steamship companies offered discounted passages, with 30 to 50 percent reductions.[164]

According to the discount system, at the Mostra's ticket office the visitor paid for a *bollo* or stamp that entitled him or her to the reduced train fare. Thus, a spectator partaking of the discounts bought a train ticket, a *bollo* and a ticket to the exhibition. The money earned by the *bolli* then reverted to another party organization. For example, a summer camp run

by the Organizzazione nazionale balilla called Campeggio Dux, received a total of 190,000 lire between January 1933 and March 1935 from the ticket validations of the Mostra della rivoluzione fascista.[165] In this way, more profitable elements of official culture subsidized the less profitable.

The Mostra's layout, with the ticket office at the back of the second floor, required the visitor to tour (or at least pass by) the displays before validating his or her train ticket. At a price of two lire, the entrance ticket itself remained low and within the purchasing range of most Italians.[166] The organizers priced entrance tickets with mass entertainment spending patterns in mind—just under the average price of a movie ticket.[167] The guidebook sold for twelve lire in order to stimulate widespread buying.[168] The substantial train fare reductions, reasonable entrance fees, and tourist programs made up an alluring array of incentives.

The regime, in its attempt to cater to the cultural tastes of those arriving in Rome for the Mostra, underwrote a sophisticated program of commercial tourism. As it had with the Venice Biennale discount programs, the government and party encouraged middle-class tourism within Italy and focused it around official cultural events. In 1934, the year following the Mostra, the regime created the Department of Tourism as a full undersecretariat of the Ministry of Press and Propaganda. This department published a series of regular bulletins for tourists and the tourist industry. Further, in this period the middle classes began to develop identities as consumers and tourists: the dictatorship eagerly catered to such emerging practices. For example, the discounted train fares to the Mostra entitled visitors to a coupon booklet that contained "nineteen coupons with which the train, tramway, automobile, and airplane companies guarantee tourists significant reductions off the normal prices."[169] These coupons were good at the capitol's theaters, zoos, and monuments. A tourist could combine national and patriotic duties with a range of entertainments. By joining its propaganda goals to support for the tourist industry, the official culture attracted the support of business, as well as that of spectators. Further, by linking visits to the Mostra with those to the zoo or the theater, the regime encouraged people to enjoy other aspects of a burgeoning national and/or mass culture.

The discount policy worked.[170] Between January 1 and 16, 1934, an average of 3,491 people visited the exhibition daily and of these only 631 spectators did not avail themselves of the discounted train fares.[171] Thus, 82 percent of those visiting the exhibition did so with discounted fares. Yet, the figures must be read as slippery and not necessarily as evidence of widespread consent for the regime, since the discounted train fares also brought to Rome those who wanted only the 70 percent discount. Simone de Beauvoir and Jean-Paul Sartre, to give a famous example, hap-

pily took advantage of the cheap fares. According to De Beauvoir, "Mussolini organized a 'fascist exposition' in Rome and, in order to attract foreign tourists, Italian trains offered a 70 percent fare reduction."[172] "We profited from it without scruple," concluded de Beauvoir. De Beauvoir and Sartre "threw a look" at the exhibition "in order to validate our tickets for the discount."[173] Barbara Allason, in *Memories of an Anti-Fascist*, describes her quick tour of the Mostra and her "peaceful awareness of having earned the discount."[174] With the passage of time, the system relaxed and "things became simpler . . . it was enough to go the office at the entrance and pay for a ticket to the Mostra . . . and the clerk would kindly stamp the ticket for the entrance and the exit."[175]

By May 1933, news of "abuses committed at the ticket office" reached the organizers.[176] Employees had been validating train tickets without the purchase of an entrance ticket and without proof of having visited the Mostra. In addition, "hotel guides, interpreters, and tourist agents" validated the train tickets of entire groups based on the purchase of a single exhibition ticket.[177] Most probably, an unacknowledged policy of validations existed between the exhibition's ticket office workers and tourist workers. Therefore, given the range of motivations for travel and tourism, the success of the travel incentive program as an indication of the widespread resonance of official culture must be mitigated by acknowledgment of other inducements, such as leisure and business.

While the discounted travel fares encouraged middle-class spectators who had the habit and/or means to make Rome their destination, officially organized group excursions brought to the exhibition constituencies who might not have attended otherwise.[178] Most often, organized trips consisted of those most regimented by Fascism, such as schoolchildren and soldiers, or those most in need of exposure to the propaganda, such as workers. Schools, Fascist mass organizations, factories, and veterans clubs all sent delegations.[179] Applications for group discounts in May 1934 included 121 Franciscan priests from Milan, 42 workers from the Fiat factory in Livorno, 453 Giovani fascisti from Sessa Aurunca, and 750 farmers from Treviso.[180] Audiences as diverse as 2,000 American Naval cadets, 5,370 former Garibaldini and their relatives, and 30 French secondary school teachers all availed themselves of the Fascist Party's group discounts.[181] The party specified a range of discounts, depending on the gravity of the need. In some cases, groups received discounted or free entrance tickets, and in others the price of the validation was deferred. The amount of discount given on entrance tickets varied. Children from the hospital Principessa di Piemonte, Avanguardisti from Campo dux, and other party organizations entered free of charge, while some groups paid a nominal fee or half price.[182] On other occasions, Mussolini's office

donated money toward bringing particular groups to the exhibition, such as the 100,000 lire paid to the Ministry of Communications to cover the costs for 2,500 "Fascists from Bolzano."[183]

The visit of the Disabled Ex-Servicemen of the Emilia-Romagna to see the Mostra and the "works of the regime" elucidates the mechanics of the discount program. In April 1933, the president of the National Association of War Invalids, Giuseppe Balestrazzi, wrote to the head of Mussolini's office:

> I beg you to obtain for these our comrades, for the most part farmers and workers, the largest possible assistance, taking into account the current economic difficulties and the hope for a total participation of our membership.[184]

The members, added Balestrazzi, could pay no more than forty lire for the entire excursion.[185] A final compromise brought the group to Rome for sixty lire per person. Wounded war veterans who were "workers and farmers" to boot could hardly be ignored by the regime. Balestrazzi's argument for party assistance based on economic hardship mirrors Maraini's use of the same excuse to encourage government support for artists. Both instances demonstrate the flexibility of official patronage and its formation from below, as well as from above.

With the special trips and tours of Rome, the Fascist regime courted the consent, or at least attempted to neutralize the dissent, of the as-yet unconverted. It also rewarded the dutiful. Veterans, Fascist officials, and Fascist mass organizations, such as the Dopolavoro and the Organizazzione nazionale balilla, received special priority for group trips and government and party contributions to them. However, more problematic groups such as workers or more marginalized constituencies also received privileged treatment. The textile factory, Ditta Tondani, brought 1,500 of its workers to Rome for a two-day tour, which included a visit with Party Secretary Starace.[186] Workers from the SNIA viscose factory of Rome, the dockworks of Castelmare di Stabia, the Falck iron and steel works in Lombardy and glassworkers from the Società veneziana industrie vetrarili all visited the exhibition.[187] The regime targeted groups from the physical and economic margins of Italian society for special treatment: for example, Mussolini paid 2,000 lire toward the travel of 300 Dopolavoro members from irredentist Zara.[188]

Requests for group excursion tickets poured into the offices of the party at an overwhelming rate. The Fascist Party, as sponsor of the exhibition, exhausted its funds and rejected many appeals. In March 1933, Starace wrote to all secretaries of local Fascist Federations, asking that

they stop sending groups to the Mostra.[189] That same month, Mussolini declared an end to excursions of more than 500 people and the Ministry of the Interior sent urgent telegrams to prefects across the country commanding them to cancel all organized trips—by order of the Duce.[190]

The Mostra facilitated "symbolic participation" in a variety of ways. A rotating honor guard drawn from worthy constituencies stood at the exhibition's doors. Duty to the dictatorship and financial need were common reasons cited for guard assignments. In some cases, such as that of a group of lawyers from the Fascist Lawyers' Syndicate of Milan, party organizers furnished funds only for travel assistance, while, in others, the party paid a stipend to those standing guard.[191] Alpine guides, dock workers from Genoa, Milanese municipal electrical workers, Fascist militia units, army and navy units, doctors' fraternities, and members of the Italian Academy all guarded the doors to Fascism's great exhibition.

The regime mobilized a publicity campaign, as it did for a range of official events, to reach those it was trying to bring to the Mostra. In a nation with an underdeveloped radio industry, visual advertising in public spaces was the most efficacious. The exhibition offices printed 100,000 posters to be installed in four postings between September and December 1932.[192] Trains, buses, ships, airplanes, trams, and taxis displayed 1,330,000 placards.[193] The advertising campaign also targeted regional and intercity transportation in an effort to reach the middle and working classes. The publicity campaign aimed at Italians and foreigners. In addition to train and steamship discounts available to foreigners, with additional discounts for foreign honeymooners, the exhibition sold French, German, Spanish, and English translations of the guidebook and a special catalog, entitled *Italiani e stranieri alla mostra della rivoluzione fascista* (Italians and Foreigners at the Show of the Fascist Revolution).[194]

As we have seen, official culture depended upon its own widespread and repeated (re)presentation. The event itself existed in large part to be reproduced through print and film. The Fascist Party worked to expand the national culture-going public beyond those actually in attendance. Press coverage also revealed Fascism's appropriation of public space: repeated images of mass Fascist exhibitions reinforced a view of an activist, interventionist dictatorship, supported by cultural producers and consumers. Beginning in the spring of 1932, *Il popolo d'Italia* almost daily reported the show's progress. The party daily prepared the way for the Mostra and the decennial with a series of anticipatory articles and illustrations. Mario Sironi contributed mythifying images in *Il popolo d'Italia*, presenting the show as "the podium of the revolution," "the hymn of the revolution," and "the flame."[195] LUCE newsreels featured twenty-seven

stories on the Mostra della rivoluzione fascista between October 1932 and October 1934—including the inauguration, the mounting of honor guards, and special visitors, and detailed views of the rooms, such as the Rooms of 1914 and 1915.[196] The visits of the king, Anthony Eden, and a group of French wounded war veterans all received special newsreel coverage.[197] LUCE coverage stressed popular mass support for the exhibition with repeated images of group visits, such as "4,000 dependents of an electrical firm arrive in the capital for the Mostra" and "5,000 dependents of the Italian sugar industry come to Rome for the Mostra."[198]

While the regime promoted travel incentives, group excursions, publicity, and advertising in order to choreograph attendance, the audience itself "injected a vast subjectivity into process."[199] Fascist self-representation became the locus of a malleable communication, which was used and reformed in a variety of ways by the audience. Assertions of spontaneous public commotion abounded in the press and in official communiques—such as the claim that the visitors were rendered "silent" by the Chapel of the Martyrs.[200] Spectators read themselves into the event in sometimes dramatic and emotional ways. Some, appropriating the Mostra as backdrop to a personal show of a faith or purpose, arrived on foot or by bicycle. More than 129 "pilgrims" walked from points as far from Rome as Berlin, Udine, Reggio Calabria, and Turin.[201] Another forty-nine people bicycled to the Mostra from locations as diverse as Paris and Palermo. These dramatic pilgrimages, undertaken primarily by Italian and European Fascists, dramatized their commitment and reveal the ways in which the event was reshaped by its spectators. The twelve young French Fascists who bicycled from Paris or the three Italian Fascists who walked from Venice transformed it into a personal voyage (of adventure as well as commitment) whose endpoint was the showcase of Fascism.

Individuals, inside and outside of the Fascist hierarchy, entered into a dialogue with the Mostra, using it to make sense of both personal and political experiences. The exhibition appeared as a focus of and backdrop to testimonials, poems, and songs. The exhibition struck a social, cultural, and political chord, and a mix of groups and individuals, in turn, tapped into that response. Rina Maria Stagi composed a lyric poem, entitled *Pellegrinaggio alla Mostra della Rivoluzione* (Pilgrimage to the Show of the Fascist Revolution), and published it with accompanying woodcut designs.[202] Stagi writes of the Mostra assuming that the audience understood references to the facade or the Chapel of the Martyrs. Her assumption of common cultural references based upon the exhibition supply clues to the show's popular and wide reception. By the time of the poem's printing by a privately run press in 1934, the Mostra had become national, collective cultural property.

An expatriate named Guelfo Andalo used the Mostra as catalyst for a personal return. In *Sono venuto a vivere la rivoluzione fascista: Impressioni di un rimpatriato* (I came to live the Fascist revolution: Impression of one repatriated), Andalo described his conversion experience at the exhibition, which led to his repatriation. His was a religious transformation: the exhibition had brought Andalo to a realization of his errant ways and gave him the strength to "make an act of faith" and return to Italy.[203] The show and the appreciation of the revolution wrought by Fascism, he claimed, made him proud to be an Italian. In the Chapel of the Martyrs, he "got down upon bended knees in devotion."[204]

For Giuseppe Bottai, the Mostra della rivoluzione fascista provided an opportunity to relive the heady, early days of Roman Fascism and his own youth; the experience provoked him to write an essay on the history of the Fascist movement in Rome. In the essay, he recalls visiting the Mostra "one morning, all together, we of the old Roman guard."[205] For him, the exhibition allowed a "a small reexamination of our own lives" and a chance to reminisce with peers: "The 'old ones' . . . went about pointing out the documents as if they were things from their own homes, such as family possessions and memories; and they pointed out to one another . . . the dear faces of comrades fallen in the battle."[206] The display strategies personalized the Mostra to such an extent that some Fascist officials responded as if in their "own homes" surrounded by "family possessions." From the Roman Fascist leader to the one-legged war veteran who bicycled from Brescia to the Mostra, the exhibition's rhetoric resonated and provided a text against which to measure a personal past, present, or future. The Mostra was semiotically and discursively flexible—like state patronage in general in this period.

Marketers also read themselves and the profit motive into the event, making use of the attraction of its images. In fact, by October 1933, aspects of the Mostra were so diffused and desired that private firms reproduced pirated and illegal postcards. The Milan police department reported that two firms, the photographic laboratories "S.A.F." and "F.A.T.A.," were selling postcards of the exhibition's facade without the permission of the party, which held the rights to the images.[207] The Roman police office discovered Ditta Eugenio Risi committing the same crime by illegally reproducing the Mostra's logo.[208] In another case, a private firm asked Giovanni Marinelli, the Fascist Party administrative secretary and party liaison to the exhibition, for permission to print luggage stickers bearing a reproduction of the facade.[209] Such pirated products supplemented the ample reproductions of images of the Mostra to be found in official postage stamps, commemorative coins, and the best-selling exhibition catalogs.[210] The interest of private firms in risking illegal action in order to

produce postcards of the Mostra attests to the exhibition's selling power, the diffusion of its images, and the broad market that must have existed for such images.

With the Mostra, official culture had both universalized and personalized the Fascist interpretation of Italian history. The regime wrote its autobiography, depicting itself as "both a participant in a national struggle and the author of an image of the past that aims to transcend that struggle."[211] According to the Mostra, the Fascist victory was predestined and an act of great national unity. Reinterpreting the past, the Mostra served as a primary site of memory and worked to shape the patterns of the nation's recollection. The Mostra della rivoluzione fascista represented Fascism's use of arts patronage to create a public sphere of commemoration. Out of Fascism's support for a new blend of aesthetics and politics came new identifications and new cultural habits. An intense mix of myth, art, and ritual gave the Fascist regime an impressive tenth-anniversary present: a party-sponsored celebration that found popular and spontaneous support, as well as critical acclaim.

The Mostra della rivoluzione fascista marked the heyday of aesthetic pluralism and experimental Fascist patronage. A policy of aesthetic diversity and experimentation had enticed the best Italian artists into official culture. Official promotion of a modern representational language led to a vibrant, provocative exhibition, which, in turn, encouraged mass support. The dictatorship had sponsored an exhibition formula, mixing avant-garde aesthetics with commercial tourism and nationalism, that catered to a range of cultural tastes and encouraged spectators to read themselves into official narratives. Fascism had transformed its act of self-representation into a national public ritual and a national spectacle.

Italian Fascist Culture Wars

FASCISM DOES NOT PROMULGATE AESTHETICS. . . .

FASCISM DOES NOT WANT AN ART OF THE STATE.

Giuseppe Bottai, 1941[1]

FUTURIST OR TRADITIONALIST, "YOUNG" OR NOT YOUNG,

THE FIRST CONDITION FROM NOW ON SHOULD BE TO

REQUIRE THAT ARTISTS BE OPENLY AND UNEQUIVOCALLY

ITALIAN—A QUALITY THAT CARRIES WITH IT HUMANITY

AND HEALTH.

Giuseppe Pensabene, 1935[2]

The Battle for Culture

WAR and empire took Fascist culture in new directions, introducing the third phase of state patronage. On October 5, 1935, Fascist Italy declared war on Ethiopia, and three days later the League of Nations voted economic sanctions against Italy. By the inauguration of the 20th Venice Biennale in June 1936, Addis Ababa had been captured and the New Italian Empire proclaimed. The Ethiopian War, Italian Fascist participation in the Spanish Civil War allied with General Francisco Franco, and the increasing political proximity to Nazi Germany combined to unravel the cultural compromise that had characterized state patronage to date. The Fascist regime's radicalization and militarization, as it moved ever closer to and more dependent on Nazi Germany, created spaces for new models of official culture, elevated alternative, more regimented cultural politics, and strengthened the power and position of the Fascist intransigents.

The final period of Fascist official culture (1937–43) was shaped by discourses and tensions different from those which determined the first

phase (1925–30) of professional and institutional regimentation or the second phase (1931–36) of experimentation and eclectic intervention. In the years between the Ethiopian War and the fall of Fascism, official culture became a locus of conflict reflecting larger schisms within the regime. In contrast to the early and middle 1930s, popular and critical support for official culture diminished after 1936, as both cultural producers and consumers found it less responsive and dialectical. In all its aspects, from administration to patronage to official taste, cultural politics after 1936 projected a conflicted attitude regarding art's role in a Fascist state at war.

The Fascist dictatorship had launched the Battle for Grain in 1925 and in 1927 the Battle for the Lira; by 1936 an unofficial Battle for Culture began in earnest. Up to that point the regime had maintained a tense truce over culture by juggling a number of different and, at times, opposing aesthetic styles and artistic movements. Equilibrium was further achieved through the decision to focus upon the consent and support of artists. "Fascist art," thus, became art displayed at government and party exhibitions—be it the rhetorically "Fascist," yet abstract work of the futurists or the classicizing modernism of the novecento. Certainly, official culture favored some schools over others, but none were excluded outright from the regime's largesse or from participation in its system of professional regimentation.

The contingencies of war and internal radicalization tore the taut fabric of the Fascist cultural compromise. The Battle for Culture testified to the contradictions inherent in a form of state patronage that had drawn strength from the decision not to enthrone a single aesthetic language or set of rhetorical strategies. Aesthetic pluralism had failed to produce an identifiable, unitary Fascist art and this failure became painfully obvious in the context of the regime's post-1935 propaganda exigencies. This last period of official culture was shaped by a series of battling and contradictory tendencies: first, the use of "radical practices" by cultural hard-liners who prescribed a total rejection of international and modernist influences in culture and the elevation of a bombastic rhetorical art of war and empire; second, a defense of aesthetic diversity and modernism by an opposing camp within the Fascist hierarchy; and third, dissident tendencies that had begun to form among young intellectuals, both within official culture and outside of it. As David Forgacs writes, "partly because of the inability of the regime to contain conflicting pressures within itself, a number of contradictions and dysfunctions began to be visible in Fascist censorship and cultural policy. It may be legitimate to speak of a crisis of control from as early as 1938 onwards."[3]

The battle between antipluralists and pluralists transformed official culture. Certainly, hard-liners' demands for the wholesale importation of Nazi cultural politics never attained hegemony. But, the struggle was significant enough to reorient Fascist culture and to privilege a new set of narratives and styles. The intensified anxiety over representation after 1936 was tied to a number of factors: the conditions produced by a regime mobilized for war and the attendant demands for cultural autarchy to match economic autarchy, by the alliance with the Nazis, and by an internal radicalization of the regime, which saw a decline in the power of former Liberals and nationalists. The League of Nations' sanctions against Fascist Italy, as a result of the invasion of Ethiopia, pushed Italy toward economic and tactical dependence upon Nazi Germany, which had cultural reverberations.

Culture wars tend to erupt at times of crisis and insecurity. As Todd Gitlin writes about contemporary American culture wars, "culture wars do not settle disputes"; they are merely symptoms of larger schism's within a political culture.[4] The Fascist "culture war" was a symptom of unresolved competing visions of Fascism and of disputes over the functioning of the regime. Hard-liners envisioned a "purified" Fascism, militantly national, cleansed of foreign influences and steeped in tradition. Like other "purification crusades," the Battle for Culture drew on fears of degeneration and contamination. Antipluralists identified the threat as the absence of a fully "Fascistized culture," and the cause was located in the enemy named modernism and internationalism. True Fascist culture (and hence true Fascism) could exist only if negative factors were purged, just as in crusade or war environments traitors must be purged. The antipluralists' anxiety over purity increased with the war, which solidified the hard-liners' belief in insiders and outsiders. The Battle for Culture was a struggle between inclusion and exclusion, between a stylistically multitudinous vision and a unitary one, a dialectical approach to culture and a monolithic one. For the antipluralists determined on an aesthetic purge, Fascist culture's hybridity implied an insecurity and weakness that threatened the very being of the regime.

The hard-liners' demands for a revision of cultural policy involved three interlocking beliefs. First, the contention that aesthetic pluralism and dependence on the voluntary and unrestricted participation of artists had not produced an identifiably Fascist art, whereas coercion and a militant cultural policy would force the creation of a Fascist art. Second, the existence of an alternative model in a fascist nation: the Nazi example of a fully purged and top-down approach made Fascist Italy's cultural politics appear indecisive and redolent of liberalism. And, third, the rising

rhetorical possibilities and priorities created by a nation at war—anti-pluralists offered empire, war, and autarchy as the themes around which to organize an enforced and optimistic official culture. For its proponents in the Fascist hierarchy, cultural autarchy meant the rejection of all that was foreign in language and the arts. According to cultural autarchy, Italian culture must be based only on elements authentically Italian and Fascist. The campaign against the *Lei* (the formal second-person singular form of address, deemed un-Italian because not Latinate), decrees against the use of words from foreign languages, and protectionist measures against foreign cinema were all part of this movement.

War, empire, autarchy, and race, asserted cultural radicals such as Roberto Farinacci, Telesio Interlandi, and Giuseppe Pensabene, offered subjects by which to determine the commitment of artists and themes by which to judge art. This pro-Nazi faction used the pages of their journals—Farinacci in his newspaper *Il regime fascista* (The Fascist Regime) and Pensabene and Interlandi in the journals *Quadrivio*, *Il Tevere*, and later in the racist, anti-Semitic journal *Difesa della razza* (Defense of the Race)—to vent their hatred of modern art and the regime's lax patronage policies. Giuseppe Pensabene and Telesio Interlandi's most zealous polemics against foreign and modern cultural influences took place in Pensabene's *La razza e le arti figurative* (Race and the Figurative Arts) and in Interlandi's *La condizione dell'arte* (The Condition of Art) and in Giovanni Preziosi's *Difesa della razza*. Roberto Farinacci, briefly secretary of the National Fascist Party (1925–26), was the powerful Fascist leader of Cremona and leader the intransigent wing of the party.[5] Farinacci's camp, whom we can call cultural hard-liners, demanded increased regulation and politicization of the arts; for this segment of the Fascist hierarchy, overt propaganda—unambiguous and easily read—was more important than a vibrant and critically acclaimed official culture.

As the detractors of aesthetic pluralism grew more strident and were armed with the models and language of National Socialist cultural politics, the tensions within the Fascist cultural compromise flared. The existence of diametrically opposed cultural factions inside the confines of the Fascist state splintered cultural life. Separate cultural camps emerged, took aim at one another, and, eventually, abandoned official institutions for ones reflective of their competing visions. The battle's frontline divided defenders of modernism and eclecticism and from its denigrators. In the late 1930s, each camp mounted an exhibition of what it considered Fascist art. Roberto Farinacci's Premio Cremona (Cremona Prize) pursued emulation of a Nazi-inspired Fascist realism, introducing theme competitions for works entitled "Listening to a Speech by the Duce on the Radio" or "Out of Blood, the New Europe."[6] In response, the Premio

Bergamo (Bergamo Prize), promulgated by then Minister of National Education Giuseppe Bottai, celebrated an art without confines and displayed artists from a range of modern tendencies, including expressionists such as Renato Guttuso and Emilio Vedova.

The Racial Laws (1938) and the Pact of Steel (1939) raised the power and prestige of pro-Nazis inside the Fascist hierarchy. The Racial Laws, modeled after the Nazi Nuremburg Laws of 1935, commenced with the expulsion of "foreign Jews" from Italy in September 1938. The regime followed them a month later with a comprehensive set of laws forbidding intermarriage between Jews and Christians and removing Jews from the professions and the public schools.[7] The Racial Laws of November 1938 also decreed the dismissal of Jews from art schools and academies, as well as from the artists' syndicates.[8] Fascist racial anti-Semitism of 1938 represented the culmination of several ideological strands, from traditional Italian religious anti-Semitism to racism emerging from Italy's occupation of Ethiopia to the Italian appropriation of Nazi ideas of biological racial superiority.[9]

Undoubtedly, the adoption of the Racial Laws, and Fascist collusion with the Nazis who had encouraged their promulgation, gave the antipluralists new weapons in their crusade against modernism. In this climate, a militarized and racialized vision of aesthetics found greater reception and some official sanction. *Quadrivio, Il Tevere,* and *La difesa della razza,* by 1938 well established in their anti-Semitic invective, used the Racial Laws to increase their demands for an end to "judeocized culture" in Italy. However, it must be noted that calls to purge Italy of "Jewish culture" came from across the culture war's spectrum, with the various pluralist camps accepting anti-Semitism as they defended modernism and worked hard to disengage the two. The rationalists endeavored to prove their "Aryan" pedigree and inspiration, as did the futurists.[10] Bottai, defender of open artistic expression and debate, signed and supported the Racial Laws.

Beginning in 1939, Farinacci promoted his own annual art exhibition, proposed as a cleansed counterpoint to the official ones. Farinacci's Premio Cremona was designed as a showcase for an Italian version of Nazi realist-naturalist propaganda art or, as one contemporary described it, an "attempt to steer Italian painting toward a purely Fascist conception."[11] For the 1939 Premio Cremona, artists selected between two topics: "Listening to a Speech by the Duce on the Radio" or "States of Being Created by Fascism."[12] In the two categories, 75,000 lire and 40,000 lire respectively were divided into first, second, and third prizes.[13] As a showcase for an Italian version of Nazi realist-illustrationist propaganda art, the Premio Cremona was a demonstration of what purified and healthy Italian art

should look like; it marked Fascist Italy's most stringent attempt to regulate the content of art.

Farinacci's administration of the Premio Cremona competitions deliberately departed from official art exhibitions. In order to guide participants properly in the 1939 competition, Farinacci solicited a number of "Comrades of secure political sensibilities" for a survey whose outcome would "offer direction to the many artists who are competing for the Premio Cremona." Farinacci asked these comrades: "If you were a painter, which speech of the Duce would you choose? Which setting? Which listeners? What would you chose for the second theme?."[14] Medici del Vascello, undersecretary of the Mussolini's cabinet, chose Mussolini's speech of May 9, 1936, in which the Duce declared the foundation of the empire. For the second category, Medici selected "a theme inspired by the regime's work in elevating the race through assistance to mothers and children."[15] Both the "guiding" referendum and Medici's exemplary response demonstrate the Premio Cremona's determination to forge an officially sanctioned culture that would dictate to artists. Farinacci collected the responses and made them available as inspirational pointers to competing artists.

Three hundred works competed and 123 paintings were exhibited at the first Premio Cremona of 1939.[16] The majority of the works depicted listeners frozen in attention to words emanating from an offstage radio. Styles ranged from idealized illustrationism to naturalizing naive. Each canvas bore a motto or epigram and was identified by number, rather than author.[17] This anonymity moved art away from the cult of celebrity, according to its organizers. The art of the Premio Cremona favored a photographic naturalism that stressed the most "healthy," "virile," and "serene" aspects of reality.[18] This art, like the canvases of the Great German Art Exhibition, located beauty in the subjects depicted rather than in pictorial styles or aesthetic choices, as in modernism. The contestants' iconography stressed family, order, patriotism, and war.

An examination of three entries in the 1939 competition for a canvas depicting "Listening to the Duce on the Radio" reveal the retrograde uniformity privileged by the Premio Cremona. In *The Clarifying Word of the Duce to the World* (fig. 29), a crowd gathers in a village square, transfixed by an unseen force. The central figures gaze upward, as a mother and children in a Madonna and child pose look outward from the foreground. A black-shirted male figure in the center faces the viewer with a provocative expression, as if to ask, "Are you outside the organic community exemplified in the painting?" The figures line-up in a simple, frieze composition, a technique that recalls both ancient Roman bas-relief

and the unity of the crowd. The uncomplicated composition refers as well to Giotto and pre-Renaissance Italian painting. Playing further on the call to Italian traditions, the setting is a timeless Italian hill town painted in quattrocento naturalism. A second entry also refers to Tuscan Renaissance styles, with some experimentation with composition: peasant figures, meant to symbolize the Italian "everyman," gather at a window to listen to the Duce's speech. The painting is framed by a window from which hangs the Italian tricolor. The only figure seen in full is a black-shirted Fascist who stands outside the window. A third entrant chose a more private rendering; in this painting, a family listens together at home to the Duce (fig. 30). Family members, save the mother, infant, and grandfather, are in Fascist uniform. The pyramidal composition, with the mother and child subordinate at the base and the father at the apex,

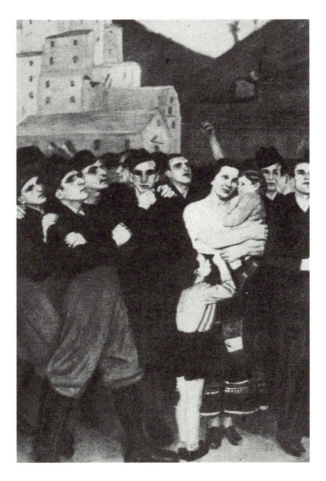

29. Premio Cremona (Cremona Prize) 1939, prize-winning entry in the competition for a painting on the topic "Listening to a Speech by the Duce on the Radio" (frieze scene).

mirrored the hierarchal structure of the state. Here the father leads the family, as Mussolini unifies and protects the nation. The dominating themes of motherhood and mobilized youth at the Premio Cremona echoed the primary tropes of National Socialist art.

While the regime demurred from directly promoting the Premio Cremona, Mussolini sent representatives, and various sympathetic members of the party and government ventured their support: the minister of Popular Culture, Dino Alfieri, inaugurated the 1939 exhibition and Foreign Minister Galeazzo Ciano officiated at the 1940 edition.[19] Alfieri applauded the event and hailed the winner as "an artist clearly Fascist and Italian, who . . . cannot help but present the most perfect understanding of the time in which we live: the time of Mussolini."[20] A government newsreel described the 1939 event as "the first attempt to draw artists to the historic reality of the Mussolini Era."[21] The funds of the Premio Cre-

30. Premio Cremona (Cremona Prize) 1939, prize-winning entry in the competition for a painting on the topic "Listening to a Speech by the Duce on the Radio" (family scene).

mona came from high-ranking Fascist officials, such as Achille Starace and Dino Alfieri, who each gave 5,000 lire toward the first exhibition, and Cremonese banks, tourist agencies, and businesses, which together donated 110,000 lire.[22]

The Premio Cremona reveals the intransigents' appropriation of Nazi cultural politics. "With the Premio Cremona," declared the 1941 catalog introduction, "we will return artists to reality, convincing them to abandon ridiculous rhetoric, imitations of foreign ways, anatomical deformations." This critique of modern art as an affront to nature mirrored that of the Nazis. The Premio Cremona declared itself an antidote to "shapeless breasts, feet and legs deformed by elephantitis."[23] In contrast to the distortions of modernism, the art of the Premio Cremona "exalted patriotic values" and "the physical and moral health of the Italian people."

As the war moved the regime toward Farinacci's cultural vision, the Premio Cremona received greater official attention. Mussolini himself chose the 1940 exhibition's topic of the Battle for Grain, which boasted 800 aspirants.[24] The third Premio Cremona of 1941 was cosponsored with Nazi officials—two functionaries from Josef Goebbels's office, the mayor of Hannover, the assistant *Gauleiter* and *Gauamtsleiter* of Hannover, among others.[25] Mussolini personally thanked Farinacci for his efforts and hailed the "reaffirmed solidarity and spiritual relations between the two allied peoples."[26] For the 1941 exhibition, Mussolini served as official patron and once again selected the topics.[27] As a reminder of Germany and Italy's shared fate, the planned but never held 1942 exhibiton was to be a joint Nazi-Fascist event equally open to Italian and German artists. But for the turning tide of the war, its theme would have been "Out of Blood, the New Europe."[28]

The winners in the 1940 and 1941 Premio Cremona carried further the tropes of racial superiority and antimodernism. In the Battle for Grain competition one of the winning canvases depicted farmers waving to their son, a departing soldier. Naturalism reigned, this time tied to a celebration of the peasant *stirpe*, a rough Italian equivalent to the German *Volk*. The farmers, toiling for the cause of the nation, bid farewell to one of their own off to fight for the same. By 1941 the Premio Cremona attracted a number of racially inspired interpretations; the competitions that year called for paintings illustrating "Italian youth of the lictor." The paintings were populated by an array of aryanized, muscular, and exaggerated male figures, especially soldiers. One winning canvas depicted a crowd of mobilized male and female youth at exercise—the youth of Italy transformed by the revitalizing environment of Fascism and war.

31. Premio Cremona (Cremona Prize) 1941, prize-winning entry in the competition for a painting on the topic "Italian Youth of the Lictor."

These figures proposed a Fascist version of the Nazi cult of the idealized body ready for war, with the genders divided into the homosocial environment required by war (fig. 31).

Neither Farinacci's cultural vision nor his importation of Nazi aesthetics attained cultural predominance. The major block to Farinacci's program came from within the Fascist hierarchy— from Giuseppe Bottai, then minister of national education, who had long represented the revisionist strand of Fascism. Bottai hailed continued stylistic pluralism, augmented by increased professional regimentation and enlarged government intervention in the means of cultural production. Many of the Fascist bureaucrats who were reluctant to follow a restricted path of arts patronage had come to Fascism from the pre-Fascist Nationalist movement and had their political and cultural roots in the Liberal era. Others who championed a nonrestrictive patronage had arrived at Fascism from the futurist or syndicalist movements. For them, a multiplicity of styles best represented Fascism, and they believed that, given the correct incentives, artists would assent to the dictatorship's projects.

Bottai, the most influential and outspoken proponent of a noncoercive policy, had reemerged to a position of power in cultural affairs just as the culture war intensified. From 1936, when he became minister of national

education, he exercised significant control over cultural policy. Throughout his career, Bottai had expressed a revisionist brand of Fascism, which called for a dynamic and technocratic Fascism of debate and struggle.[29] He used his many government positions—minister of corporations from 1929 to 1932, governor of Rome until his appointment as minister of education in 1936—to promote his commitment to the corporate state as Fascism's defining characteristic, in contradistinction to socialism and capitalism. The journals he directed, *Critica fascista*, *Il diritto del lavoro*, and *Archivi di studi corporativi*, stood throughout the Fascist period as mouthpieces of his corporatist and revisionist position. In 1940, he founded the arts journal *Primato* as a final response to the cultural hardliners, which defended the need for open political and cultural debate.[30]

Bottai's speech at the 1938 Biennale inauguration suggests the contours of the pluralist position. While stressing the importance of art mobilized within and for the Fascist state, Bottai declared that "socially useful" art had to be "good" art: "A relationship between art and politics exists only for this: that work lacking artistic quality, whatever its ideological or emotional content, is also politically useless, since such content does not express anything and where it does, it does so confusedly, or wrongedly."[31] For Bottai, the Fascist state, rather than force a single reactionary aesthetic upon artists, would gain the most as protector of aesthetic integrity. In his attack on Farinacci and the Nazi model, Bottai called upon his audience to work against "an absolute fusion between artistic interests and political interests." If art were to become the blunt instrument desired by the antipluralists, it would lose all integrity, warned Bottai, and, therefore, all "effective propaganda possibilities."[32]

Increased and active official intervention in culture, according to Bottai's faction, would resolve the problem of creating "Fascist art." Politicized artists and official sanction for modern art would produce a culture worthy of Fascism in its time of crisis. Fascism, wrote Bottai, should ask "the artistic energies of the nation for a militant participation in political activity ... for the defense of civilization against all disintegrative forces and bankrupt ideologies."[33] In contrast to the intransigents' exaltation of naturalism and classicism, Bottai invoked "an art of our time"—a modernism mobilized for the Fascist revolution.[34]

Bottai's battle plan involved the establishment of an Office for Contemporary Art in the Ministry of National Education to foster the careers of artists and to develop a patrimony of modern Italian art. These ends would be achieved through three primary means: (1) use of the new department as a headquarters for information and support for modern art; (2) greater funds for acquisitions; and (3) passage of the "Two Percent Law."[35] The Two Percent Law legislated that "in all public works two

percent of the total construction costs will go toward decoration"—embellishments such as frescoes and mosaics.[36] "What is important," wrote Bottai, "is making obligatory artists' participation in works of public good."[37]

In 1939, in a direct slap at the pro-Nazis, Bottai inaugurated his own exhibition, the Premio Bergamo, as a gathering place for those who believed that "Fascism does not promulgate aesthetics." The exhibition promoted open competition categories and demonstrated support for artists who wanted to participate in broadly defined, but Fascist-sponsored culture—a clear rejection of "political" painting.[38] The inaugural Premio Bergamo of 1939 promoted a series of prizes for "Italian landscapes."[39] The second edition called for "works of art in which two or more human figures . . . are the primary subject of the piece."[40] The third and final Premio Bergamo was completely open, accepting compositions with figures, landscapes, or still lifes.[41] Though the war intensified pressures for aesthetic conformity, Bottai's exhibition became progressively less restrictive. The total prize monies offered increased from 70,000 lire in 1940 to 100,000 lire in 1942.[42] In 1939, artists placed 585 paintings in competition and the jury accepted 274; the number of contestants was nearly double that of the Premio Cremona. Like the Premio Cremona, the Premio Bergamo was neither an official nor unofficial event, but was nonetheless held in conjunction with the local Fascist artists' syndicate.[43]

Bottai conceived of the Premio Bergamo as the birthplace of an innovative and modern Fascist art, which would win the battle for culture through a mobilization of younger artists committed to Fascism and modernism. He hoped the exhibition would "gather together the young . . . who propose creative 'contagion' between the life of art and daily life."[44] Open competitions, concluded Bottai, pushed artists to produce the best work possible. In an environment of "study, research, activity, investigation, sensitivity, love, enthusiasm, dialectics, struggle" in which the regime ". . .encouraged and promoted [art]," Fascism would oversee a great cultural renaissance.[45] "Cultural action" and encouraging artists to "enter publicly into a process of cultural judgment," not partisan specifics, represented Bottai's solution. He interpreted the division of Fascist culture into competing spheres as a potential source of strength: "Leave everyone free to prefer Bergamo to Cremona, Cremona to Bergamo. . . . For the state, what is important is the fact there exist expressions of consent and dissent; namely, a vitally dialectic human condition."[46]

A broad coalition of artists from many backgrounds responded to the opportunity to defend uncensored expression and eclectic state patronage, from postimpressionists such as Filipo de Pisis (1896–1956) and Ar-

turo Tosi (1871–1956) and novecento artists such as Achille Funi and Felice Casorati to a number of emerging talents alienated from official culture's embrace of representation, naturalism, and forced optimism. Younger artists drawn to the possibilities embodied in the Premio Bergamo included figures such as the abstract and expressionist artists of the Galleria Milione and the corrente movement. De Pisis and Tosi, both associated with the Novecento, won first and second prize at the 1939 Premio Bergamo. Tosi worked in the postimpressionist tradition, with romantic influences; de Pisis saw his art as inspired by the mannerists. More importantly, the Premio Bergamo hosted younger artists who translated their discontent with official culture into calls for a new perception of artists' ethical commitment and for a "realist" relationship between artists and their environment.[47]

Artists who would soon be the leaders of the postwar contemporary Italian art world, such as Emilio Vedova, Giacomo Manzù, and Renato Guttuso, participated in the exhibition. In 1942, Guttuso's impassioned expressionist canvas, *Crucifixion*, won second prize and unleashed a controversy over its critical content and disturbing allegory for the tragedy of Europe. The painting, with its dynamic and contorted composition, ridiculed the static and stylized optimism of much official culture. Guttuso chose a Picasso-inspired, cubist space for his modernized crucifixion scene: the foreground and background are flattened and the colors are the violent reds and oranges of expressionism. Guttuso's twisted, suffering horse clearly refers to *Guernica*'s anguished horse (fig. 32). Armando Pizzinato, the abstract painter whose observation of the dictatorship as a stylistically impartial patron opened this book, was also honored for his celebrations of workers and industrial landscapes. One year after accepting prizes from Fascist Minister of National Education Vedova, Guttuso and Pizzinato all joined the partisan struggle against Fascism.

The cultural antipluralists' demands and the pressures of the Nazi model had a limited, but significant, impact on policy and practice. Fascism's promotion of stylistic diversity and its search for consent had left both artists and audiences with expectations that could not be quickly reoriented. Efforts to reassess cultural policy and patronage practices failed to produce the monolithic Fascist culture which some Fascists worked toward in the late 1930s and early 1940s. Advocates of an eclectic cultural life for Fascist Italy through aesthetic pluralism continued to defend their positions and hold their ground. With the factionalization of cultural life, Fascism's lack of a coherent system became increasingly obvious. Neither the "total politicization of art" nor the "mobilization of artists" nor "commitment to aesthetic pluralism" was firmly decided

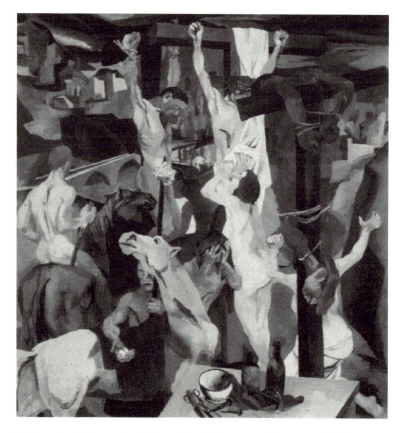

32. Renato Guttuso, *Crucifixion*, Premio Bergamo (Bergamo Prize) 1942.

upon. Fascism's attempt to bring all positions under its umbrella had produced a vibrant equilibrium in the early 1930s, but this coexistence soon disintegrated.

On July 19, 1937, National Socialism's battle against modern art reached a dramatic peak. Four years of accelerating coordination of the arts and antimodernist rhetoric climaxed in two simultaneous exhibitions, the Entartete Kunstaustellung (Degenerate Art Exhibition) and the Grosse deutsche Kunstaustellung (the Great German Art Exhibition).[48] The first, an officially orchestrated denigration of modern art, held up in derision the aesthetics rejected by Nazi dictatorship. The second offered Germans an opportunity to worship the new and cleansed German art celebrated by the Nazis. With this now infamous dual spectacle, the Nazis claimed that they allowed Germans themselves to decide

which art they prefered: modern, abstract, internalist formulations or naturalist, easily read, "positive subjects." In the Degenerate Art Exhibition, two million Germans saw the disturbing, anxiety-producing figures of George Grosz, Emile Nolde, and Paul Klee placed above denunciations such as "Mockery of German Womanhood" and "Vilification of German Heroes." In contrast, the Great German Art Exhibition provided sanitized images of the farmers, maidens, and soldiers of the New Germany.

Nazi Germany's purge of modern art and the avant-garde, together with its imposition of a homogenous idealized aesthetic and its creation of institutions for the rigid control of artists, posed a problem for its allied Fascist regime in Italy. Fascist Italy had evolved a very different vision of the relationship between art and the state, but the pressures of the alliance forced a reconsideration and a realignment of cultural forces within Mussolini's Italy. At the time of the Nazi Degenerate Art Exhibition in July 1937, cultural life in Fascist Italy stood in a holding pattern in which competing bureaucracies and cultural factions locked horns over the direction of official culture. Mussolini sent a large delegation to the inauguration of the Great German Art Exhibition. Antonio Maraini, a member of the delegation, returned to Italy sobered by what he had seen. He wrote Mussolini: "Since my return from Munich, where I assisted in the great festivities held in honor of art by the Reich, I have realized how useful a greater amount of discipline would be, considering the real uncertainty of our artistic policies."[49] Maraini sounded a regret that some Fascist leaders had spoken since the middle 1930s.

Cultural exchanges between the two regimes were common after 1935. Repeating larger splits in Italian Fascist cultural politics, bureaucrats returned with a variety of readings on what the Nazi example had to offer the Italians. Luigi Freddi, head of the Office for Cinema, also traveled to Germany to assess Nazi cultural policies. After his 1936 trip, he concluded that Nazi intervention had affected German film production "for the worse" and blamed "political and administrative intervention by the state of crushing weight and violence" and "the forced exodus of the Jews" for the decline in German cinema.[50]

The Fascist press reported Nazi cultural developments from a distance. It showed limited support, couched in a language that Nazi cultural politics represented a divergent tradition.[51] One of Italy's long-standing nationalist cultural journals reproduced Hitler's speech at the Great German Art Exhibition, but held it at arm's length, stating "the thoughts of Adolf Hitler on contemporary art deserve to be known and understood" for the insights they provide into the German political and spiritual situation.[52] Even *Gerarchia*, the magazine of the Fascist establishment,

maintained a critical distance from Hitler and concluded a September 1937 piece with the following doubts: "Nonetheless, the remedy [offered by Hitler] is like those poisons which when taken in small doses, if they don't kill the organism itself, can cure the disease."[53] The party newspaper, *Il popolo d'Italia*, reticently supported the German exhibitions of July 1937. The Milanese daily, *Corriere della sera*, neglected altogether to report on the German art events.[54]

If the Fascist establishment kept its distance from Hitler's war against modernism, the Nazi purifying crusade did encourage reactionaries within Italian Fascism to seize the initiative. Polemics between the hard-liners and defenders of modernism and diversity reached a fevered pitch in the wake of the Degenerate Art Exhibition. The conflicts that had raged since the early 1930s between Farinacci's faction and certain modernists, led by the futurists and rationalists, found a new language and intensity. In late 1937 and 1938, the antipluralists, taking their cue from Hitler, appropriated a new vocabulary, which attacked modern art as "Bolshevik" and "Jewish."[55] "We think that 'modern,'" wrote Interlandi in 1938, "is a trap set by Jews and judeocized intellectuals in order to get their hands on our artistic life."[56]

From the pages of *Quadrivio* and *Il Tevere*, Pensabene and Interlandi decried the bulk of contemporary Italian art as "degenerate."[57] Armed with a racialized interpretation of modern art, they denounced as un-Italian, un-Fascist, and overly international the celebrities of the novecento school such as Giorgio De Chirico, Carlo Carrà, and Filippo De Pisis; the expressionists of the scuola romana, including Corrado Cagli and Massimo Campigli; the futurists, especially their leader F. T. Marinetti and Gino Severini; the abstract artists of the Galleria Milione; and even the rationalist architect and committed Fascist Giuseppe Terragni.[58] All these so-called degenerate artists were bulwarks of Fascist official culture. Their art had been consistently purchased, commissioned, and prized by the regime and represented the cultural production of the era. In an attempt at a purge, the intransigents attacked nearly the whole of what had been to date Fascist art. They assaulted not only the practioners of the art, but the vast bureaucratic and institutional apparatus of official culture that supported such art. "Journalists, critics, exhibition organizers . . .," wrote Telesio Interlandi in 1938, "have bowed to the tyranny of the International . . . by giving exhibition space and prizes worth tens of thousands of lire to the clumsy bursts of a Chagall or an Ernst."[59]

In defense of the avant-garde, the futurists launched their own campaign in the Battle for Culture. Under Marinetti's guidance, the futurists presented themselves as a bulwark against the cultural hard-liners and as

an alternative to Bottai's form of interventionism. Continuing to see his futurist movement as the repository of the modern and avant-garde tradition in Italy, Marinetti fought Farinacci's "degenerate art" campaign in writing and with a continued highly visible cultural presence.[60] As a movement, the futurists held onto their abstraction in the face of demands for a representational Fascist art. At the same time, they continually adapted the rhetorical bases of their art to the regime's evolving priorities: futurist *aeropittura* and *plastica murale* stridently accommodated the motifs of the Ethiopian war, the war in Spain, and the empire in Africa. The confrontation with the intransigents was not over the necessity for a politicized, rhetorically militant art, but over the best style for representing it.

Marinetti and the futurists he led explicitly and publicly promulgated a cultural philosophy opposed to that of the National Socialists and the Fascist hard-liners. "Most important," wrote Marinetti in 1934, "is the search for an art that directly expresses our age, in contrast to aesthetic tendencies which, in homage to the presumed immutability of the Earth and Humanity, refuse any contemporary inspiration."[61] Excoriating the Nazi contention that art was transcendent and eternal, the futurists demanded a Fascist art that was "an exalted and continual synthesis of our radiant mechanical society."[62] In 1938, Marinetti and Mino Somenzi, editor of the futurist magazine *Artecrazia*, responded to Farinacci's threats by holding a mass demonstration in Rome and Como "to fight in defense of civilization and for the liberty of art and the human spirit."[63] That same year, Marinetti persuaded Mussolini to deny entrance into Italy to a traveling Nazi show of "degenerate art," which included futurism.

Rationalist architects, who had designed much of Italy's modern architecture under government commission, joined the futurists in support of modernism and the avant-garde. Giuseppe Pagano, in particular, used the pages of the avant-garde architecture journal *Casabella* to defend the Italian and Fascist pedigree of functionalist architecture. He accused the anti-pluralists of "a cynical act of sabotage against the good name of Italian art."[64] Pagano declared that despite the recriminations of the "tyrants and petty tyrants among our art critics," "modern architecture, whether rationalist or functionalist, is known and practiced . . . by the vast majority of Italian builders."[65]

The pro-Nazi right's attempt to wage a degenerate art campaign in Fascist Italy failed. Sixteen years of official sanction for modernist and avant-garde–influenced art and architecture had produced movements that were committed to defending their styles and saw their approaches as authentically Fascist as the National Socialist one. Further, much of the

cultural bureaucracy was not behind the crusade. In 1940, C. E. Oppo, the director of Italy's major exhibition of national art, the Quadriennale, was asked to list the "race" of invited artists. He refused. In part, the Italian degenerate art campaign failed because it had only partial support from within the Fascist hierarchy and because the Mussolini dictatorship had constructed a relationship between art and the state that even a pro-Nazi faction and the changed conditions of war could not completely recast. It also failed because Italian Fascism never had integrated fully the discourses of racial degeneration and scientific racism required to fuel such a purge, aesthetic or otherwise.

The discourse surrounding the search for a Fascist aesthetic in the 1930s embraced nationalism, *romanità* (Romaness), and *italianità* (Italianess)—fluid categories that changed meaning over time and which did not prescribe a specific style. With the greatest force and the least grace, after the declaration of empire in 1935 the regime encouraged a rich iconography of *romanità* and empire. This iconography asked Italians to identify the Rome of Augustus with the Italy of Mussolini; *romanità* in art and architecture offered "a neo-imperialist style based on the monuments of ancient Rome."[66] Following the war in Ethiopia, *romanità* assimilated a racial component, often depicting Africans and political opponents (such as the Spanish Loyalists) as subhuman or animal-like. More than race, however, late Fascist culture elevated bombastic historical and national categories to produce a kitsch "Roman" style known as the *stile littorio*. Filippo Sgarlata's bas-relief *It Is the Plow That Draws the Sickle, but It Is the Sword Which Defends It*, which was prized at the 1938 Venice Biennale, offers an example of the exaggerated and awkward *romanità* of late Fascist culture (fig. 33). In the bas-relief, the static and monumental figures of a soldier and peasant unite to feed and protect the empire. The classicized rendering represents Sgarlata's attempt to update the Roman imperial style.

Despite Fascism's failure to embrace the Nazi critique of modern art and the art world as a corrupt and Jewish hoax visited on a population yearning for the eternal beauty inherent in art, the two cultural ideologies shared many elements. Both the Nazis and the Fascists called for the reintegration of the artist into productive work. The bohemian painting in his attic for private patrons was to be replaced by the artist creating in the name of the state. Both Fascist states knew the importance of art for self-representation and legitimation: both spent handsomely on commissions and purchases through their last days in power. And, as their architectural remains testify, both regimes took aesthetics to heart as a primary means of achieving the interpenetration of ideology, state, and society.

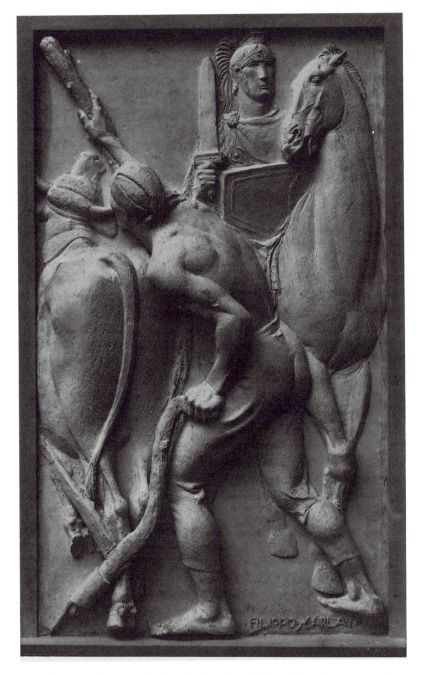

33. Filippo Sgarlata, *It Is the Plow That Draws the Sickle, but It Is the Sword Which Defends It*, personal purchase of Mussolini and 1938 Venice Biennale bas-relief competition winner.

The Coercive Patron

The Battle for Culture and its attendant radicalization and fragmentation of cultural life in Fascist Italy had an impact on official events across the cultural landscape. From international and national fine arts exhibitions to the local shows of the Fascist syndicates to the mass culture exhibitions, state patronage after 1936 became more coercive and more bombastic. The Fascist state as a coercive patron demanded more explicit adhesion from artists and adopted a didactic and condescending attitude toward audiences. In the late 1930s and early 1940s, Fascist patronage of the fine arts assumed new practices as the regime searched for a more legible and legitimately "historical" and "national" Fascist art. Thus, Fascist bureaucrats cast about for a patronage style that could produce a Fascist outcome while falling short of outright purges.

Challenges to aesthetic pluralism and a revised patronage style arrived at the Venice Biennale in 1936. The shifts in state patronage found a variety of expressions, including changed requirements for the competitions, new buying patterns on the part of the government and the party, and a new language of cultural politics as articulated in exhibition catalogs and reviews. Fascist bureaucrats after 1936 showed an interest in breaking down traditional patronage patterns and in challenging the power of the established celebrities of the art world. Good workers, party hacks, and malleable young artists replaced the stars of the art world as the primary recipients of state patronage.

Antonio Maraini, secretary-general of the Venice Biennale, revived theme competitions after 1936, but revised them so as to avoid the perceived mistakes of 1930 and 1932. The rigidly defined program, which wove together a number of rising ideological strands, offered two competitions: one for "seven frescoes" and one for "eight statues to decorate a central hall chosen for this purpose."[67] All submitted works had to be "on themes of Fascist life." Most importantly, regulations stipulated that participating muralists and sculptors present preliminary sketches, giving the jury preemptive power over a possible disappointing outcome.

The change in patronage patterns was most obvious in the restrictions of age and experience at the 1936 Biennale competitions. Contributing artists had to be under thirty-five years of age, members of the Fascist syndicates, and among those not invited to the Biennale. Past prize competitions had accepted all willing Italian artists, but now youth and outsider status were prerequisite. Artists with established reputations, those who previously had triumphed in the Fascist exhibition system, had not met the regime's expectations.

The requirements for participation reflected the concerns of the cultural antipluralists, as well as broader Fascist ideological shifts. First, the designation of outsider status (noninvited, youth) emerged from a critique that saw prizes and patronage at the large exhibitions as an insider's network fraught with nepotism. As vehemently expressed in *Quadrivio*, this position maintained that the same unqualified artists repeatedly won and that the prizes had become "simply subsidies."[68] Cultural hard-liners viewed successful artists as overly concerned with the marketplace and private patrons; this dependence on the art market, claimed the intransigents, prevented many artists from making the transition to politicized and public art. These commercially successful artists had been in the system so long as to become a "parasitic class," interested only in their own promotion.[69] The prescription of young artists trained under Fascism and not previously invited to the Biennale promised an infusion of new blood that cultural extremists hoped would produce a clearly celebratory outcome.

Indeed, by 1936 the turn to the young had become a central plank of the regime's propaganda campaign for a perpetual Fascist revolution. Concerned with the creation of the next generation of Fascist leaders, Fascist cultural policy in the late 1930s devoted significant time and energy to cultivating the young. Many in the party hierarchy perceived youth as the source of rejuvenation for a Fascism gone soft. From films focusing on the potential of youth to government and party funded programs, such as the Littoriali, late 1930s Fascist culture stressed the cultivation and education of the young.[70] After the declaration of war against Ethiopia, this propaganda added the image of fighting youth as the saviors of the nation. Thus, state patronage directed at artists under thirty-five mirrored the concerns of the regime as it moved from the relatively stable early and mid 1930s into war. If older artists, who had come of age in Liberal Italy, continued to be too egoistical, perhaps a new generation of artists, raised under Fascism, would be selfless enough to redefine their art in accordance with political contingencies.

Of course, the disillusion with established artists and the turn to young artists trained under Fascism took place across the patronage system. The regional and provincial exhibitions of the Fascist syndicates began in the years after 1936 regularly to include competitions and prizes for younger artists. The 1942 Exhibition of the Fascist Syndicate of the Fine Arts of Lazio designated *all* of its prizes for young artists. There were four prizes, two Premi del Duce (Duce's Prize), one Premio Partito Nazionale Fascista (Prize of Fascist Party), and a prize of the Ministry of Corporations, totaling 4,000 lire and destined for "any artist belonging to the syndicate who is under thirty years of age."[71]

At the 1936 Venice Biennale, a number of artists responded to the more restrictive patronage style. Eighty-three painters presented ninety designs for murals and sixty-five sculptors submitted seventy models.[72] The level and quality of the presented works pleased the jury, which declared the "successful outcome of the competitions."[73] The jury concluded that "the appeal found a profound echo in the souls of the young, who were particularly moved."[74] The 1936 mural competition in particular won the plaudits of the jury, which chose eight rather than the original estimate of seven winners to execute their designs on the Biennale interior. In addition, the jury awarded two minor panels for decoration, and seven muralists and sculptors received "distinction" for their efforts.[75]

Following the assignment of awards, the winners had two months to complete the murals and sculpture for the designated section of the Biennale. Maraini controlled the process: he had direct and final editorial rights over the work and could request specific revisions.[76] The youth of the participants eased the imposition of the coercive policy. Young artists given an unprecedented opportunity to show at the Biennale were less likely to rebel against regulations. Where many established artists had refused to participate in government-coordinated competitions and had scorned control over content, young artists, without many options beyond official culture, made a more malleable target.

The winning murals at the 1936 Biennale shared a common topical and stylistic orientation. Celebrated works stayed close to the assignment of "themes of life in Fascist Italy" and bore the mark of the Italian "return to order" movement and an overarching interest in *italianità*. In one such frescoe, Goffredo Trovarelli's *Vita agreste (Rural Life)*, a black-shirted farmer is about to shovel seed from a bag (fig. 34). Steeped in sentimentality and references to Renaissance quattrocento painting, it responds to the call to mine Italian painterly styles. The mood is quiet and static, evoking the healthy, organic life of the countryside. While the painting manifests the "return to order" and classicism that many cultural conservatives sought both topically and stylistically, it also, in the lighting and use of landscape, reveals the influence of Cezanne and impressionism. For *La rassegna italiana*, it was "characterized by a Tuscan equilibrium, which one could call classical, between figures and rural landscape, between linear rhythms and full-bodied hues."[77] Ezio Buscio's *Martirio di Berta (The Martyrdom of Berta)* demonstrates another interpretation of the call to historical styles: his impassioned, agonized depiction of the martyrdom of a young Fascist named Giovanni Berta draws on both the northern European and Italian Renaissance (fig. 35). He reconfigured crucifixion imagery to embody Fascist martyrdom: the bridge from which Berta was killed becomes a crossbar and Berta, a Christ figure. On the left of the

frescoe, a Fascist *squadrista* triumphs over the monster of subversion, making Berta's death a contribution to national regeneration. The wild, distraught faces of the mourners and the contorted rendering of the central figure recalls northern European crucifixion scenes, as does the apocalyptic landscape. The tower in the background brings us back to Italy, as it refers to Piero della Francesca.

Cafiero Tuti's *Opera assistenziale* (*Works of Aid*) offered a crowded village scene in which party officials donated cakes and grain to villagers. Other noted entries included Valerio Fraschetti's *Rappresentatione epica ispirata della partenza nocturna dei soldati per l'Africa Orientale* (*Epic Depiction Inspired by the Nighttime Departure of the Troops for East Africa*) and two depictions of *Maternità*.[78]

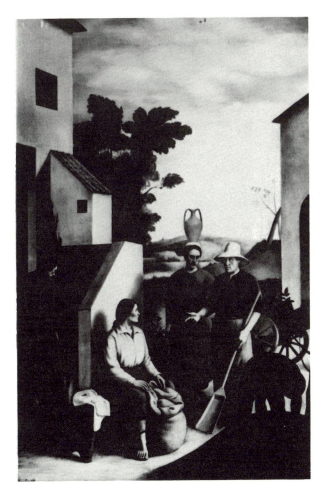

34. Goffredo Trovarelli, *Vita agreste* (*Rural Life*), 1936 Venice Biennale fresco competition winner.

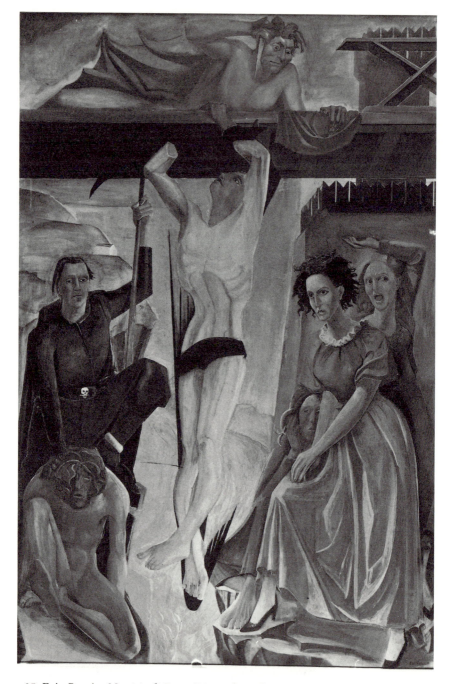

35. Ezio Buscio, *Martirio di Berta* (*Martyrdom of Berta*), 1936 Venice Biennale fresco competition winner.

With the declaration of empire and Fascist mobilization for the war in Spain, shifts in state patronage accelerated. By 1938, public art executed by young artists or by those who had played the regime's game represented the core of state-sanctioned fine arts. Given the success of the highly regimented Venice Biennale competitions of 1936, Maraini expanded the program. Whereas the previous Biennale promoted two competitions, the 1938 show proposed six opportunities for any artist belonging to the Fascist Syndicate of the Fine Arts. In fact, the only route for most artists to appear at this Biennale was through the rigidly defined competitions. That year, the Biennale promoted competitions for frescoes, bas-reliefs, portraits, landscapes, engravings, and commemorative medals. Each category specified that the works "will have to be inspired by events or aspects of Italian life during the Fascist era."[79] The competition for a commemorative medal, for instance, required that one side bear the image of a figure "most representative of the Fascist era" and on the other an "allegory drawn from the work of the person depicted."[80]

Again, organizers found the responses to the stricter competitions "quite remarkable": in 1938, 2,491 artists (not including those involved in the fresco contest) competed in the five contests with 957 participants for the portraiture competition, 372 for the sculpted-bust contest, 909 for the landscape category, 191 for cityscape engravings, and 62 for the commemorative medals competition. In contrast to the early 1930s when the competitions requiring specific themes failed, the rigidly defined competitions—celebratory portraiture—fared equally as well as the loosely constructed ones for landscapes.[81]

Synchronicity between the Biennale administration and the acceptance jury was a further element of the new patronage style and the major reason why the competitions found greater success. Official commitment to a jury's aesthetic integrity and autonomy of the early 1930s had faded. Instead, the jury for the 1938 competitions evinced official culture's rising impulses. The artists chosen for the jury had made timely aesthetic shifts, readapting their styles to the altered cultural environment. Nine artists joined Maraini to select the winners. Vincenzo Ciardo, Arturo Dazzi, Ferruccio Ferrazzi, Michele Guerrisi, Arturo Martini, Fabio Mauroner, Carlo Alberto Petrucci, Bortolo Sacchi, and Alberto Salietti all contributed regularly to the Biennales and Quadriennales of 1930–40 and received frequent government support.[82] For example, the Ministry of National Education had purchased Salietti's work at the 1930, 1932, and 1934 Biennales and at the 1935 and 1939 Quadriennales. In addition, four of the jury members won prizes in the competitions of the 1938 Biennale: Martini, Ciardo, Guerrisi, and Ferrazzi. Five members of the jury, Ferrazzi, Guerrisi, Martini, Mauroner, and Petrucci, were chosen for personal

retrospectives at the 1938 Biennale. Ciardo and Guerrisi had further shown their commitment to the Fascist organization of the arts by serving on the Fascist Syndicate of the Fine Arts' National Directorate between 1936 and 1942. Such juries were willing to compromise quality for a large turnout.

Ferruccio Ferrazzi, who sat on the jury and won in one of the competitions, is a telling example of an artist who rode the shifting tides of state patronage. His work adapted to changing Fascist rhetoric in the later 1930s by stressing "the idea of the strength and blood of the race, the blood myth of the race, and Renaissance and classical myths."[83] He added Italian and neoclassical elements to his futurist and symbolist influenced pictorial style. Previously associated with the Roman Novecento, Ferrazzi "opted for grand mural painting" in the late 1930s. Ferrazzi's commitment to an antimodern aesthetic had grown so palpable that in 1939, when organizing the Premio Cremona, Farinacci invited him to sit on the jury.

This jury of 1938 selected 157 artists, or 8 percent of those competing. The majority of Italian artists at the 1938 Biennale appeared via the competitions. Between the competitions and the personal retrospectives, the structural changes of 1938 produced a regulatable situation. In this case, Fascist patronage promoted simultaneously elitist and popular positions: the personal retrospectives were based on the elitist notion that great masters best represented art (a parallel to the cult of the leader), while the competitions welcomed all artists belonging to the Fascist artists' syndicates. The admissions policy removed a large portion of the Italian pavilion from the regular jury process and left it to be filled through the competitions, now tied tightly to the production of Fascist-inspired art. A comparison to earlier Biennales shows the move away from the inclusion and consensus philosophy: where the 1938 exhibition consisted of 50 personal retrospectives and 157 competition winners, the 1934 Biennale had shown 512 Italian artists and that of 1936 displayed the work of 748 Italian artists. By reducing the number of artists shown and allowing them to show only through competitions or long-standing reputation, Maraini put reins on aesthetic pluralism without directly censoring it.

In order to emphasize visually the more regimented and more public form of patronage, the works of the competition winners filled the first five rooms of the main Biennale pavilion. Maraini placed the much publicized competitions for frescoes and bas-reliefs in the entrance and central reception halls. Two years earlier, in 1936, the competition results had been exhibited in the thirty-ninth of fifty available rooms. As discussed in chapter 4, the location of public art at the front of the Biennale indicated

a challenge to established patronage patterns. This was the regime's physical declaration of a new set of aesthetic priorities. It relegated the private art of the easel to the back of the display space (see fig. 21).

With the onset of World War II, coercive cultural practices intensified and the regime's previous anxiety over overt censorship dissipated. Official culture of the early 1930s had used incentive and inclusion to draw in artists; by 1940 overt exertions of state power and restriction over content and style defined much of state patronage. Backward-looking, static and celebratory works dominated the 1940 Venice Biennale. That year the government- and party-sponsored competitions composed the exhibition's most salient characteristic. This Biennale dictated both form and content to those competing, as the competitions combined Fascist topics with public and Roman-inspired art forms. Seven competitions were divided among frescoes and bas-reliefs on "themes of Fascist life," etchings "illustrating the words of Mussolini," medallions "inspired by sports," garden statues, paintings "interpreting antiquity," and Venetian landscapes.[84] The requirements held that the frescoes and bas-reliefs be based on one of the following themes: "The Duce and the People," "The March on Rome," "The New Cities," "The Empire," "Squadrismo," or "Legionnaires."[85] Accelerating the trend begun in 1938, Maraini accorded the fresco and bas-relief competition winners the "grand central hall."[86]

These first wartime Biennale competitions privileged the language of both cultural autarchy and Nazi cultural ideology. Nationalism, idealism, classicism, and *romanità* bore increasingly narrow and stylized definitions. The portrait competition called for work that would present the "eternal humanity in art"—a formulation that repeated the Nazi precept that art was transcendent and universal, not shaped by political and social contingencies.[87] The competition for garden statues declared that it recaptured "an antique and characteristic Italian tradition." With the belligerent rejection of international influences and the search for an "imperial culture," the "looking back" to classical Rome became the central aspect of *italianità*. Maraini introduced the seventh competition for "an interpretation of the antique in painting, sculpture, engraving, or drawing." "Studying the legacy of the ancients directly," continued Maraini, ". . .would allow artists to remain faithful to the genius of the *race*."[88]

Since the dictatorship's new patronage style was more concerned with the production of art that was measurably Fascist than consent on the part of artists, it chose the competition winners in 1940 in a way that rewarded those explicitly committed to the regime's policies. The fresco and bas-relief competitions reserved half the winning places for "young artists enrolled in the Gruppi universitarie fascisti (Fascist University Groups) and half for artists belonging to the Fascist Syndicate of Fine

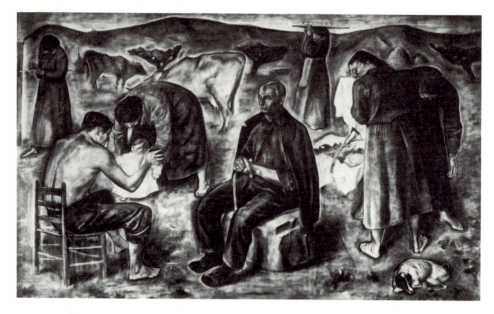

36. Ilario Rosi, *La famiglia* (*The Family*), 1940 Venice Biennale fresco competition winner.

Arts.[89] In total, artists submitted fifty-eight fresco proposals, of which the jury chose eight from the university competitors and eight from the syndicates. Six of the sixteen selected works were entitled *The Family*, with the others called *Legionnaires at Rest, They Found the Cities, Dawn of October 28th*, and *Towards Empire*.[90] The fresco and bas-relief categories drew 415 competitors. A total of 1,470 artists competed in the seven competitions. Of this number, 304 or 20 percent were chosen.[91] This was the highest percentage of competitors selected from the competitions since the first competitions of 1932. The usual rate of acceptances had been approximately 8 percent, but this commission had been "very broad" in its acceptances because it wanted to reward the young participants.[92] The winners were primarily newcomers to the exhibition system, as few of the 1930s most prominent artists had competed.[93] Fascism's revised patronage strategy had exchanged celebrity for commitment.

Censorship inhered in the commission's "certain suggestions" to the winners. The commission asked the author of the fresco, *Costruiscono le città* (*They Found the Cities*), to give the central figure of his composition a closer resemblance to Mussolini.[94] The committee requested that Ilario Rosi dress the nude female figure in his *La famiglia* (*The Family*) which, they claimed, "had no reason for being that way" (fig. 36).[95] Another winner, according to the commission, had to reduce the elements of easel

painting, which kept his work from truly reflecting the character of murals. Four of the university winners redid their murals to the jury's specifications.[96]

The wartime jury was above all interested in an artist's ability to follow directions. It noted that "artists have responded from all over Italy with great engagement, *while also* reaching a notable level of artistic achievement."[97] Engagement had become more important than critical success. Like the other juries that presided over fine arts exhibitions in Fascism's last years, this jury consisted of artists associated with the elevation of historicism and *italianità*: in this case, Ferrazzi, Felice Carena, Edoardo Rubino, Vincenzo Ciardo.[98]

The radicalization of Fascist cultural politics was not unanimously supported. Critical reactions to the fresco competitions mirrored larger discord and competing visions of late Fascist culture. The responses of the critics also showed the legacy of the early 1930s, when the regime had pursued critical acclaim. Responses ranged from tacit support for policies that pursued artists' voluntary engagement, to a fear of censorship, to demands that the regime move toward greater regulation of the arts. Moderate critics reacted to the contrived nature of the frescoes on Fascist themes. "We understand the good intentions behind the competitions," wrote the reviewer for the art journal *Maestrale*, but "these three attempts are going increasingly worse": "The first time (1936), one room was sufficient; . . . the second time, they called upon adults, in addition to young artists and everyone responded poorly."[99] The third attempt of 1940, for this critic, was the "worst . . . because the attraction of a prize invites artists to do something they do not believe in." "The goal of these artists," he continued, "is not do to the best [work] possible, but to win the competition, or, at least, to place themselves well in the arts bureaucracy." Few artists, for this reviewer, excelled at subject painting—to compel many to attempt it only encouraged mediocrity. The Biennale would surely fail once it abandoned "judgments strictly critical and independent of any and all external demands."[100] For the competitions "the best artists are rejected," lamented another critic.[101] Critics accustomed to the flexibilities of aesthetic pluralism considered themselves free to judge this element of official culture a failure.

In *La nuova antologia*, Virgilio Guzzi called many of the frescoes "excuses for rhetoric and didacticism," which "overall were entrusted to people who were overcome by the novelty of the technique." "Some of these artists," he added "had produced cartoonist and crudely rhetorical work out of a lack of imagination."[102] Guzzi offered the ever present Ferruccio Ferrazzi as an example of problematic and forced *italianità*. Ferrazzi, noted Guzzi, endangered his work through "the weight of his

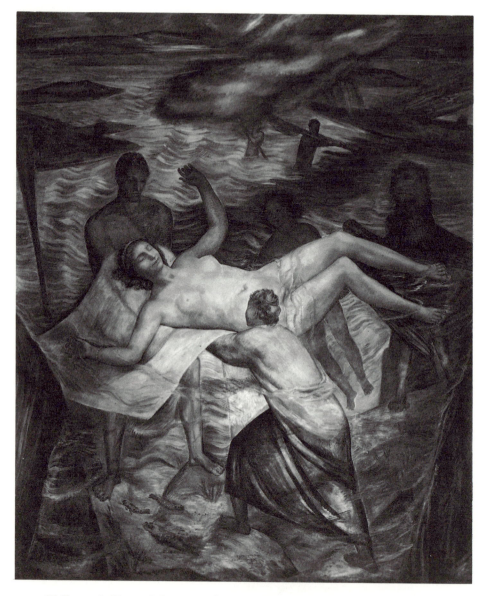

37. Ferruccio Ferrazzi, *La nascita di Venezia* (*The Birth of Venice*), 1938 Venice Biennale fresco competition winner.

glorious intentions."[103] Ferrazzi's winning fresco, *La nascita di Venezia* (*The Birth of Venice*), depicted Venice's mythic origins (fig. 37). The fresco portrays a primordial lagoon scene in which a female figure at the center floats just above the water. She reclines in a birthing pose and is held up

by four figures, one of which is the winged lion of Saint Mark. The artist has self-consciously recruited Italianate references: Venetian symbolism, secular Italian art historical references, and religious ones. Reenacting a baptism, the figures are all partially immersed and the Venetia figure lies in a cruciform pose. She emerges from the sea, like Botticelli's Venus, but the lack of interest in perspective plays on the composition of medieval frescoes. The artist resorted to a dual aesthetic, mixing his metaphysical roots with, as a critic bemoaned, "a realism not without fragments of scholasticism."

Where moderates found the competitions overly constraining for artists, cultural intransigents saw not enough regulation. For Pensabene in *Il Tevere*, while some "healthy forces remain concentrated in painting and sculpture," overall the arts were still too "international."[104] In another article on this same Biennale, Pensabene played the racial card, which fused anti-semitism, modern art, and foreign influences; he accused the exhibition of operating in a "Jewish climate."[105]

In contrast, the journal of Bottai's Ministry of National Education, *Le arti*, used a growing cultural opposition figure to declare its stand against the restrictive policies. Renato Guttuso, a young expressionist painter who came of age under Fascism and who later became one of the central cultural figures of the postwar Italian Communist Party, embodied the system's tensions and contradictions. He belonged to a cultural *fronde* growing from within the regime itself that decried the bombacity and vulgarity of militarized Fascist culture, while also participating in less restrictive components of official culture, such as the Premio Bergamo. Revised patronage at the Biennale, wrote Guttuso, offered a "static" vision of Italian art. For Guttuso, the regulations had strangled the creative impulses of participating artists to the point of inertia. "The selection criteria . . . are founded on the principle of traditionalism," he lamented, almost "signifying reaction."[106]

Even Maraini admitted disappointment with the competitions, citing that they "had not given results worthy of the anticipation they provoked."[107] However, Fascism's new patronage style, which stressed the importance of official events as training grounds, made the competitions essential, even if they failed to meet expectations. The landscape and portraiture competitions might be reduced in the future, but not the historically loaded frescoes and bas-reliefs, because "these [competitions], even when they were not completely successful, represent a possibility of training and examination for the young in the field of mural painting."[108]

The onset of World War II and the mounting pressure by example of Italy's Nazi allies mobilized art fully into the war effort. Maraini designed the 1942 Biennale—the Mostra di guerra (War Exhibition)—as a tightly

coordinated celebration of war propaganda. He explained that it was a Mostra di guerra both "for the moment and climate in which it opened" and for "some of the special programs that will constitute the most salient elements of the show."[109] Regulations announced that the show would focus "around the artistic production of the Axis." Further, declared the official announcement, "the adhesion of friendly nations guarantees the exhibition a level of success commensurate with the faith and the spiritual force with which Italy faced the difficulties of mounting the show."[110] For *Il popolo d'Italia* the presence of friendly nations at the Biennale "offers proof of their confidence in Fascist Italy and documents their faith in an undeniable Axis victory and in the destiny of a New Europe."[111] Of course, "friendly nations" meant Axis allies and puppet states—Germany, Japan, Spain, and the Protectorate of Bohemia Moravia.

At the 1942 Biennale, the regime controlled cultural production tightly enough to mount an exhibition that unambiguously displayed work supportive of its policies. But, such a coordination of artistic display had a price both in terms of public and critical response. The Mostra di guerra centered on "three grand collections of painting, sculpture, and drawings inspired by military activities today operating on land, water, and air."[112] The Ministries of War, Aeronautics, and the Navy directly administered the three main displays and required that the works contained therein relate to the accomplishments of the sponsoring ministry. Maraini explained that the Biennale's "goal" in promoting such exhibits was "to give artists a chance to demonstrate the part they play in the Italian people's effort toward attaining victory."[113] The Biennale hoped that "art inspired by war" would go beyond depictions of war into "illustrations of aspects of civilian life created by the state of war" and of "the activity of the most diverse sectors in preparation and assistance to the armed forces." Maraini looked forward to portrayals of "the assistance given to the wounded and the families of the soldiers," as well as of "the take off and landing of the navy and air force."[114]

In addition to the war pavilions, the 1942 Biennale promoted four competitions open to all members of the Fine arts syndicate and all "young artists enrolled in the G.U.F. [Gruppi universitarie fascisti], students or graduates of the Royal Academies of the Fine Arts and Royal Institutes of the Arts."[115] The four competitions were the last in regime's attempt to shape cultural production through the policy of theme competitions. Those of 1942 called for "compositions in either painting, sculpture, engraving, or medals with one or more personalities who represent aspects of the contemporary life of Fascist Italy."[116] These were the most rigidly constructed of all the competitions promoted by the regime in its fifteen years of arts patronage. Previously the Biennale propounded tightly con-

ceived competitions alongside those for landscapes or portraits or garden statues. But not in 1942.

Despite the fact that Maraini extended the closing date for the 1942 competitions, the response was very weak. The war and the regime's embattled position both at home and at the front drained such events of the interest of both artists and spectators. In addition to a lackluster showing on the part of artists, the submitted works were of poor quality and often paid little attention to assigned themes. For the competitions requiring works based on "contemporary Fascist personalities," Maraini complained that "these compositions were understood" in such a loose manner "that they often consisted of a simple portrait or in no more than a landscape with a few characters."[117] Nonetheless, the jury accepted many such entries because "when faced with the alternative of leaving the competitions empty or interpreting the regulations loosely, it preferred the latter."[118] The commission's willingness to embrace art that failed to respond to the competitions' requirements, as well as its ability to express disappointment, showed the gap between policy and practice. The Italian Fascist attempt to emulate Nazi restrictions upon content consisted of an incomplete imposition of a policy that became flexible once put into practice.

The heightened patriotic rhetoric surrounding the competitions failed to stir the passion of artists. The regime had altered its patronage style, but a vast majority of artists remained outside. In the pavilions of the armed forces, 172 artists displayed 460 works of painting, sculpture, and drawings. The other competitions displayed 115 works of art by 98 artists.[119] The pavilions of the armed forces consisted of a collection of official portraits, stylized and bombastic war-related scenes, such as battle camps, submarine bases, soldiers at rest, and infantry maneuvers. Some of the drawings of Soviet soldiers and prisoners of war had integrated Nazi racial ideology to the point of offering barbaric, animal-like, and deranged renderings of the enemy. Taken together, the art of this War Biennale consisted of a lifeless collection of illustrationist and Fascist-realist renderings of combat and war.

The 1942 Biennale was the regime's attempt to orchestrate a visual celebration of a nation at war. As at all the Biennales of the 1930s, Maraini's choices for the grand central halls represented a barometer of official priorities. Poorly executed neoclassical frescoes adorned the grand entrance hall in 1942. With their depictions of four "dates representing particularly heroic moments in the history of Fascism," these frescoes promised to rouse feelings of fervent patriotism in the viewers.[120] In the middle of the hall towered monumental effigies of Mussolini and Emperor Victor Emmanuel. The combination of frescoes detailing Fascist

victories and statues of Mussolini and Victor Emanuel solidified the presentation of the war as a fully national-Fascist struggle. "In this way," wrote Maraini, "from the moment of arrival the visitor will feel the military atmosphere in which the show is being held and in which the artists have come to be prepared." If the Biennale of the early 1930s asked the viewer to choose from a range of styles, this Biennale told the spectator what to see and how to interpret it.

Even though it was Fascism's time of crisis, many critics were not on the official bandwagon. The Battle for Culture's many camps remained intact through the regime's collapse. Many critics had not been brought into the cultural *Gleichschaltung* and remained by and large unenthusiastic about the War Biennale. One local newspaper reported that "on the artistic front, there is nothing worthy of note."[121] Another critic, from Fiume, wrote, "a panorama of the XXIII Biennale has so little to offer . . . many [artists] seem feeble and in decline."[122] Yet another reviewer lamented, "Once seen, this Biennale disappoints."[123]

On the other hand, cultural antipluralists, whose power and influence had grown significantly with the war, finally celebrated official culture. *Il Tevere*, the virulent pro-Nazi and anti-Semitic journal headed by Giovanni Preziosi, called the 1942 Biennale exhibition "an impressive collection of international art." *Quadrivio*, the consistent supporter of an Italian Fascist emulation of Nazi cultural policies, wrote that "this Biennale of War has a certain tone of engagement on the part of painters and sculptors which differentiates it from the past. . . . One could say that each [artist] has refound himself through an artistic sincerity that often has been missing these days."[124] Throughout the 1930s the figures around *Quadrivio* had been dissatisfied with the regime's failure to discipline the arts. Only the level of politicization and censorship imposed by the war and the subordination of Italian Fascism to Nazism contented the cultural hard-liners. Pippo Rizzo, the *Quadrivio* critic, found the pavilion of art dedicated to war sturdy and "well nourished."[125] According to Rizzo, competitions based on the subject of war were restorative and educative, since "artists of every genre can put themselves to the test with this subject."[126]

Government and party prizes and purchases were the other primary forms of state patronage of the fine arts. These mainstays of the Fascist incentive system also were redefined after 1936. As attention moved to the competitions and to demanding specific responses from artists, the offices of the party and government allotted less money for prizes. In 1938, the number of prizes at the Venice Biennale fell to six, evenly divided between Italian and foreign artists. Mussolini personally sponsored two Premi del Duce (Duce's Prizes) worth 25,000 lire each, for

a foreign painter and sculptor.[127] The city of Venice designated 25,000 lire for an Italian painter and sculptor, respectively, and President Volpi offered 5,000 lire to an Italian and foreign engraver.

An international jury selected the 1938 prize winners. The composition of the "international jury" attested to the growing conflation of Fascist foreign and cultural policy. In addition to Maraini and the painter Felice Carena (whom we have already seen as a participant in the Premio Cremona), the jury consisted of Eugenio d'Ors, national head of the Fine Arts of Spain; Professor Fredrich Willis, president of the German Academy of the Fine Arts in Rome; and Professor André Dezzarois, director of the Jeu de Paume Museum in Paris.[128] Nonwithstanding the designation "international," the jury consisted of members from nations allied with Fascist Italy (Spain and Germany) and/or promoters of either a conservative historicist aesthetic or a celebratory, classicizing one. The conservative jury chose conservative and traditional artists. The Premi del Duce went to the Spanish painter Ignacio Zuloaga and Swiss sculptor Hermann Hubacher.[129] Zuloaga, who had won a prize at the 1903 Biennale, was honored for his portrait of a bullfighter.

In 1940, Mussolini promoted two Premi del Duce for a foreign painter and sculptor and the city of Venice offered two prizes to an Italian painter and sculptor.[130] While the members of the 1938 international jury had shared conservative aesthetic tastes, the 1940 prize jury not only held common conservative outlooks, but came exclusively from the ranks of Fascist allies. The members of this jury included the president of the Reich Chamber of Art, a Hungarian professor of art history, a Spanish parlimentary deputy, C. E. Oppo, and Maraini.[131] Professor Adolf Ziegler of the Reich Chamber of Art, the Nazi representative, was a favorite painter of Hitler's and the organizer of the Degenerate Art Exhibition. Soon after the Nazi takeover, he quickly purged state collections of the work of Chagall, Klee, Kandinsky, Degas, Van Gogh, and Cezanne, among others. His depiction of ideal and racially pure Aryan maidenhood, *The Four Elements*, hung over Hitler's fireplace. This jury awarded the Premi del Duce to the Hungarian painter William Aba Novak and the German sculptor Arno Breker.[132] Breker's work, which found great favor in Nazi cultural circles, consisted of hyperclassicized depictions of Nazi heroes and soldiers. His allegorical figure, *The Party*, flanked one of the entrances to the new Reich Chancery in Berlin.

While government and party prizes represent a clear indicator of changing tastes and priorities, official acquisitions had been the primary consent-building technique at state-sponsored exhibitions. These too change character after 1936. Official buyers made new demands upon artists. Acquisitions had been the site of the eclectic patronage, which had

acquired for the government and party large collections of contemporary Italian art that included a broad spectrum of styles and talents. After 1936, gone were the days when mere participation sufficed. Fascist officials now used purchases as rewards for commitment, rather than as incentives for participation or as a way of creating a national patrimony of critically acclaimed contemporary art.

Official purchases of Italian art at the 1936 Biennale moved dramatically away from an emphasis upon the novecento school and other modern-inspired movements. Instead, the Ministry of National Education spent much of its 76,000 lire on the work of younger artists and competition winners, such as Fabio Mauroner and Ugo Ortona.[133] Artists active in the syndical organizations, such as Ferruccio Ferrazzi and Michele Guerrisi, were sure to be purchased.

If the government and party became more demanding and selective in their patronage, they did not decrease their spending. Despite the Ethiopian War and a drop in both attendance and total sales figures in 1936, government and party patronage remained financially strong.[134] Total sales declined to 912,000 lire in 1936 from 970,000 in 1934 and 1,154,675 in 1932.[135] Nonetheless, the combined purchases of the government and party totalled 168,850 lire, or 27 percent of total sales, which was close to the average figure for 1930–36.[136] The major government ministries bought 45,000 lire worth of foreign art, as compared with 10,000 lire in 1934 and nothing in 1932 and 1930.[137] As in 1934, the choices of the Office of the Council of Ministers, the Ministry of Foreign Affairs, and the Ministry of Press and Propaganda echoed geopolitical realities: works of sculpture and painting by seven Austrians, six Hungarians, and four Germans were bought to adorn government offices.[138] The purchases of the Office of the Council of Ministers, totaling 19,550 lire, were made officially in the name of the Duce.[139] Those purchases consisted of seven works by Austrians, Germans, and Hungarians, and a single canvas, entitled *Combattimento di Debrambà* (*The Battle of Debrambà*), by the Italian futurist, Arturo Menin.[140] For the previous Biennale of 1934, Mussolini authorized the purchase of thirty-three works, of which only seven were by foreigners.[141] In 1936, although concerned with German domination of Austria, the League of Nations' sanctions and the reality that Germany now provided Italy with much of its war materials pushed Mussolini closer to Nazi Germany. Improved Italo-German relations were manifest at the Biennale by Mussolini's purchase of a granite sculpture by one of Hitler's favorite artists, Joachin Utech.

In 1938, Mussolini augmented his promotion of Premi del Duce with 20,000 lire worth of personal purchases. The Duce's five purchases in-

cluded the work of two Italians, two Germans, and a Hungarian artist.[142] The Italian artists, Armando Baldinelli and Filippo Sgarlata, had won in the fresco and bas-relief competitions. Sgarlata's bas-relief, entitled *It Is the Plow That Draws the Sickle, but It Is the Sword Which Defends It*, and Baldinelli's fresco, *Episodio di Padre Giuliani (Episode of Father Giuliani)*, responded to the new imperatives in both style and content. Baldinelli's fresco, a depiction of the death of a priest during the Ethiopian War (fig. 38), employs racialized and stereotypical representations of the Ethiopians as savages: they are dark antiheroes in chaotic motion while Father Giuliani is calm, swathed in white. A veiled rider implies the priest's impending martyrdom. The compositional void above the priest symbolizes his martyrdom and his imminent ascension to heaven. The denuded landscape with the battle of swords compressed in the foreground refers to Sienese Renaissance frescoes, such as those by Paolo Uccello. Sgarlata's bas-relief, which depicts an idealized Roman soldier and farmer bound together in the their service to the state, turned to a different set of historical Italian references—ancient Roman bas-relief. The static, monumental figures focus on exaggerated musculature and idealized symbolic representation, as in the soldier's face and armor (see fig. 33). Steeped in references to the Italian artistic patrimony, both works embraced military and "historical" themes.

The foreign purchases also attested to the changed climate: in addition to a naturalist genre painting, *Peasant*, by Thomas Baumgartener, Mussolini bought a *Bust of Hitler* by Josef Thorak, whom Maraini hailed as a "noteworthy, rich artist, beloved by the Führer."[143] Thorak specialized in the grand scale monumental figurative sculpture preferred by the Nazi hierarchy.[144]

By 1938 rewards with few strings attached were gone: if the category of appropriate "Fascist art" remained vague, at least revised Fascist patronage would reward those who committed themselves to the competitions and the rhetorical bases implied in them. Government ministries and party organizations together spent 350,00 lire (including prize monies) out of total purchases of 1,225,456.65 lire—a slightly higher percentage of the total than in past years.[145] Private sales declined from 1932–36 levels. The government's emphasis on the purchase of works by foreign artists, begun in 1936, grew in 1938. The Ministry of National Education, which spent the preponderance of official money, alloted 58,000 lire for foreign works and 74,000 lire for Italian art, as compared with 130,000 lire solely for Italian art in 1930–34.[146] In tune with diplomatic considerations, Italy's allies received the heaviest patronage and most of the art purchased came from Germany, Spain, and Hungary.

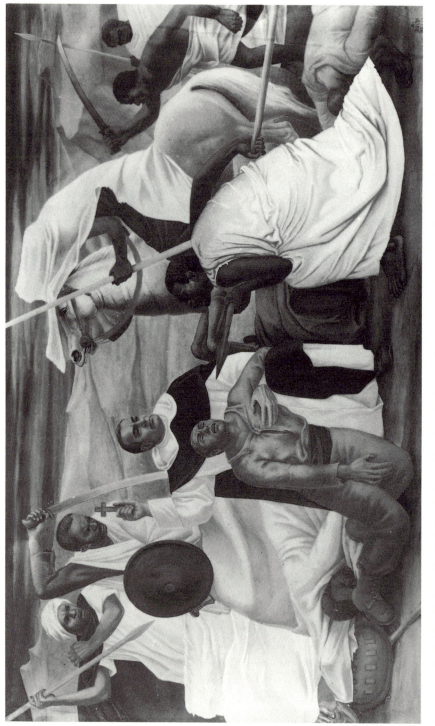

38. Armando Baldinelli, *Episodio di Padre Giuliani* (*Episode of Father Giuliani*), personal purchase by Mussolini and 1938 Venice Biennale fresco competition winner.

Like the theme competitions, official acquisitions cultivated young artists who cooperated in the altered cultural climate. In 1940, for the first time in the history of the Fascist administration of the Biennale, government ministries issued specific directives regarding purchases. The Ministry of National Education "frequently showed a preference for young artists, the support of whom seemed worthy of encouragment and reward."[147] Further, the ministry declined to purchase the work of artists who had either shown "a large number of paintings or sculpture" or who had been "regularly patronized by the state."[148] Of the fifty-three pieces of Italian art bought by the Ministry of National Education in 1940, over half were the work of competition winners.[149]

World War II notwithstanding, government and party expenditures for acquisitions rose. For the 1940 Biennale, the contributions of the various government ministries and party organizations rose to 40 percent of total sales.[150] Total sales fell to 1,070,295 lire from 1,225,456 lire in 1938, but the government and party spent 390,000 lire, compared with a contribution of 350,000 in 1938 and 168,450 in 1936.[151] Maraini noted that now the "majority of purchases" were "made by so-called 'officials.'"[152] Despite a political situation that demanded financial restraint, money continued to flow into the purchase of art.

The Italian casualties on the Russian front and the changing fortunes of the war did not threaten the regime's commitment to expenditures on the arts. On the contrary, government and party purchases at the 1942 Biennale reached unprecedented levels. To start, in 1942 the regime put forward 289,000 lire in prizes in addition to its purchases. The government spent a record 650,000 lire on foreign works, overwhelmingly of German and Austrian authorship.[153] Significant new buyers were the Ministry of Aeronautics, the Ministry of the Marine and the Army.

 In the early and middle 1930s, the bulk of state patronage had gone to the celebrities of the novecento and "return to order" movements. The regime had hailed its ability to select the best work of the most acclaimed artists. With the wartime anxiety about commitment to Fascism, the regime shifted the bulk of its patronage away from the celebrities of the novecento, futurist, and strapaese movements to younger, more malleable artists. By 1940 few of the once familiar names—Casorati, De Chirico, Morandi, or Sironi—were on the lists of government purchases. Instead, the government and party rewarded young artists, members of the Gruppi universitarie fascisti (Fascist University Groups) or of the syndicates. The highest prices paid by the Ministry of National Education in 1940 were 8,000 lire for *Il ritorno der legionari*

(*The Return of the Legionnaires*), by Giovanni Barbisan, and 9,000 lire for *La protezione della maternità e l'infanzia* (*The Protection of the Mother and the Child*)—both the work of unknown, young artists who had played by the rules and had joined the competitions.[154]

Thus, in all its elements, from prizes to competitions to purchases, state support of the fine arts after 1936 mirrored both Fascism's changed attitude toward art and the distintegration of cultural life. No victor had been declared in the Battle for Culture, but the collateral damage of the war put an end to aesthetic pluralism as the dominate ideology of Fascist cultural politics.

The Rejection of Bourgeois Patronage

The simplified, rationalist facade of the main pavilion at the Venice Biennale designed by Dullio Torres in 1932 provided insight into the character of Fascist patronage; so did the alterations added to it in 1938. For the inauguration of the 1938 Biennale, Maraini commissioned two large frescoes for Torres's clean, crisp facade. Revising the earlier contention that the unadorned facade bore a "sober harmony" capable of attracting vast audiences, two allegories now educated. Left of the entry stood *La regina del mare* (*The Queen of the Seas*) by Antonio Santagata (fig. 39).[155] Santagata's composition consisted of an upper and lower register: at the top a figure representing "the queen of the seas" filled the foreground, with a topography of Venice in the background. The lower foreground of the fresco was divided between Saint Mark pointing to his Gospel and two World War I soldiers looking toward the World War I trench scene that occupied the remainder of the space. The fresco's structure is that of a Renaissance altarpiece following an "assumption of the Virgin" typology, though in this case the "Queen of the Seas" figure is more architectural and powerful than common depictions of the Virgin. Her seated regal bearing and costume (ermine gown) bring her close to representations of *ecclesia* (the church). The iconography is both national and regional, as the primary symbols of Venice—Saint Mark, the sea, and the city itself—share the space with references to national and Fascist strength. The Queen of the Seas figure holds a fascio in one hand and a Venetian galley ship in the other. The fresco's lessons contain both past and present: Venice, given strength by Fascism, will again predominate, and Fascism, as the embodiment of all Italian historical triumphs, has the blessing of history—secular and Christian.

Francesco Gentilini's *La nascita di Roma* (*The Birth of Rome*), a naturalist-archaic pastoral scene of peasants surrounding Rome's founders,

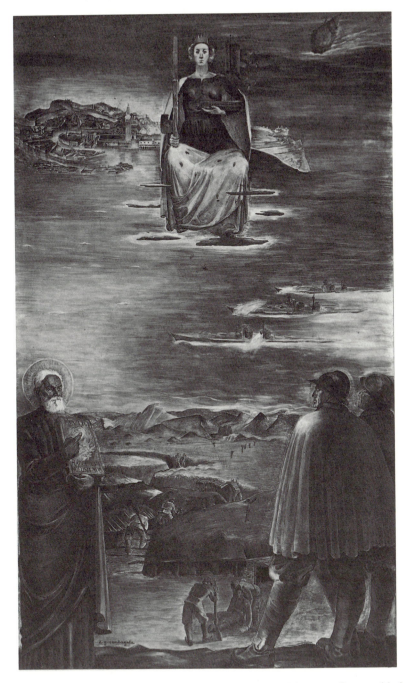

39. Antonio Santagata, *La regina del mare* (*The Queen of the Seas*), fresco added to the Italia pavilion facade in 1938.

Romulus and Remus, decorated the facade's right side.[156] These frescoes, emphasizing *italianità* and empire, reminded the visitor that official culture now carried certain messages, both formally and discursively. Both frescoes, representational and historically inspired, connected historical Italian triumphs and struggles (the founding of Rome and Venetian naval glory) to contemporary Fascist ones (World War I and the empire in Ethiopia).

The changes in the practices of arts patronage amounted to a rejection of the bourgeois patronage styles that had characterized the regime's behavior at fine arts exhibitions. The attitude of the offices of the party and the government toward artists and audiences had undergone a revolution. The regime abandoned the conception of the artist and arts patronage it had inherited from pre-Fascist elites. The earlier conception saw the artists as isolated individuals pursuing aesthetic creation. In the "art for art's sake" philosophy, the work of art was to be purchased by private patrons for individual pleasure and consumption.

As of the late 1930s, official arts bureaucrats often interpreted the stylistic preoccupations of modernism to an elitist, ivory tower conception of cultural politics. Aesthetic pluralism, modernist-inspired art, and art tied to the art market of private patrons had failed to represent Fascism. Official culture articulated the attack on bourgeois patronage in a variety of ways, including less fear of challenging the celebrities of the art world, a more condescending view of the public, and a diminished interest in gaining public consent through accommodation. At the Venice Biennale, this was seen in the rise of public art, an overt didacticism that often translated into diminished interest in pleasing critics and artists, and an administrative reorganization that centralized state patronage.

With the mobilization required by war, the regime unhinged the Biennale from its origins and the genre received the greatest transformation of the decade. In 1936, Maraini's language shifted, reflecting a shift in the much of the Fascist bureaucracy's understanding of the purpose of official cultural institutions. As one of the dictatorship's primary cultural administrators—he was both secretary-general of the Biennale and head of the artist's syndical organization—Maraini's understanding of the purposes of official culture was critical. He exchanged, by 1936, an earlier praise of the quantity and variety of Italian art shown at the Biennale for a celebration of the victory of "Fascist civilization." Maraini looked back disdainfully to the competitions of 1930 and 1932 which had centered on easel painting:

> Who does not remember, in fact, the theme competitions of the 1930 and 1932 Biennales? Then, the attempt seemed to defile the ivory tower

of that so-called "pure art." Today its repercussions and developments are found everywhere and are among the aspects of artistic life that arouse the greatest interest.[157]

The competitions, for Maraini, proved the integration of artistic production into the national cause.

Art, Fascism began to declare, would have to provide more than a source of legitimation. Maraini articulated these revised goals: "The Biennale wants to be more than an exhibition. . . . The development of the collective life of the nation asks continually more from artists capable of understanding it, of representing it, of exalting it. And we have the duty to help them, discover them, and display them."[158] The Biennale's task now was to lead those artists willing to take up the cause of the nation. Where earlier Maraini spoke of bringing in the best of Italian art, by 1938 he saw the Biennale as a "training ground" for the development of an art expressive of "the collective life." The new conceptions of artists' role and audience's influence reverberated throughout official culture. Official culture replaced the philosophy of consensus through diversity with the "aspiration to a cultural goal and an aesthetic purpose."[159]

The Pact of Steel with Germany of May 22, 1939, and Italian intervention in World War II in June 1940 narrowed the gap between Italian and National Socialist patronage styles. The increased power of the cultural antipluralists and their appointment to high-level posts in the Ministry of Popular Culture produced attempts to "totalitarianize" cultural policy. With the war, a number of moderates fell from power to be replaced by pro-Nazi hard-liners. One such figure, Alessandro Pavolini had been appointed to the Biennale Administrative Council in 1938 and in October 1939 he replaced Dino Alfieri at the Ministry of Popular Culture.[160] Trained as a journalist and lawyer, Pavolini was an early adherent to Fascism who, by 1934, was a member of parliament and the Fascist Party Directorate. Between 1937 and 1939, he served as president of the Fascist National Confederation of Professionals and Artists. When he became minister of popular culture in 1939, Pavolini imposed his militant cultural views and drive for bureaucratic centralization upon the ministry.[161] He supported the anti-Semitic racial laws adopted by the regime at Nazi insistence in July 1938 and wrote for the anti-Semitic journal *Il Tevere*. Pavolini's pro-Nazi sentiments intensified with World War II: after escaping to Germany at the time of the armistice between Italy and the Allies in September 1943, he served as secretary of the Fascist Republican Party in the Salò Republic and was captured and killed by partisans, along with Mussolini, on April 27, 1943.[162] Other figures, such as Celso Luciano and Luigi Freddi, also brought a hard-line influence to official culture. The

new Biennale appointees of 1938 bore witness to a centralized cultural policy. A number of prominent ideologues and functionaries of the Ministry of Popular Culture joined the Biennale committees at this point: by 1939, the Administrative Council consisted of Volpi, Maraini, the *podestà* of Venice, the *preside* of Venice, Domenico Fabbri, Virginio Bertuccioli, Celso Luciano, and Alessandro Pavolini.[163]

The regime's abandonment of the cultural practices of the early 1930s meant the alienation of many spectators from official culture. Of course, it is difficult to determine the extent to which audience disinterest was the result of war conditions or the regime's revised cultural policies. The 1940 Biennale opened its doors in the weeks prior to the Nazi invasion of France and the Italian declaration of war on the side of the Axis. The decline in public interest was marked. Attendance numbers at the Venice Biennale fell in direct correlation with the imposition of the restrictive policies. Attendance dropped from 450,000 visitors in 1934 to 270,000 in 1936, and in 1940 to 87,391 spectators for the exhibition's five month duration of May 18, 1940, to October 20, 1940.[164] For the 1942 edition, this figure would drop again to only 76,679 visitors. On Sunday, July 1, 1942, for example, the Biennale counted 702 visitors, compared with 3,610 visitors on Sunday, September 17, 1934, and 4,756 on Sunday, September 24, 1934.[165] As a result of the Battle for Culture, the Fascism's once overriding interest in bringing together audiences for official events was subordinated to the ideological consistency. Thus, the impulse of official culture that had encouraged mass support at the cost of flexibility and incentive dissipated. This was obvious in the government's reduction of the travel incentives it offered: the Ministry of Communications markedly cut the train fare discount program, which had been a central component of the Venice Biennale's expansion in the 1930s. In 1940, travel discounts dropped from 70 to 50 percent and the days for using them fell drastically.[166] The war and propaganda considerations made it impossible to offer the incentives and to cater to cultural tastes of a few years earlier. The lifeless art, the conditions of war, and the disappearance of the incentives that had drawn in audiences meant that official culture in its last moments played to an empty house.

The Battle for Culture of the late 1930s divided official culture into fiefdoms, with each respective camp offering competing visions of what Fascist art and cultural politics should look like. A historicist, coercive, and censored patronage style, which asked artists to produce specific artworks with defined themes, dominated a number of cultural institutions. While the cultural hard-liners' attempted emulation of Nazi cultural politics and their degenerate art campaign failed, these rejectors of aesthetic

pluralism and modernist influences destroyed the cultural compromise that had reigned to date.

As long as a majority of the regime's cultural policy makers believed aesthetic pluralism the best way to bind together cultural producers, the regime, and audiences, the system functioned. As factions broke off, elevating conflicting patronage patterns and counterdiscourses regarding the relationship between art and the state, the state's hegemonic control over the means of representation diminished. With this, the system unraveled, as many artists and spectators abandoned it.

The Rise and Fall of the

Fascist *Gesamtkunstwerk*

THE Mostra della rivoluzione fascista, the tenth-anniversary exhibition of 1932, permanently reshaped state patronage and Fascist mass culture. The Mostra, interpreted as a Fascist *Gesamtkunstwerk* of pathos, myth, and power, was praised by officials, artists, and critics alike as truly innovative and uniquely Fascist. "We will say soon that this represented the first true attempt of Fascist art," wrote Francesco Barone, ". . . not so much for the originality of some of the pieces . . . [but] because it synthesized the most impassioned aspects of the life of our time."[1]

The Mostra della rivoluzione fascista quickly became the prototype for a developing Fascist mass exhibition culture. The Fascist Party, which promoted the vast majority of such topical exhibitions, placed them at the center of its mass culture program in the 1930s. With the Mostra della rivoluzione fascista, the dictatorship had discovered a mass exhibition formula that attracted fervent support from artists, critics, and audiences. As discussed in chapter 5, the Mostra della rivoluzione's success was based on three primary factors: (1) the integration of aesthetics and artifacts and the appropriation of avant-garde exhibition design and architecture; (2) the mobilization and mythification of the discourse of national culture and the reformulation of the Fascist cult into the national cult, through its articulation as open-ended and inclusive; and (3) the use of mass culture techniques of audience incentive.

The Fascist-sponsored exhibitions that followed strove to reproduce the 1932 triumph, but, as the decade progressed and modernism came under attack, the formula was eventually abandoned in favor of less ambiguous and more documentary exhibition formats. This chapter focuses on the two directions in which the regime took its mass exhibition patronage after 1932: with the Mostra aeronautica, the dictatorship expanded the form of the modernist political exhibition. As the decade evolved some elements of the original style remained, but such elements were leavened by ever greater doses of classicism and *romanità*. The ris-

ing rhetorical demands of autarchy, empire, and war radicalized the aesthetics and narratives of official culture. With the exhibitions of the Circus Maximus (1936–38) and with the second edition of the Mostra della rivoluzione fascista in 1937, the regime exchanged the dynamic, modernist, and successful exhibition formula in favor of a legible and documentary one not diluted by the abstraction and ambiguity of modernism.

Paralleling official patronage at art exhibitions, official choices at topical exhibitions fell victim to demands from cultural antipluralists for a more nationalist, imperial, and totalitarian cultural politics. In an environment of autarchy and war, a growing faction within the Fascist hierarchy considered modernism "too international." Fascism's post-1936 priorities of empire, war, and race required, what some cultural hard-liners considered, clearer, more easily read forms.

In the search for ways to articulate the increasingly central discourses of empire, war, and race, Fascist exhibition organizers turned to a static reverence for documents and artifacts with which they replaced the intextuality of object, art, and viewer. Neoclassical and naturalist aesthetics, by and large, took the place of functionalist architecture and constructivist-futurist exhibition design. The decline of the formula also entailed limiting the power of artists to define Fascism—art returned to a decorative or rhetorical function and exhibition designers gave the power to convince to documents and simulations.

Expansion of the Formula

The Mostra aeronautica (Aeronautics Exhibition) held in Milan from June to October 1934 quickly followed in the path of the Mostra della rivoluzione fascista, utilizing many of the elements of the 1932 Mostra in its celebration of the past and future of Italian aviation.[2] Like its precursor, the Mostra aeronautica blended modern art and architecture with artifacts and documentation. The exhibition's itinerary began with a history of Italian aviation, led to a Sala dell'aviazione nella guerra libica (Room on Aviation in the Libyan War) and the Sala d'Annunzio (Room of D'Annunzio), and culminated in the Sala dell'aviazione e fascismo (Room of Aviation and Fascism) and the Sala d'Icaro (Room of Icarus). The exhibition rooms stressed an Italian destiny to triumph in aviation. According to the exhibition's narrative, Italy's destiny to dominate the air dated from Leonardo Da Vinci's experiments with flight and reached peaks with Fascist triumphs such as Italo Balbo's 1932 trans-atlantic flight, the "crociera del decennale" (long-distance flight of the

decennial). The Mostra aeronautica, like its predecessor of 1932, attracted a popular following that required the exhibition's extension beyond its projected run.[3]

The formal similarities between the Mostra aeronautica and the Mostra della rivoluzione fascista reveal the birth of a genre and Fascism's continued modernist self-representation. Several artists and one historian from the 1932 Mostra had moved on to the Mostra aeronautica: prominent modernists such as Mario Sironi, Esodo Pratelli, Marcello Nizzoli, and Antonio Monti participated. Though less monumental than the 1932 facade, the Mostra aeronautica facade suggested a similar rationalist symbolism and futurist geometry. Erberto Carboni recovered the preexisting facade with "a blue background, a swarm of airplanes, a map of the world, and a shining *fascio littorio*, symbolizing the primacy of Italian flight."[4] The swarm of airplanes floating above an abstracted cloud took inspiration from futurist *aeropittura* with its interest in aerial perspectives. A stylized metal fascio dominated the entrance, as at the Mostra della rivoluzione fascista; this time, the fascio floated over a circle that contained an abstracted map of Europe and Africa. Below this minimalist iconography hung the words "Esposizione aeronautica italiana" in sans serif lettering. This facade, even more minimal and futurist-inspired than its 1932 predecessor, implied that Fascism would dominate Europe and Africa through its technology and its military. The abstracted trope of Fascist technological-military triumph offered an optimistic, open reading of the future.

In addition to the synthesis of art and documentation and a common symbolism, the two exhibitions shared an itinerary that began with historical-topical rooms and climaxed in a chapel or locus for spirituality and meditation. At the Mostra aeronautica, a room dedicated to the myth of Icarus concluded the exhibition and acted as a chapel dedicated to those who died trying to cast man aloft. Giuseppe Pagano's Room of Icarus "exalted the efforts of pilots and inventors who have attempted to conquer the air."[5] Like the Chapel of the Martyrs, the Room of Icarus utilized constructivist-inspired repeated, cylindrical forms: the circular space focused on a blue metal spiral reaching from a pit in the floor up to a "black sky." Frescoes of abstracted airplane parts and birds in flight covered the circular walls. One wall bore a sculpture of Icarus in flight above inspirational words by D'Annunzio, the "poet-soldier."[6] This installation, inspired by constructivist and futurist set design, attempted to visually recreate the sensation of flight. To do so, it depended upon color, material, and design to create the meditative mood.

The Mostra aeronautica represents a peak of modernist influence upon official culture. Giuseppe Pagano and Carlo Felice were the artistic direc-

tors. The government patron, the *Podestà* of Milan, left them free to hire the artists and architects they pleased. Pagano's role was determinative and it marked a level of rationalist influence not to be equaled again in official culture. Giuseppe Pagano, editor of *Casabella*, was a strident defender of rationalism and functionalism against the monumentalizing wing of Fascist-supported architecture. As evidenced by his Room of Icarus, Pagano believed abstraction the most effective method for Fascist mythmaking and propaganda. Felice, an abstract painter, was increasingly marginalized from official culture after 1935, due to his own experiments with forging a Fascist abstraction.

The great Italian exponents of a European-wide inspired modern architecture lent their talents to the Mostra aeronautica. Luigi Figini, Gino Pollini, Ernesto Rogers, Luigi Banfi, and Ludovico Belgioso all helped to design the exhibition rooms. They did so waving the flag of contemporary European art and architecture, celebrating their borrowings from Le Corbusier, Gropius, Breuer and the Bauhaus, and expressionism. The room designed by Edouardo Persico with Marcello Nizzoli evoked Melnikov and Kandinsky with its "expressionist" use of the expository space. The designers bathed the room in an "unreal light" and used gradations of white wall displays against a black ceiling and floor to dramatize the environment.[7]

The abstraction, the aestheticization of documents and artifacts, and the reconstruction of preexisting architecture first used at the Mostra della rivoluzione fascista became the baseline onto which a range of narratives could be grafted. Reviewers explicitly stressed the paradigmatic value of the 1932 Mostra for the Mostra aeronautica. "The Milanese Aeronautics show," wrote *Architettura*, "can consider itself the little sister of the Mostra della rivoluzione . . . [which] has not failed to bear fruit."[8] For *Casabella*, the expansion of the 1932 model boded well for rationalist and avant-garde art and architecture and demonstrated the "spiritual affinity existing between many Italian artists and the most lively minds of modern day Europe"—an unabashed celebration of Fascist art's connection to the European avant-garde.[9] In the Room of Aviation in the Libyan War, artist Esodo Pratelli acknowledged the "inspiration of the Mostra della rivoluzione fascista":

> With the violent opposition of tones and the solidity of volumes, the forms and colors work to create a dramatic atmosphere. In this room, red and black are employed to evoke a scorching and burning climate. . . . The documents, as at the Mostra della rivoluzione, are assembled without precise selection criteria; a recent memory of facts are enough to hold attention and elicit interest.[10]

In the exhibition formula and official patronage style that dominated Fascism's middle years, documents played backdrop to aesthetic construction; this formula depended upon the moods provoked by a volatile blend of color, shape, and texture. Color (especially red and black), texture, and form evoked mood and abstracted Fascist priorities into a new symbolism. Art absorbed history in order to create myth. The Mostra della rivoluzione fascista and the Mostra aeronautica represented the apotheosis of a Fascist modernism, which would soon be left behind.

A Fascist Theme Park

At eight o'clock on the evening of November 18, 1938, Benito Mussolini threw a switch which opened the Mostra autarchica del minerale italiano (Autarchic Exhibition) and illuminated Rome's archaeological treasures, from the Palatine Hill to the Aventine Hill.[11] As reported by the Fascist press agency, Mussolini activated a lever attached to "thousands and thousands of machines," while "an incandescent rain fell from above" and a series of sirens wailed.[12] Hundreds of party officials and thousands of eager spectators witnessed this spectacular nighttime sound-and-light show. In the weeks that followed, the official press and LUCE newsreels dramatically reproduced the attractions for those who had missed them.[13]

The Circus Maximus exhibitions, of which the Mostra autarchica was the fourth and last, materialized the Fascist regime's political, social, and economic concerns, from its demographic campaign to its autarchy policy. Between 1936 and 1939, the administrative offices of the Fascist Party mounted four major exhibitions in the Circus Maximus in Rome. Two of them addressed Fascism's social concerns, the Mostra Nazionale delle colonie estive e dell'assistenza all'infanzia (National Exhibition of Summer Camps and Assistance to Children) (June–September 1937) and the Mostra del Dopolavoro (Dopolavoro Exhibition) (May–August 1938). The Mostra delle colonie estive hailed government and party advances in infant health care and demographic growth. The Mostra delle colonie estive, by presenting all that the regime had accomplished in improving the social welfare of mothers and children, offered a vision of a healthy, racially fit people ready for war. Its displays and pavilions covered topics from the regime-led war against tuberculosis to its crusade against illiteracy. The Mostra del Dopolavoro highlighted the successes of Fascism's after-work organizations. It stressed the educational and leisure opportunities provided by the regime's coordination of the workplace and of workers' after-work time: the exhibition hosted sports competitions be-

tween groups of workers and a range of entertainments, including film festivals, concerts, and athletics.

The two other exhibitions in the Circus Maximus concentrated on Fascism's economic policies in the late 1930s. The Mostra del tessile nazionale (Exhibition of National Textiles) (November 1937–March 1938) and the previously mentioned Mostra autarchica del minerale italiano (November 1938–May 1939) translated late Fascist economic policies to a mass audience.[14] These two exhibitions focused on developments in domestic industries in the wake of the Ethiopian War and the League of Nations sanctions against Italy for the invasion of Ethiopia. The Mostra del tessile nazionale centered around displays and demonstrations detailing government-supported advances in domestic textile production—from the cotton grown in recently conquered Ethiopia to the rayon and lanital synthetically produced in government-assisted industries. The Mostra autarchica, taking place in the months before World War II, stressed Fascist Italy's industrial self-sufficiency: the exhibition celebrated the glories of the autarchic heavy industry. Coal mining, synthetic fuels, and steel production all proved Italy's preparedness for war and its ability to fight that war.

The Circus Maximus exhibitions disclose shifts in the organization of culture that occurred during the regime's final years. They also reveal the abandonment of the modernist-inspired formula that had shaped state patronage to date. Fascist culture after 1936 challenged the eclecticism and modernism of the early and middle 1930s with an imperial and increasingly racial and militarist aesthetic. In its selling of war and empire, the Fascist Party rejected the dynamic format that had drawn the spectator into a transformative experience in favor of overwhelming displays of Fascism's triumphs and strengths. The post-1936 exhibitions pursued overawed, passive spectators convinced of Fascist supremacy, rather than the engaged participants of the Mostra della rivoluzione.

State patronage at mass exhibitions after 1936 redefined the balance between art and propaganda. Official culture in this period segregated art from artifact: documents and artifacts returned to their display cases. The swirling of past and present, of fact and myth and the redemptive possibilities that had defined the Fascist *Gesamtkunstwerk* were replaced by static display cases, which convinced the visitor through facts and numbers. Late Fascist culture used art decoratively or monumentally to declare the power and legitimacy of the state and its explicit connection to historical elites. The art commissioned at the Circus Maximus, though in a few cases still drawing on futurist inspiration, was predominantly steeped in a representational imperial, monumental aesthetic, with *romanità* regnant.

The exhibitions of the Circus Maximus subordinated the viewer to the project, and did not draw him or her into it, other than to take pride in Fascist triumphs. Fascist mass culture had always depended on elements of spectacle and attracted audiences through the strategic use of the discourses of Fascist supremacy and Fascist-created national renewal. But by the late 1930s, the regime defensively exaggerated such strategies and became dependent upon militarist and xenophobic imageries. The exhibitions of the Circus Maximus mobilized spectacle to sell the Fascist project and the idea of Fascism's ability to resolve social, political, and economic conflict. These exhibitions proposed transcendence through Fascist technological and military predominance.

The Fascist Party built the exhibition city of the Circus Maximus (1936–39) in the final phase of state patronage. These final years (1936–43) witnessed the fragmentation of Fascist aesthetic pluralism into its constituent cultural fiefdoms, with some bureaucrats advocating emulation of National Socialist cultural politics and others defending aesthetic pluralism as authentically Fascist. In response to political and economic pressures, such as the war in Ethiopia, the alliance with Nazi Germany, and internal political crises, the regime adopted a more coercive and authoritarian patronage style in the late 1930s. As war, international economic sanctions, and worsening economic conditions at home challenged the dictatorship from without, and as a faction of pro-Nazi hard-liners radicalized it from within, official culture increasingly diverted the gaze of the populace and emphasized a mass culture of didactic propaganda and illusion. The emotionalized, transformative rhetoric of Fascist modernism gave way to overbearing messages of power and might, given form through Romanized monumentalism and high technology: the dominant inspiration for official culture shifted from the art of the European avant-gardes to the art of the Caesars.

The vision of Fascist supremacy embodied in the theme park of the Circus Maximus distracted visitors from the real city and the growing fissures on the outside of the Circus Maximus. Rosalind Williams, in her study of consumption strategies at the 1900 Universal Exposition of Paris, reveals the "dream worlds" created by the display of exoticized commodities.[15] In her conceptual framework, the arrangement and variety of new mass-produced goods forged worlds of fantasy and desire in fin de siècle spectators. In the case of Italian Fascist mass culture of the late 1930s, the "dream worlds" built from the mix of propaganda, spectacle, and mass entertainment offered ingestion of the national, Fascist project and participation in a high-technology utopia.

The Fascist Party built its theme park–ideal Fascist city in the middle of the actual city, in the historical heart of Rome. By constructing a parallel

or analogous city in the center of the living city, the regime presented a utopian reflection of the world outside. As M. Christine Boyer has written in reference to contemporary "historical" urban renovations, such constructions "enclosed its spectators, regulated their pleasures, and focused their gaze."[16] The Fascist theme park, constructed in a monumental but also functionalist style, depicted a clean world of social peace, harmony, and Fascist predominance, devoid of the dirt, conflict, and ambiguity of the real city outside. The sleek, monumental promenades, fountains, and triumphal passageways of the exhibition city bespoke social order and progress. The pavilions and walkways combined modernity and imperial monumentality, using marble and metal—white, modern, and shining. The scale was grand. Forced-perspective architecture directed the visitor's gaze toward the main facades and walkways. For each of the exhibitions, the spectator faced entry boulevards drawing the eye toward a central facade or a series of monumental sculptures. To stress the hierarchies of Fascism at war each exhibition was built around a central axis, a triumphal boulevard. These constructions stood in oversized contrast to the crowded medieval ghetto neighborhoods on the other side of the Palatine Hill, which the regime was in the process of tearing-down, relocating its working-class inhabitants to new suburbs on the outskirts of Rome.

By building an imperial theme park between the Roman Forum and the Aventine Hill, the dictatorship forced spectators to associate the Roman past and Fascist future. The Fascist future, according to the exhibition, while distinctly different from imperial Rome, could nonetheless be comfortably nestled in the glorious Roman cradle. The choice of the Circus Maximus, the ruins of the Roman Empire's site of sport and leisure, was a rich one. It was a reminder of the regime's desire to occupy physically the space left millennia earlier by the Romans. The use of a red-brick second-story by Adalberto Libera and Mario De Renzi for their Padiglione dei congressi (Congress Hall) at the Mostra delle colonie estive mirrored the colors and materials of the imperial Roman residences on the Palatine Hill, which looked down upon the exhibition, making clear the historical legacy of ancient Rome. The repeated use of marble, fountains, and columns reinforced the connection to the Roman monuments in the Roman Forum, just the other side of the Palatine (fig. 40).

Such a "framing" of Rome turned the city itself into a spectacle. The Fascist theme park's relationship to Rome parallels Disneyland's relationship to Los Angeles. In the Circus Maximus, all visitors had access to the planned, technological Fascist society depicted in the displays and entertainments, just as in Disneyland all could partake of Main Street's American Dream.[17]

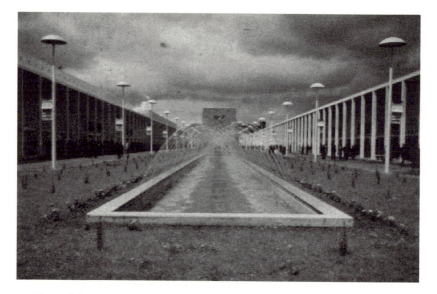

40. View of the central promenade at the 1938 Autarchy Exhibition (Mostra autarchica del minerale italiano) in the Circus Maximus.

A utopian city created by its organizers in the Fascist Party, this city was a controlled and orchestrated version of a functioning city. It was removed from external social and political contexts. The clean, new public spaces of the exhibition city were climate-controlled piazzas where the state determined both the spectators and the shape of the spectacle. Just as there are no demonstrations in Disneyland, dissent was irrelevant in the Fascist utopia of the Circus Maximus.[18] Instead of the spontaneity of normal city streets, the public spaces of the Circus Maximus hosted the rallies and parades of the party's mass organizations, from the Fasci femminili (Fascist Women's Organization) to the Gruppi universitare fascisti (Fascist University Groups).

The theme cities of the Circus Maximus were self-enclosed and self-sufficient environments. Late Fascist culture pursued a variety of forms of analogous and "new" cities at home and in the newly established empire. The phenomenon began in the middle 1930s with the "new towns" built on the drained swampland of southern Italy and was repeated in North Africa and Ethiopia. The final and most extensive of such analogous cities was to be the Esposizione universale di Roma (Universal Exposition of Rome), which the regime planned as a grandiose Fascist-built "new" Rome located between the actual Rome and the sea.

Not only were the Circus Maximus exhibitions analogous cities, they were autonomous cities. Each exhibition boasted a full range of facilities

from restaurants to hotels to theaters. The Mostra delle colonie estive, which advertised itself as "The City of Children," ran a functioning summer camp on the site for the duration of the exhibition.[19] The exhibitions re-created on site wholesale environments, from regional villages to hospitals. In its stress on technology and Fascism's ability to procure it, the exhibition's party organizers bragged that the Circus Maximus provided full accommodations for journalists, replete with offices, typewriters, telephones, and telexes—making recourse to the outside world unnecessary. The cities of the Circus Maximus were expansive in scale as well: the twenty-three pavilions of the Mostra autarchica spread over 35,000 square meters and its piazzas, boulevards, and garden areas occupied an area of 24,000 square meters.[20] As a sign of its Herculean urbanistic powers, the dictatorship heralded its ability to build a full-scale city in seventy days, with the mobilization of "2,500 workers, thirty-five participating firms, forty architects, fifty engineers, and 1,750,000 man hours."[21]

Powerful evidence of changes in official culture can be seen in the roles played by art and architecture. At the Circus Maximus, the regime separated and distanced art and architecture from one another and from the artifacts and information displayed. This quarantining of aesthetics was in striking contrast to the interpenetration of art, architecture, and artifacts that had defined the Mostra della rivoluzione fascista. Gone were the three-dimensional *plastica murale* that projected from the walls in an array of modernist angles and textures. In their place, the Fascist party commissioned primarily Roman-inspired art, such as at the entryway of the Mostra del Dopolavoro, which displayed monumental allegories of "work," "sport," and "culture" in linear triumphal procession. These marble statues of oversized classical proportions represented Fascist translations of Roman imperial statuary.

Each of the exhibitions contained a central pavilion with a facade. Again, these exhibition facades reveal the distance traveled by state patronage between 1932 and 1937. The facade of the main pavilion of the Mostra autarchica consisted of "aluminum and glass [which] sends blinding rays and broadcasts in cubic characters the word AUTARCHY." Below the giant metal letters spelling-out autarchy hung an enormous metal imperial eagle. Underneath the eagle, along the pediment, ran the words, in capital letters, "Mussolini ha sempre ragione" (Mussolini is always right). This overbearing combination of text and monumental sculpture left no doubts regarding the dominance of the dictator and the empire. The increasingly shared tastes of the now allied Nazi and Fascist regimes were obvious in the similarity between Kurt Schmid-Ehmen's *Eagle and Swastika* of the facade of the National Socialist Pavilion at the 1937 Paris International Exposition and the Mostra autarchia facade. In both cases,

the power of the state is represented by imperial eagles with full-spread wings; the claws of these eagles grasp, in the Nazi case, the wreathed swastika, and in the Fascist one, branches.

The art that the exhibition organizers chose to support the displays at the Circus Maximus exhibitions was separated from the displays and educational materials. The exhibition built a positivist cordon sanitaire between decoration and information, rejecting an earlier appeal to emotions through the collapsing of documents and art. The party was loathe to lose the support of prominent and committed artists, but their work— rejecting the modernist project of arousing emotion through shape, form, and color—played a different and secondary function. Mario Sironi, a leader of the Novecento movement in the arts and best known as the official artist of *Popolo d'Italia*, contributed mosaics and murals to two of the exhibitions.[22] The futurist painter Enrico Prampolini designed the entrance of the autarchy pavilion, which reviewers described as a "plastic synthesis of Italian autarchy."[23] In his wall panel, Prampolini encircled a graphic design of Mussolini's decrees on autarchy with replications of abstracted Roman battle standards. In each of these examples, the mosaics and wall panels remained separate from and not touching the display cases.

As a result of state patronage's rejection of the modernist aesthetic project, official culture turned to earlier artistic traditions. The Circus Maximus's party organizers embraced Italy's art of the past. As it abandoned the possibility of using contemporary aesthetics to construct a Fascist imaginary, the regime mined evermore the Italian historical patrimony, particularly those aspects of it which stressed *italianità*. The Mostra del tessile nazionale boasted a display of antique and arts textiles, on loan from the great museums of the nation. Other exhibitions included masterpieces of the Italian patrimony, albeit often in a contrived manner. The Mostra delle colonie estive included an "Exhibition of the Child in Art," displaying a range of Italian Renaissance and baroque art, but only pieces in which motherhood or a baby appeared. In this way, working-class Italians who were unlikely to have the trained aesthethic eye of bourgeois audiences, could learn to appreciate a Raphael or a Botticelli.[24] The Mostra autarchica presented a sculpture exhibition of works "created with material of the Italian soil: marble, bronze, iron, etc."[25] The inclusion of high art in legible guises brought spectators to identify with the national cultural patrimony, which the regime hoped to co-opt in its favor. The appearance of historical artwork identified Fascism with the past and offered messages of stasis and continuity, rather than experimentation.

41. Adalberto Libera and Mario De Renzi, Congress Hall at the 1937 Exhibition of Summer Camps and Assistance to Children (Mostra delle colonie estive) in the Circus Maximus.

The displays reasserted the distance between the spectator and the material. The objects returned to static, enclosed glass cases. At the Mostra della rivoluzione fascista, the artifacts—the relics of the Fascist assumption of power—had been immediate and open, reaching into the expository space. For each of the four exhibitions in the Circus Maximus, graphs, figures, and documents offering data of production quotas, economic growth, and industrial development drove the narrative of Fascist success.

While the displays and the art used to support them marked a shift in state patronage, the exhibition buildings of the Circus Maximus still bore a modernist influence. The same architects who had given Fascist modernism its character remained. Modernist-inspired architecture gave form to the representations of Fascist progress and supremacy. The pavilions, halls, and theaters of the exhibition city were functionalist, with an emphasis on open spaces, glass, industrial design, and minimal ornamentation. For the Exhibition on Summer Camps, Adalberto Libera and Mario De Renzi constructed the Padiglione dei congressi (Congress Hall), a building of sleek lines, rounded corners, and a cantilevered second story (fig. 41). The exhibition city's overall look was contemporary, or, as a

recent critic has written, "The exhibitions were extremely popular and were well served by a building style as lightweight, airy, and modern as anything in Europe."[26] At the time, a reviewer labeled the Mostra delle colonie estive the product of young architects "raised in the clarifying atmosphere of functionalism."[27]

The celebrities of Italian modernist and rationalist art and architecture contributed to the exhibitions and experimented with their government commissions. The Italian branch of the international movement in architecture, rationalism, which drew its inspiration from the Bauhaus and Le Corbusier, figured prominently. Leading members of the rationalist movement, including Libera and De Renzi, as well as younger modernist architects such as Luigi Moretti and Ettore Rossi participated. More precisely, the architecture of the Circus Maximus reflected the hybrid modernist-monumentalism of Fascist Italy's post-1935 cultural patronage. A monumental functionalism particularly suited late Fascist culture in its ability to articulate a range of messages and in its capacity as an embodiment of both modernity and tradition. Together with the continued remnants of International Style modernism, the buildings carried a consistent overlay of classicism and monumentalism. The architectonic embodiment of imperialist rhetoric transformed the ideal Fascist city into an imperial city. Classical proportions, triumphal arches, and columns, although stylized, predominated. The urge toward classicism was greatest in the Mostra autarchica of 1938. Mario De Renzi, Giovanni Guerrini, Mario Paniconi, and Guido Pediconi executed a general plan emphasizing a central axis which concluded on the dominant autarchy pavilion. The blend of modernism and classicism continued the connection to the archaeological monuments surrounding the exhibitions. As it reinforced the regime's staging of itself as the new Roman empire, this architecture also deepened the spectators' fantasy of participation in a grand new imperial project. The monumental proportions and imperial Roman motifs simultaneously inspired and overwhelmed the spectator, encouraging collectivism in the face of Fascist achievements.

In the buildings of the Circus Maximus, modernist-monumental architecture became a container of shifting messages.[28] The exhibitions' varied rhetorical needs demanded that the buildings articulate changing aspects of Fascist progress and power—from Fascism as protective parent to Fascism as economic giant able to battle successfully the economic sanctions of the League of Nations. The architects of the Mostra delle colonie estive built a site that balanced a festive sense with the scientific sobriety required by the regime's demographic campaign. For Giuseppe Pagano, one of the most visible proponents of rationalist architecture, this exhibition's thirteen pavilions on subjects from schools to health care combined

"unity of style, a clear urbanistic sense, [and] an expository vigor."[29] The next exhibition in the series, the Mostra Dopolavoro, which celebrated the regime's efforts at organizing the working class, called for an ambience of sport and propaganda. Architects constructed a grand park with three pools, an ice-skating rink, and a number of theaters.[30] According to *Architettura*, the Mostra autarchica, the last in the series, was a "constructed environment, suited to an industrial and autarchic exhibition, achieved with sobriety and elegance through the use of the most common industrial elements. This architectonic-urbanistic complex is different from the previous shows, as it is much more unitary and lucid."[31]

The exhibition city's simple but imperial ornamentation reinforced messages of Fascism's Brave New World. The dominant and repeated iconography stressed stylized fasci, eagles, workers, and soldiers often in marble or metal. The monumental and Romanized statuary of the exhibition depicted, as the case required, the fertility of Fascist motherhood or the strength of the Fascist worker and soldier. For spectators well accustomed by the late 1930s to Fascism's iconographic repetriore of fasci, eagles, and soldiers, the symbols of the Circus Maximus were familiar and decipherable.

The architecture of the Circus Maximus mobilized theatrical design elements, such as the manipulation of scenery, perspective, and facades, to create an environment of illusion and pleasure.[32] Spectacular nighttime inaugurations, with their emphasis on lighting, deepened the theatrical quality by providing dramatic scenes. Architects used large reflecting pools and fountains to further the holiday-garden sensibility. Theater design allowed for physical and rhetorical flexibility. The metal skeletons of the exhibition pavilions awaited redesigning for the regime's next "staging." As in set design, facades and perspective were central, particularly forced-perspective architecture, which regulated viewing. For each of the exhibitions, the spectator faced entry boulevards drawing the eye toward a central facade or a series of monumental sculptures. The visitor to the Mostra autarchica immediately faced the full-spread imperial eagle of the autarchy pavilion, with its injunction from Mussolini just below. The gaze then moved to the four petroleum extraction pumps flanking the pavilion.

In addition to the influence of set design, the architects borrowed from advertising, especially the then recent application of avant-garde design to the selling of commodities. The influence of advertising was evident in the facades and the graphic displays. At the Mostra delle colonie estive, the entry sign consisted of a simple square with the letters PNF (National Fascist Party) and the Roman numerals XV to designate the year of the Fascist era and, finally, the title of the event. Highly abstracted fasci

decorated the base of the structure. The sans serif letters and an abbreviated and staccato style came directly from the Bauhaus and the International Style (fig. 42). The constructivist and Bauhaus influence is clear in the bold, sans serif lettering and the ability to see through to the internal structure. Another view of the entryway reveals the metal fasci which also refer to constructivism, with its use of sheet metals and provisory character.

By the time of the Circus Maximus exhibitions, state patronage had created a group of architects who had achieved national reputations and exposure based on their exhibition architecture. The scale of the Circus Maximus exhibitions provided a large number of architects and artists with work and public notoriety. By way of example, the Mostra autarchica del minerale italiano hired 40 architects, 50 engineers, and 160 artists and technicians to construct its twenty-three pavilions.[33]

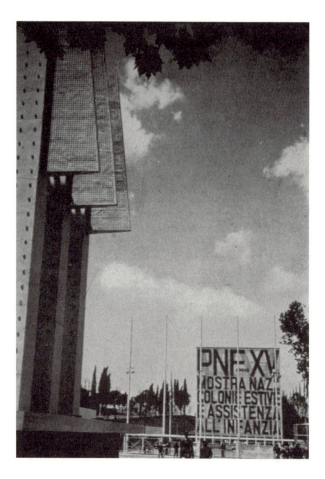

42. Entryway to the 1937 Exhibition of Summer Camps and Assistance to Children (Mostra delle colonie estive) in the Circus Maximus.

Many artists and architects, traveling from exhibition to exhibition, executed some of their most significant work of the decade at official exhibitions. The rationalists often experimented on exhibition architecture and were given space at official exhibitions at a time when commissions for less temporary structures went to the romanizing, monumental faction of Fascist architecture. Mario De Renzi constructed parts of the Mostra della rivoluzione, the Mostra delle colonie estive, the Mostra del tessile nazionale, and the Mostra autarchica del minerale italiano. Adalberto Libera collaborated with De Renzi on the general plan of the Mostra delle colonie estive and its Padiglione dei congressi. Libera joined Giovanni Guerrini on the Mostra del tessile. The Mostra delle colonie estive had a full showing of rationalists, with Luigi Moretti designing the Organizzazione nazionale balilla pavilion and Ettore Rossi the tourism pavilion. Moretti had been a mainstay of official culture and had winning entries in the Palazzo di littorio and Esposizione universale di Roma (EUR) competitions. Rossi was later involved in the general plan for Esposizone universale di Roma.

Visual artists, as well as architects, devoted large portions of their careers to official exhibitions. Mario Sironi, who had designed the core cycle of rooms at the Mostra della rivoluzione fascista, contributed to the Mostra aeronautica, painted a mural for the Mostra del Dopolavoro, and executed murals and mosaics for the Italian pavilion at the 1937 Paris International Exposition.[34] Enrico Prampolini, the futurist painter, created a range of artwork—installations, paintings, frescoes, and mosaics—for the major Fascist Party exhibitions of the 1930s. For prominent artists in search of exposure or aspiring artists in search of commissions, official exhibitions offered notoriety, work, and the opportunity to give form to Fascist priorities.

 In addition to a retreat from aesthetic pluralism and from the patronage of modernism to define Fascism, late Fascist culture was characterized by official use of simulation. Simulations of nonpresent environments played a central role at the Circus Maximus. The analogous city and its attendant Fascist dream world came to life through simulation. Each of the exhibitions employed simulated environments—from reconstructed regional villages to rebuilt sites of industrial production—to convey the larger propaganda message. All aspects of human activity from coal mining to the production of synthetic cloth became spectacle through simulation. At the Mostra autarchica, visitors watched miners extract coal from a reconstructed (but operational) mine shaft. They could then move to the adjacent marble quarry to view "the enormous saw cut the load into blocks."[35] The work was done, the coal

extracted, and the marble cut, without the dirt, danger, and sweat of actual work: coal mining under Fascism had become entertainment.

Jean Baudrillard has described the transformation of the objects and activities of daily life into simulations and, in turn, into "hyperreality."[36] The simulations of the Circus Maximus turned daily processes into spectacle through an inversion of representation and sign: images previously associated with "work" became "show." The museumification and artificiality of familiar forms force the viewer to ask, Which is more real, the simulation of mining or mining itself? Why did the regime need both to produce synthetic fibers and fuels and to reenact the process in its theme park? Spectacle testifies to a basic insecurity; the policy could not be "real" until it had also been simulated.[37] In its effort to convince the spectator of Fascist power, the exhibition city presented constructed settings as authentic experience.[38]

The Mostra autarchica, the last in the series, which took place in the months before World War II, reflected the regime's growing militarism and its exaggerated and defensive use of simulation. For this epic demonstration of Fascism's power, on the third anniversary of the League of Nations' declaration of sanctions, the Fascist Party re-created entire industries on location. Reconstructed, decontextualized, but working, coal mines, marble quarries, petroleum pumps, and synthetic fuels laboratories gave the impression of Fascist invincibility (see fig. 43). The re-created environments masked Fascism's inability to prepare for the coming war. As Umberto Eco has noted in reference to simulated "grand masterpieces," decontextualized reproduction is a way of telling the spectator "we are giving you the reproduction so you will no longer feel any need for the original."[39] Militaristic rhetoric and display covered failed production quotas. The simulation of what the dictatorship wanted to produce was to signify reality: "Italians can see, examine, realize," declared one reviewer, "all that has as of today been achieved in the minerals industry toward the achievement of autarchy."[40]

The existence of working petroleum pumps within the exhibition hall turned the exhibition into a theater, as did the creation of artisanal workshops—glassblowers and weavers—within the hall. The extraction of images permitted viewers to experience a voyeurism similar to that of cinema. The incorporation of audiences into film applies to these spectacles as well: the "performance" put forward by the simulations and the proximity of the spectator to the performance put the audience in a privileged and voyeuristic position similar to film.[41]

Simulations of sanitized versions of rural life, in the form of the "Rustic Village," constituted a highly popular aspect of the Mostra del Dopolavoro. Here the regime that had consistently outlawed and fought region-

alism constructed, to quote one reviewer, "a green meadow [with] cabins and cottages, displaying the architectural motifs dearest to our sense of the rural folk."[42] The simulated regional villages were peopled with regional Italians, dressed for the part. These imported props performed local crafts and cooked the foods of their respective regions. The inauguration of the Mostra del Dopolavoro included a song and dance production in regional costume by Dopolavoro members from Imola, Aviano, and Erba.[43] The inclusion of costumed rural Italians among the attractions had similar implications to the use of natives and reconstructed native villages at colonial and international expositions since the middle of the nineteenth century: it turns phenomena that could be fraught with tension and conflict into passive commodities for viewing. They become part of the show. As part of the show, these folk figures become a quaint attraction against which the spectator can measure his or her own progress—or, in this case, provide a way to measure national progress.[44] Here the regime resurrected regionalism in order to prove its domestication and its otherness.[45]

While some of the tropes and design techniques of late Fascist exhibition culture represented a departure from the earlier model, many of the

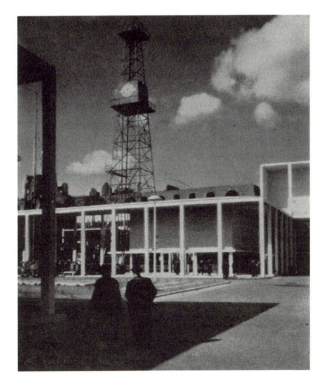

43. View of the Fuels pavilion with reconstructed oil pumps at the 1938 Autarchy Exhibition (Mostra autarchica del minerale italiano).

key elements of official culture remained. Propaganda joined to entertainment continued as a defining characteristic of Fascist culture. By attaching entertainment to propaganda, the exhibitions merged education of the masses, in the form of displays, with old and new forms of mass leisure, such as film festivals, concerts, swimming pools, and ice-skating rinks. At the exhibitions, the spectator could be simultaneously fun loving, traveling, patriotic, and Fascist. At the Mostra delle colonie estive, displays on infant health care, racial hygiene, and demographics mixed with children's games and dance competitions. The Mostra del Dopolavoro gave visitors, in addition to pavilions on the activities of the Dopolavoro, the chance to use "three grand swimming pools: one for children, one for swimmers, and one for competitions."[46] The Mostra del tessile nazionale blended technical discussions of synthetic fibers with a show of Italian fashion and the Mostra autarchica integrated pavilions on combustible solids and ferrous minerals with thermal baths and mineral water stands.[47]

The exhibitions of 1936–39, like the majority official Fascist cultural events, pursued mass participation through attendance incentives—from party-organized group excursions to special travel discounts and arrangements. For the Mostra delle colonie estive, which, because of its focus on demographics and infant hygiene, was targeted at a mass audience, the regional Fascist federations organized special trains to bring women to Rome.[48] At the inauguration alone, the regime transported "60,000 Fascist women" to Rome.[49] The party organizers of the Mostra del Dopolavoro transported many Dopolavoro members to the capital for the celebration of "the education and recreation of the masses under the sign of the *littorio*."[50] The Mostra del tessile nazionale and the Mostra autarchica, with their economic and more middle-class appeal, organized a series of special trains: for the week of December 11, 1937, the Fascist Party designated ten trains from destinations as distant as Udine and Salerno to arrive at the Mostra del tessile nazionale.[51] The regime's interest in developing the tourist industry and, in particular, domestic travel led to travel incentives in the form of discounted train fares and hotel packages.

Consumption has played a pivotal function in the expansion of the exhibition as a modern cultural form. Historians compare the ability of exhibitions and department stores to provide self-enclosed environments of leisure and consumption, with needs from eating, to viewing, to sport all met in one location. In the case of department stores and exhibitions, the variety of attractions and competing imageries cater to shortening attention spans, challenging reality, and encouraging fantasy. Susan Buck-Morss, in her exegesis of Walter Benjamin's Arcades Project, delineates the ways in which complexes of shops, galleries, and exhibitions

created a buzz of activity, spectacle, and consumption, which distract and disorient.[52] While the modern politics of consumption operated at the Circus Maximus exhibitions, its consumption strategies differed from those of contemporary liberal democracies. The Fascist state, at war and preparing for more war, could not offer high levels of consumer goods; thus, in addition to promoting mass consumption, such as at the Mostra del tessile's ready-to-wear fashion show, it promoted consumption of the Fascist project.

The exhibitions of the Circus Maximus spoke to audiences through a discourse of militant Fascist supremacy and power. The discourse, as articulated in the exhibitions' displays and activities, presented an unquestionable world of Fascist predominance. The regime, declared the various displays, could work miracles—economic, social, and political. The Mostra del tessile nazionale and the Mostra autarchica asserted Fascist economic strength. The displays implied that the regime could wave its magic wand and the glorious synthetic fibers of lanital and rayon could resolve the nation's need to import cotton. And where synthetic fibers did not meet demand, the regime offered the cotton plantations of the newly conquered empire in Africa. With the Mostra delle colonie estive, the all-powerful state became a parental figure, ministering to the needs of the nation's babies and mothers and making the world healthy and safe. The Mostra del Dopolavoro assured visitors that Fascism had resolved class conflict and that it had created a happy, dedicated working class. "The Fascist National Party," celebrated the Mostra del Dopolavoro catalog, "offers [the exhibitions], with a succession of continuously greater means and results, to illustrate . . . how deeply the regime has achieved its goal of giving the nation a fiery heart and a foundation of steel."[53]

The exhibition's aesthetic and documentary components sought to present a shared national vision based on progress, unity in the face of threats to the national community, and common purpose in the Fascist project. From the Mostra della rivoluzione fascista forward, official exhibitions played on a rhetoric of unifying national culture and of speaking to all Italians, regardless of class or region. The Fascist Party presented the exhibitions as national, mass events available to all willing to attend and second the regime. Fascist propaganda constructed identities accessible to all citizens, which it contrasted to the divisive ones of Liberal Italy. Fascism called on people as Italians, contributors to the national program, and as consumers of mass culture, rather than as members of classes or regions.

Selling the idea of the national community was central: every spectator had equal access to the "dream world" of the exhibitions, without regard

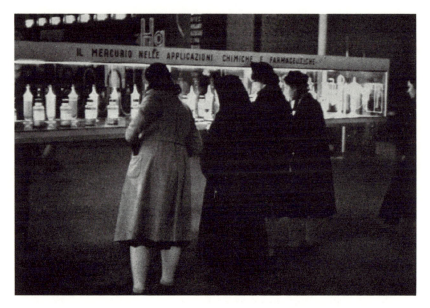

44. Nuns and schoolgirls enjoying the displays explaining the uses of mercury at the 1938 Autarchy Exhibition (Mostra autarchica del minerale italiano) in the Circus Maximus.

to class, gender, or region.[54] The exhibitions sought to suppress conflict through images of a peaceful national community based on contribution to Fascist triumphs and denial of difference. Press coverage stressed the exhibition's across-the-board appeal. For example, to stress the accessibility of the Circus Maximus exhibitions to all Italians, two of the six photographs which accompanied coverage of the Mostra autarchica in the government publication *Capitolium* showed nuns and schoolgirls enjoying the displays (fig. 44).[55] Even when an exhibition's topic targeted a particular group, the regime constructed the audiences as a cross-section of the nation. For the exhibition on infant health care, the party stressed the representative nature of the audience, declaring that "Fascist university women, Fascist girls, rural women, working-class women, mothers of families, women of the people" all partook of the event.[56]

Held in Rome, the shows drew crowds to the national capital. The Roman location played a critical ideological role in reinforcing the idea of a Fascist-enabled national unity—a national unity grounded both in the present and in the historic past. For many of those whom the regime bused, trained, or trucked to Rome, these events represented their first introduction to the Italian nation. The regime used the Roman location "at the heart of the nation" to stress Fascism's connection to ancient

Rome and to elevate Rome as the spiritual, national home of all Italians. The site "is one of the most beautiful legacies of the past," declared the catalog of the Mostra delle colonie estive: "on one side are Rome's two 'hills of destiny' . . . which are symbols of the most splendid classicism: the hills that witnessed the glories of more than a millennium."[57] On many nights, floodlights illuminated "the archaeological promenades, the baths of Caracalla, the Palatine and the Aventine."[58] The dramatized Roman ruins towering above the exhibition city provided a theatrical staging of the Fascist historical mission. Against such a backdrop, the predestination of Fascist triumph was clear. The highly charged combination of technology, consumption, simulation, and mass culture was by no means limited to Fascist Italy. The field of cultural studies has amply demonstrated the diffusion of spectacle and mass culture into a range of modern settings, times, and places. The contemporaneous American World's Fair in New York recruited similar themes of national community and the resolution of class conflict through technological utopia.[59] As in the Circus Maximus, the reconstruction of "total environments" attracted spectators in Chicago in 1933 and New York in 1939, where General Motors and other corporate sponsors built attractions that were functioning assembly lines and factory shop floors. Both of these exhibitions, taking place in the midst of the depression, offered visitors the experience of industry devoid of conflict and danger.

If in some respects the Fascist exhibitions of the late 1930s shared much with contemporaneous American World's Fairs of the 1930s, they differed significantly in the types of consumption and patronage they promoted. First, the American exhibitions stressed the private and individual consumption of commodities—from refrigerators to radios, from ashtrays to postcards. The Fascist exhibitions sold, above all, consumption of the Fascist and national project, with the limited tourist trinkets of secondary importance. The take-home items available at the Circus Maximus consisted of guidebooks, postcards, and commemorative stamps—all of which reenforced the dominant images of the exhibition.[60]

Second, a centralized state and party organized and promoted the Circus Maximus exhibitions, with local governments and business interests playing an auxiliary role. In the Circus Maximus, the goal of presenting a series of unified messages was not fundamentally challenged by the needs of conflicting interest groups. The profit motive that underwrote the New York World's Fair played a secondary, but welcome, role at the Fascist exhibitions. The corporate sponsors of the New York and Chicago World's Fair's were often at odds with the official version of state and society; in fact, some corporate sponsors hoped to use the medium of the fair to present their vision. As Roland Marchand has noted for Norman

Bel Geddes's Futurama (the simulated world of the future built inside the General Motors pavilion), General Motors' planned utopian corporate city carried a not-so-hidden critique of New Deal statism.[61] While the Circus Maximus exhibitions implied that only through state coordination could the technological utopia come to life, the New York World's Fair sold a message of transcendence through the corporation freed from state intervention.

As the Fascist reality became less and less what the government and the party dreamed it would be, official illusion became more and more sophisticated, bringing to bear developments in mass culture and consumption. With the Circus Maximus exhibitions, the regime gave spectators the world as they dreamed it would be—a world in which Fascism could resolve all conflict and difference. Instead of providing the resolution implied in the theme park, the Fascist culture in its last years diverted the gaze of spectators and fed them on leisure and illusion.

The Permanent Show of the Fascist Revolution: Abandonment of the Formula

In the wake of the excitement surrounding the Mostra della rivoluzione fascista in 1932, Mussolini proclaimed it a permanent monument. Before the exhibition's closing on October 28, 1934, he announced plans for a "more complete" and "definite" exhibition to be housed on the newly constructed Via dell'impero, the Fascist-built artery that connected the Piazza Venezia, the Roman Forum and the Colosseum.[62] The Palazzo littorio was to house both the exhibition-museum and the National Fascist Party headquarters. The Fascist Party and the Royal Academy sponsored a highly publicized national competition for the Palazzo littorio, but no building was ever constructed.[63] The commission included Achille Starace, Giovanni Marinelli (administrative secretary of the Fascist Party), Giuseppe Bottai (then governor of Rome), and Marcello Piacentini. The competitors were given specific directives as to size and space, but left free to make stylistic decisions. Prizes of 90,000, 50,000, 25,000, and 15,000 lire were offered. Guiseppe Terragni's design won first place.

With attention to "the extreme delicateness" and "danger of ruin" of the artifacts, party officials dismantled the Mostra between November 1934 and January 1935.[64] In anticipation of a permanent home for the Mostra, the Ministry of National Education stored the "glorious relics of the Fascist Revolution" in the Galleria d'arte moderna on Rome's Valle

Giulia, where a section of the art museum was temporarily given over to the remains.[65]

Repeated efforts between 1937 and 1942 to construct a Mostra permanente della rivoluzione (Permanent Exhibition of the Fascist Revolution) failed and the Fascist Party never reproduced the exhibition's popular following of 1932. A revised Mostra della rivoluzione opened on September 23, 1937, in Rome's Galleria d'arte moderna. The combination of a changed cultural atmosphere and an altered exhibition saw the ultimate failure of the project—a defeat that mirrors the larger crisis of Fascist culture in the late 1930s.

The Fascist Party, contradicting an earlier vehement rejection of the form, constructed the second Mostra della rivoluzione fascista as a static museum. A document-based format and a neoclassical aesthetic dominated the exhibition. Despite attempts to reproduce a mass following and critical acclaim, the later incarnations of the Mostra della rivoluzione fascista never recaptured the dynamism of its first incarnation. Fascist culture had shifted in the late 1930s toward a balance that favored control over consent, monumental didacticism over stylstic pluralism. This change was obvious in the desiccated 1937 Mostra della rivoluzione fascista.

Further, cultural autarchy, a concept that had been gaining credence since the early 1930s, had come into its own with the League of Nations' sanctions of 1936 and the declaration of empire.[66] Cultural autarchy brought into question the use of avant-garde European aesthetics in Fascism's self-representation. Government and party calls to reject foreign influences and to have culture reflect national traditions touched all the arts, from fashion design to architecture. As Marcello Piacentini declared in July 1938, "one must have the courage to carry out some rejections, and prepare for a stabilization on values more our own; more our own in terms of epoch and more our own as a people."[67] The search for cultural expressions "more our own" together with the charged rhetoric of italianità and romanità made the use of a futurist-rationalist aesthetic mélange untenable, especially in the act of Fascist self-commemoration. Fascism could hardly ask Italians to reject American films and French fashions and then use photomontage and constructivism in its major propaganda exhibition.

The reopened Mostra della rivoluzione fascista bore little resemblence to its predecessor. From its inception, the Fascist Party designed the revised Mostra as a unmediated demonstration of the dictatorship's strength. Alessandro Melchiori of the party's administrative office acted as the exhibition's director, and no artistic director was appointed. As at

the exhibitions in the Circus Maximus, the regime distanced the role of artists in the task of representing Fascism. Here the artists were altogether absent. The curatorial task was given to a party official who had little or no artistic training. Instead, Melchiori came to the exhibitions with an established reputation as a "Fascist of the first hour." He had served as a Fascist parliamentary deputy (1929), the vice-secretary of the party, counsel general of the *milizia*, and, as of 1935, president of the *ente autonomo* of the Fair of Tripoli.[68]

The inauguration of the 1937 Mostra della rivoluzione fascista offered clues to the regime's new cultural tastes and priorities. On the opening day of September 23, 1937, public buildings, festooned with flags and Fascist symbols, remained illuminated well into the evening.[69] The government required all Romans holding a party card and all members of youth organizations to attend the exhibition in uniform.[70] The inaugural events fetishized the founding days of Fascism: uniformed officials and Fascist heroes processed the banners and pennants from the first *Fascio di combattimento* (Fascist fighting squads of 1919–21) to the entrance like relics. "The colors of Fascism's firstborn," described one observer, had "an escort of *sansepolcristi*" who lent the relics to the exhibition for a year.[71] While choruses from the youth organizations sang Fascist hymns, "the Duce ordered the opening of the Mostra" with machine gun volleys and artillery salutes.[72]

The primary participants on opening day—members of the Fascist Grand Council, party officials, federal secretaries—came from the Fascist Party hierarchy, in contrast to the celebrities, artists, royalty, and foreign dignitaries who celebrated the opening of the first Mostra della rivoluzione fascista.[73] The highly choreographed inauguration stressed hierarchy and militarism, as opposed to the earlier exhibition's emphasis upon a broad cross section of the nation and its use of the inauguration to depict the exhibition as a pan-Italian event. In contrast to the festive, almost carnivalesque, atmosphere of the opening day of the 1932 Mostra, the 1937 exhibition revolved around regimentation and military choreography.

In a rhetorically laden coordination, the Fascist Party reopened the Mostra della rivoluzione fascista together with its celebration of the bimillennial of the birth of the Emperor Augustus, the Mostra Augustea della romanità (Exhibition of Augustus and Romanness). Thus, on September 23, 1937, two "imperial exhibitions" opened in Rome.[74] The Mostra Augustea della romanità observed the 2,000th anniversary of the birth of Augustus as the occasion for a vast archaeologically focused exhibition celebrating the Roman Empire at its apex. With the Mostra Augustea della romanità, Fascism represented itself as the inexorable culmination

of millennia of Italian history.[75] The reconstructions of Augustan monuments and art, together with the vast numbers of artifacts collected and restored for the occasion, stressed the connection between the past glories of Augustus—empire builder, peacemaker, and warrior—and present victories of Mussolini. The link, though constant in the exhibition, was most explicit in the paired monumental statues of Augustus and Mussolini that flanked the entrance to the Mostra Augustea della romanità.

In dramatic coordination, Mussolini opened both exhibitions the same morning, one within an hour of the other.[76] Their simultaneity reinforced Fascism's imperial-militarist and now backward-looking self-image. The dual events stressed the unity of the Roman past and the Fascist present, and the new cultural environment occasioned by the creation of empire. As *Corriere della sera* declared:

> The contemporaneous inauguration on the first day of the Year of Augustus of the spectacular Mostra Augustea and the rennovated Mostra della rivoluzione fascista is full of significance. *Romanità* and Fascism are manifestations of the same spirit. The two great historical phenomena that led to the creation of the Empire of Augustus and to our Empire represent two moments in the millennial life of a people who have rediscovered their own virtues and reconquered their youth.[77]

The exhibitions, hailed as "the Mostre of eternal Roman strength" and as "great documents of Italic glory," were two sides of the same coin. Together they marked the antimodernist turn of official culture. They functioned as complementary, educative elements in the "Renaissance of Roman virtue, stimulated by Fascism."[78] The Augustean exhibition presented the Fascist interpretation of the Roman Empire and its value as providing eternal inspiration and purpose for the Italian people; the Mostra della rivoluzione fascista illustrated the Fascist resurrection and incarnation of those Roman values. The contemporaneous inaugurations wrapped the Mostra della rivoluzione fascista in a cloak of ancient, historically predestined empire. "Italians will resee," one reviewer wrote, "when visiting its rooms, a magnificent summary of the glorious and epic deeds that have given the Patria its new Empire."[79] Their coexistence in two locations in the heart of Rome spread the Fascist cult of empire and its interpretation of Mussolini as the incarnation of Augustus across the capital. The presence of two "imperial" exhibitions physically inscribed Fascism upon the city.

For the 1937 Mostra della rivoluzione fascista, Fascist Party organizers rejected the conception of the exhibition as a "total work of art" which would engage the viewer on levels from the emotional to the intellectual.

Instead, they drastically reduced aesthetic elements in favor of a documentary format. Flat, traditional wall displays and glass display cases replaced the three-dimensional constructions of 1932. In 1932 there had been no isolated display cases to reify and separate the documents, which had been made living through their integration into the exhibition design. The documents—newspaper clips, early party cards, martyrs relics—had been absorbed into the artwork that defined them and gave them a mythic quality; in 1937 their distance from the spectator characterized them.

The 1937 Mostra della rivoluzione fascista, from the facade to the final room, carried a quintessentially different focus from its predecessor. With the deemphasis on the constructive and aesthetic elements, the relics were fetishized and dead. The mythologized seizure of power of 1921 that had dominated the first Mostra della rivoluzione became only a single element of the exhibition, as Fascism in power, the empire, and the war in Spain superseded the generative narrative. Whereas the earlier exhibition separated past and present, leaving the depiction of post-1922 Fascist policies ambigious, unresolved, and open to interpretation, the 1937 exhibition offered the didactic concerns and the self-aggrandizment of a nation at war.

A classical four-pilastered, highly ornamented facade adorned with inscriptions and bas-reliefs took the place of the rationalist metal facade of 1932. Architect Cesare Bazzani designed the 1937 facade at the Galleria d'arte moderna, which was constructed with 100,000 lire donated by the Ministry of National Education.[80] In contrast to the prevailing metal fasci of 1932, an enormous DUCE, with the name of the exhibition in smaller letters above it, dominated the doorway in 1937. Each side of the entrance bore a bas-relief. One side commemorated the March on Rome and the other, the Declaration of Empire. Publio Morbiducci's two accompanying bas-reliefs, *La rivolta* (*The Revolt*) and *La vittoria* (*The Victory*), depicted soldiers led by the angel of victory in a heavy, Romanized style. Morbiducci executed the static, oversized soldiers, with disproportionately large hands, feet, and jaws.

Melchiori's decision against the stylized metal fasci of 1932 had to have been a conscious one: by 1937, those fasci had become easily identifiable cultural icons. This decision against a popular symbol reveals the pressures on the regime to reject an avant-garde self-representation, even if it held potentially popular significance.

As evidenced by the lack of an artistic director for the exhibition, the power and might of the regime was to be represented as "literally" as possible. Above the facade's bas-reliefs stood two of Mussolini's prescriptions encouraging the nation to further battle. The iconographic tension

of the 1932 facade, with its combination of modernism and monumentality, of domination and invitation, and its lack of detailed imagery had left a range of interpretations open to the viewer. This 1937 facade dictated its meanings in discrete visual messages, written and sculpted: the visitor first saw the affirmation of the leader, then the celebration of war and empire. As with frescoes added to the Biennale facade in 1938, government interest in ornamentation and easily read art replaced earlier patronage of modern, rationalist styles that proposed a multiplicity of readings.

Of the exhibition's thirty rooms, only eighteen dealt with the original subject of Fascism's rise to power, compared with fifteen out of nineteen in 1932. Melchiori added certain topics and subtracted others. The focus was on specific Fascist martyrs and post-1922 developments, while the constructed and constructivist-inspired theme rooms—the Salon of Honor, the Gallery of Fasci, and the Chapel to the Martyrs—disappeared. The exhibition expanded the cult of the Duce and the myth of D'Annunzio through larger and more detailed documentation of both figures' early careers.[81] The exhibition began with three rooms on *fasci all'estero* (Fascist organizations abroad) and concluded with two rooms each on the empire and the Civil War in Spain, a Room of the Duce, and a room dedicated to Marconi.[82] Rather than conclude with the Chapel to Fascism's fallen, the 1937 exhibition concluded with Mussolini's reconstructed office and a collection of his writings. The word and image of the Duce had become the focus, to the exclusion of rite and mysticism. This exhibition stressed individual figures—D'Annunzio, Marconi—and Fascism in power, rather than the collective rising of a nation.

Melchiori placed some elements of the 1932 exhibition alongside the display cases occasionally to reinforce the documents and relics. For example, Domenico Rambelli's statue *Il re/soldato* (The Soldier/King), which had stood in Room C, La guerra italiana, also adorned the room on World War I in 1937. The "den" containing Mussolini's *Il popolo d'Italia* office, which had been the focal point of Sironi's Salon of Honor, was placed at the end of the 1937 exhibition in a room containing only display cases and a bust of Arnaldo Mussolini. Those pieces of the original exhibition that the organizers chose to use were detached from their original accompanying environments and drained of their evocative power.

Between 1932 and 1937, the Fascist cult had superseded the national cult in Fascist ideology. The theme rooms of the first Mostra della rivoluzione fascista, which fused the symbols of Fascism with those of the Italian nation-state, had stressed continuity. The narrative of Italian nationhood reaching fulfillment in Fascism that had been so central now held second place Fascist symbols and history and promises of continued Fascist triumphs. Whereas the first exhibition was semiotically available to any

Italian, even the noncommitted, this exhibition catered to committed and identified Fascists.

The 1937 Mostra della rivoluzione fascista also appropriated much of its world view from Fascism's National Socialist allies. The enemies and friends articulated in the exhibition's narrative were those jointly held by the two regimes—the demonic, racially polluted Communists and duplicitious, degenerate liberal democracies. The exhibition highlighted artifacts from the recent Fascist victories in the Ethiopian War and the Spanish Civil War. For example, in February 1937, General Edmondo Rossi sent the Mostra "some Masonic symbols taken from the lodge in Malaga on the day of the occupation."[83] In 1938, Melchiori included objects from the boxes of arms, banners, and other objects arriving from the conflict in Spain. The anti-Bolshevik struggle took on a central emphasis: many of the relics displayed had recently returned from Nuremberg and Berlin where they appeared in the Nazi Mostra anti-bolscevica (Anti-Bolshevik Exhibition). According to *Corriere della sera*, "These [relics] . . . full with the memories of the African expedition and the documentation of the heroic contribution of our legioners to the war in Spain . . . met with enormous success at the anti-Bolshevik show in Nuremberg."[84] The dominant narrative, rather than regeneration and redemption through Fascism, was current and future Fascist military strength and vigilance against an array of foreign enemies. The enemies were racialized, as stereotypical depictions of savage Africans and heathen Spanish Republicans dotted the exhibition.

The Axis made the reopened Mostra an element of joint cultural programs. As well as displaying portions of the exhibition in Nuremberg and Berlin,[85] in 1939 the Nazis included a Mostra della rivoluzione fascista room in the National Socialism Museum in Hannover, organized by the Reich Ministry of Education.[86] The Fascist Party secretary sent various relics and documents, including the uniforms and banners of Fascist organizations, to Hannover for the occasion.[87]

Press reviews of the reopened Mostra stressed the Fascist Party's conscious decision to deemphasize the role of art in Fascist self-representation. Critics, reflecting the official explanation of the change in official culture, interpreted this development as a move away from emotion toward reason. "The excessive preoccupation with art," wrote Vincenzo Talarico, ". . . has given way to a schematic composition that speaks more to the mind than to the emotions."[88] The relics of the 1932 Mostra "spoke to the heart and memory of the visitor" and "had above all a sentimental value." "Today, instead of emotion," wrote one critic, "there is a document collection which encourages minute analysis."[89] Where

the aesthetics of the 1932 exhibition moved the visitor to passion, in 1937 "the visit is made easier by the extreme simplicity of the displays, and the eye is not distracted by mixed symbols and polemics."[90] *Corriere della sera* declared that the Mostra "has tremendously enhanced its documentary power" and the frenzied arts that had impressed the viewer "has given way to a more serene display."[91]

For *Corriere della sera*, which celebrated this transformed Mostra della rivoluzione fascista, the relics and documents spoke for themselves. According to the newspaper, the earlier formula with its swirl of art and artifact, could not achieve the "truth" found in an ordered display. The documents "convince, they exalt, they move: the primary reason for [the exhibition's] success is the impartial eloquence of the artifacts, the images, the documents, and the relics."[92] The documents, distanced from the spectator and out of the hands of artists, now determined Fascism self-representation. The reopened Mostra della rivoluzione fascista rejected experimentation with the form of the exhibition: the integration of art and documentation that had made the 1932 exhibition ground breaking had been replaced by the isolation of artifacts.

The regime's changed view of its publics and lack of trust in artists to give form to history led to a rejection of the ambigious, emotional, and multidisciplinary exhibition. In 1932, the dictatorship had catered to a range of publics and had pursued mass support with multiple messages and methods. By 1937, the regime depended upon a document-based transmission of the power and history of the Fascist state for its self-representation. This turn to unmediated didacticism came in part out of a condescending view of its publics, which saw audiences as confused by indirect messages and by modern, nonrepresentational art. Without the avant-garde inspired aesthetic that had given the Mostra and its relics a modernist tension, the exhibition bespoke only consolidation.

The 1937 Mostra della rivoluzione fascista produced little popular response. Soon after the inauguration, one disillusioned visitor, Emilio Di Mattia, wrote to the director of the first Mostra della rivoluzione fascista, Dino Alfieri. Di Mattia lamented the "cold chronology of the past" which had supplanted "the live and pulsating environment" and "the heat and passion" of the 1932 exhibition. Nostalgic for the Chapel of the Martyrs, he added, "the visitor . . . needs the mystic chorus of souls . . . in order to feel the passionate enthusiasm which the Duce always elicits." This concerned observer isolated the failure of the second Mostra della rivoluzione in particular, and of late Fascist culture in general: the Mostra should "not be only a museum for historians but also a living and moving idealistic environment for the masses [who are] always eager for emotion."[93]

The 1937 exhibition, with its fear of experimental (and potentially trans-formative) aesthetics mobilized to give form to myth, had lost its power to engage.

Melchiori soon bemoaned the empty exhibition rooms. Between November 1937 and January 1938 only 10,000 tickets were purchased a month, compared to 96,000 a month for the original Mostra.[94] After this initial period, attendance declined further with a total of only 54,745 spectators arriving between the opening day of September 23, 1937 and Christmas Day 1939.[95] Between January 31 and August 9, 1940 only 3,520 people visited the exhibition.[96] As daily attendance dwindled to nearly zero, the exhibition staff complained of "an absence" of visitors.[97] In response to low interest levels, organizers limited opening hours for the exhibition to six hours per day. Closing time was set at two o'clock in the afternoon compared with times as late as midnight for the 1932 Mostra.[98]

Those who did attend were coerced: they came from Fascist youth organizations, whose attendance became obligatory after June 1938, and from groups from Axis nations touring Rome.[99] In March 1939, a delegation of eighteen Spanish Falangists and ten Nazis toured the Mostra; a month later Herman Goering led a group through the exhibition. Delegations from the German Workers' Front and twenty-five students from the German elementary school in Feldafing also attended the exhibition—the German schoolchildren were rewarded with German language copies of the catalog.[100] The striking fact is not that such political allies toured the Mostra, but they did so to the nearly total exclusion of the larger public. Catalog sales also bespeak the lack of popular interest: between April 30, 1936 and October 31, 1938 only 148 Italian-language catalogs were sold.[101] During the period October 7, 1940, to April 17, 1942, of 16,137 catalogs in inventory, only 20 were sold and 16,067 were eventually donated to Assistenza materna (Assistance to Mothers) and 50 to the Dante Alighieri Association.[102] None of the Spanish, German, English, or French editions sold and all were given away.

The regime's first multimedia exhibitions, best represented by the decennial exhibition, the Mostra della rivoluzione fascista of 1932, had introduced aestheticized depictions of Fascism's past and rise to power. In the wake of the form's development in the early 1930s, official exhibitions employed an explosive mixture of modernist aesthetics, historical documentation, mass culture, and an emotionalized-spiritualized interpretation of the Fascist revolution. At their most sophisticated, these exhibitions were a Fascist *Gesamtkunstwerk*, combining art, architecture, historical reconstructions, ritual, and theater.

This chapter has traced the rise and fall of an exhibition formula and of an approach to state patronage. In the years immediately following the

Mostra della rivoluzione fascista, modernism remained the touchstone of official culture, reaching an apex in the Milanese Mostra aeronautica. By 1937, Fascist Party organizers abandoned a patronage strategy that mobilized art to produce myth, ritual, tension, and transcendence for one they believed unitary and legible. By 1937, party bureaucrats preferred the stasis and authority of the museum to the dynamism and spontaneity of the modernist exhibition. The Mostra della rivoluzione fascista and Fascist official culture had become the static museum of dead objects its founders had once declared it would never be.

Conclusion

INSPIRED by the successful celebration of its tenth anniversary in 1932 at the Mostra della rivoluzione fascista, the Mussolini dictatorship planned in 1942 to commemorate twenty years of Fascist rule and five years of empire with a vast, marble exhibition metropolis. In the midst of World War II, the Fascist regime began the herculean project of constructing a monumental exhibition city in an area located between Rome and the Mediterranean Sea. Like the Caesars and the popes, Mussolini too wanted to leave his indelible mark on Rome. The Duce's imperial urban monument was to be a complimentary "new Rome" in marble and granite that would extend the existing city all the way to the sea—a physical symbol of Italy's domination of the Mediterranean.[1]

The extensively organized and publicized Esposizione universale di Roma (Universal Exposition of Rome) was to represent the culmination of Fascist urbanism and official culture.[2] It was to consist of a series of permanent monuments and temporary exhibition pavilions. The plan, designed by Marcello Piacentini, focused upon a grand central axis that linked the isolated monuments. The monuments were elevated and included a church whose dome was second only to Saint Peter's and the Palace of Italian Civilization, a square Colosseum replete with 216 arches. The planned celebration of twenty years of Fascism was to include exhibitions on popular traditions, science, romanità, Italian civilization, contemporary art, and Fascist politics.[3] This extravaganza, advertised as the "Olympiad of Civilizations," would have offered a total of seventy-three different exhibitions.[4] The exposition never opened, as construction was suspended in late 1941 due to the war. Instead, Fascism left behind an eerie monumental, marble ghost town that would eventually be transformed into an office suburb by the Republic of Italy.

It is fitting that one of Fascism's larger physical legacies is a would-be exhibition city. As this book has shown, the Mussolini dictatorship located art and architecture and the places where these cultural forms were displayed and consumed at the center of its cultural politics. Fascism's attempted great final act of state patronage marked the end point of the trajectory traced in *The Patron State*. In the partially constructed Esposizione universale di Roma, the tensions and failures of official culture

stand out in relief. EUR is part vulgar Romanized-monument, full of unconvincing bas-relief, mosaics, and triumphal statuary, and part Fascist theme park. The dominant monuments, such as the Church of Saints Peter and Paul and the Palace of Italian Civilization, are ungainly and sterile. They have aged poorly and today appear as hyper-Roman stage sets. But, the hybrid and inconsistent impulses remained in Fascist taste up to the end: Adalberto Libera's Congress Hall, one of the central buildings, continued the task of blending Fascist rhetorical demands with a modern, functionalist architectural idiom. In the thick of hyperbolic Romanism, Libera continued to experiment: his building included a square reception hall covered by a monumental, open cross vault and an open-air theater on the roof. In Fascism's final days, Fascist modernism had been subsumed but was not without influence.

The goal of this book has been to excavate a series of interlocking relationships that came together to produce culture under Italian Fascism. The character of Fascist cultural politics emerges in three relationships: between the bureaucrats of the regime and cultural producers, between those official patrons and the public, and between cultural products and their consumers. Each of those relationships was negotiated and shaped by a range of factors, of which state power was only one.

The Fascist cultural compromise was a negotiated system in which some of the regime's legitimation goals were met in exchange for meeting some of the interests of producers and consumers. With a policy of relative tolerance for artists and styles, the regime won, for a time, the consent and participation of a large portion of the Italian community of artists and the assent of audiences. Contemporary celebrities, from Mario Sironi to Giuseppe Terragni to Enrico Prampolini, lent their formidable talents to the project of giving Fascism a cultural identity. The adhesion of prominent and unknown artists, in turn, gave the dictatorship a cultural legitimacy that further cemented its rule.

Aesthetic pluralism, a cultural political ethos that pursued a diversity of aesthetic styles, defined the dominant ethos of the era. In fact, the trajectory of aesthetic pluralism parallels the expansion and contraction of official culture and the levels of critical and popular support for that culture. Through allowing itself to be represented in an aesthetically diverse manner, Italian Fascism found ways more nuanced and, ultimately, more successful than overt state power and repression to integrate artists and the public into state institutions and the Fascist project.

A variety of motivations and forces compelled the regime to promote for a time an experimental, modernist culture: artists' experimentations, the pressures of mass politics, developments in mass culture, and Fascism's own hybrid cultural origins. As we have seen, Fascism's failure to

designate a monolithic official art was not a fallback position, but an acknowledged policy. In return for stylistic flexibility, the Italian Fascist dictatorship found both a range of artists and aesthetics willing to answer its call and accept its price.

As long as a majority of the regime's cultural policy makers saw it as the best way to create a symbiosis between cultural producers, the state, and audiences, it functioned. As factions broke off and elevated conflicting patronage patterns, the system unraveled, with many artists and spectators abandoning it. Aesthetic pluralism carried within it a set of internal contradictions. As the 1930s progressed, factions that believed that heterogeneity could not meet the regime's rhetorical and disciplinary aspirations grew more vociferous. As a result of internal and external factors, such as the war in Ethiopia, and the rise of a pro-Nazi faction within the party and the growing alliance with Nazi Germany, aesthetic pluralism was challenged and subverted after 1936. In the last years of Fascist arts patronage, hard-liners attacked modernism and demanded more rigid, imperial, and racist styles to represent Fascism.

This book has focused on two problems. How did the Mussolini dictatorship behave as patron and administrator toward cultural producers and consumers? What factors lay behind the regime's promotion in the early 1930s of an extensive and stylistically pluralist and hybrid official culture, and what caused its ultimate demise? The permitting and, at times, encouraging of what I call a pluralistic culture by Italian Fascism had a number of root causes. Fascist "imperfect totalitarianism" saw it as unnecessary, for the better part of the dictatorship, to isolate and restrict groups and behaviors that seemed not to threaten the basic work of the dictatorship. Beyond an affinity toward modernism, Fascism came to power without a designated position on the arts. Fascism's culturally composite origins of futurism, "return to order," and classicism, compounded by lack of a unanimous vision within the Fascist hierarchy, encouraged an approach of appropriating many representational imageries.

Further, the culture bureaucrats of Fascism embraced the tenet of Italian culture that saw aesthetics as central to Italian national (and regional) identity. The flowering of centuries of artistic culture on Italian soil was a source of pride and identity that the Fascists gratefully inherited. The society that gave birth to Leonardo Da Vinci, Michelangelo, and Raphael could not allow itself to be seen as philistine or vulgar.

Aesthetic pluralism not only provided Italian Fascism with a variety of aesthetic production with which to represent its ideology, it also prevented the creation of an artist underground. No artists were driven from Italy or forced to abandon their careers due to stylistic choices. Certainly, anti-Fascist artists left Italy or went underground to continue their politi-

cal work. In addition, the absence of a cultural purge also translated into artistic continuity between the pre-Fascist, Fascist, and post-Fascist eras. Many artists who had participated in official culture in the 1930s remained active in Italian postwar cultural circles. Some, in fact, who had accommodated the regime's demands for representation in the late 1930s, riding the tides of changing patrons, embraced abstraction by the late 1940s.

As Raymond Williams writes, "the most fundamental cultural history is always a history of forms."[5] Here the cultural form of the exhibition, as transformed by the Fascist dictatorship, has allowed us to follow the politics of Fascist patronage. *The Patron State* has used official exhibitions as a barometer of Fascist priorities. As we have seen, exhibitions filled a variety of cultural, social, economic, and political functions. Official patronage focused on and transformed two exhibition genres in particular, the art exhibition and the theme or topical exhibtion. Fascist sponsorship led to the integration of art exhibitions into the Fascist artist's syndicates and brought in government and party money and administration. Official patronage also opened up the high culture of art exhibitions to new social groups and new art forms. At official art and theme exhibitions, the regime underwrote the blending of high and low culture: the new form of the theme exhibition, which took shape after 1930, crossed cultural borders and employed painting and sculpture in the service of mass culture, such as at the Mostra della rivoluzione fascista (1932). The Fascist pursuit of expanded audiences and its call for socially engaged art forced a stretching of the boundaries of the high arts to include film, the decorative arts, and public art.

This book has presented the dilemma of the artist faced with a well-funded and stylistically tolerant patron who was also a repressive authoritarian dictatorship. Flexible Fascist policies and the regime's openness to modernism appealed to artists committed to Fascist politics and priorities. It also made the accommodation of those not outrightly opposed less noxious and more easily rationalized. Many Fascists were modernists and vice versa. Fascism and modernist culture shared a totalizing aspiration that drew the two together, for a time. In contrast to the other interwar dictatorships to which Italian Fascism is often compared, Nazi Germany and the Soviet Union, the legacy of Fascist intervention in the arts was less the story of ruptures and purges and more a complex tale of accommodation and collaboration.

In the light of contemporary American debates over the role of the state in the production and display of art, the issue of the relationship between art and the state, and how that relationship is resolved according to the political culture, has wide resonance and broad interest. Political cultures across the temporal divide from the Pharoahs of Egypt to the

Renaissance popes to the American democracy of the late twentieth century have patronized the arts and searched for cultural forms evocative of their moment and cosmology. State patronage reveals the contours of a ruling elite's self-image and its limits of the aesthetically acceptable. This book has explored the tensions implicit in state intervention in the arts and the way in which a nondemocratic but modernizing and market-oriented polity confronted them.

■ ■ ■ ■ ■ *NOTES*

Abbreviations

ACS	Archivio central dello stato
ASAC	Archivio storico dell'arte contemporanea
MCP	Ministero della cultura populare
MPI	Ministero dell'istruzione pubblica
MRF	Mostra della rivoluzione fascista
PCM	Presidenza consiglio dei ministri
PNF	Partito Nazionale Fascista
Seg. Part. del Duce	Segretario particolare del Duce

Chapter One
Introduction

1. Benito Mussolini, "Agli artisti della Quadriennale," in *Scritti e discorsi*, vol. 7 (Milano: Ulrico Hoepli, 1934), p. 282.

2. Walter Benjamin, "The Work of Art in the Age of Mechanical Reproduction," in *Illuminations*, ed. Hannah Arendt (New York: Schoken Books, 1969), p. 241.

3. Susan Sontag, "Fascinating Fascism," in *Under the Sign of Saturn* (New York: Vintage Books, 1980), pp. 73–105.

4. Boris Groys, "The Struggle against the Museum; or, The Display of Art in Totalitarian Space," in *Museum Culture*, ed. Daniel Sherman and Irit Rogoff (Minneapolis: University of Minnesota Press, 1994), p. 144.

5. George Mosse, "The Political Culture of Italian Futurism," *Journal of Contemporary History* 25, nos. 2–3 (1990): 257.

6. Walter Adamson asserts the dominance of Fascism's "modernist" origins in *Avant-Garde Florence: From Modernism to Fascism* (Cambridge, Mass.: Harvard University Press, 1993); Zev Sternhell makes a case for syndicalism's defining role in *The Birth of Fascist Ideology* (Princeton, N.J.: Princeton University Press, 1994).

7. *Pizzinato: L'arte come bisogno di libertà*, cat. exh. (Venice: Marsilio, 1981); *Pizzinato*, cat. exh. (Milan: Rebellato, 1975).

8. Interview with Armando Pizzinato, Venice, July 17, 1989.

9. A. M. Mazzucchelli, "Stile di una mostra," *Casabella* 7, no. 80 (August 1934): 6.

10. Ester da Costa Meyer, *The Work of Antonio Sant'Elia* (New Haven, Conn.: Yale University Press, 1995), p. 194.

11. Fascist cultural intervention began in the late 1920s, since until the consolidation of the dictatorship and the abrogation of the constitution in 1925–27, the regime stressed the organization of other aspects of Italian society and polity. For details of the consolidation of the dictatorship, see Renzo De Felice, *Mussolini il fascista: L'organizzazione dello stato fascista* (Turin: Einaudi, 1968); Adrian Lyttleton, *The Seizure of*

Power (Princeton, N.J.: Princeton University Press, 1986); Alberto Aquarone, *L'organizzazione dello stato totalitario* (Turin: Einaudi, 1965).

12. See, for example, George Mosse, "Fascism and the Avant-Garde," in *Masses and Man* (New York: Howard Fertig, 1980); Marcia Landy, *Fascism in Film* (Princeton, N.J.: Princeton University Press, 1986); Richard Etlin, *Modernism in Italian Architecture, 1890–1940* (Cambridge, Mass.: MIT Press, 1991); Thomas Schumacher, *Surface and Symbol: Giuseppe Terragni and the Architecture of Italian Rationalism* (New York: Princeton Architectural Press, 1991).

13. Only recently has futurism (1909–43) been studied as a whole and not divided into futurism and "second wave" futurism. See Enrico Crispolti, *Storia e critica del futurismo* (Bari: Laterza, 1986). For an examination of the ideological continuities between the movements' two periods, see Claudia Salaris, *F. T. Marinetti* (Florence: La Nuova Italia Editrice, 1988), *Le futuriste: Donne e letterature d'avanguardia in Italia (1909–1944)* (Milan, 1982), and *Storia del futurismo* (Rome: Editore Rivriti, 1985).

14. James von Geldern, *Bolshevik Festivals, 1917–1920* (Berkeley: University of California Press, 1993), p. 6.

15. Herman Lebovics, *True France: The Wars over Cultural Identity, 1900–1945* (Ithaca, N.Y.: Cornell University Press, 1992), p. 180.

16. The debate concerning to what extent the populace "consented to," rather than was "coerced into," fascism has produced a number of excellent studies of Nazism and Fascism. See Renzo De Felice, *Il Duce: Gli anni consenso* (Turin: Einaudi, 1974); Victoria de Grazia, *The Culture of Consent: The Mass Organization of Leisure* (Cambridge: Cambridge University Press, 1981), and *How Fascism Ruled Women* (Berkeley: University of California Press, 1992); Detlev Peukert, *Inside Nazi Germany* (New Haven, Conn.: Yale University Press, 1985).

17. Renzo De Felice, *Mussolini il fascista: La conquista del potere* (Turin: Einaudi, 1966). On the *Historikerstreit* (the "historians debate"), see Richard Evans, *In Hitler's Shadow* (New York: Pantheon, 1989), and Charles Maier, *The Unmasterable Past* (Cambridge, Mass.: Harvard University Press, 1987).

18. Peukert, *Inside Nazi Germany*. See also Detlev Peukert, *The Weimar Republic* (New York: Hill and Wang, 1993).

19. Zev Sternhell, *The Birth of Fascist Ideology* (Princeton, N.J.: Princeton University Press, 1994).

20. Gianni Scalia has described this polarity as the "either/or" approach: either there was "no Fascist culture" or "all culture was Fascist." Gianni Scalia, "Tre interpretazioni del Fascismo," in *Cinema italiano sotto il Fascismo*, ed. Riccardo Redi (Venice: Marsilio, 1979), pp. 19–28.

21. Nicola Tranfaglia, "Diavolo si, diavolo no," *La repubblica*, December 29, 1982.

22. Benedetto Croce, *Trent'anni di storia italiana* (Turin: Einaudi, 1961), and "Il Fascismo come parentesi," in *Il Fascismo: Antologia di scritti critici*, ed. Costano Casucci (Bologna: il Mulino, 1982).

23. Umberto Silva, *Ideologia e arte del Fascismo* (Milan: Mazzotta, 1973), and Norberto Bobbio, "La cultura e il Fascismo," in *Fascismo e società italiana* (Turin: Einaudi, 1973), dismiss any notion of Fascist culture and see the culture offered by the dictatorship as an outgrowth of its program of control and oppression. Edward Tannenbaum also reduces regime-sponsored culture to an element of its propaganda campaign in *The Fascist Experience: Italian Society and Culture, 1922–1945* (New York: Basic Books, 1972).

24. Bobbio, "La cultura e il Fascismo," p. 211.

25. A series of essays written in the wake of 1970s and 1980s revisionism digested the legacy of the entrenched Fascist/anti-Fascist polarity and its impact on postwar Italian scholarship and society. See Jader Jacobelli, ed., *Il Fascismo e gli storici oggi* (Bari: Saggi Tascabili Laterza, 1988).

26. Nicola Tranfaglia, "Intellettuali e Fascismo. Appunti per una storia da scrivere," in *Dallo stato liberale al regime fascista* (Milan: Feltrinelli, 1973), p. 115.

27. Ibid.

28. See Bobbio, "La cultura e il Fascismo," p. 214. For more on the problem of Fascism and intellectuals, see Emilio Papa, *Storia di due manifesti* (Milan: Marsilio, 1958); Alastair Hamilton, *The Appeal of Fascism: A Study of Intellectuals and Fascism* (New York: Macmillan, 1971); Mario Isnenghi, *Intellettuali militanti e intellettuali funzionario: Appunti sulla cultura fascista* (Turin: Einaudi, 1979); Gabriele Turi, *Il Fascismo e il consenso degli intellettuali* (Bologna: Il Mulino, 1980); Giuseppe Carlo Marino, *L'autarchia della cultura* (Rome: Riuniti, 1983).

29. Until the 1970s, the majority of art-historical studies of modern Italian art in the 1920s and 1930s focused on the work of a few great masters and left "political" questions untouched. See Emilio Lavagnino, *L'arte moderna*, vol. 2 (Turin: Unione Tipografico Torinese, 1956).

30. Guido Armellini, "Fascismo e pittura italiana: I. Carrà, Sironi, Rosai," *Paragone*, no. 271 (1973): 51.

31. Raffaelle De Grada, "La critica del novecento," in *Mostra del Novecento italiano*, ed. Rossana Bossaglia, cat. exh. (Milan: Mazzotta, 1983), p. 43.

32. For assessments of the relationship between Fascism and the artists and movements of the era, see Fernando Tempesti, *Arte dell'Italia fascista* (Milan: Feltrinelli, 1976); Guido Armellini, *Le immagine del Fascismo nelle arte figurative* (Milan: Fabbri, 1980); Alessandro Masi, *Un'arte per lo stato* (Naples: Marotta and Marotta, 1991).

For placing the novecento, futurism, and other avant-garde movements of the 1930s in historical context, see Rossana Bossaglia, ed., *Il novecento italiano—storia, documenti, iconografia* (Milan: Feltrinelli, 1979: repr. 1995); Crispolti, *Storia e critica del futurismo* and Simonetta Lux, *Avanguardia, traduzione, ideologia: Itinerario attraverso un ventennio di dibattito sulla pittura e plastica murale* (Rome: Bagatto Libri, 1990). Masi, *Un'arte per lo stato*.

33. *Mario Sironi: 1885–1961*, Galleria nazionale d'arte moderna cat. exh. (Milan: Electa, 1993), and Giorgio Ciucci, ed., *Giuseppe Terragni: Opera completa* (Milan: Electa, 1996).

34. Renzo De Felice, *Le interpretazioni del Fascismo* (Rome-Bari: Laterza, 1969), *Mussolini il rivoluzionario* (Turin: Einaudi, 1965), *Mussolini il fascista: La conquista del potere, Mussolini il fascista: L'organizzazione dello stato fascista, Il Duce: Gli anni del consenso*, and *Il Duce: Lo stato totalitario* Turin: Einaudi, (1981).

35. For more on De Felice and the controversy his work unleashed in Italy, see Renzo De Felice, *Rosso e nero*, a cura di Pasquale Chessa (Milan: Baldini & Castoldi, 1995); Borden W. Painter Jr., "Renzo De Felice and the Historiography of Italian Fascism," *American Historical Review* 95, no. 2 (April 1990): 359–402; Jacobelli, *Il Fascismo e gli storici oggi*; Giovanni De Luna and Marco Revelli, eds., *Fascismo/antifascismo* (Florence: La nuova italia, 1995).

36. A variety of work has considered the regime's modes of ideological transmission. On education, see Tracy H. Koon, *Believe, Obey, Fight: Political Socialization of*

Youth in Fascist Italy, 1922–1943 (Chapel Hill: University of North Carolina Press, 1985), and Teresa Maria Mazzatosta, *Il regime fascista tra educazione e propaganda* (Bologna: Cappelli, 1978). On Fascism's transmission of its ideology to "Fascist youth" and on the construction of a Fascist "mentalitè," see U. Alfassio Grimaldi and M. Addis Saba, *Cultura a passo romano* (Milan: Feltrinelli, 1983), and Pier Giorgio Zunnino, *L'ideologia del Fascismo* (Bologna: Il Mulino, 1985).

37. De Grazia, *The Culture of Consent.*

38. David Forgacs, *Italian Culture in the Industrial Era* (Manchester: Manchester University Press, 1990), p. 3.

39. For the visual arts, Laura Malvano described the multiplicity of imageries supported or accepted by Fascism and Fascism's changing use of those imageries; see *Fascismo e la politica dell'immagine* (Turin: Bollati Boringhieri, 1988). The notion of Fascist artistic diversity came into general acceptance with the 1982 Milan exhibition *Annitrenta*; see Vittorio Fagone, ed., *Gli AnniTrenta: Arte e cultura in Italia*, cat. exh. (Milan: Mazzota, 1983).

Reassessments of the architectural legacy of Fascist Italy have been particularly fertile. See Giorgio Ciucci, *Gli architetti e il Fascismo* (Turin: Einaudi, 1989); Diane Ghirardo, "Italian Architects and Fascist Politics: An Evaluation of the Rationalists Role in Regime Building," *Journal of the Society of Architectural Historians* 39, no. 2 (May 1980): 109–27, and *Building New Communities* (Princeton, N.J.: Princeton University Press, 1989); Silvia Danesi and Luciano Panetta, eds., *Il razionalismo e l'architettura in Italia durante il Fascismo* (Venice: Edizione La Biennale di Venezia, 1976); Dennis Doordan, *Building Modern Italy* (New York: Princeton Architectural Press, 1989); Etlin, *Modernism in Italian Architecture, 1890–1940*; Schumacher, *Surface and Symbol.*

Film studies have produced a number of works detailing the varied forms the cinematic arts took during the Fascist era. See Gian Piero Brunetta, *Cinema italiano tra le due guerre* (Milan: Mursia, 1975); James Hay, *Popular Film Culture in Fascist Italy* (Bloomington: Indiana University Press, 1987); Landy, *Fascism in Film*; Riccardo Redi, ed., *Cinema italiano sotto il Fascismo* (Venice: Marsilio, 1979); Elaine Mancini, *Struggles of the Italian Film Industry during Fascism, 1930–1935* (Ann Arbor: UMI Research Press, 1985). On theater under Fascism, see Mabel Berezin, "The Organization of Political Ideology: Culture, State and Theater in Fascist Italy," *American Sociological Review* 56 (October 1991): 643–46.

On literary culture and Fascism, see Richard Golsan, ed., *Fascism, Aesthetics, and Culture* (Hanover, N.H. University Press of New England, 1992); Achille Mango, ed., *La cultura italiana negli anni '30–'45* (Salerno: Pubblicazioni dell'universita degli studi di Salerno; Edizioni scientifiche italiane, 1984); Ruth Ben Ghiat, "Fascism, Writing and Memory: The Realist Aesthetic in Italy, 1930–50," *Journal of Modern History* 67, no. 3 (1995): 627–65, and "The Politics of Realism: *Corrente di vita giovanile* and the Youth Culture of the 1930s," *Stanford Italian Review* 8, nos. 1–2 (1990): 139–64.

40. In the world of art history and art criticism, the shift has been evidenced by an explosion of exhibitions and monographs on artists of the Fascist period and attempts to bring them back from scholarly and popular obscurity. The 1970s witnessed the promotion of many exhibitions on individual artists or groups who had earlier been considered too "implicated." For a few examples, see Comune di Milano, *Mario Sironi*, cat. exh. (Milan: Electa, 1973); Sassari, Padiglione dell'artigianato sardo, *Mario Sironi, Opere 1902–1960*, cat. exh. (Milan: Arnoldo Mondadori, 1985); Enrico Crispolti,

ed., *Riconstruzione futurista dell'universo*, cat. exh. (Turin: Museo Civico di Torino, 1980). With the 1980s, large scale exhibitions began to look at the Fascist-promoted culture of the 1930s as a totality. See Fagone, *Gli Anni Trenta: Arte e cultura in Italia*, cat. exh.; Bossaglia, *Mostra del novecento italiano*, cat. exh.; Maurizio Calvesi and Enrico Guidoni eds., *E42: Utopia e scenario del regime*, cat. exh. (Venice: Marsilio Cataloghi, 1987); Emily Braun, ed., *Italian Art in the Twentieth Century*, cat. exh. (London and Munich: Royal Academy and Prestel Verlag, 1989).

41. Adamson, *Fascism and Modernism*.

42. Robert Dombroski, Review of Walter Adamson, *Avant-Garde Florence*, *Journal of Modern Italian Studies* 1, no. 1 (1995): 145.

43. Antonio Gramsci, *Selections from the Prison Notebooks*, ed. and trans. Quinton Hoare and Geoffrey Nowell-Smith (London: Lawrence and Wishart, 1971). For an explication of the concept of hegemony, see Joseph V. Femia, *Gramsci's Political Thought* (Oxford: Clarendon Press, 1981). For a recent application of the concept of hegemony to Fascism's ideologicial stabilization, see Zunnino, *L'ideologia del Fascismo*.

44. De Felice, *Il Duce: Gli anni del consenso* pp. 54–322.

45. De Grazia, *The Culture of Consent*, preface and chap. 1.

46. Gaetano Arfè, "Revisionismo, non riproposta," in *Il Fascismo e gli storici oggi*, ed. Jader Jacobelli (Bari: Laterza, 1988), p. 16.

47. Cultural historians have mined these forms of representation in a search for the interconnections between culture and society in the modern world, as it adjusted to capitalism, democracy, and social discord. Examples of this innovative and synthetic approach that merge the study of art, society, and politics are Thomas Richards, *The Commodity Culture of Victorian England: Advertising and Spectacle, 1851–1914* (Stanford, Calif.: Stanford University Press, 1990); Robert Rydell, *All the World's a Fair* (Chicago: University of Chicago Press, 1984); Patricia Mainardi, *Art and Politics of the Second Empire* (New Haven, Conn.: Yale University Press, 1989); Debora L. Silverman, *Art Nouveau in Fin-de-Siècle France* (Berkeley: University of California Press, 1989), and "The 1889 Exhibition: The Crisis of Bourgeois Individualism," *Oppositions* 8 (Spring 1977): 71–91; Whitney Walton, *France at the Crystal Palace* (Berkeley: University of California Press, 1992).

Contemporary analyses by scholars, museum practitioners, and artists focus on the interaction between contemporary cultural products, producers, dominant ideologies, and the marketplace. See Timothy Luke, *Shows of Force: Power, Politics, and Ideology in Art Exhibitions* (Durham, N.C.: Duke University Press, 1992); Susan Pearce, *Museum Studies in Material Culture* (Leicester: Leicester University Press, 1989); Michael Belcher, *Exhibitions in Museums* (Washington, D.C.: Smithsonian Institution Press, 1991); Ivan Karp and Steven Lavine, eds., *Exhibiting Cultures* (Washington, D.C.: Smithsonian Institution Press: 1991).

48. Robert Rydell, *Worlds of Fairs* (Chicago: University of Chicago Press, 1993), pp. 6–11.

49. Arturo Lancellotti, *L'inquadramento sindacale degli artisti e la disciplina delle mostre d'arte in Italia* (Rome: Istituto Nazionale per le Relazioni Culturali con l'Estero, 1940), p. 13.

50. Michele Guerrisi, "Sindacato e civiltà artistica," *Le professioni e le arti* 3, no. 5 (May 1933): 3–4.

51. "Artisti d'Oggi," *Le professioni e le arti* 4, no. 4 (April 1934): 4–5.

52. Boris Groys, "The Struggle against the Museum; or, The Display of Art in Totalitarian Space," in Sherman and Rogoff, *Museum Culture*, p. 143.

53. Giuseppe Pagano, "La Mostra delle colonie estive," *Casabella* 10, no. 116 (August 1937): 6–7.

54. George Mosse, "The Poet and the Exercise of Political Power: Gabriele D'Annunzio," *Yearbook of Comparative and General Literature* 22 (1973): 33.

55. George Mosse, *The Nationalization of the Masses* (New York: Howard Fertig, 1975); Emilio Gentile, *Il culto del littorio* (Bari: Laterza, 1993), and "Fascism as a Political Religion," *Journal of Contemporary History* 25, nos. 2–3 (1990): 229–51.

56. Gian Capo, "La mostra azzurra," *L'illustrazione italiana*, June 24, 1934, p. 954.

57. In the "Technical Manifesto of Futurist Painting" of April 11, 1910, the futurists declared, "it is easy to demolish the works of Rembrandt, of Goya, and of Rodin." Cited in Maurizio Fagiolo dell'Arco, *Futurism* (Rome: De Luca, 1984), p. 18.

58. F. T. Marinetti, *Teoria e invenzione futurista*, ed., Luciano De Maria (Milan: Mondadori, 1968), p. 11.

59. Fagiolo dell'Arco, *Futurism*, p. 56.

60. Ibid.

Chapter Two
Bureaucratization, State Intervention, and the
Search for a Fascist Aesthetic

1. Ivan Karp and Steven Lavine, *Exhibiting Cultures* (Washington, D.C.: Smithsonian Institution Press, 1991), p. 15.

2. Howard Becker, *Art Worlds* (Berkeley: University of California Press, 1982), p. 101.

3. The Matteotti Affair of 1924, the suspension of the constitution, and the new institutional framework imposed in 1925–26 marked the end of Fascism's attempts to rule within the confines of the constitution. For details of the consolidation of the dictatorship, see Alexander De Grand, *Italian Fascism*, 2 ed. (Lincoln: University of Nebraska Press, 1989); Renzo De Felice, *Mussolini il fascista: L'organizzazione dello stato fascista* (Turin: Einaudi, 1968); Adrian Lyttleton, *The Seizure of Power* (Princeton, N.J.: Princeton University Press, 1986); Alberto Aquarone, *L'organizzazione dello stato totalitario* (Turin: Einaudi, 1965).

4. For the story of the Fascistization of La Scala Opera, see Enzo Santarelli, *Storia del movimento e del regime fascista* (Rome: Feltrinelli, 1967).

5. David Forgacs, *Italian Culture in the Industrial Era* (Manchester: Manchester University Press, 1990), p. 60.

6. On the National Fascist Institute of Culture, see Vittoria Albertina, "Totalitarianismo e intelletuali: L'istituto nazionale fascista di cultura dal 1925 al 1937," *Studi Storici* 23 (October–December 1982): 897–918.

7. Lazzero Ricciotti, *Il partito nazionale fascista* (Milan: Rizzoli, 1985), p. 213.

8. Antonio Maraini, "L'inquadramento sindacale degli artisti," *Le professioni e le arti* 6, no. 8 (August 1936): 13.

9. Antonio Maraini, ed., *L'ordinamento sindacale fascista delle belle arti* (Rome: Sindacato Nazionale Fascista Belle Arti, 1939), p. 146.

10. C. E. Oppo, "L'arte e lo stato," *Le professioni e le arti* 2, no. 5 (May 1932): 9.

11. Mario Bocci, "Ordinamento sindacale fascista," *Bibliografia fascista* 8, no. 11 (November 1933): 886–92; Oppo, "L'arte e lo stato," p. 9.

12. Maraini, *L'ordinamento sindacale fascista delle belle arti*, pp. v–vi.

13. Giuseppe L. Pomba, ed., *La civiltà fascista* (Turin: Unione Tipografica, 1928), p. 218.

14. On Italian corporativism, see Fernando Cordova, *Le origini dei sindacati fascisti, 1918–1926* (Bari: Laterza, 1974); David Roberts, *The Syndicalist Tradition and Italian Fascism* (Chapel Hill: University of North Carolina Press, 1979); and Alberto Aquarone, "Italy: The Crisis and Corporate Economy," *Journal of Contemporary History* 4, no. 4 (October 1969): 37–58. On the corporate regimentation of intellectuals, writers, and artists, see Philip V. Cannistraro, *La fabbrica del consenso* (Rome: Laterza, 1975), pp. 25–65.

15. Mabel Berezin has noted the impact of the corporate ethic on Fascist theater and the same attention to the structures of production, rather than content in theater production and playwriting, see "The Organization of Political Ideology: Culture, State, and Theater in Fascist Italy," *American Sociological Review* 56 (October 1991): 643–46.

16. Maraini, "L'inquadramento sindacale degli artisti," p. 13.

17. *IV Esposizione d'arte del sindacato regionale fascista belle arti della Venezia Giulia*, cat. exh. (Trieste, 1930), p. 9.

18. Bruno Biagi, "Il sindacato, l'arte ed i giovani," *Gerarchia* 11 (February 1933): 89.

19. *VI Esposizione sindacale d'arte del sindacato interprovinciale fascista belle arte Venezia Tridentina*, cat. exh. (1937).

20. Biagi, "Il sindacato, l'arte ed i giovani," p. 89.

21. Lyttleton, *The Seizure of Power*, p. 388.

22. "Artisti d'oggi," *Le professioni e le arti* 4, no. 4 (April 1934): 5.

23. Maraini, *L'ordinamento sindacale fascista delle belle arti*, p. 235.

24. "Attività Confederale," *Le professioni e le arti* 3, no. 5 (May 1933), and Maraini, *L'ordinamento sindacale fascista delle belle arti*, pp. 148–49.

25. Arturo Lancellotti, *L'inquadramento sindacale degli artisti e la disciplina delle mostre d'arte in Italia* (Rome: Istituto Nazionale per le Relazioni Culturali con l'Estero, 1940), pp. 2–3.

26. Mostra, the Italian term used for art exhibitions, political exhibitions, and economic fairs, is used throughout this text.

27. Lancelloti, *L'inquadramento sindacale degli artisti e la disciplina delle mostre d'arte in Italia*, p. 2.

28. Regolamento Generale, *IV Esposizione regionale d'arte, sindacato belle arti di Sicilia*, 1933, ACS, MPI, divisione III, dir. gen. AA.BB., 1930–35, busta 129.

29. Regolamento Per la *Mostra regionale del sindacato belle arti delle Marche* (Ancona), 1932, ACS, MPI, divisione III, dir. gen. AA.BB.AA., 1930–35, busta 127.

30. F. Cosera, *Le professioni e le arti nello stato fascista* (Rome: Tipografia dello stato, 1941), pp. 179–81.

31. Maraini, "L'inquadramento sindacale degli artisti," p. 14; Cosera, *Le professioni e le arti nello stato fascista*, pp. 201, 211.

32. Cosera, *Le professioni e le arti nello stato fascista*, pp. 201, 211.

33. Barbara Cinelli, "Firenze 1861: Anomalie di un'esposizione," *Ricerche di storia dell'arte*, no. 18 (1982): 21–26.

34. Maria Mimita Lamberti, "L'esposizione nazionale del 1880 a Torino," *Ricerche di storia dell'arte*, no. 18 (1982): 37.

35. Società amatori e cultori di belle arti, *XCIV Esposizione di belle arti*, cat. exh. (Rome: Enzo Pinci, 1928); Elizabeth Gilmore Holt, *The Art of All Nations, 1850–1873* (Princeton, N.J.: Princeton University Press 1982), p. 334.

36. Robin Lenman, "Painters, Patronage and the Art Market in Germany," *Past and Present*, no. 123 (1989): 110.

37. Holt, *The Art of All Nations, 1850–1873*, p. 334.

38. Ibid.

39. Cinelli, "Firenze 1861: Anomalie di una esposizion," p. 21.

40. This type of exposition first appeared in Great Britain with the Crystal Palace Exhibition of 1851 and soon had French successors in 1855, 1867, and 1889. For more on nineteenth-century exhibitions, see Thomas Richards, *The Commodity Culture of Victorian England: Advertising and Spectacle, 1851–1914* (Stanford, Calif.: Stanford University Press, 1990); Robert Rydell, *All the World's a Fair* (Chicago: University of Chicago Press, 1984); Whitney Walton, *France at the Crystal Palace* (Berkeley: University of California Press, 1992); Patricia Mainardi, *Art and Politics of the Second Empire* (New Haven, Conn.: Yale University Press, 1989); Debora L. Silverman, *Art Nouveau in Fin-de-Siècle France* (Berkeley: University of California Press, 1989), and "The 1889 Exhibition: The Crisis of Bourgeois Individualism," 8 *Oppositions* (Spring 1977): 71–91.

41. Gianna Piantoni, ed., *Roma 1911*, cat. exh. (Rome: Galleria d'Arte Moderna, 1980).

42. For more on the history of Triennale of Milan during the Fascist period, see Agnolodomenico Pica, *Storia della Triennale di Milano, 1918–1957* (Milan: Edizioni del Milione, 1957).

43. Lancelloti, *L'inquadramento sindacale degli artisti e la disciplina delle mostre d'arte in Italia*, p. 3.

44. David Rubinstein, "The Mystification of Reality: Art under Italian Fascism" (Ph.D dissertation, New York University, 1978); and *Le mostre d'arte in Italia* 1–5 (January 1934–December 1938); *L'arte nelle mostre italiane* 1–3 (January 1939–December 1941).

45. Società amatori e cultori di belle arti, *XCIV Esposizioni di belle arti*, and *IV Esposizione d'arte del sindacato regionale fascista belle arti della Venezia Giulia*, cat. exh. (Trieste, 1930), p. 11.

46. The dictatorship's adaptation of preexisting institutions to new uses took place in a number of arenas. Victoria de Grazia described the grafting of Dopolavoro clubs onto earlier "working class clubs—ex-reformist socialist, ex-democratic, and most rarely ex-communist—. . . [and] also the small-town bourgeois circolo and hundreds of peasant hang-outs." Victoria de Grazia, *The Culture of Consent: The Mass Organization of Leisure* (Cambridge: Cambridge University Press, 1981), p. 16.

47. Laura Malvano, *Fascismo e la politica dell'immagine* (Turin: Bollati Boringhieri, 1988), p. 35.

48. The Ministry of Commerce commonly granted train fare discounts for a period of time following the opening of an exhibition; discounts ranged from 20 to 70 percent and all visitors were eligible.

49. Law, April 7, 1927, no. 515, "Norme relative alla organizzazione e istituzione di fiere, mostre ed esposizioni," *Confederazione fascista dei professionisti ed artisti*, in Cosera, *Le professioni e le arti nello stato fascista*, p. 157.

50. Mussolini's official approval of an exhibition program was often published in art journals, trade and syndical journals of artists, and the national press. See, for example, "Notizario—L'on. Maraini ricevuto dal Duce," *Le professioni e le arti* 5, no. 8 (August 1935): 13; "Direttive del Duce per la XXII Biennale," *L'arte nelle mostre italiane* 6, nos. 1–4 (January–April 1940): 4.

51. Law, April 7, 1927, no. 515, "Norme relative alla organizzazione e istituzione di fiere, mostre ed esposizioni," in Cosera, *Le professioni e le arti nello stato fascista*, p. 157.

52. Law, December 5, 1932, n. 1734, "Istituzione presso il Ministero delle corporazioni, di un comitato permanente per l'esame di autorizzazione ad indire Mostre, Fiere, ed Esposizioni nel Regno," in ibid., p. 165. Art exhibitions fell under the jurisdiction of the Ministry of National Education, and agricultural shows were authorized by the Ministry of Agriculture.

53. Law, January 29, 1934, no. 454, "Norme per il disciplinamento delle Mostre, Fiere, ed Esposizioni," in ibid., p. 170.

54. Ibid., pp. 171–72.

55. Maria Cecilia Mazzi, "Modernità e tradizione: Temi della politica artistica del regime fascista," *Ricerche di storia dell'arte*, no. 12 (1980): 19.

56. Antonio Maraini, "Il nuovo assetto della Biennale Veneziana," *Rassegna dell'istruzione artistica* (February 1930): 35.

57. Forgacs, "The Fascist State and the Cultural Industries," in *Italian Culture in the Industrial Era*, chap. 3, pp. 55–82.

58. Paul Di Maggio and Michael Useem, "Cultural Democracy," in *Art and Society: Readings in the Sociology of the Arts*, ed. Arnold Foster and Judith Blau (Albany: SUNY Press, 1989), p. 166.

59. Sergio Romano, *Giuseppe Volpi: Industria e finanza tra Giolitti e Mussolini* (Milan: Bompiani, 1979), pp. 10–11.

60. Romolo Bazzoni, *Sessant'anni della Biennale di Venezia* (Venice: Lombroso Editore, 1962), p. 14.

61. "Regolamento del 1895," reprinted in ibid., appendix, p. III.

62. Paolo Rizzi and Enzo di Martini, eds., *La Storia della Biennale 1895–1982* (Milan: Electa, 1982), pp. 15, 23.

63. 1934 Press Release, ASAC, busta 82. In the 1920s, Spain, Czechoslovakia, Greece, the United States, Denmark, Switzerland, Austria, and Poland built national pavilions.

64. Lawrence Alloway, *The Venice Biennale, 1895–1968* (London: Faber & Faber, 1969), p. 94.

65. Modris Ecksteins gives a compelling interpretation of the impact of modernist aesthetics on post–World War I society and culture, see *The Rite of Spring: The Great War and the Birth of the Modern Age* (Boston: Anchor Books, 1989).

66. La Biennale di Venezia, *XIII Esposizione internazionale d'arte della città di Venezia*, cat. exh. (Florence: Casa Editrice d'arte Bestetti e Tumminelli, 1922). Despite some welcoming of impressionism and secessionism after World War I, Picasso appeared at the Biennale for the first time only in 1948.

67. Alberto Schiavo, *Futurismo e Fascismo* (Rome: Giovanni Volpe, 1981), p. 38.

68. Philip Cannistraro and Brian Sullivan have written a fine biography of Sarfatti detailing her cultural role, as well as her personal relationship with Mussolini. *The Duce's Other Woman* (New York: William Morrow, 1993).

69. Maraini, "Il nuovo assetto della Biennale Veneziana," p. 35.

70. "Autorizzazione in via permanente della 'Esposizione internazionale d'arte' di Venezia e della 'Esposizione quadriennale nazionale d'arte' di Roma," *Gazzetta ufficiale del'Regno d'Italia*, no. 19, January 23, 1929.

71. Letter, Giuliano to Mussolini, December 7, 1929, ACS, PCM (1940–42), busta 14.1.730, sottofascicolo 1.

72. Ibid.

73. Ibid.

74. Margherita Sarfatti, "Spiriti e forme nuove a Venezia," *Il popolo d'italia*, May 4, 1930.

75. *Gazzetta ufficiale*, February 12, 1930, pp. 573–74.

76. On Giuseppe Volpi Conte di Misurata, see Roland Sarti, "Giuseppe Volpi," in *Uomini e volti del Fascismo*, ed. Fernando Cordova (Rome: Bulzoni, 1980), pp. 523–46, who finds Volpi exceptional for his abilities in both politics and industry; and Romano, *Giuseppe Volpi*, especially chap. 18, "Il mito di Venezia," pp. 195–202.

77. Romano, *Giuseppe Volpi*, p. 8.

78. One intrepretation credits Volpi with a "grand strategy for Venice"—to link its industrial port, Porta Marghera, with its tourist port, Piazza San Marco. Rizzi and di Martini, *La Storia della Biennale*, p. 37.

79. As of November 1926, a government-appointed *podestà* replaced the earlier elected *sindaco* or mayor. According to Lazzaro, "the podestà was always chosen from among those of secure commitment and with a Fascist Party card. In the larger cities, they were often party leaders." Lazzaro Ricciotti, *Il partito nazionale fascista: Come era organizzata e fumzionava il partito che mise l'Italia in camicia nera* (Milan: Rizzoli, 1985), p. 435.

80. Previous government contributions to the Biennale were as follows: 1905, 50,000 lire; 1909, 50,000 lire; 1914, 50,000 lire; and 1920, 100,000 lire. *ASAC*, busta 57.

81. Memo, Ministro dell'educazione nazionale to Ministro delle Finanza, March 28, 1930, ACS, MPI, divisione III, 1930–35, busta 141.

82. Further, in exchange for the 50,000 lire offered by the provincial government, they demanded "their own representative on the administrative committee of the institution." Memo, Prefetto Bianchetti to PCM, capo gabinetto, April 16, 1930, ACS, MPI, divisione III, 1930–35, busta 141; memo, 1930, PCM to Ministro dell'educazione nazionale, May 5, 1930, ACS, MPI, divisione III, 1930–35, busta 141.

83. Memo, "Amministrazione provinciale di Venezia," April 14, 1930, ACS, PCM (1940–42), busta 14.1.730, sottofascicolo 2 b-1.

84. Memo, "Relazione per il Consiglio dei Ministri," ACS, PCM (1940–42), busta 14.1.730, sottofascicolo 2 b-1; "Assegnazione di contributi da erogarsi in favore de Ente Autonomo 'Esposizione biennale internazionale d'arte a Venezia,'" *Gazzetta ufficiale del'regno d'Italia*, no. 286, July 12, 1931.

85. Memo, PCM to Ministro dell'educazione nazionale, July 12, 1931, ACS, MPI, divisione III, 1930–35, busta 141.

86. Ibid.

87. Memo, Volpi to Ministro dell'educazione nazionale, March 29, 1933, ACS, MPI, divisione III, 1930–35, busta 141.

88. Memo, PCM to Ministro dell'educazione nazionale, June 12, 1931, ACS, MPI, divisione III, 1930–35, busta 141.

89. *Statuto dell'ente autonomo "Esposizione biennale internazionale d'arte" con sede in*

venezia, August 29, 1931, as cited in Bazzoni, *Sessant'anni della biennale di Venezia*, appendix, pp. x–xiv.

90. Copia del Decreto, November 8, 1934, ACS, PCM (1940–42), busta 14.1.730, sottofascicolo 1-c.

91. From 1936 to 1942, Carena served on the National Directorate of the Fascist Syndicate of the Fine Arts and on the juries of the Premio Cremona in 1939 and 1940.

92. "Norme per il disciplinamento delle Mostre, Fiere, ed Esposizioni," *Gazzetta ufficiale del'regno d'Italia*, no. 454, January 29, 1934.

93. La Biennale di Venezia, *XVI Esposizione internazionale d'arte della città di Venezia*, 3d ed., cat. exh. (Venice: Carlo Ferrari, 1928), p. 11.

94. La Biennale di Venezia, *XIX Esposizione biennale internazionale d'arte, 1934*, cat. exh. (Venice: Carlo Ferrari, 1934), p. 6.

95. La Biennale di Venezia, *XVII Esposizione biennale internazionale d'arte, 1930*, cat. exh. (Venice: Carlo Ferrari, 1930).

96. Maraini also pursued artists and intellectuals with professional conferences. In 1934, he organized an international conference to coincide with the Biennale. The two themes of the conference were "le arti contemporanee e la realtà" (contemporary art and reality) and l'arte e lo Stato (art and the State). A number of Fascist cultural figures and functionaries presented papers, including Antonio Maraini, Roberto Paribeni, Balbino Giuliano, Marcello Piacentini, Carlo Carrà, and Margarita Sarfatti. Some prominent members of the international art world also participated, such as Le Corbusier, Waldemar George, and Herbert Read. See "Il convegno internazionale d'arte alla XIX Biennale di Venezia," *Le professioni e le arti* 4, no. 9 (September 1934): 42–43, and *Le mostre d'arte in Italia* 4, no. 1 (January 1939): 23.

97. The Archivio storico d'arte contemporanea has evolved into an important Italian resource on twentieth-century art and continues to be run under the auspices of the Biennale.

98. *Le mostre d'arte in Italia* (a cura dell'Archivio Storico d'Arte Contemporanea della Biennale) 1–5 (January 1934–December 1938); *L'arte nelle mostre italiane* 1–3 (January 1939–December 1941).

99. For a reprint of selections of the debate in *Critica fascista*, see Alessandro Masi, *Un'arte per lo stato* (Naples: Marotta and Marotta, 1991), pp. 125–89.

100. Mazzi, "Modernità e tradizione: Temi della politica artistica del regime fascista," p. 21.

101. La Biennale di Venezia, *XVII Esposizione biennale internazionale d'arte, 1930*, p. 5.

102. Ibid., p. 6.

103. Cipriano Effisio Oppo, *Critica fascista* 5, no. 3 (February 1, 1927): 44, as reprinted in Jeffrey Schnapp and Barbara Spackman, eds., "Selections from the Great Debate on Fascism and Culture: *Critica Fascista* 1926–27," *Stanford Italian Review* 8, nos. 1–2 (1990): 264.

104. Giuseppe Bottai served as minister of corporations from 1929 to 1932 and then as governor of Rome in 1936. He was a leading theorist of the corporate state as the defining characteristic of Fascism, in contrast to socialism and capitalism. His journal *Critica fascista* stood throughout the Fascist period as the mouthpiece of his revisionist position. In 1940, he founded the journal *Primato* as a response to the cultural

hardliners, to defend the need for open political and cultural debate. For more on Bottai, see Alexander De Grand, *Bottai e la cultura fascista* (Bari: Laterza, 1978), "Giuseppe Bottai e il fallimento del fascismo revisionista," *Storia contemporanea* 6, no. 4 (December 1975): 697–731, and Giordano Bruno Guerri, *Giuseppe Bottai: Un fascista critico* (Milan: Feltrinelli, 1976).

105. For Sarfatti's philosophy of art, see Margherita Sarfatti, *Storia della pittura moderna* (Rome: Paolo Cremonese, 1930).

106. Cannistraro and Sullivan, *The Duce's Other Woman.*

107. Margherita Sarfatti, "L'arte e il Fascismo," in *La civiltà fascista*, ed. Giuseppe L. Pomba (Turin: Unione Tipografica, 1928), p. 218.

108. Ibid., p. 219.

109. On Farinacci's career, see Harry D. Fornari,"Roberto Farinacci," in *Uomini e volti del Fascismo*, ed. Fernando Cordova (Rome: Bulzoni, 1980), and U. Alfassio Grimaldi and Gherardo Bozzetti, *Farinacci: Il più fascista* (Milan: Bompiani, 1972).

110. In the mid 1930s, Interlandi's positions were to the right of the Mussolini dictatorship, although after 1936 he increasingly reflected the position of the regime, as it moved to the right. After 1937, Interlandi's views received their broadest exposure through the racist, pro-Nazi journal *Il Tevere*. For more information on Interlandi and the group around him, see Cannistraro, *La fabbrica del consenso*, and Enrico Crispolti, *Il mito della macchina e altri temi del futurismo* (Celebes: Trapani, 1969).

111. Roberto Farinacci, *Il regime fascista*, March 28, 1935, as quoted in Umberto Silva, *Ideologia e arte del Fascismo* (Milan: Mazzotta, 1973), p. 20.

112. For example, Telesio Interlandi took a strong position on the dictatorship's need to control film production. As Gian Piero Brunetta argued, Interlandi believed in the possibility and necessity of politicizing all forms of film, and he used the pages of *Quadrivio* and later *La difesa della razza* to vent his polemics. Gian Piero Brunetta, *Cinema italiano tra le due guerre* (Milan: Mursia, 1975), p. 42.

113. Fernando Tempesti, *Arte dell'Italia fascista* (Milan: Feltrinelli, 1976), p. 216.

114. The artists who participated in the first novecento exhibition in Milan in 1926 worked in a range of styles and were united mostly by the decision to exhibit together. The 1926 show displayed the following artists: Ugo Bernasconi, Agostino Bosia, Anselmo Bucci, Guido Cadorin, Massimo Campigli, Felice Carena, Aldo Carpi, Carlo Carrà, Felice Casorati, Giorgio de Chirico, Filippo de Pisis, Rafaelle de Grada, Giovanni Vagnetti, Antonio Donghi, Achille Funi, Virgilio Guidi, Piero Marussig, Cesare Monti, Giorgio Morandi, C. E. Oppo, Ottone Rosai, Alberto Salietti, Pio Semeghini, Gino Severini, Mario Sironi, Ardengo Soffici, Arturo Tosi.

115. Sarfatti, "L'arte e il fascismo," p. 218.

116. Simonetta Lux, ed., *Avanguardia, tradizione, ideologia: Itinerario attraverso un ventennio di dibattito, sulla pittura e plastica murale* (Rome: Bogatto Libri, 1990), p. 3.

For a discussion of the influence of the novecento movement on the culture of the *mostre*, see Rossana Bossaglia, "Caraterri e svilupi di Novecento," *Mostra del novecento italiano*, ed. Bossaglia, cat. exh. (Milan: Mazzotta, 1983), pp. 19–32; Raffaele De Grada, "La critica del novecento," in Bossaglia, *Mostra del novecento italiano*, pp. 43–52; Emily Braun, "Illustrations of Propaganda—The Political Drawings of Mario Sironi," *Journal of Decorative and Propaganda Arts* 3 (Winter 1987): 85–107.

117. Philip V. Cannistraro, "Fascism and Culture in Italy, 1919–1945," *Italian Art in the Twentieth Century*, ed. Emily Braun (London and Munich: Royal Academy and Prestel Verlag, 1989), p. 152; ASAC, Registre Vendite, 1928–34.

118. "Manifesto della pittura murale," *La colonna* (December 1933), as reprinted in Lux, "Avanguardia, traduzione, ideologia," p. 274.

119. For more on the novecento polemic, see Rossana Bossaglia, *Il novecento italiano—storia, documenti, iconographia* (Milan: Feltrinelli, 1979), pp. 42–53.

120. Enrico Crispolti, *Storia e critica del futurismo* (Bari: Laterza, 1986), p. 38.

121. Schiavo, *Futurismo e Fascismo*, and Enrico Crispolti, "Second Futurism," in Braun, *Italian Art in the Twentieth Century*, pp. 165–167.

122. The other signatories included Balla, Marinetti, Fillia, Tato, Somenzi, and Benedetta Marinetti.

123. "Riunione della commissione consultiva," June 8, 1931, ASAC, busta 55.

124. The following are examples of the approach that separates "first" and "second" futurism: Joshua C. Taylor, *Futurism* (New York: Doubleday, 1961), and the 1986 Palazzo Grassi Show in Venice, *Futurismo e futurismi*, cat. exh. (Milan: Pontus Hulten, 1986). Recent work by Enrico Crispolti, Andrew Hewitt, Jeffrey Schnapp, Barbara Spackman, and Claudia Salaris attempts to uncover and acknowledge both formal and ideological continuities between the movement's phases. See Crispolti, *Storia e critica del futurismo*; Andrew Hewitt, *Fascist Modernism* (Stanford, Calif.: Stanford University Press, 1993); Jeffrey Schnapp, "Forwarding Address," *Stanford Italian Review* 8, nos. 1–2 (1990): 53–80; Jeffrey Schnapp, "Mafarka and Son: Marinetti's Homophobic Economics," *Modernism/Modernity* 1, no. 3 (September 1994): 89–108; Claudia Salaris, *Storia del futurismo* (Rome: Editore Riuniti, 1985), and idem, *F. T. Marinetti* (Florence: La Nuova Italia Editrice, 1988).

Guido Armellini begs the question by acknowledging continuties but asserting that the dictatorship appropriated futurist "style" without futurist "content"; see *Le immagine del Fascismo nelle arti figurative* (Milan: Fabbri, 1980), pp. 9–31.

125. Emily Braun, "La Scuola Romana: Fact or Fiction," *Art in America*, no. 3 (March 1988): 128–37.

126. Corrado Maltese, *Storia dell'arte italiana, 1785–1943* (Turin: Einaudi, 1960), p. 365.

127. Ibid. For more on the experience of abstract artists under Fascism, see Luciano Caramel, "Abstract Art in the Thirties," Braun, *Italian Art in the Twentieth Century*, pp. 187–92, and "Gli astratti," in *Gil AnniTrenta: Art e Cultura in Italia*, ed. Vittorio Fagone, cat. exh. (Milan: Mazzotta, 1980), pp. 151–74; Armellini, *Le immagine del Fascismo nelle arte figurative*, pp. 94–100; Città di Prato, *Anni creativi al "Milione" 1932–1939*, cat. exh. (Milan: Silvana Editoriale), p. 1980.

128. Atanasio Soldati participated in the 1935 Quadriennale; Lucio Fontana showed his work at the 1930 Biennale and the 1935 Triennale, and he also constructed part of the decoration for the Salone d'Onore at the 6th Triennale of Milan. Radice assisted Terragni on the decoration of the Casa del Fascio of Como. Paolo Fossati rejects the contention that these abstract artists were isolated by the regime's cultural politics. See Paolo Fossati, *L'immagine sospesa—pittura e scultura astratte in Italia, 1934–40* (Turin: Einaudi, 1971).

129. Neil Harris, *Humbug: The Art of P. T. Barnum* (Chicago: University of Chicago Press, 1973), and Peter Greenhalgh, *Ephemeral Vistas: The Expositions Universelles, Great Exhibition and World's Fair, 1851–1939* (Manchester: Manchester University Press, 1988).

130. Peter Stansky, "The Japan-British Exhibition, London 1910," paper presented at the American Historical Association, San Francisco, January 8, 1994.

131. On the Italian Nationalist Association and its relationship to Fascism, see Alexander De Grand, *The Italian Nationalist Association and The Rise of Fascism in Italy* (Lincoln: University of Nebraska Press, 1978).

132. "Torre di sopra di Antonio Maraini," *Il popolo d'Italia*, March 23, 1930.

133. "Lo scultore Antonio Maraini commissario del sindacato nazionale delle belle arti," *Il popolo d'Italia*, July 20, 1932.

134. Lancelloti, *L'inquadramento sindacale degli artisti e la disciplina delle mostre d'arte in Italia*, p. 1.

135. "Antonio Maraini nominato commissario nazionale belle arti," *Le professioni e le arti* 2, no. 7 (July 1932): 32.

136. P. M. Bardi, "Il nuovo assetto del sindacato belle arti in una intervista con Antonio Maraini," *Le professioni e le arti* 3, nos. 1–2 (January–February 1933): 34–37.

137. Antonio Maraini, "Un anno di mostre sindacati regionali," *Dedalo* (1929–30): 679–720.

138. "Antonio Maraini nominato commissario del sindacato nazionale belle arti," p. 32.

139. See letters from Maraini to Guido Beer, Capo Ufficio, and "S. E. Benito Mussolini, Capo del Governo Nazionale," dating from February 1928 through March 1931, in ACS, PCM (1931–33), busta 14.1.734, sottofascicolo 1.

140. Letter, Antonio Maraini to Guido Beer, February 18, 1928, ACS, PCM (1931–33), busta 14.1.734, sottofascicolo 1.

141. Cannistraro, *La fabbrica del consenso*, pp. 36–37.

142. Vittorio Fagone, "Arte, politica, propaganda," in Fagonne, *Anni Trenta*, p. 48.

143. Fabio Benzi, "Materiali inediti dall'archivio di Cipriano Efisio Oppo," *Bolletino d'arte*, nos. 37–38 (May–August 1986): 169; *Le professioni e le arti* 2, no. 7 (July 1932): 32.

144. Benzi, "Materiali inediti dall'archivio di Cipriano Efisio Oppo," p. 169.

145. Giuseppe Pagano, "La Mostra delle colonie estive," *Casabella* 10, no. 116 (August 1937): 6–7.

146. Cipriano Efisio Oppo, "Arte fascista e arte di stato," *Critica fascista* 5, no. 3 (February 1, 1927): 44, as quoted and translated in Jeffrey Schnapp and Barbara Spackman, eds., "Selections from the Great Debate on Fascism and Culture: *Critica fascista* 1926–27," *Stanford Italian Review* 8, nos. 1–2 (1990): 265.

147. Ibid.

148. Corrado Maltese found Oppo's Quadriennale "a model of equilibrium and relative 'democracy,'" compared with Maraini's Biennale. Maltese, *Storia dell'arte italiana*, p. 362.

149. ACS, PNF Direttorio, Ufficio Stralcio, busta 274, and Leo Pollini, "La mostra del fascismo," *Il popolo d'Italia*, March 12, 1932.

150. ACS, PNF Direttorio, Ufficio Stralcio, busta 274, and "Prima bozza del piano generale per la Mostra del fascismo," *ACS*, MPI, divisione III, dir. gen., AA.BB.AA. (1930–35), busta 137.

151. *Chi è?* Rome: A. F. Formiggiani, (1936), 6:72.

152. Telespresso, Pavolini to Ambasciata d'Italia Berlino, May 26, 1942, ACS, MCP, busta 113, sottofascicolo 2, "Alfieri."

153. Memo, 1933, ACS, MCP, busta 113, sottofascicolo 2, "Alfieri."

154. Telespresso, Pavolini to PCM, October 26, 1942, ACS, MCP, busta 35, sottofascicolo 444.

155. Phillip V. Cannistraro, ed., *Historical Dictionary of Fascist Italy* (Westport, Conn.: Greenwood Press, 1982), p. 13; Silvio Lanaro, "Simbologia, immaginari di massa ed estetica della politica nell'Italia negli anni '30," lecture at the Istituto Gramsci di Bologna, April 11, 1987. The reconstruction of early Fascist Party credentials and the ex post facto assignment of party card numbers was by no means a rarity.

156. Telespresso, Pavolini to MCP Gabinetto, October 26, 1942. *ACS*, MCP, busta 35, sottofascicolo 444.

157. In 1929, in anticipation of the Mostra del Fascismo, Alfieri authored a history of Italy since 1919, entitled *Il libro d'Italia* (The book of Italy), which he hoped might become the intellectual foundation of the exhibition. Dino Alfieri, *Il libro d'Italia* (Milan: Istituto Fascista di Cultura, 1929).

Chapter Three
Aesthetic Pluralism Triumphant

1. Giuseppe Pensabene, "L'arte e i funzionari," *Quadrivio*, December 30, 1934 p. 1.

2. "L'architettura alla Biennale di Venezia," *Architettura* 1, no. 7 (July 1932): 358.

3. La Biennale di Venezia, *XVIII Esposizione biennale internazionale d'arte, 1932*, cat. exh. (Venice: Carlo Ferrari, 1932), p. 16.

4. Paolo Rizzi and Enzo di Martini, *La storia della Biennale, 1895–1982* (Milan: Electa, 1982), p. 37.

5. Seth Koven, "The Whitechapel Picture Exhibitions," in *Museum Culture*, ed. Daniel Sherman and Irit Rogoff (Minneapolis: University of Minnesota Press; 1994), p. 41.

6. Antonio Gramsci, *Selections from the Prison Notebooks*, ed. and trans. Quintin Hoare and Geoffrey Nowell-Smith (London: Lawrence and Wishart, 1971).

7. Ibid., p. 57.

8. Benito Mussolini, "Agli artisti della Quadriennale," *Scritti e discorsi*, 7 (Milano: Ulrico Hoepli, 1934), p. 281.

9. Regolamento Generale, *IV Esposizione regionale d'arte, sindacato belle arti di Sicilia, 1933*, ACS, MPI, divisione III, dir. gen. AA.BB., 1930–35, busta 129.

10. Regolamento, III Mostra regionale sindacato fascista belle arti della Romagna-Emilia, Ferrara 1933, ACS, MPI, divisione III, dir. gen. AA.BB., 1930–35, busta 129. The *3a Mostra Senese del sindacato fascista belle arti*, cat. exh. (Siena, 1933), promulgated the same instructions, as did the *Va Mostra regionale d'arte—Udine, 1931*, cat. exh. (Udine, 1931). The Udine exhibition declared: "Si basa sul criterio di accogliere con larghezza di vedute, ogni tecnica con la massima obbiettività per quanto riguarda le tendenze e le scuole."

11. Regolamento, Mostra regionale del sindacato belle arti delle Marche (Ancona), 1932, ACS, MPI, divisione III, dir. gen. AA.BB.AA., 1930–35, busta 127.

12. Giuseppe Bottai, "Per l'inaugurazione del Terzo Premio Bergamo," *Le arti* 4 (October–November 1941): 1.

13. Ugo Ojetti, cited in Fernando Tempesti, *Arte dell'Italia fascista* (Milan: Feltrinelli, 1976), p. 222.

14. Bruno Biagi, "Il sindacato, l'arte ed i giovani," *Gerarchia*, 11 (February 1933): 90.

15. Willibald Sauerlander, "The Nazis' Theater of Seduction," *New York Review of Books* 41, no. 8 (April 1994): 16.

16. Howard Becker, *Art Worlds* (Berkeley: University of California Press, 1982), p. 103.

17. Pierre Bourdieu, *Distinction: A Social Critique of the Judgement of Taste* (Cambridge, Mass:. Harvard University Press, 1984).

18. Paul Di Maggio and Michael Useem, "Cultural Democracy," in *Art and Society: Readings in the Sociology of the Arts,* ed. Arnold Foster and Judith Blau (Albany: SUNY Press, 1989), p. 174.

19. Becker, *Art Worlds,* p. 100.

20. Ibid.

21. Whitney Walton has written convincingly on the relationship among bourgeois taste, consumption, and production in nineteenth-century France. Whitney Walton, *France at the Crystal Palace* (Berkeley: University of California Press, 1992), pp. 5–19. Patricia Mainardi uses the International Espositions of 1855 and 1867 to trace the impact of new social, political, and economic forces on arts patronage; see *Art and Politics of the Second Empire* (New Haven, Conn.: Yale University Press, 1989).

22. Some Fascist cultural figures associated beaux arts sentimentality and florid ornamentation with pre-Fascist elites, reminiscent of an effete nineteenth-century order. On the attraction to ornamentation as a sign of "wealth and social distinction" in the nineteenth century, see Walton, *France at the Crystal Palace,* pp. 23–48.

23. Di Maggio and Useem, "Cultural Democracy," p. 174.

24. ASAC, Registre Vendite (4), (5), 1930–42.

25. This figure for total purchases had been superseded only during the immediate postwar Biennales of 1920, 1924, and 1926, when the first showings of modern art, and the collectors attracted by it, had produced a flurry of purchasing. "Diciasettesima Biennale di Venezia, 1930—Elenco delle opere vendute," ACS, MPI, divisione III, 1930–35, busta 141. Also cited in memo, Maraini to Capo Gabinetto, December 23, 1932, PCM, ACS, PCM (1934–36), 14.1.283, sottofascicolo 4.

26. ASAC, Registre Vendite (4), 1930. The total for all *enti pubblici,* which includes banks, corporations, and the Rotary Club, was 575,525 lire.

27. "Elenco delle opere," ACS, MPI, divisione III, 1930–35, busta 141. The government founded the Galleria d'arte moderna in 1930 as the site for a planned state collection of national modern art.

28. "Elenco delle opere vendute, 18th Biennale," ACS, MPI, divisione III, 1930–35, busta 141; ASAC, Registre Vendite (4), 1930.

29. Memo, Guiliano to Mosconi, April 4, 1932, ACS, MPI, divisione III, 1930–35, busta 141.

30. Ibid.

31. ASAC, Registre Vendite (4), 1928, 1930, and 1932.

32. ASAC, Registre Vendite (4), 1932.

33. Ibid.

34. Despite a lower total number of lire brought in, the Biennale sold more pieces of art in 1934: drawings, watercolors, and decoratives arts pieces had become increasingly popular and were more reasonably priced. See ibid.

35. "Elenco delle opere vendute," 1934, ACS, PCM (1940–42), busta 14.1.730, sottofascicolo 2B-1.

36. Letter, Ministro delle finanze to Ministro dell'educazione nazionale, November 11, 1930, ACS, MPI, divisione III, 1930–35, busta 136; letter, C. E. Oppo to Balbino

Giuliano, Ministro dell'educazione nazionale, October 20, 1930, ACS, MPI, divisione III, 1930–35, busta 136.

37. Letter, Ministro delle finanze to Ministro dell'educazione nazionale, March 21, 1993, ACS, MPI, divisione III, 1930–35, busta 136.

38. "Diciasettesima Biennale di Venezia, 1930—Elenco delle opere vendute," ACS, MPI, divisione III, 1930–35, busta 141.

39. ASAC, Registre Vendite, 1930. Antonio Donghi, *Cacciatore* (7,000 lire); Alberto Salietti, *Ragazza che legge"* (6,000 lire); Enrico Prampolini, *Benedetta Marinetti* (5,000 lire); Marino Marini, *Donna Dormiente* (5,000 lire).

40. Receipts for art purchased, September 1931, ACS, MPI, divisione III, dir. gen. AA. BB., 1930–35, busta 136.

41. Ibid. Mario Sironi's price of 6,000 lire represented an exceptionally high one.

42. Fifteen percent of the purchase price went to the Ente autonomo quadriennale d'arte nazionale.

43. *ASAC*, Registre Vendite (4), 1932.

44. *IV Esposizione d'arte del sindicato regionale fascista belle arti della Venezia Giulia,* cat. exh. (Trieste, 1930).

45. *IV Esposizione d'arte del sindicato regionale fascista belle arti della Venezia Giulia,* cat. exh. (Trieste, 1932).

46. *3a Mostra Senese del sindacato fascista belle arti,* cat. exh. (Siena, 1933).

47. *Prima quadriennale d'arte nazionale,* cat. exh. (Rome: 1931).

48. List of purchases, Second Roman Quadriennale, 1935, *ACS*, MPI divisione III, dir. gen. AA.BB., 1930–35, busta 136.

49. Ibid. (emphasis added).

50. Artists' trade and syndical journals, such as *Le arti* and *Le professioni e le arti*, ran regular columns listing prominent purchases, as did *Il popolo d'Italia*.

51. *ASAC*, busta 63.

52. *ASAC*, Registre Vendite (4), 1934; letter, Bianchetti, Capo di Gabinetto to Direttore della Biennale, February 6, 1935, *ACS*, PCM (1934–36), 14.1.283, sottofascicolo 6.

53. Letter, Volpi to Bianchetti, June 29, 1934, *ACS*, PCM (1934–36), 14.1.283 sottofascicolo 6.

54. Ibid. Italian artists were additionally given the honor of offering Mussolini a discount: "The prices requested by the artists were reduced, which I am certain all will accept, considering the honor given them."

55. Ibid.

56. Memo, B. Tartaglia and Co. to PCM, January 29, 1935, ACS, PCM (1934–36), 14.1.283, sottofascicolo 6. See also Renzo De Felice, *Il Duce: Gli anni del consenso* (Turin: Einaudi, 1974), pp. 486–509; Charles Delzell, *Mediterranean Fascism, 1919–45* (New York: Harper and Row, 1970), p. 190.

57. Giuseppe Pensabene, "L'arte e i funzionari," *Quadrivio*, December 30, 1934, p. 1.

58. Letter, Maraini to Ministro dell'educazione nazionale, November 1, 1932, ACS, MPI, divisione III, 1930–35, busta 141.

59. Relazione sul Piano Finanziario Per la Mostra regionale del sindacato belle arti delle Marche, 1932, ACS, MPI, divisione III, dir. gen. AA.BB.AA., 1930–35, busta 127.

60. Letter, Attilio Ferrucci, il direttore della segreteria, to Francesco Armentano, April 13, 1931, *ACS*, MPI divisione III, dir. gen. AA.BB., 1930–35, busta 136.

61. La Biennale di Venezia, *XVII Esposizione biennale internazionale d'arte, 1930*, cat. exh. (Venice: Carlo Ferrari, 1930), p. 17.

62. *VI Mostra del sindicato belle arti del Lazio*, cat. exh. (Rome: Enzo Pinci, 1936), p. 14.

63. *IV Esposizione d'arte del sindicato regionale fascista belle arti della Venezia Giulia*, cat. exh. (Trieste, 1930); *V Esposizione d'arte del sindicato regionale fascista belle arti della Venezia Giulia*, cat. exh. (Udine, 1931), pp. 19–20.

64. *IIIa Mostra sindacale d'arte*, cat. exh., Mostra del sindacato interprovinciale fascista belle arti della venezia tridentina (1933).

65. Pensabene, "L'arte e i funzionari," p. 1.

66. "Relazione della giuria per il conferimento dei premi alla XVII Biennale," ACS, MPI, divisione III, 1930–35, busta 141, p. 1.

67. Lawrence Alloway, *The Venice Biennale, 1895–1968* (London: Faber & Faber, 1969), p. 104.

68. "Relazione della giuria per il conferimento dei premi alla XVII Biennale," ACS, MPI, divisione III, 1930–35, busta 141, p. 2.

69. Postcards mailed by Maraini, June 23, 1930, ASAC, busta 55.

70. The jury included Biennale President Volpi, Giuseppe Bottai, Carlo Basile, representative of the Fascist Party, Giacomo di Giacomo, president of the Fascist National Confederation Professionals and Artists, C. E. Oppo, the secretary of the Fascist Syndicate of the Fine Arts, Roberto Forges Davanzati, the president of the Society of Authors and Editors, and Antonio Maraini.

71. Jury deliberations, September 8, 1930, ASAC, busta 55.

72. "Relazione della giuria per il conferimento dei premi alla XVII Biennale," p. 2.

73. Ibid., p. 3.

74. Ibid., p. 2.

75. Carpanetti had already worked within the Fascist exhibition system, winning the Premio Principe Umberto at the second exhibition of the Fascist Syndicate of the Fine Arts of Lombardy in 1930. Piero Torriano, "La seconda mostra del sindicato fascista Lombardo e la biennale di Brera," *L'illustrazione italiana*, October 19, 1930, p. 1062.

76. "Incipit Novus Ordo," ASAC, busta 57.

77. The painting *Incipit novus ordo* remained unpurchased in December 1933. At that point, Carpanetti was using his contribution to the Mostra della rivoluzione fascista as the reason why the party should pay 25,000 lire for it. On December 5, 1933, Alfieri wrote Achille Starace, secretary of the Fascist Party, on Carpanetti's behalf, calling him "one of the most valued collaborators on the Mostra della rivoluzione" and asking if "the party could acquire his beautiful painting." Alfieri continued, "Now, I must let you know that Carpanetti, as you know a long-standing Fascist, finds himself in particularly difficult straits, as the result of work on the Mostra della rivoluzione with a form of nervous breakdown, for which he must urgently take a cure and a period away from work." ACS, PNF direttorio, Ufficio Stralcio, busta 273.

Carpanetti presented a mural at the VI Triennale di Milano in 1936 entitled "Sintetizza pittoricamente della millenaria civiltà italica." ASAC, fototeca.

78. See, for example, "La XVIII Biennale di Venezia e il X anniversario della Marcia su Roma," *Corriere della sera*, September 3, 1931; "I concorsi alla Biennale di Venezia per opere glorificanti il regime fascista," *Il popolo d'Italia*, January 2, 1932, p. 3; "I

premi per la XVIII Biennale di Venezia," *Gazzetta di Venezia*, September 3, 1931; "Il regolamento per i premi della XVII Biennale di Venezia," *Gazzetta di Venezia*, January 2, 1932; "I premi della Biennale Veneziana nel Decennale," *Le professioni e le arti* 2, no. 3 (March 1932): 21.

When the announced deadline of June 30, 1932, elapsed without significant responses, Maraini extended the deadline for participation to July 15, 1932. "Le iscrizioni ai premi della Biennale," *Gazzetta di Venezia*, June 23, 1932.

79. "Regolamento per i premi della XVIII Biennale di Venezia," ACS, MPI, divisione III, 1930–35, busta 141.

80. Ibid.

81. "La XVII Biennale di Venezia," *Il popolo d'Italia*, August 14, 1932.

82. Memo, la giuria to Presidente della Biennale, September 6, 1932, ACS, MPI, divisione III, 1930–35, busta 141.

83. Ibid.

84. "La celebrazione del Decennale fascista alla Biennale di Venezia," *L'illustrazione italiana*, October 9, 1932, p. 499.

85. La Biennale di Venezia, *XVII Esposizione biennale internazionale d'arte, 1930*, p. 13; "XVII Esposizione internazionale della città di Venezia—1930—Riassunto," ASAC, busta 55.

86. "Relazione della giuria, per il conferimento der premi all XVII Biennale."

87. Ibid.

88. "La celebrazione del Decennale fascista alla Biennale di Venezia," p. 498. Dottori has been called "a precursor of *aeropittura* with his aerial views and dilated perspectives." Corrado Maltese, *Storia dell'arte italiana, 1785–1943* (Turin: Einaudi, 1960), p. 368.

89. "La celebrazione del Decennale fascista alla Biennale di Venezia," p. 499. *Squadristi* were the fighting bands of the early Fascist Party.

90. *Annuario statistico italiano*, 6, 3d ser. (1932), pp. 238, 250, and 263. *Il popolo d'Italia*, October 27, 1932.

91. See the interview with Maraini for an official enunciation of this position: Antonio Maraini, "L'inquadramento sindacale degli artisti," *Le professioni e le arti* 6, no. 8 (August 1936): 13–15.

92. Letter, Antonio Discovolo to Maraini, June 23, 1930, ASAC, busta 55.

93. Letter, Marinetti to Volpi, May 1932, ACS, MPI, divisione III, 1930–35, busta 141.

94. For a discussion of Cornelio Di Marzio's faction, see Philip V. Cannistraro, *La fabbrica del consenso* (Rome-Bari: Laterza, 1975), pp. 36–38, 124–26.

95. "Relazione della Commissione pel conferimento dei premi della Biennale per celebrare con l'arte il Decennale della Marcia su Roma," November 1, 1932, ACS, MPI, divisione III, 1930–35, busta 141.

96. Ibid., p. 2.

97. Alberto Neppi, "L'opera degli artisti alla Mostra della rivoluzione fascista," *Rassegna dell'istruzione artistica* 15 (November–December 1932): 335.

98. Ibid.

99. For more on the interwar European avant-garde debate over the function of art in modern society, see John Willet, *Art and Politics in the Weimar Period* (New York: Pantheon, 1978), and Edward Timms and Peter Collier, eds., *Visions and Blue-*

prints: Avant–garde Culture and Radical Politico in Twentieth–Century Europe (Manchester: Manchester University Press, 1988).

100. *Va Esposizione d'arte del sindacato regionale della Venezia Giulia*, Udine, Edizioni d'arte "tip. fiorini" (Udine, 1931), p. 15.

101. Antonio Maraini, ed., *L'ordinamento sindacale fascista delle belle arti* (Rome: Sindacato Nazionale Fascista Belle Arti, 1939), pp. 191–96.

102. Romolo Bazzoni, *Sessant, anni della Biennale di Venezia* (Venice: Lombroso Editore, 1962), appendix, p. XLIV.

103. *ASAC*, busta 55.

104. Maria Cecilia Mazzi, "Modernità e tradizione: Temi della politica artistica del regime fascista," *Richerche di storia dell'arte*, no. 12 (1980): 22, and Bossaglia, *Il "novecento italiano*," pp. 42–48.

105. La Biennale di Venezia, *XIX Esposizione biennale internazionale d'arte, 1934*, cat. exh. (Venice: Carlo Ferrari, 1934), pp. 11–16.

106. Ibid., pp. 22–24.

107. Pierre Bourdieu, *The Field of Cultural Production*, ed. Randal Johnson (New York: Columbia University Press, 1993), p. 11.

108. Andrew Ross, *No Respect: Intellectuals and Popular Culture* (New York: Routledge, 1989), p. 5.

109. Mazzi, "Modernità e tradizione," p. 22.

110. Margherita Sarfatti, "La diciottesima Biennale a Venezia," *La rivista illustrata del popolo d'italia* 4 (June 1932), p. 37.

111. Ibid., pp. 38–40.

112. Balbino Giuliano, "Commento alla Biennale di Venezia," *Bibliografia fascista* 9 no. 6 (June 1934): 435.

113. Ibid., p. 436.

114. Francesco Sapori, "Alla XIX Biennale Veneziana," *Rassegna dell'istruzione artistica* (April–May–June 1934): 83.

115. Ibid., p. 89.

116. Ibid., p. 96.

117. In the mid 1930s, Interlandi's positions were to the right of the Mussolini dictatorship, although after 1936 he increasingly reflected the position of the regime, as it moved to the right. After 1937, Interlandi's views received their broadest exposure through the racist, pro-Nazi journal *Il Tevere*. For more information on Interlandi and the group around him, see Cannistraro, *La fabbrica del consenso*, and Enrico Crispolti, *Il mito della macchina e altri temi del futurismo* (Celebes: Trapani, 1969).

118. Pippo Rizzo was an important figure in Fascist exhibition culture: he showed at all the Biennales of 1926 through 1942 and the Quadriennales of 1931, 1935, and 1943. He sat on the jury of the 1943 Quadriennale, directed the Sicilian Regional Syndicate of the Fine Arts between 1928 and 1932, and sat on the syndicate's National Directorate between 1936 and 1942. For further information on Pippo Rizzo, see Pietro Mignosi, *Pippo Rizzo e le nuove correnti della pittura siciliana* (Rome: Edizione d'Arte "Quadrivio," 1936), and Enrico Crispolti, *Ricostruzione futurista dell'universo*, cat. exh. (Turin: Museo Civico di Torino, 1980).

119. Pippo Rizzo, "Un passo avanti? La XIX Biennale d'arte di Venezia," *Quadrivio*, May 20, 1934, p. 3.

120. Giuseppe Pensabene, "L'arte e i funzionari," p. 1.

121. Rizzo, "Un passo avanti? La XIX Biennale d'arte di Venezia," p. 3.

122. Ibid.

123. *III Mostra regionale sindacato fascista belle arti della Romagna-Emilia*, cat. exh. (Ferrara, 1933); *ACS*, MPI, divisione III, dir. gen. AA.BB, 1930–35, busta 129.

Chapter Four
Challenging the Social Boundaries of Culture

1. "Il programma della I Esposizione d'arte cinematografica," *Gazzetta di Venezia*, August 3, 1932.

2. *L'arte nelle mostre italiane* no. 1 (January 1939): 3.

3. "La prima esposizione internazionale d'arte cinematografica," *Gazzetta di Venezia*, May 24, 1932.

4. Giuseppe Carlo Marino, *L'autarchia della cultura* (Rome: Riuniti, 1983), p. x.

5. Paolo Rizzi and Enzo di Martini, *La Storia delle Biennale, 1895–1982* (Milan: Electa, 1982), p. 37.

6. Pierre Bourdieu, *Distinction: A Social Critique of the Judgement of Taste* (Cambridge, Mass.: Harvard University Press, 1984).

7. Lawrence Levine, *Highbrow/Lowbrow: The Emergence of Cultural Hierarchy in America* (Cambridge, Mass.: Harvard Universtiy Press, 1988); Lawrence Levine, "William Shakespeare and the American People: A Study in Cultural Transformation," and Paul Di Maggio, "Cultural Entrepreneurship in Nineteenth-Century Boston: The Creation of an Organizational Base for High Culture in America," in *Rethinking Popular Culture*, ed. Chandra Mukerji and Michael Schudson (Berkeley: University of California Press, 1991), pp. 157–97, 374–97.

8. David Forgacs, *Italian Culture in the Industrial Era* (Manchester: Manchester University Press, 1990), p. 47.

9. Victoria de Grazia, *The Culture of Consent: The Mass Organization of Leisure* (Cambridge: Cambridge University Press, 1981), p. 127.

10. Martin Clark, *Modern Italy, 1871–1982* (London: Longman, 1984), p. 271.

11. Funk and Wagnalls, *Standard Desk Dictionary* (New York, 1969).

12. Mussolini announced the strategy of "decisively reaching out to the people" in a 1932 speech, "Al popolo napoletano," in *Opera omnia*, eds. Edoardo Susmel and Dullio Susmel (Florence: La Fenice, 1958), 25:50.

13. On the growth of the party in the 1930s and attempts to mobilize larger portions of the population see Teresa Maria Mazzatosta, *Il regime fascista tra educazione e propaganda, 1935–43* (Bologna: Cappelli, 1978).

14. On youth organization and socialization, see Tracy Koon, *Believe, Obey, Fight: The Political Socialization of Youth in Fascist Italy, 1922–43* (Chapel Hill: University of North Carolina Press, 1985), and Carmen Betti, *L'Opera nazionale balilla e l'educazione fascista* (Florence: La Nuova casa editrice, 1984). On women and Fascism, see Victoria de Grazia, *How Fascism Ruled Women* (Berkeley: University of California Press, 1992).

15. Victoria de Grazia discusses the targeting of Fascist culture according to social class in *The Culture of Consent*. See especially "Privileging the Clerks," pp. 127–50, and "The Formation of Fascist Low Culture," pp. 187–224.

16. Simonetta Lux, ed. *Avanguardia, traduzione, ideologia: itinerario attraverso un ventennio di dibattito sulla pittura e plastica murale* (Rome: Bagatto Libri, 1990), p. 4.

17. In a process similar to the one responsible for the reorganization of the figurative arts show, Maraini lobbied Mussolini, Giuliano, and Giurati in March and April of 1931 for government funding and support. With official backing established in late 1931, the music festival took the shape it would hold for the rest of the decade.

18. *ASAC*, busta 88, "corrispondenza varie."

19. The press welcomed the symmetrical organization of the music and art shows: "there will be certain 'national pavilions,' concerts dedicated to the music of a single nation, and certain 'international pavilions' that will offer the music of several nations in the same concert. "Il 2a Festival internazionale di musica," *Gazzetta di Venezia*, January 13, 1932.

20. Press Release, 1934 Biennale, *ASAC*, busta 83.

21. *ASAC*, busta 88, "corrispondenze varie."

22. *ASAC*, busta 62.

23. *ASAC*, busta 88, "corrispondenze varie."

24. Press release, 1934 theater festival, *ASAC*, busta 82.

25. Elio Zorzi, "Inaugurazione della III Mostra internazionale del cinema," *L'illustrazione italiana*, August 18, 1935, p. 345, and "La prima Esposizione internazionale d'arte cinematografica," *Gazzetta di Venezia*, May 24, 1932. The films at the first show came from Germany, the United States, France, the Soviet Union, Great Britain, Italy, Czechoslovakia, Poland, and Holland, with the largest number of entries coming from the United States and Germany. "Un elenco di films," *Gazzetta di Venezia*, July 24, 1932.

26. Zorzi, "Inaugurazione della III Mostra internazionale del cinema," p. 345.

27. *L'arte nelle mostre italiane* 4, no. 1 (January 1939): 7, 24.

28. Elio Zorzi, "Inaugurazione della III Mostra internazionale del cinema," p. 345.

29. "Un elenco di films." "Referendum pubblico—Ia Esposizione internazionale d'arte cinematografica," *ACS*, PCM (1934–36), 14.1.4677. Gian Piero Brunetta, *Cinema italiano tra le due guerre* (Milan: Mursia, 1975), pp. 67, 71. Marcia Landy, *Fascism in Film* (Princeton, N.J.: Princeton University Press, 1986), p. 15. See also Vito Zagarrio, "Il modello sovietico: Tra piano culturale e piano economico," in *Cinema italiano sotto il Fascismo*, ed. Riccardo Redi (Venice: Marsilio, 1979), pp. 185–200.

30. "Relazione per l'assegnazione dei premi alla Mostra internazionale d'arte cinematografica," *ACS*, PCM (1934–36), 14.1.4677.

31. "Il convegno internazionale di teatro–bando per il concorso d'arte drammatica," *ASAC*, busta 82.

32. Patricia Mainardi makes a similar point about the Second Empire's search for the allegiance of spectators and cultural producers. Patricia Mainardi, *Art and Politics of the Second Empire* (New Haven, Conn.: Yale University Press, 1989), p. 17.

33. "Relazioni per il conferimento dei premi," *ASAC*, busta 92.

34. Wolfsonian Foundation, Miami Florida, medallion collection, 82.782.1.1.

35. In 1936 foreign films accounted for 84 percent of box office returns and in 1938, 87 percent, with Hollywood films composing the bulk of these. Forgacs, *Italian Culture in the Industrial Era*, p. 69.

36. Ibid., p. 62.

37. "L'esito del referendum," *Gazzetta di Venezia*, August 24, 1932.

38. On the interest in Fascist Italy in Soviet realist film, see Ruth Ben Ghiat, "The Formation of a Fascist Culture: The Realist Movement in Italy, 1930–43" (Ph.D. dissertation, Brandeis University, 1991), pp. 110–54.

39. *Il gazzettino*, August 8, 1932.

40. Ibid.

41. Brunetta, *Cinema italiano tra le due guerre*, pp. 67, 71.

42. English language brochure, 1934, *ASAC*, busta 92.

43. *Il gazzettino*, July 11, 1937.

44. Anne Friedberg, *Window Shopping* (Berkeley: University of California Press, 1993), p. 122.

45. Press release 1934 Biennale.

46. "Stampati," and "La Biennale di Venezia—II Esposizione internazionale d'arte cinematografica—Relazioni per il conferimento dei premi," *ASAC*, busta 92.

47. Zorzi, "Inaugurazione della III Mostra internazionale del cinema," p. 345.

48. Peter Bondanella, *Italian Cinema from Neo-Realism to the Present* (New York: Fredrick Ungar, 1983), pp. 11 –12.

49. "Appunto per S.E. il Capo del Governo," December 18, 1933, *ACS*, PCM (1934–36), 14.1.4677. This propaganda film placed "special emphasis upon the birth of the province of Littoria."

50. Gian Piero Brunetta, *Storia del cinema italiano* (Rome: Riunite, 1979), p. 42.

51. The Istituto Luce was founded in 1924 by decree of Mussolini as a production center for informational and propaganda films; the institute produced newsreels and propaganda features, and screened and censored foreign newsreels. After 1926, a LUCE newsreel had to be shown by law prior to each feature film. For more on the Istituto Luce and government intervention in the film industry in Fascist Italy, see Brunetta, *Storia del cinema italiano*; Philip V. Cannistraro, *La fabbrica del consenso* (Rome-Bari: Laterza, 1975); Redi, *Il cinema italiano sotto il Fascismo*; Geoffrey Nowell-Smith, "The Italian Cinema under Fascism," in *Rethinking Italian Fascism*, ed. David Forgacs (London: Lawrence and Wishart, 1986); and James Hay, *Popular Film Culture in Fascist Italy* (Bloomington: Indiana University Press, 1986), especially chap. 7, "LUCE/Cinema/Shadows," pp. 201–32.

52. The Ministero della stampa e propaganda (Ministry of Press and Propaganda) existed as an undersecretariat until June 1935 when it was elevated to a full ministry and Count Galeazzo Ciano became the first minister of the press and propaganda. The Direzione generale della cinematografia was established in September 1934, at which time subdepartments of tourism, music, literature, and theater were also created. The office was headed by Luigi Freddi who also had been assistant chairman of the Mostra della rivoluzione in 1932. For discussions of the Direzione generale della cinematografia, see Nowell-Smith, "The Italian Cinema under Fascism"; and Brunetta, *Cinema italiano tra le due guerre*, especially chap. 3, "L'organizzazione delle strutture."

53. *Le mostre d'arte in Italia* 4, no. 1 (January 1939): 7; "Appunto per S.E. il Capo del Governo," September 9, 1935, *ACS*, PCM (1934–36), 14.1.4677. The figure of 55,237 for 1937 was also cited by Maraini in a telegram to Mussolini on September 9, 1937. See *ACS*, PCM (1937–39), 14.1.2966, sottofascicolo 5.

54. "Appunto per S.E. il Capo del Governo," September 9, 1935.

55. "Relazione," September 3, 1935, *ACS*, PCM (1934–36), 14.1.4677.

56. Letter and attachment, Maraini and Volpi to Mussolini, September 3, 1935, *ACS*, PCM (1934–36), 14.1.4677.

Triumph of the Will won the prize offered by the Istituto Luce for "Best Foreign Documentary"; *Becky Sharp* won the Biennale prize for "Best Film in Color";

Promised Land, was produced by Urim Palestine F.C., was given a diploma of "Honorable Mention" by the jury.

57. Nowell-Smith, "The Italian Cinema under Fascism," in p. 154; *Il gazzettino*, July 11, 1937. According to James Hay it "met with only lukewarm critical reaction" at the cinema show, and according to Gian Piero Brunetta it failed "because of blocks of dialogue which broke up its internal rhythm, as well as [due to] the silliness of its expression and technique." Hay, *Popular Film Culture in Fascist Italy*, p. 115, and Brunetta, *Cinema italiano tra le due guerre*, p. 77.

58. Nowell-Smith, "Italian Cinema under Fascism," p. 150. Roberto Rossellini worked as coscriptwriter on this film.

59. Brunetta, *Storia del cinema italiano*, p. 313.

60. Telegram, Biennale to Mussolini, August 31, 1938, ACS, PCM (1937–39), 14.1.2966, sottofascicolo 6.

61. *Gazzetta ufficiale del regno d'Italia*, no. 122, May 27, 1936, pp. 1758–59.

62. Ibid.

63. *ACS*, PCM (1937–39), 14.1.2966, sottofascicolo 4.

64. *Gazzetta di Venezia*, October 1, 1940.

65. "La giornata di Goebbels e Pavolini a Venezia," *Il gazzettino*, August 31, 1942.

66. *Il gazzettino*, September 1, 1942.

67. "Appunto per il Duce," June 13, 1943, ACS, PCM (1937–39), 14.1.2966, sottofascicolo 8.

68. 1934 Venice Biennale English Language Brochure, *ASAC*, busta 92.

69. *ASAC*, busta 63, fascicolo "Padiglione Venezia"; "XVII Biennale d'arte—Le norme per la sezione d'arte decorativa," *Gazzetta di Venezia*, November 21, 1931. The decorative arts section was subject to the same regulations as the figurative arts section.

70. La Biennale di Venezia, *XIX Esposizione biennale internazionale d'arte, 1934*, cat. exh. (Venice: Carlo Ferrari, 1934), p. 18.

71. *ASAC*, Registre Vendite (4), 1932 and 1934.

72. Volpi, Biennale closing speech, October 14, 1934, *ASAC*, busta 80, "Biennale propaganda."

73. Susan Sellers, "Mechanical Brides: The Exhibition," *Design Issues* 10, no. 2 (Summer 1994): 70.

74. Whitney Walton, *France at the Crystal Palace* (Berkeley: University of California Press, 1992) p. 32.

75. Debora Silverman writes of the dual function of the craft renaissance in the French Third Republic. See *Art Nouveau in Fin-de-Siècle France* (Berkeley: University of California Press, 1989) pp. 43–51.

76. La Biennale di Venezia, *XIX Esposizione biennale internazionale d'arte, 1934*, p. 213.

77. Some Fascist officials, such as Emilio Bodrero, proposed the decorative arts as an arena for employment opportunities: "Richiamo alle arti decorative," *Il popolo d'Italia*, October 14, 1931.

78. *Confederazione degli artisti e professionisti*, documents (*ASAC* library), p. 185.

79. "Artisti d'oggi," *Le professioni e le arti*, 4, no. 4 (April 1934): 4–5.

80. See Barbara Melosh, *Engendering Culture* (Washington, D.C.: Smithsonian Institution Press, 1991), and Walter Kalaidjian, *American Culture between the Wars* (New York: Columbia University Press, 1993).

81. The same was true in the context of New Deal America; See Melosh, *Engendering Culture*, p. 7.

82. Antonio Maraini, ed., *L'ordinamento sindacale fascista delle belle arti* (Rome: Sindacato Nazionale Fascista Belle Arti, 1939), p. xi.

83. Ibid., p. xii.

84. "Manifesto della pittura murale," *La colonna* (December 1933), as reprinted in Lux, *Avanguardia, traduzione, ideologia*, p. 272.

85. Ibid.

86. Mario Sironi, "Pittura murale," in *Storia moderna dell'arte in Italia*, ed. Paola Barocchi (Turin: Einaudi, 1990), p. 131.

87. Ibid. p. 132.

88. *Prima mostra nazionale di plastica murale per l'edilizia fascista*, cat. exh. (Genoa: Palazzo Ducale, 1934), p. 4.

89. "La plastica murale futurista—manifesto," *2a Mostra nazionale di plastica murale per l'edilizia fascista in italia e in africa*, cat. exh. (Rome: Edizioni futuriste di 'poesia,' 1936), p. 3.

90. *Prima mostra nazionale di plastica murale per l'edilizia fascista*, cat. exh. (Genoa: Palazzo Ducale, 1934), p. 4.

91. Ibid.

92. Ibid., p. 6.

93. *2a Mostra nazionale di plastica murale per l'edilizia fascista in italia e in africa*, cat. exh. (Rome: Edizioni futuriste di 'poesia,' 1936), p. 7.

94. Dawn Ades, Tim Benton, David Elliot, and Iain Boyd White, eds., *Art and Power: Europe under the Dictators, 1930–45*, cat. exh. (London: Hayward Gallery / South Bank Centre, 1995), p. 132.

95. Reproductions of these murals can be found in the illustrations 115 and 116 of Barocchi, *Storia moderna dell'arte in Italia*.

96. *Le mostre d'arte in Italia* 2, no. 6 (June 1935), p. 1.

97. Ibid.

98. La Biennale di Venezia, *XXII Esposizione biennale internazionale d'arte, 1940*, cat. exh. (Venice: Carlo Ferrari), p. 10.

99. Ugo Ojetti, "Concorsi e ritratti," *Corriere della sera*, June 9, 1940.

100. Vincenzo Costantini, "Il Premio Cremona—arte umana per il popolo," *L'illustrazione italiana*, May 20, 1939, pp. 1159–60.

101. Relazione sul Piano Finanziario Per la Mostra regionale del sindacato belle arti delle Marche, 1932, ACS, MPI, divisione III, dir. gen. AA.BB.AA., 1930–35, busta 127.

102. *VI Mostra del sindicato belle arti del Lazio*, cat. exh. (Rome: Enzo Pinci, 1936), p. 12.

103. Robin Lenman, "Painters, Patronage, and the Art Market in Germany, 1850–1914," *Past and Present*, no. 123 (1989): 127.

104. Diane Crane, *The Transformation of the Avant-Garde* (Chicago: University of Chicago Press, 1987), p. 7.

105. *ASAC*, busta 57, "pubblicità—1930."

106. Letter, Società Italiana Affisioni to Zorzi, April 18, 1930, *ASAC*, busta 57, fascicolo "pubblicità—1930."

107. *ASAC*, busta 63, "pubblicità—1932."

108. *ASAC*, busta 57, "pubblicità—1930."

109. *ASAC*, busta 63, "pubblicità—1932."

110. Ibid.

111. Ibid.

112. *ASAC*, busta 57, "pubblicità—1930."

113. *Il gazzettino*, July 17, 19, and 22, 1930; *Il popolo d'Italia*, October 24–25, 1930.

114. *Notiziario turistico*, April 9, 1934; *ASAC*, busta 92, fascicolo "stampati—1934."

115. *ASAC*, busta 88, fascicolo "corrispondenza varie—1934—comunicati stampa."

116. Biennale memo, October 5, 1934, *ASAC*, busta 88, "corrispondenza varie 1934."

117. Ibid.

118. Ibid.

119. Reale Decreto Legge, no. 76, ACS, PCM (1937–39), 14.1.112.

120. *ASAC*, busta 105, "stampati vari."

121. Letter, Biennale to Ente Provinciale per il Turismo, July 29, 1936, *ASAC*, busta 81.

122. *ASAC*, busta 89, "Corrispondenza.

123. Ibid.

124. *ASAC*, busta 80, "piano di pubblicita."

125. Telegram, Maraini and Volpi to Mussolini, October 17, 1934, ACS, PCM (1934–36), 14.1.283, sottofascicolo 5.

126. Memo, Biennale to PCM, gabinetto, December 13, 1932, ACS, PCM (1934–36), 14.1.283, sottofascicolo 4; letter, Maraini to Mussolini, May 7, 1934, ACS, PCM (1934–36), 14.1.283, sottofascicolo 5.

127. Memo, Maraini to PCM, Capo Gabinetto, December 23, 1932, ACS, PCM (1934–36), busta 14.1.283, sottofascicolo 4. "La chiusura della 18a Biennale Veneziana," *Il popolo d'Italia*, November 2, 1932, p. 9.

128. Minutes of meeting of the Comitato Direttivo, January 29, 1935, ACS, PCM (1940–42), busta 14.1.730, sottofascicolo 1-D. Attendance figures for 1934 reveal a discrepancy: in 1939 Maraini quoted 361,917 visitors for 1934, as opposed to Volpi's 450,000. *Le mostre d'arte in Italia* 6, no. 1 (January 1939): 6.

129. A law of 1926 required that all theaters show a LUCE newsreel prior to the main attraction.

130. *Cinecittà*, Istituto LUCE, cinegiornali, May 1930, no. 572.

131. Ibid., no. 573.

132. *Cinecittà*, Istituto LUCE, cinegiornali, 1930–40: May 1930, nos. 572, 573 (inauguration), May 1932: no. 953 ("Il Re inaugura la Biennale"), 1934: no. 462 ("i preparativi per la Biennale"), nos. 470, 472, 474 ("XIX Biennale inaugurata dal Re"), no. 488 ("Il Duce alla Biennale"), no. 494 (chiusura della Biennale), June 1936: no. 899 (inaugurazione XX Biennale), no. 950 ("Goebbels alla Biennale"), 1937: no. 1034 (Mostra del cinema), no. 1159 (Mostra del cinema), 1938: nos. 1319, 1355 (Mostra del cinema—Alfieri), July 1939: nos. 1565, 1566 (Mostra del cinema), May 1940: no. 35 (Il Re inaugura XXII Biennale).

133. *Cinecittà*, Istituto Luce, cinegiornali, 1930, nos. 495–705; 1931, nos. 706–901. Between 1931 and 1940, the LUCE produced 1,693 films, an average of three to four a week; see Alberto Farassino, "Quei dieci anni di cinema italiano," in *AnniTrenta: Arte e cultura in Italia*, ed. Vittorio Fagone, cat. exh. (Milan: Mazzota, 1983), p. 394.

134. *Cinecittà*, Istituto Luce, cinegiornali, 1932, nos. 901–1037. The sound newsreel began to appear in late 1931; in 1932 the Luce produced both sound and silent news-

reels, by 1933 all newsreels had sound. The average sound reel for 1932 was about 250 to 300 meters and contained five to seven stories.

135. *Cinecittà*, Istituto Luce, cinegiornali, 1937, nos. 1019–1227; 1938, nos. 1228–1435; 1939, nos. 1436–1645.

136. "R. Decreto-legge, 21 luglio 1938-XVI—Nuovo ordinamento dell'Esposizione biennale internazionale d'arte di Venezia," article 12, p. 3. ACS, PCM (1940–42), 14.1.730, sottofascicolo 1–2.

137. Ibid.

138. "Atti parlimentari, Senato del Regno (no. 2539)," Disegno del legge, articolo 7, p. 2, ACS, PCM (1940–42), 14.1.730, sottofascicolo 1–2.

139. Lauro Malvano, *Fascismo e la politica dell'immagine* (Turin: Bollati Boringhieri, 1988), p. 33.

140. "Decreto 11 novembre 1938," ACS, PCM (1940–42), 14.1.730, sottofascicolo 2B-2.

141. Ibid.

142. Ibid.

143. Memo, Ministero della finanza to Ministero dell'educazione nazionale, May 31, 1938, ACS, PCM (1940–42), 14.1.730, sottofascicolo 2B-2.

144. *Le mostre d'arte in Italia* 5, no. 12 (December 1938): 2.

145. *Le mostre d'arte in Italia* 5, nos. 8–11 (August-November 1938): 1.

146. Ibid.

Chapter Five
Fascist Mass Culture and the Exhibition of the Fascist Revolution

1. Giuseppe Pagano, "La mostra azzurra," *Casabella* 6, n. 80 (August 1934): 4.

2. P. M. Bardi, "Esposizioni," *Bibliografia fascista* 7, no. 11 (November 1932): 701.

3. Ibid.

4. John Willet, *Art and Politics in the Weimar Period* (New York: Pantheon, 1978), p. 137. On Bauhaus design and theory, see Marcel Franciscono, *Walter Gropius and the Creation of the Bauhaus* (Urbana: University of Illinois Press, 1971), and Arturo Cucciola, *Bauhaus: Lo spazio dell'architettura* (Bari: Edipuglia, 1982).

5. On Melnikov's exhibition design, see S. Frederick Starr, *K. Mel'nikov–Le pavillon sovietique* (Paris: L'Equerre, 1981).

6. Willet, *Art and Politics in the Weimar Period*, p. 138, and Herbert Bayer ed., *Bauhaus, 1919–1928* (New York: Museum of Modern Art, 1938), pp. 158–59.

7. Mostra autarchica del minerale italiano (1937), Mostra del nazionalsocialismo (1939), Mostra della razza (1940).

8. *Prima Mostra nazionale istruzione tecnica*, cat. exh. (Rome: Fratelli Palombi, 1936).

9. Gino Salocchi, ed., *Mostra nazionale delle colonie estive e dell'assistenza all'infanzia*, cat. exh. (Milan: Unione Tipografica, 1937).

10. *Esposizione dell'aeronautica italiana*, cat. exh. (Milan: Edizioni d'arte Bestetti, 1934).

11. Raymond Williams, "Theatre as a Political Forum," in *Visions and Blueprints: Avant-Garde Culture and Radical Politics in Early Twentieth-Century Europe*, ed. Edward Timms and Peter Collier (Manchester: University of Manchester Press, 1988), p. 307.

12. Walter Kalaidjian, *American Culture between the Wars* (New York: Columbia University Press 1993), p. 3.

13. Williams, "Theatre as a Political Forum," p. 307.

14. Marcia Landy, *Fascism in Film* (Princeton, N.J.: Princeton University Press, 1986), p. 27.

15. Mario Morandi, "Significato di una mostra," *Critica fascista* 15, no. 19 (August 1, 1937): 321.

16. Detlef Hoffman, "The German Art Museum and the History of the Nation," in *Museum Culture*, ed. Daniels Sherman and Irit Rogoff (Minneapolis: University of Minnesota Press, 1994), p. 11.

17. Pagano, "La mostra azzurra," p. 4.

18. Guelfo Andalo, *Sono venuto a vivere la rivoluzione fascista: Impressioni e confessioni di un rimpatriato* (Milan: Studio Editoriale Bussetto, 1934), pp. 23–24.

19. Recent years have seen a significant amount of work on this exhibition. For published archival materials, see Giovanna Fioravanti, *Archivio Centrale dello Stato: Partito Nazionale Fascista—Mostra della rivoluzione fascista* (Rome: Archivio di Stato, Ministero per i Beni Culturali e Ambientali, 1990). Recent secondary sources include Marla Stone, "Staging Fascism: The Exhibiton of the Fascist Revolution," *Journal of Contemporary History* 28, no. 2 (April 1993): 215–43; Jeffrey Schnapp, "Epic Demonstrations: Fascist Modernity and the 1932 Exhibition of the Fascist Revolution," in *Fascism, Aesthetics, and Culture*, ed. Richard Golsan (Hanover, N.H.: University Press of New England, 1992), pp. 1–33; Libero Andreotti, "The Aesthetics of War: The Exhibition of the Fascist Revolution," *Journal of Architectural Education* 45 (February 1992): 76–86. Emilio Gentile devotes a large section to the ritual and rhetorical components of the exhibition in *Il culto del littorio* (Bari: Laterza, 1993), pp. 212–35.

20. *ACS*, PNF Direttorio, Ufficio Stralcio, busta 274, and Leo Pollini, "La mostra del Fascismo," *Il popolo d'Italia*, March 12, 1932. *Fasci di combattimento* were the earliest organizational cells of Fascism. The first one was founded in Piazza San Sepolcrio in Milan on March 23, 1919.

The National Fascist Institute of Culture was founded in 1925 by Giovanni Gentile to transmit Fascist culture and ideology on the local and regional level. By 1931, there were eighty-eight branches in provincial capitals. Lazzero Riccioti, *Il partito nazionale fascista: Come era organizzata e funzionava il partito che mise l'Italia in camicia nera* (Milan: Rizzoli, 1985), p. 213.

21. *ACS*, PNF Direttorio, Ufficio stralcio, busta 274, and "Prima bozza del piano generale per la Mostra del fascismo," *ACS*, MPI, divisione III, dir. gen. AA.BB.AA., 1930–35, busta 137.

22. "Prima bozza del piano generale per la Mostra del fascismo," *ACS*, MPI, divisione III, dir. gen. AA.BB.AA, 1930–35, busta 137.

23. Ibid.

24. In order to collect the necessary documents and materials for the planned 1929 show, Alfieri, with the help of the Ministero della pubblica istruzione, circulated a memo to government ministries, cultural institutes, and professional schools asking for documents, relics, or information relating to the birth and development of early Fascism. Memo, MPI to sigg. direttori generali, January 26, 1929, *ACS*, MPI, divisione III, dir. gen. AA.BB.AA, 1930–35, busta 137.

25. Pollini, "La mostra del fascismo."

26. F. P. Mulè, "La Mostra della rivoluzione fascista," *Capitolium* 9 (January 1933): 2.

27. For a discussion of *romanità* and its culmination in the Mostra augustea della romanità, see Laura Malvano, *Fascismo e la politica dell'immagine* (Turin: Bollati Boringhieri, 1988), especially chap. 3.3. On *romanità*'s role in Fascist doctrine and its effect upon classical studies, Romke Visser, "Fascist Doctrine and the Cult of the *Romanità*," *Journal of Contemporary History* 27 (1992): 5–22; Luciano Canfora, "Classicismo e Fascismo," in *Matrici culturali del Fascismo* (Bari: Laterza, 1977), pp. 85–112; Mariella Cagnetta, *Antichisti e impero fascista* (Bari: Laterza, 1979).

28. Margarita Sarfatti, "Nel Decennale: Orientamenti e presagi," *Gerarchia* 12 (December 1932): 879.

29. *Il popolo d'Italia*, March 12, 1932.

30. Alessandro Melchiori, "Una grande opera di fede," *L'illustrazione italiana*, April 2, 1933, pp. 512–14.

31. Gigi Maino, "La Mostra della rivoluzione fascista," *La rassegna italiana* 16, no. 178 (March 1933): 206.

32. "Per l'organizzazione della Mostra del Fascismo," *Il popolo d'Italia*, January 5, 1932.

33. "La Mostra politico del Fascismo," *Il popolo d'Italia*, March 13, 1932, p. 1.

34. "Alla Mostra della rivoluzione fascista—Importantissimo cimelo," *Il popolo d'Italia*, September 4, 1932.

35. *ACS*, MRF, busta 101. The Archivio Centrale dello Stato in Rome has a document collection, entitled Mostra della rivoluzione fascista, of the tagged and collated items from the show. Each clipping, artifact, or photograph in this collection has a tag that details when and from whom it was sent. *ACS*, MRF, buste 17–201. According to the filing system devised by Alfieri, each item "was tagged with a receipt that guaranteed its restutition at the Mostra's close." See "La Mostra della rivoluzione— Vivissima attesa per la più originale manifestazione storico-artistica del Decennale," *Il popolo d'Italia*, October 22, 1932.

36. For example, Alfieri asked the Roman police chief for help in locating "an anti-Bolshevik pamphlet" which "the Roman Fascio di Combattimento published on May 1, 1920." In some cases, special committees facilitated the transfer of needed materials. Letter, Alfieri to Giuseppe Cocchia, July 4, 1932, *ACS*, MRF, Appendix I, Altocommissariato per le sanzioni contro il fascismo, tit. XVIII, n. 10, vol. 2. The Associazione delle famiglie dei caduti fascisti (Association of Families of Fallen Fascists) formed a commission to send materials to the Mostra del Fascismo. *Il popolo d'Italia*, May 22, 1932.

37. Maino, "La Mostra della Rivoluzione Fascista," p. 206.

38. Dino Alfieri and Luigi Freddi, *Mostra della rivoluzione fascista*, cat. exh. (Bergamo: Istituto Arti Grafiche, 1933), p. 53; "I lavori di allestimento," *Il popolo d'Italia*, August 14, 1932.

39. Dino Alfieri and Luigi Freddi, eds, *Mostra della rivoluzione fascista*, cat. exh. (Bergamo: Istituto Italiano Grafiche, 1933), p. 53.

40. *Il popolo d'Italia*, March 13, 1932.

41. "La Mostra della rivoluzione—Vivissima attesa per la più originale manifestazione storico-artistica del Decennale"; Roberto Papini, "Arte della rivoluzione," *Emporium* 77 (April 1933): 195.

42. *ACS*, PNF direttorio, Ufficio Stralcio, busta 273, fascicolo, "Edoardo Alfieri."

43. Dino Alfieri and Luigi Freddi, *Traccia storico-politica per la Mostra del Fascismo* (Rome: Bozze di Stampa, Tipografia della Camera dei Deputati, 1932).

44. "Per la Mostra del Fascismo ai camerati di tutta Italia," *Il popolo d'Italia*, April 27, 1932.

45. "I Lavori delle sezioni," *Il popolo d'Italia*, May 22, 1932.

46. *Chi è?* (Rome: A. F. Formiggiani, 1936), 4:393. *Chi è?* also described Freddi as an "autodidact."

47. Ibid.; Landy, *Fascism in Film*, p. 11.

48. Landy, *Fascism in Film*, p. 12. See also Gian Piero Brunetta, *Cinema italiano tra le due guerre* (Milan: Mursia, 1975).

49. Simonetta Lux, ed., *Avanguardia, traduzione, ideologia: Itinerario attraverso un ventennio di dibattito sulla pittura e plastica murale* (Rome: Baggatto Libri, 1990), p. 137; Alberto Neppi, "L'opera degli artisti alla Mostra della rivoluzione fascista," *Rassegna dell'istruzione artistica* 15 (November–December 1932): 336.

50. Fabio Benzi, "Materiali inediti dall'archivio di Cipriano Efisio Oppo," *Bolletino d'arte*, nos. 37–38 (May–August 1986): 169; *Le professioni e le arti* 2, no. 7 (July 1932): 32.

51. "La Mostra della rivoluzione—Vivissima attesa per la più originale manifestazione storico-artistica del Decennale."

52. Maino, "La Mostra della rivoluzione fascista," p. 205.

53. *Chi è?* (1936), 6:435.

54. Ibid. p. 328. *Sansepolcrista* is the title given to the original members of the Fascist Party who had been in attendance at the founding meeting of the movement in Piazza San Sepolcro in Milan on March 23, 1919. *Diciannovista* ('19er) is an equivalent title.

55. Alfieri and Freddi, *Mostra della rivoluzione fascista*, p. 93.

56. Margarita Sarfatti, "Architettura, arte e simbolo alla Mostra del Fascismo," *Architettura* 2, no. 12 (January 1933): 5.

57. Alfieri and Freddi, *Mostra della rivoluzione fascista*, p. 8.

58. Ibid. p. 9.

59. "La Mostra della rivoluzione—Vivissima attesa per la più originale manifestazione storico-artistica del Decennale."

60. Edoardo Persico, "Mostra della rivoluzione fascista," *Casabella* 5, no. 59 (November 1932): 28.

61. In addition to the incentive of contributing to a national event and the opportunity to put aesthetic formulations into practice, artists were paid for their work on the Mostra. Alfieri paid 673,886 lire to the artists out of a total of 8,875,979 lire alloted for the mounting of the show. "La Mostra della rivoluzione fascista—Situazione patrimoniale al 22 Novembre 1933," *ACS*, PNF Direttorio, Ufficio Stralcio, busta 271.

62. Other artists who rose through the Fascist syndical and exhibition system include Antonio Santagata and Gerardo Dottori. Gerardo Dottori won the Ministry of Corporations competition at the 1932 Biennale. In 1938, Antonio Santagata received the commission to fresco the exterior of the Biennale pavilion. In 1936, both artists became members of the National Directorate of the Fascist Syndicate of the Fine Arts.

63. Neppi, "L'opera degli artisti all Mostra della rivoluzione fascista," p. 338.

64. Enrico Crispolti, *Storia e critica del futurismo* (Bari: Laterza, 1986), p. 273. For

more on "plastica murale," see Crispolti's chapter 12, sec. 2, "Allestimenti futuristi privati e pubblici."

65. Sarfatti, "Architettura, arte e simbolo alla Mostra del Fascismo," p. 3.

66. Alfieri and Freddi, *Mostra della rivoluzione fascista*, p. 66.

67. Papini, "Arte della rivoluzione," p. 195.

68. Ottavio Dinale, "La Mostra della rivoluzione—visioni d'arte," *Rivista illustrata del popolo d'Italia* 11 (June 1933): 42.

69. Mulè, "La mostra della rivoluzione," fascista p. 2.

70. Sarfatti, "Architettura, arte e simbolo alla Mostra del Fascismo," p. 7.

71. Vieri Quilici, *Adalberto Libera l'architettura come ideale* (Rome: Officina Edizioni, 1981); Diane Ghirardo, "Italian Architects and Fascist Politics: An Evaluation of the Rationalist Role in Regime Building," *Journal of the Society of Architectural Historians* 39, no. 2 (May 1980): 113.

72. Giorgio Ciucci, *Gli architetti e il Fascismo* (Turin: Einaudi, 1989), pp. 57–76, 93–107.

73. For the history and development of rationalist architecture in Italy, see Silvia Danesi and Luciano Patteta, eds., *Il razionalismo e l'architettura in Italia durante il Fascismo* (Venice: Edizioni La Biennale di Venezia, 1976); Dennis Doordan, *Building Modern Italy* (Princeton, N.J.: Princeton Architectural Press, 1988); Cesare De Seta, *La cultura archtettonica in Italia tra le due guerre* (Bari: Laterza, 1972).

74. The pavilion for the Chicago Exposition, also done in collaboration with Mario De Renzi, was a stylized airplane with a metal fasci at its prow.

75. Quilici, *Adalberto Libera l'architettura come ideale*, p. 18.

76. Ada Francesca Marciano, *Giuseppe Terragni: Opera completa, 1925–43*, (Rome: Officina Edizioni, 1987), p. 74; Thomas Schumacher, *Surface and Symbol: Giuseppe Terragni and the Architecture of Italian Rationalism* (New York: Princeton Architectural Press, 1991), p. 173.

77. Alfieri and Freddi, *Mostra della rivoluzione fascista*, p. 191.

78. Sarfatti, "Architettura, arte e simbolo alla Mostra del Fascismo," p. 7.

79. Maino, "La Mostra della rivoluzione fascista," p. 210.

80. Guglielmo Usellini, "La mostra," *Emporium* 77 (April 1933): 236.

81. De Seta, *La cultura architettonica in Italia tra le due guerre*, p. 201. See also Schumacher, *Surface and Symbol*.

82. Giuseppe Terragni as quoted in Mario Fosso and Enrico Mantero, *Giuseppe Terragni, 1904–43*, cat. exh. (Como: Comune di Como, 1982), p. 95.

83. In 1932, the Como secretary of the PNF commissioned the twenty-eight-year-old Terragni to construct a *casa del fascio*. After much publicity and debate, the building, based on "the fundamental principles of the new architecture" within "a Le Corbusierian framework." opened in 1936. Enrica Torelli Landini, "Terragni e il completamento della Casa del Fascio a Como," p. 377, in Lux, *Avanguardia, tradizione, ideologia*.

84. L. Ferrario and D. Pastore, *Giuseppe Terragni: La casa del fascio* (Rome: Istituto Mides, 1982), p. 7; Schumacher, *Surface and Symbol*, pp. 139–70.

85. As Diane Ghirardo has aptly pointed out, a number of prominent rationalist architects joined the Fascist Party well before membership was obligatory for a place on the employment rosters. For example, Adalberto Libera joined the party on August 1, 1926, and Giuseppe Terragni on April 26, 1928. Diane Ghirardo, "City and

Theater: The Rhetoric of Fascist Architecture," *Stanford Italian Review* 8, nos. 1–2 (1990): 181.

86. Lux, *Avanguardia, traduzione, ideologia*, p. 134; Marciano, *Giuseppe Terragni: Opera completa, 1925–43*, p. 74; Schumacher, *Surface and Symbol*.

87. Alfieri and Freddi, *Mostra della rivoluzione fascista*, p. 195.

88. Ibid.

89. Dinale, "La Mostra della rivoluzione," p. 51.

90. Alfieri and Freddi, *Mostra della rivoluzione fascista*, p. 215.

91. Ibid., p. 216.

92. Mario Sironi, "L'architettura della rivoluzione," *Il popolo d'Italia*, November 8, 1932. Sironi had designed the interiors of the Italian press pavilion at the 1928 Cologne and 1929 Barcelona international exhibitions; it was in Cologne that he saw El Lissitsky's constructions at first hand.

93. Alfieri and Freddi, *Mostra della rivoluzione fascista*, p. 192. Sironi first came to *Il popolo d'Italia* as a caricaturist and illustrator in August 1921 and he continued to execute drawings for the publications of the regime until its fall in 1945. For more on Sironi's work as a propagandist, see Emily Braun, "Illustrations of Propaganda— The Political Drawings of Mario Sironi," *Journal of Decorative and Propaganda Arts* 3 (Winter 1987): 84–107; Fabio Benzi and Andrea Sironi, *Sironi illustratore: Catalogo ragionato* (Rome: De Luca Editore, 1988).

94. Sironi's life and work is placed in historical and art-historical context by Emily Braun, *Mario Sironi, 1920–1945: Art and Politics in Fascist Italy* (Cambridge: Cambridge University Press, 1999); see also Braun, "Illustrations of Propaganda: The Political Drawings of Mario Sironi," p. 88. For Sironi's writings and works, see Ettore Camesasca, ed., *Mario Sironi: Scritti editi e inediti* (Milan: Feltrinelli, 1980), and Fortunato Bellonzi, *Sironi* (Milan: Electa, 1985).

95. Emily Braun, "Mario Sironi and a Fascist Art," *Italian Art in the Twentieth Century*, ed. Braun (London and Munich: Royal Academy and Prestel Verlag, 1989), pp. 173–80.

96. Sarfatti, "Architettura, arte e simbolo alla Mostra del Fascismo," pp. 9–10. More recently, art historian Laura Malvano has called Sironi the "principle coordinator and holder of a determinative role in the realization of the show." Malvano, *Fascismo e la politica dell'immagine*, p. 63. Oppo so respected Sironi's talent that for two of the sections under his auspices, The Salon of Honor and the Gallery of Fasci, Sironi maintained total control, without having a "historian" beside him to oversee his work.

97. This visual rhetoric was used for the catalog cover as well.

98. Maino, "La Mostra della rivoluzione fascista," p. 206.

99. Guido Armellini, *Le immagine del Fascismo nelle arti figurative* (Milan: Fabbri, 1980), p. 89.

100. Enrico Crispolti, "Second Futurism," in Braun, *Italian Art in the Twentieth Century*, p. 169; Armellini, *Le immagine del Fascismo nelle arti figurative*, p. 87.

101. Armellini, *Le immagine del Fascismo nelle arte figurative*, p. 89.

102. Crispolti, *Storia e critica del futurismo*, p. 278.

103. Ghirardo, "Italian Architects and Fascist Politics: An Evaluation of the Rationalists Role in Regime Building," p. 113.

104. Giorgio Ciucci, "L'autorappresentazione del Fascismo," *Rassegna* 4, no. 10 (June 1982): 50.

105. Lux, *Avanguardia, traduzione, ideologia*, p. 8.

106. Simonetta Lux, Courtauld Institute Lecture, December 6, 1995, for the "Art and Power" Exhibition at the Hayward Gallery, London, England.

107. For more on the question of European governments and the avant-garde, see John Willet, *Art and Politics in the Weimar Period* (New York: Pantheon, 1978), and James von Geldern, *Bolshevik Festivals, 1917–1920* (Berkeley: University of California Press, 1993).

108. Persico, "Mostra della rivoluzione fascista," p. 30.

109. Neppi, "L'opera degli artisti alla Mostra della rivoluzione fascista," 335.

110. P. M. Bardi, "Il cartellone," *Bibliografia fascista* 8, no. 11 (November 1933): 3–5.

111. Memo, Alfieri, August 1, 1932, Alfieri, *ACS*, MRF Appendix I, Altocommissione per le sanzioni contro il Fascismo, tit. XVIII.

112. Letter, September 26, 1932, *ACS*, MRF Appendix I, Altocommissione per le sanzioni contro il Fascismo, tit. XVIII.

113. Mulè, "La Mostra della rivoluzione fascista," pp. 6–7.

114. Alfieri and Freddi, *Mostra della rivoluzione fascista*, pp. 80, 83. The construction was by Esodo Pratelli.

115. This narrative of Italian redemption from class-based civil war into a national community also appeared in a number of 1930s films, such as *Vecchia guardia* (*Old Guard*). See Landy, *Fascism in Film*, pp. 40–41.

116. This refers to Domenico Rambelli's sculpture of the "re/soldato," which appeared in Room C, "La guerra italiana."

117. Alfieri and Freddi, *Mostra della rivoluzione fascista*, p. 114.

118. Giulio Santangelo, "Anno decimo: La mostra della rivoluzione fascista," *Bibliografia fascista*, no. 7 (July 1932): 424.

119. Ibid.

120. Malvano, *Fascismo e la politica dell'immagine*, pp. 63–64, and Philip V. Cannistraro, *La fabbrica del consenso* (Rome-Bari: Laterza, 1975), p. 65.

121. *Il popolo d'Italia*, October 22, 1932.

122. Santangelo, "Anno decimo: La Mostra della rivoluzione fascista," p. 422.

123. Mulè, "La mostra della rivoluzione fascista," p. 3 (emphasis added).

124. Andalo, *Sono venuto a vivere la rivoluzione fascista*, p. 161.

125. Victoria de Grazia, *The Culture of Consent: The Mass Organization of Leisure* (Cambridge: Cambridge University Press, 1981), p. 187.

126. Ibid., p. 21.

127. Gentile, *Il culto del littorio*, p. 44.

128. Giovanni Biadene, "La mostra della rivoluzione fascista (da via Nazionale a via dell'Impero)," *L'illustrazione italiana*, October 28, 1934, p. 667.

129. Francesco Barone, *Tappe d'ottobre* (Rome: Edizioni Luzzati, 1934), p. 107.

130. Andalo, *Sono venuto a vivere la rivoluzione fascista*, p. 167.

131. Ibid. p. 9.

132. Biadene, "La Mostra della rivoluzione (da via Nazionale a via dell'impero)," p. 667.

133. Gentile, *Il culto del littorio*, pp. 199–235.

134. George Mosse, *The Nationalization of the Masses* (New York: Howard Fertig, 1975), p. 90.

135. Cornelio Di Marzio, "La mostra del Fascismo," *Bibliographia fascista* 7, no. 5 (May 1932): 259, 264.

136. Mino Maccari, "Il carattere popolare della Mostra della rivoluzione fascista," *L'illustrazione italiana*, April 2, 1933, p. 498.

137. "Grande publico per la mostra della rivoluzione," *Il popolo d'Italia*, November 13, 1932.

138. George Mosse, "The Poet and the Exercise of Political Power: Gabriele D'Annunzio," *Yearbook of Comparative and General Literature* 22 (1973): 38.

139. Ottavio Dinale, "Il Sacrario dei Martiri," *La rivista illustrata del popolo d'Italia* no. 3 (March 1933), p. 31. A member of the *Il popolo d'Italia* staff, Dinale also wrote a monograph, entitled *La rivoluzione che vince* (Rome: Franco Campitelli, 1934), in honor of the Decennale.

140. Usellini, "La mostra," p. 249.

141. Andalo, *Sono venuto a vivere la Mostra della rivoluzione*, p. 162.

142. Mosse, *The Nationalization of the Masses*; E. J. Hobsbawm and Terence Ranger, eds., *The Invention of Tradition* (Cambridge: Cambridge University Press, 1983). Mosse also discusses the new political culture necessitated by the rise of nationalism in "The Poet and the Exercise of Political Power: Gabriele D'Annunzio," pp. 32–42.

143. Mosse, *The Nationalization of the Masses*, p. 74.

144. Von Geldern, *Bolshevik Festivals*, p. 9.

145. Di Marzio, "La mostra del Fascismo," 264.

146. "Le scuole resteranno chiuse dal 24 ottobre al 5 novembre," *Il popolo d'Italia*, October 21, 1932. The Fascist Party also sponsored a series of conventions in Rome just prior to the Decennale, such as the Conference of Professionals and Artists and the Italian Juridical Conference.

147. "Grandi manifestazioni celebrative del Decennale," *Il popolo d'Italia*, October 27, 1932.

148. Ibid. The post offices were located in Bergamo, Biella, Cagliari, Gorizia, Salerno, Brescia, and Forli. Oreste Del Buono has cited 243 political prisoners released out of a total of 1,056, and the commutation of the sentences of 216 prisoners; see *Eia, Eia, Eia, Alala: La stampa italiana sotto il Fascismo* (Milan: Feltrinelli, 1971), p. 175.

149. Ruggero Zangrandi, *Il lungo viaggio attraverso il Fascismo* (Milan: Feltrinelli, 1962), p. 46.

150. Memo, PCM, gabinetto to Appunto per il Capo il Governo, October 24, 1932, ACS, PCM (1934–36), 14.1.1593.

151. "Mostra della rivoluzione—La ceremonia inaugurale," *Il popolo d'Italia*, October 30, 1932.

152. "L'affluenza dei visitatori," *Il popolo d'Italia*, October 20, 1932; memo, PCM, gabinetto to Appunto per il Capo del Governo, October 24, 1932, ACS, PCM (1934–36), 14.1.1593.

153. ACS, PNF Direttorio, Ufficio Stralcio, busta 271.

154. Ibid.

155. Nine exhibitions, originally to be held in the Palazzo delle esposizioni in 1932, had to be cancelled as the Mostra was extended from April 1932 to October 1933 and, finally to April 1933. Memo, PCM, Gabinetto, ACS, PCM (1934–36), 14.1.1593.

156. Letter, Giorgio Chiurco to Starace, May 6, 1933, ACS, PNF Direttorio, Ufficio Stralcio, busta 273.

157. Gian Capo, "La mostra della rivoluzione (da Via nazionale a Via dell'impero)," *L'illustrazione italiana*, October 28, 1934, p. 667.

158. Verbale, November 7, 1934, *ACS*, PNF direttorio, Ufficio Stralcio, busta 271, fascicolo 3; memo, October 28, 1934, *ACS*, PNF Direttorio, Ufficio Stralcio, busta 273.

Fagone noted the 3 million attendance figure as evidence of "extraordinary popular success." Vittorio Fagone, "Arte, politica e propaganda," in *AnniTrenta: Arte e cultura in Italia*, ed. Fagone (Milan: Mazzotta, 1983), p. 48. Francesco Gargano, in *Italiani e stranieri alla mostra della rivoluzione fascista* (Rome: SAIE, 1935) and "Da Augusto a Mussolini," *Il popolo d'Italia*, September 23, 1937, cited the figure at 3,854,927 visitors.

159. *ACS*, PNF Direttorio, Ufficio Stralcio, busta 572.

160. "Mostra della rivoluzione fascista—Situazione patrimoniale al 22 novembre 1933," *ACS*, PNF Direttorio, Ufficio Stralcio, busta 271.

161. "Riduzioni del 70 per cento sulle FF. SS. per la Mostra della rivoluzione," *Il popolo d'Italia*, October 21, 1932; *Rivista illustrata del popolo d'Italia* 10, no. 10 (October 1932). The *Rivista illustrata del popolo d'Italia* ran a poster by Paulucci announcing the 70 percent discounts.

162. *Notiziario turistico—Bollettino di informazioni*, edito dall'Ente Nazionale Industrie Turistiche, Roma, April 9, 1934, p. 4.

163. "Riduzioni del 70 per cento sulle FF. SS. per la Mostra della rivoluzione fascista," *Il popolo d'Italia*, October 21, 1932.

164. "Facilitazioni di viaggio," *Il popolo d'Italia*, October 27, 1932.

165. Letter, Marinelli, Seg. amm. del PNF, to Renato Ricci, Presidente ONB, March 1, 1935, *ACS*, PNF Direttorio, Ufficio Stralcio (inv. 590), busta 271.

166. Barbara Allason, *Memorie di un'antifascista 1919–1940* (Milan: Edizioni Avanti, 1961), p. 125.

167. Most movie tickets cost just over two lire in 1929. De Grazia, *The Culture of Consent*, p. 159.

168. Alfieri and Freddi, *Mostra della rivoluzione fascista*, backcover.

169. "Riduzioni del 70 per cento sulle FF. SS. per la Mostra delle rivoluzione fascista," *Il popolo d'Italia*, October 21, 1932.

170. In February 1934, in conjunction with debates over the possibility of extending the Mostra's closing date, Fascist Party Secretary Achille Starace asked Alfieri to determine how many of the visitors had taken advantage of the travel discounts.

171. Letter, Alfieri to Starace, February 5, 1934, *ACS*, PNF Direttorio, Ufficio Stralcio, busta 273.

172. Simone de Beauvoir, *La force de l'age* (Paris: Gallimard, 1960), p. 178.

173. Ibid., p. 179. De Beauvoir found the "esposition fasciste" less than convincing, claiming "Nous jetames un coup d'oeil sur les vitrines où etaient exposès les revolvers et les matraques des 'martyrs fascistes.'"

174. Allason, *Memorie di un'antifascista*, p. 125. Barbara Allason associated with the group of Turinese anti-Fascist intellectuals that included Giulio Einaudi, Augusto Monti, and Leone Ginzburg. Zangrandi, *Il lungo viaggio attraverso il fascismo*, p. 54.

175. Allason, *Memorie di un'antifascista*, p. 125.

176. Memo, Renato Indrizzi to Luogotenente generale commandante il gruppo legioni ferroviarie e portuarie, May 19, 1933, *ACS*, PNF Direttorio, Ufficio Stralcio, busta 273.

177. Ibid.

178. The Archivio centrale dello stato has a document collection containing requests for assistance from groups desiring to attend the Mostra: *ACS*, PNF Direttorio, Ufficio Stralcio, busta 271, fascicolo 2.

179. Ibid.

180. Ibid.

181. Ibid.

182. Ibid.

183. Memo, Ministro delle comunicazione to PCM, May 19, 1933, *ACS*, PCM (1934–36), 14.1.1593.

184. Letter, Giuseppe Balestrazzi to Beer, April 27, 1933, *ACS*, PCM (1934–36), 14.1.1593.

185. Letter, Balestrazzi to Beer, May 6, 1933, *ACS*, PCM (1934–36), 14.1.1593.

186. Memo, Mario Chieso, Prefetto di Como, to PCM, Gabinetto, July 15, 1933, *ACS*, PCM (1934–36), 14.1.1593.

187. *ACS*, PCM (1934–36), 14.1.1593; PNF Direttorio, Ufficio Stralcio, busta 271.

188. Letter, Preffeto di Zara to PCM, May 18, 1933, *ACS*, PCM (1934–36), 14.1.1593. As with many of the regime's cultural incentives, the group visits were reported in the party newspaper, as evidence of government interest in the people.

189. Memo, Starace to Segretari delle Federazioni dei Fasci dei Combattimento, March 31, 1933, *ACS*, PCM (1934–36), 14.1.1593.

190. Memo, Arpinati, Minstero Interno to Preffeti Regno April 5, 1933; telegram, Arpinati to Regno, March 31, 1933, *ACS*, PCM (1934–36), 14.1.1593. A group of 500 workers from Terni had organized a trip to the Mostra for April 1933, which had to be cancelled.

191. Letter, Carlo Peverelli to Marinelli, June 4, 1934, *ACS*, PNF Direttorio, Ufficio Stralcio, busta 271. In this case, Marinelli responded that all the party could offer the lawyers' group were discounts on the entrance tickets and nothing on the *bollo*. Marinelli explained that suspension of the *bollo* was offered "only to large groups of workers."

192. *ACS*, PNF Direttorio, Ufficio Stralcio, busta 273.

193. Ibid., Alfieri spent 427,037 lire on advertising and publicity, out of a total budget of approximately 8 million lire. "La Mostra della rivoluzione fascista—Situazione patrimoniale al 22 Novembre 1933," *ACS*, PNF Direttorio, Ufficio Stralcio, busta 271.

The connection between the state railways and cultural institutions under Fascism was central: not only did the major discount programs come from the railways, but, as the experience of the Venice Biennale and the Mostra della rivoluzione fascista demonstrated, much of the publicity took place in railway stations. For example, posters and copies of the Mostra catalog were permanently on view in Italian train stations.

194. Gargano, *Italiani e stranieri alla mostra della rivoluzione fascista*.

195. These Sironi drawings ran on July 25, July 30, and October 26, 1932, respectively.

196. *Cinecittà*, Istituto Luce, cinegiornali, 1932–34. Since LUCE newsreels were required by law to be shown prior to any feature-length film, a majority of Italians were repeatedly exposed to images of the Mostra della rivoluzione fascista.

197. Ibid., nos. 252, 424, 448, 1033, 1037.

198. *Cinecittà*, Istituto Luce, cinegiornali, 1933, nos. 193, 233.

199. Von Geldern, *Bolshevik Festivals*, p. 11, makes this point for the festivals of the Bolshevik Revolution.

200. "L'affluenza dei visitatori alla mostra della rivoluzione," *Il popolo d'Italia*, October 29, 1932.

201. *ACS*, PNF Direttorio, Ufficio Stralcio, busta 273.

202. Rina Maria Stagi, *Pellegrinaggio alla Mostra della rivoluzione* (Pisa: Nistri-Lischi Editori, 1934).

203. Andalo, *Sono venuto a vivere la rivoluzione fascista*, p. 17.

204. Ibid. p. 162.

205. Giuseppe Bottai, *Roma nella mostra delle rivoluzione fascista* (Rome: L. Cappellini, 1934), reprinted from *Roma* (January 1934), pp. 3–8.

206. Ibid., p. 3.

207. Letter, Marinelli to Rino Parenti, Segretario Federazione fasci di combattimento, October 2, 1933, *ACS*, PNF Direttorio, Ufficio Stralcio, busta 272.

208. Letter, Questore di Roma to Marinelli, October 6, 1933, *ACS*, PNF Direttorio, Ufficio Stralcio, busta 272.

209. Letter, Marinelli to Ministero dell'interno, June 1, 1933, *ACS*, PNF Direttorio, Ufficio Stralcio, busta 272.

210. The most reproduced images came from the nonchronological elements of the show: the facade, the Chapel of Martyrs, and Sironi's Gallery of Fasci.

211. Ariella Azoulay, "With Open Doors: Museums and Historical Narratives in Israel's Public Space," in Sherman and Rogoff, *Museum Culture*, p. 86.

Chapter Six
Italian Fascist Culture Wars

1. Giuseppe Bottai, "Per l'inaugurazione del Terzo Premio Bergamo," *Le arti* 4 (October–November 1941): 1.

2. Giuseppe Pensabene, "Disintossicare l'arte italiana," *Quadrivio*, December 29, 1935, p. 3.

3. David Forgacs, *Italian Culture in the Industrial Era* (Manchester: University of Manchester, 1990), p. 85.

4. Todd Gitlin, *The Twilight of Common Dreams* (New York: Metropolitan Books, 1995), p. 3.

5. For details of Farinacci's career, see Harry Fornari, "Roberto Farinacci," in *Uomini e volti del Fascismo*, ed. Fernando Cordova (Rome: Bulzoni, 1980), and Alfassio Grimaldi and Gherardo Bozzetti, *Farinacci: Il più fascista* (Milan: Bompiani, 1972).

6. Vittorio Fagone, "Arte, politica e propaganda," in *AnniTrenta: Arte e Cultura in Italia*, ed. Fagone (Milan: Mazzota, 1983), p. 51.

7. *La menzogna della razza*, cat. exh. (Bologna: Grafis Edizioni, 1994), p. 299.

8. "Notizario," *Rassegna dell'istruzione artistica* 21, nos. 7–8 (July–August 1938).

9. On anti-Semitism during Fascism and the Fascist Racial Laws, see Meir Michaelis, *Mussolini and the Jews* (Oxford: Oxford University Press, 1978); Susan Zuccotti, *Italy and the Holocaust* (New York: Basic Books, 1987).

10. Ester Da Costa Meyer, *The Work of Antonio Sant'Elia* (New Haven, Conn.: Yale University Press, 1995) pp. 204–05.

11. "Vernice del Premio Cremona," May 22, 1939, *ACS*, Segretario Particolare del Duce, 520.683.

12. Comitato manifestazioni artistiche Cremona, *Premio Cremona*, cat. exh. (Cremona: Cremona Nuova, 1939).

13. "Vernice del Premio Cremona," May 22, 1939, *ACS*, Segretario Particolare del Duce, 520.683.

14. Letter, Farinacci to PCM, September 21, 1938, *ACS*, PCM (1940–42), 14.1.419, sottofascicolo 1.

15. Letter, Farinacci to Medici, October 5, 1938, *ACS*, PCM (1940–42), 14.1.419, sottofascicolo 2.

16. Comitato manifestazioni artistiche Cremona, *Premio Cremona*. The jury that selected the 130 paintings consisted of Farinacci, Tullio Bellomi, Dino Alfieri, Ugo Ojetti, Anselmo Bucci, Felice Carena, Pietro Gaudenzi, Carlo Prada, Torquato Bruni, and Antonio Sianesi.

17. First prize went to an unknown painter from Piacenza, Luciano Ricchetti, and the rest of participants were equally unfamiliar names to Fascist exhibition culture. Fernando Tempesti, *Arte dell'italia fascista* (Milan: Feltrinelli, 1976), p. 229.

18. Guido Armellini, *Le immagine del Fascismo nelle arte figurative* (Milan: Fabbri, 1980), p. 165.

19. Letter, PCM, sottosegretario di stato, to Duce, June 13, 1939, *ACS*, PCM 1940–42, 14.1.419. At the 1939 inauguration, Farinacci asked Alfieri to deliver to Mussolini a copy of his recent publication on racial purity, with special attention to be given to the section entitled, "i non ebrei e il Talmud." "Ciano inaugura Il Premio Cremona, 20 Maggio 1940" (Notiziario), *Le arti* 2 (December–January 1940): v.

20. "Vernice del Premio Cremona," May 22, 1939, *ACS*, Segretario Particolare del Duce, 520.683.

21. *Cinecittà*, Istituto Luce, cinegiornali, May 24, 1939, no. 1519.

22. David Rubinstein, "The Mystification of Reality: Art under Italian Fascism" (Ph.D. dissertation, New York University, 1978), p. 105.

23. Ente autonomo manifestazioni artistiche Cremona, *III Premio Cremona*, cat. exh. (Cremona, 1941).

24. "800 Artisti parteciperanno al Premio Cremona," *Il Messaggero*, February 15, 1940; "Il Premio Cremona," *Le arti* 2 (December–January 1940), p. vi.

25. Telegram, Prefetto Carini, Cremona, to Minstero dell'interno, June 15, 1941, *ACS*, PCM (1940–42), 14.1.419, sottofascicolo 3. The Nazis named were Dr. Bierach, Dr. Schaefet (from Goebbels's office), Dr. Haltenkoff (mayor of Hannover), Dr. Knop (vice-gauleiter of Hannover), and Dr. Kebusch (gauamtsleiter of Hannover).

26. Telegraph Dispatch, Mussolini to Farinacci, July 21, 1941, *ACS*, PCM (1940–42), 14.1.419, sottofascicolo 3. A portion of the exhibition traveled to Hannover, as a sign of Italian cultural efforts. "Opere del Premio Cremona destinate all'Esposizione di Hannover," *Le arti* 2 (September 1941): i.

27. Letter, Farinacci to Russo, July 16, 1941, *ACS*, PCM (1940–42), 14.1.419, sottofascicolo 3.

28. In 1939, 300 works competed and 123 were exhibited; by 1940, Farinacci boasted 800 aspirants. Comitato manifestazioni artistche Cremona, *Premio Cremona*; "800 artisti parteciperanno al Premio Cremona," *Il Messaggero*, February 15, 1940.

29. Bottai's battle against intransigence dated from Fascism's first years in power. Alexander De Grand, "Giuseppe Bottai e il fallimento del Fascismo revisionista," *Storia contemporanea* 4, no. 4 (December 1975): 697–731.

30. For more on Bottai, see Alexander De Grand, *Bottai e la cultura fascista* (Bari:

Laterza, 1978), and "Giuseppe Bottai e il fallimento del Fascismo revisionista," pp. 697–731; and Giordano Bruno Guerri, *Giuseppe Bottai un fascista critico* (Milan: Feltrinelli, 1976).

31. "Discorso pronunziato da S. E. Bottai nella inaugurazione della XXI Biennale a Venezia," *Rassegna dell'istruzione artistica* (May–June 1938): 183.

32. Ibid.

33. Ibid., p. 184.

34. Interview with Bottai, *Corriere della sera*, January 24, 1940, reprinted in "Note," *Le arti* 2 (February–March 1940): 183.

35. Ibid., pp. 184–185.

36. Antonio Maraini, ed., *L'ordinamento sindacale fascista delle belle arti* (Rome: Sindacato Nazionale Fascista Belle Arti, 1939), p. xi.

37. Giuseppe Bottai, *Le arti* 3 (April–May 1940): 243.

38. Bottai, "Per l'inaugurazione del Terzo Premio Bergamo," p. 1; "Il Premio Bergamo," *Le arti* 2 (October–November 1939): ii–iii. The exhibition's second edition called for "works of art in which two or more human figures . . . are the primary subject of the piece." "Premio Bergamo per un'opera di pittura," *Le arti* 3 (December–January 1940): vi–vii.

39. *Premio Bergamo: Mostra nazionale del paesaggio italiano*, cat. exh. (Bergamo, 1939), p. 10.

40. "Premio Bergamo per un'opera di pittura," pp. vi–vii.

41. "Il IV Premio Bergamo di pittura," *Le arti* 4 (June–September 1942): vi.

42. "Premio Bergamo per un'opera di pittura," pp. vi–vii; "Il IV Premio Bergamo di pittura," p. vi.

43. *Premio Bergamo: Mostra nazionale del paesaggio Italiano*.

44. Fagone, "Arte, politica e propaganda," p. 51.

45. Bottai, "Per l'inaugurazione del Terzo Premio Bergamo," p. 3.

46. Ibid., p. 1.

47. Pia Vivarelli, "Personalities and Styles in Figurative Art of the Thirties," *Italian Art in the Twentieth Century*, ed. Emily Braun (London and Munich: Royal Academy and Prestel Verlag, 1989), p. 185.

48. Stefanie Barron, ed., *Degenerate Art: The Fate of the Avant-Garde in Nazi Germany*, cat. exh. (Los Angeles: Los Angeles County Museum of Art; 1991).

49. Letter, Maraini to Mussolini, July 26, 1937, ACS, PCM (1940–42), 14.1.730, sottofascicolo 4.

50. This episode is detailed in Forgacs, *Italian Culture in the Industrial Era*, p. 72.

51. See, for example, Federico Federici, "L'arte nello stato nazionalsocialista," *Gerarchia* 15 (September 1937): 630–38; "Hitler e l'arte contemporanea," *La nuova antologia* 3, no. 1588 (May 16, 1938): 155–64; G. Sommi Picenardi, "Organizzazione, controllo, e disciplina dell'arte in Germania," *La vita italiana* 2 (May 1937): 573–83; Giuseppe Piezza, "Il critico sostituito in Germania dal resocontista d'arte," *Le professioni e le arti*, no. 11, year VI (November 1936): 13–14.

52. "Hitler e l'arte contemporanea," *La nuova antologia*, no. 1588 (May 16, 1938): 164.

53. Federici, "L'arte nello stato nazionalsocialista," p. 638.

54. *Corriere della sera*, July 15, 1937–August 1, 1937.

55. Enrico Crispolti, "Second Futurism," in Braun, *Italian Art in the Twentieth Century*, p. 171.

56. Telesio Interlandi, "Arte e razza," *Quadrivio*, November 20, 1938, p. 1.

57. Enrico Crispolti, *Italian Art* (Milan: Rizzoli, 1988), p. 213; Enrico Crispolti, *Storica e critica del futurismo* (Bari: Laterza, 1986), pp. 221–24; Alberto Schiavo, *Futurismo e Fascismo* (Rome: Giovanni Volpe, 1981), pp. 48–57.

58. Armellini, *Le immagine del Fascismo nelle arte figurative*, 170.

59. Interlandi, "Arte e razza," p. 1.

60. Fagone sees Marinetti and his fervid defense of the modernist tradition as a mirror image of the "zealous advocates of cultural autarchy." Fagone, "Arte, politica e propaganda," p. 51.

61. *Prima mostra nazionale di plastica murale per l'edilizia fascista*, cat. exh. (Genoa: Palazzo Ducale, 1934), p. 6.

62. Ibid., p. 7.

63. Crispolti, *Storia e critica del futurismo*, p. 45; Da Costa Meyer, *The Work of Antonio Sant'Elia*, p. 204.

64. Giuseppe Pagano, "Alla ricerca dell'italianità," *Casabella* 10, no. 119 (November 1937), p. 2.

65. Ibid.

66. Da Costa Meyer, *The Work of Antonio Sant'Elia*, p. 193.

67. *Le mostre d'arte in Italia* 2 no. 6 (June 1935): 1.

68. Giuseppe Pensabene, "Premi per le belle arti," *Quadrivio*, April 12, 1936, p. 1.

69. Ibid.

70. On Fascism's emphasis on the young in 1930s films, see Marcia Landy, *Fascism in Film* (Princeton, N.J.: Princeton University Press, 1986), pp. 33–71. For a discussion of Fascist youth culture and the stress on the cultivation of a new generation of Fascist leaders, see Marina Addis Saba and Ugoberto Alfassio Grimaldi, *Cultura a passo romano* (Milan: Feltrinelli 1983), and Tracy H. Koon, *Believe, Obey, Fight: Political Socialization of Youth in Fascist Italy, 1922–43* (Chapel Hill: University of North Carolina Press, 1985), especially chap. 7, "Formation of the Fascist Ruling Class." Ruth Ben Ghiat discussed the regime's relationship with Fascist intellectual youth in "The Politics of Realism: *Corrente di vita giovanile* and the Youth Culture of the 1930's," *Stanford Italian Review* 8, nos. 1–2 (1990): 139–64. Ruggero Zangrandi's memoir offers a view of both Fascism's attempt to train a young elite leadership and the gradual disillusionment of that generation: *Il lungo viaggio attraverso il Fascismo* (Milan: Feltrinelli, 1962).

71. *XI Mostra del sindicato belle arti del Lazio*, cat. exh. (Rome: Enzo Pinci, 1942), p. 9.

72. *Le mostre d'arte in Italia* 2, nos. 11–12 (November–December 1935): 11.

73. Ibid., p. 12.

74. La Biennale di Venezia, *XX Esposizione biennale internazionale d'arte, 1936*, cat. exh. (Venice: Carlo Ferrari, 1936), p. 16.

75. Ibid., p. 17.

76. Ibid.

77. Alberto Neppi, "La XX Biennale a Venezia e la VI Triennale a Milano," *La rassegna italiana* 19 (July 1936): 492.

78. Ugo Nebbia, "L'arte Italiana alla XX Biennale," *Rassegna dell'istruzione artistica* 19 (July–August 1936): 219.

79. La Biennale di Venezia, *XXI Esposizione biennale internazionale d'arte, 1938*, cat. exh. (Venice: Carlo Ferrari, 1938), p. 15.

80. *Le mostre d'arte in Italia* 4, nos. 7–10 (July-October 1937): 65.

81. *Le mostre d'arte in Italia* 4, nos. 11–12 (November–December 1937): 90.

82. As of 1934, Felice Carena also sat on the Biennale's Commitato Amministrativo. In addition to being a member of the Accademia D'Italia, Carena was president of the Reale accademia di belle arti.

83. Corrado Maltese, *Storia dell'arte italiana, 1785–1943* (Turin: Einaudi, 1960) p. 362.

84. La Biennale di Venezia, *XXII Esposizione biennale internazionale d'arte, 1940,* cat. exh. (Venice: Carlo Ferrari, 1940), p. 8; *Gazzetta del popolo,* May 24, 1939; *Vedetta fascista,* May 24, 1939; *Corriere della Sera,* May 24, 1940; and "La XXII Biennale—Regolamento," *ACS,* PCM (1940–42), 14.1.730, sottofascicolo 6.

85. *L'arte nelle mostre italiane* 6, nos. 2–3 (February–March 1939): 7.

86. La Biennale di Venezia, *XXII Esposizione biennale internazionale d'arte, 1940,* p. 10.

87. Ibid., p. 19.

88. Ibid., p. 19.

89. Letter, Maraini to Presidente della R. Accademia di belle arti di Venezia, October 5, 1939, *ACS,* MPI divisione III, 1935–50, busta 279. *L'arte nelle mostre italiane* 7, nos. 1–4 (January–April): 4.

90. "Concorso per affreschi, bassorilievi, e statue da giardino—Verbali delle sedute 21–22 Novembre 1939," *ASAC,* busta 107.

91. La Biennale di Venezia, *XXII Esposizione biennale internazionale d'arte, 1940,* p. 8.

92. Letter, Maraini to Bottai, April 19, 1940, *ACS,* MPI, divisione III, 1935–50, busta 279.

93. "Il verdetto della commissione per i concorsi," *L'arte nelle mostre italiane* 7, nos. 1–4, (January–April 1940): 7.

94. "Concorso per affreschi, bassorilievi, e statue da giardino—Verbali delle sedute 21–22 Novembre 1939," p. 1, *ASAC,* busta 107.

95. Ibid.

96. Ibid.

97. Memo, Commission to Volpi, April 18, 1940, *ACS,* MPI, divisione III, 1935–50, busta 279. Italics mine.

98. "Il verdetto della commissione per i concorsi," *L'arte nelle mostre italiane* 7, nos. 1–4 (January–April 1940): 5–6.

99. Aristarco, "Riflessioni e critiche sulla XXII Biennale," *Maestrale* 1, no. 2 (July 1940): 72.

100. Ibid.: 73.

101. "La ventunesima Biennale Veneziana," *Emporium* 88 (June 1938): 285.

102. Virgilio Guzzi, "La XXI Biennale Veneziana," *La nuova antologia* 73, no. 1588 (May 16, 1938): 431.

103. Ibid.

104. Giuseppe Pensabene, "Meglio tardi che mai," *Il Tevere,* June 25–26, 1938.

105. *Il Perseo,* July 15, 1937.

106. Renato Guttuso, "La XXII Biennale," *Le arti* 2 (June–September 1940): 366.

107. Antonio Maraini, "La XXI Biennale," *Le tre venezie* 13, no. 6 (June 1938): 183.

108. Ibid.

109. *L'arte nelle mostre italiane* 8, nos. 7–12 (July–December 1941): 55.

110. *ASAC,* busta 105. The participating nations consisted of Germany, Spain, Bulgaria, Romania, Hungary, Croatia, Slovakia, Sweden, Switzerland, and Denmark.

111. "La XXIII Biennale di Venezia," *Il popolo d'Italia*, June 22, 1942.

112. *L'arte nelle mostre italiane* 8, nos. 7–12 (July–December 1941): 55. Alongside the competitions and special exhibitions ran a number of *mostre personali*, including displays of the work of Di Chirico, Casorati, Bartolini, and Cadorin.

113. La Biennale di Venezia, *XXIII Esposizione biennale internzionale d'arte, 1942*, cat. exh. (Venice: Carlo Ferrari, 1940), p. 21.

114. Ibid. p. 22.

115. Ibid. p. 20.

116. "Concorsi per opere di composizione in pittura, scultura, incisione e medaglia," *ASAC*, busta 107; "Concorsi per opere di composizione in pittura, scultura, incisione e medaglia," *L'arte nelle mostre italiane* 8, nos. 7–12 (July–December 1941): 63; La Biennale di Venezia, *XXIII Esposizione biennale internazionale d'arte, 1942*, p. 14.

117. La Biennale di Venezia *XXIII Esposizione biennale internazionale d'arte, 1942*, p. 32.

118. Ibid.

119. Ibid., p. 36.

120. "Regolamento per la XXIII Biennale," *ASAC*, busta 107.

121. Giuseppe Gorino, "A che punto siamo con l'arte?" *Corriere padano*, June 21, 1942.

122. Umbro Apollonio, "Alla Biennale Veneziana," *Vedetta di Italia*, June 30, 1942.

123. Michelangelo Masciotta, "La XXII Biennale di Venezia," *Maestrale* 3, no. 7 (July 1942): 19.

124. Pippo Rizzo, "Primo squardo al Padiglione Italiana," *Quadrivio*, June 28, 1942, p. 1. For the details of Rizzo's career both inside and outside of the Fascist culture bureaucracy, see chapter 3.

125. Pippo Rizzo, "Padiglioni dei concorsi e della guerra," *Quadrivio*, July 26, 1942.

126. Ibid.

127. "Communicazione fata da Roma ai giornali sui due premi del Duce alla XXI Biennale," February 22 1937, *ACS*, PCM (1940–42), 14.1.730, sottofascicolo 6; *Regolamento—La XXI Biennale*, *ACS*, PCM (1940–42), 14.1.730, sottofasicolo 6. *Il gazzettino di Venezia*, July 11, 1937.

128. Letter, Maraini to Osvaldo Sebastiani, Segretario particolare del Duce, June 3, 1938, *ACS*, PCM (1940–42), 14.1.730, sottofascicolo 6. Eugenio d'Ors was an art critic known for his zealous views against modern art: Raffaelle De Grada, "La critica del novecento," in *Mostra del novecento italiano*, cat. exh. (Milan: Mazzotta, 1983), p. 47.

129. Letter, Maraini to Osvaldo Sebastiani, Segretario particolare del Duce, June 3, 1938, *ACS*, PCM (1940–42), 14.1.730, sottofascicolo 6.

130. Mussolini's prizes for the 1940 Biennale were announced by the Agenzia Stefani on May 18, 1939. *ACS*, PCM (1940–42), 14.1.730, sottofascicolo 4.2.

131. Memo, May 19, 1940, *ACS*, MPI, divisione III, 1935–50, busta 279.

132. "Le premazioni della XXII Biennale," *L'arte nelle mostre italiane* 7, nos. 5–10 (May–October 1940), p. 51.

133. *ASAC*, Registre Vendite (4), 1936.

134. Memo, "Biennale Venezia," *ACS*, PCM (1934–36), 14.1.283, sottofascicolo 8.

135. *ASAC*, Registre Vendite (4), 1932, 1934, 1936.

136. *ASAC*, Registre Vendite (4), 1936.

137. *Le mostre d'arte in Italia* 3, no. 12 (December 1936): 19–39.

138. Ibid. pp. 19–22.

139. "Elenco delle opere acquistate dal Duce alla XX Biennale (PCM)," *ACS*, PCM (1934–36), 14.1.283, sottofascicolo 6.

140. Letter, Romolo Bazzoni, Direttore amministrativo della Biennale to Ufficio Economato della PCM, November 6, 1936, *ACS*, PCM (1934–36), 14.1.283, sottofascicolo 6.

141. Letter, Bianchetti, Capo di gabinetto, PCM, to Direttore della Biennale, *ACS*, PCM (1934–36), 14.1.283, sottofascicolo 6.

142. Letter, Bazzoni to Presidenza Consiglio dei ministri, November 10, 1938, *ACS*, PCM (1940–42), 14.1.730, sottofascicolo 5.

143. Baumgartener, a prominent artist in Nazi Germany, specialized in depictions of German farmers and attempted some classicizing historical scenes. Berthold Hinz, *Art in the Third Reich* (New York: Pantheon, 1979), pp. 160–61. The *Bust of Hitler* was made of stone, but Thorak offered to produce a second one of bronze for the discounted price of 4,000 lire, if Mussolini so desired. "Appunto per il Duce," July 20, 1938, *ACS*, PCM (1940–42), 14.1.730, sottofascicolo 5.

144. Manuela Hoelterhoff, "Art of the Third Reich: Documents of Oppression," *Art Forum* 14, no. 4 (December 1975): 61.

145. *ASAC*, Registre Vendite (4), 1938; "Elenco delle opere vendute—Ventunesima Esposizione internazionale d'arte," *Le mostre d'arte in Italia* 5, no. 12 (December 1938).

146. Memo, Volpi to Bottai, August 17, 1938, *ACS*, MPI, divisione III (Venezia), 1935–50, busta 279.

147. Letter, Commission to Bottai, May 16, 1940, *ACS*, MPI, divisione III, 1935–50, busta 279.

148. Ibid.

149. "Acquisti del Ministero dell'educazione nazionale alla XXII Biennale 1940," *ACS*, MPI divisione III, 1935–40, busta 279.

150. *ASAC*, Registre Vendite, 1940.

151. Ibid. "Elenco delle opere vendute," *L'arte nelle mostre italiane* 7, nos. 11–12 (November–December 1940): 116–35.

152. *L'arte nelle mostre italiane* 7, nos. 11–12 (November–December 1940): 115.

153. *Le arti* 5 (October 1942): v.

154. "Acquisti del Ministero dell'educazione nazionale alla XXII Biennale 1940," *ACS*, MPI, divisione III, 1935–40, busta 279.

155. At the time of his commission to paint the fresco, Santagata sat on the National Directorate of the Fascist Syndicate of the Fine Arts.

156. La Biennale di Venezia, *XXI Esposizione biennale internazionale d'arte, 1938*, p. 41. The 1932 facade and the 1938 frescoes still stand on the Biennale grounds, though in a state of disrepair.

157. Ibid., p. 35.

158. Antonio Maraini, "XXI Biennale," *Le tre venezie* 13, no. 6 (June 1938): 183.

159. La Biennale di Venezia, *XXI Esposizione biennale internazionale d'arte, 1938*, p. 34.

160. On Pavolini's role in the centralization of the cultural bureaucracy in the late 1930s, see Philip Cannistraro, *La fabbrica del consenso* (Rome-Bari: Laterza, 1975), pp. 122–50.

161. Ibid., p. 162.

162. Philip V. Cannistraro, ed., *Historical Dictionary of Fascist Italy* (Westport, Conn.: Greenwood Press, 1982), pp. 415–16.

163. Agenzia Stefani, February 23, 1939, *ACS*, PCM (1940–42), 14.1.730, sottofascicolo 1. *L'arte nelle mostre italiane* 6, nos. 2–3 (February–March 1939), pp. 1–3.

164. *L'arte nelle mostre italiane* 7, nos. 5–10 (May–October 1940): 55; Paolo Rizzi and Enzo di Martini, *La Storia della Biennale, 1895–1982* (Milan: Electa, 1982), p. 83.

165. *ASAC*, busta 88, "corrispondenza varie—1934"; "Segnalazioni," *Il gazzettino*, July 1, 1942.

166. *ASAC*, busta 105, "stampati vari."

Chapter Seven
The Rise and Fall of the Fascist *Gesamtkunstwerk*

1. Francesco Barone, *Tappe d'ottobre* (Rome: Edizioni Luzzati, 1934), p. 109.

2. Fiera di Milano, *Esposizione dell'aeronautica italiana*, cat. exh. (Milan: Edizioni d'arte Bestetti, 1934).

3. Letter, *Podestà* of Milan to Mussolini, October 7, 1934, *ACS*, PCM (1934–36), 14.1.868.

4. *Esposizione dell'aeronautica italiana*, p. 23.

5. *Ibid*. pp. 134–35.

6. Carlo Saliva, *Ali italiane alla mostra di milano* (Milan: Vercelli, 1934), p. 64.

7. A. M. Mazzucchelli, "Stile di una mostra," *Casabella* 6, no. 80 (August 1934): 6.

8. Ferdinando Reggiori, "L'esposizione dell'aeronautica italiana nel palazzo dell'arte di Milano," *Architettura* 2, no. 9 (September 1934); 532.

9. Mazzucchelli, "Stile di una mostra," p. 6.

10. Fiera di Milano, *Esposizione dell'aeronautica italiana*, p. 81.

11. The Exhibition of Italian Autarchy in Minerals.

12. "Agenzia Stefani," November 18, 1938, *ACS*, PCM (1937–39), 14.1.6198.

13. The government newsreels, produced by the Istituto Luce, emphasized exhibitions, the preparations surrounding them, their inauguration, the visits of prominent guests, and other aspects of interest. By law, these newsreels were shown before and after feature films. The Mostra autarchica appeared ten times between November 19, 1938, and February 2, 1939, in the twice-weekly newsreels. The LUCE filmed the construction and the inauguration of the Mostra autarchica, as well as the visits of Nazi officials and group tours by various Fascist mass organizations. *Cinecittà*, Istituto Luce, Cinegiornali, 1938, nos. 1392–1453.

14. See Gino Salocchi, ed., *Mostra nazionale delle colonie estive e dell'assistenza all'infanzia*, cat. exh. (Milan: Unione Tipografica, 1937); *Mostra del Dopolavoro*, cat. exh. (Milan: Unione Tipograficia, 1938); and *Mostra autarchica del minerale italiano*, cat. exh. (Rome: Pubblicazioni ufficiali a cura della direzione della Mostra, 1938). See also Partito Nazionale Fascista, *Mostra delle colonie estive e dell'assistenza all'infanzia: Guida del padiglione della scuola*, cat. exh. (Rome: Società Tipografica "Leonardo Da Vinci," 1937); *Prima Mostra nazionale del Dopolavoro—Guida per stranieri*, cat. exh. (Rome: Partito Nazionale Fascista, 1938); and Ministero dell'Educazione Nazionale, *Istruzione tecnica alla Mostra autarchica del minerale italiano* (Rome: Fratelli Palombi, 1939).

15. Rosalind Williams, *Dream Worlds* (Berkeley: University of California Press, 1982).

16. M. Christine Boyer, "Cities for Sale," in *Variations on a Theme Park*, ed. Michael Sorkin (New York: Noonday Press, 1992), p. 186.

17. "Disneyland" currently composes one of cultural studies' and deconstruction's "hottest" topics and has been dissected from many sides as a way into the social formations and the consumption modes of the future. For a series of essays on Disneyland, see Susan Willis, ed., "The World according to Disney," *South Atlantic Quarterly*, 92, no. 1 (Winter 1993).

18. Michael Sorkin, "See You in Disneyland," in Sorkin, *Variations on a Theme Park*, p. 231.

19. Saloccchi, *Mostra nazionale delle colonie estive e dell'assistenza all'infanzia*, preface.

20. Claudio Longo, "Mostra autarchica del minerale italiano a Roma," *Architettura* 7, no. 4 (April 1939): 197.

21. Press release, Agenzia Stefani, November 18, 1938, ACS, PCM (1937–39), 14.1.6198.

22. The novecento movement in the arts declared its goal to be the reconciliation of modernity and tradition within an Italian context. The group of artists who painted, sculpted, and designed under its banner was highly patronized by the dictatorship. See Rossana Bossaglia, ed., *Il "Novecento italiano"—Storia, documents, iconographia* (Milan: Feltrinelli, 1979). On Mario Sironi's contribution to official culture, see *Mario Sironi 1885–1961*, cat. exh., Galleria nazionale di arte moderna (Rome: Electa, 1993), and Emily Braun, "Illustrationions of Propaganda—The Political Drawings of Mario Sironi," *Journal of Decorative and Propaganda Arts* 3 (Winter 1987): 84–107.

23. Longo, "Mostra autarchica del minerale italiano a Roma," 216.

24. Alberto Neppi, "Alla Mostra delle colonie estive," *La rassegna italiana* 2 (July 1937): 508.

25. Salocchi, *Mostra nazionale delle colonie estive e dell'assistenza all'infanzia*, p. 22; Longo, "Mostra autarchica del minerale italiano a Roma," p. 201.

26. Dawn Ades, Tim Benton, David Elliot, and Iain Boyd White, eds., *Art and Power: Europe under the Dictators, 1930–45*, cat. exh. (London: Hayward Gallery / South Bank Centre, 1995), p. 125.

27. Neppi, "Alla Mostra delle colonie estive," p. 506.

28. Diane Ghirardo, "Italian Architects and Fascist Politics: An Evaluation of Rationalists in Regime Building," *Journal of the Society of Architectural Historians* 39, no. 2 (May 1980): 113.

29. Salocchi, *Mostra nazionale delle colonie estive e dell'assistenza all'infanzia*, p. 12.

30. "La prima Mostra del Dopolavoro inaugurata dal Duce," *L'illustrazione italiana*, May 29, 1938, p. 895.

31. Longo, "Mostra autarchica del minerale italiano a Roma," p. 216.

32. On the application of such techniques in contemporary urban architecture, see Boyer, "Cities for Sale," p. 184.

33. Press release, "Agenzia Stefani," November 18, 1938, *ACS*, PCM (1937–39), 14.1.6198.

34. *Prima Mostra nazionale del Dopolavoro—Guida per stranieri*.

35. *Cinecittà* Istituto, Luce, 19/38, no. 1392.

36. Jean Baudrillard, *Simulations* (New York: Semiotext(e), 1983).

37. Guy De Bord, *The Society of the Spectacle* (Detroit: Red & Black, 1983).

38. For a nineteenth-century version of the "constructed environment," see Michael Wilson, "Consuming History: The Nation, the Past and the Commodity at L'Exposition Universelle de 1900," *American Journal of Semiotics* 8, no. 4 (1991): 145.

39. Umberto Eco, *Travels in Hyperreality* (New York: Harcourt, Brace Jovanovich, 1983), p. 19.

40. Carlo Magi-Spineri, "La prima mostra autarchica del minerale italiano," *Architettura* 7, no. 7 (July 1939): 209.

41. Marcia Landy, *Fascism in Film* (Princeton, N.J.: Princeton University Press, 1986): 27.

42. "La prima Mostra del Dopolavoro inaugurata dal Duce," p. 895.

43. Ibid.

44. Ivan Karp and Steven Lavine, *Exhibiting Cultures* (Washington, D.C.: Smithsonian Institution Press, 1991); Herman Lebovics, *True France: Wars over Cultural Identity, 1900–1945* (Ithaca, N.Y.: Cornell University Press, 1992), pp. 51–97; Robert Rydell, *World's of Fairs* (Chicago: University of Chicago Press, 1993).

45. This phenomenon has provocative parallels to the recent interest in "primitive" tourism, in the very popular forms of treks and safaris during which natives can be seen in their "natural" habitat. See Dean MacCannell, *The Tourist Papers* (New York: Routledge, 1992).

46. "La prima Mostra del Dopolavoro inaugurata dal Duce," p. 895.

47. "Foglio d'ordini," no. 190, November 13, 1937, ACS, PCM (1936–38), 14.1.1224, sottofascicolo 2.

48. *Mostra nazionale delle colonie estive e dell'assistenza all'infanzia*, p. 4.

49. "Cronache del mese," *Gerarchia* 15 (July 1937): 503.

50. *Mostra del Dopolavoro*, p. 18.

51. "Foglio di disposizioni," no. 927, December 10, 1937, ACS, PCM (1936–38), 14.1.1224.

52. Susan Buck-Morss, *The Dialectics of Seeing* (Cambridge, Mass.: MIT Press, 1990).

53. *Mostra nazionale del Dopolavoro*, p. 23.

54. Attendance at the Fascist Party exhibitions remained high through the end of the 1930s: the Mostra delle colonie estive attracted over 500,000 visitors, the Mostra del tessile nazionale had an audience of 600,000, and the Mostra autarchica del minerale brought in 1,091,435 people.

55. Carlo Magi-Spineri, "La prima mostra autarchica del minerale italiano," *Architettura* 7, no. 7 (July 1939): 209–20.

56. "Cronache del mese," *Gerarchia* 15 (July 1937): 503.

57. *Mostra nazionale delle colonie estive e dell'assistenza all'infanzia*, p. 6.

58. "Foglio d'ordini," no. 190, November 13, 1937, ACS, PCM (1936–38), 14.1.1224.

59. See, in particular, Warren Susman, "The People's Fair," in *Culture as History: The Transformation of American Society in the Twentieth Century* (New York: Pantheon, 1984); Roland Marchand, "The Designers Go to the Fair: Walter Dorwin Teague and the Professionalization of Corporate Industrial Exhibits, 1933–1940," *Design Issues* 8, no. 1 (Fall 1991): 5–17, and "The Designers Go to the Fair II: Norman Bel Geddes, the General Motors 'Futurama,' and the Visit to the Factory Transformed," *Design Issues* 8, no. 2 (Spring 1992), 23–40; Helen Harrison, ed., *Dawn of a New Day: The New York World's Fair, 1939/40* (New York: New York University Press, 1980).

60. For both the Mostra della colonie estive (Exhibition of Summer Camps and Assistance to Children) and the Mostra del tessile nazionale (Exhibition of National Textiles) the regime published commemorative stamps: Memo, 18 October 1937, to PCM, from Ministero dell'instruzione pubblicas, ACS, PCM (1936–38), 14.1.1224.

61. Marchand, "The Designers Go to the Fair: Norman Bel Geddes, the General Motors 'Futurama,' and the Visit to the Factory Transformed," p. 35.

62. Giovanni Biadene, "La Mostra della rivoluzione (da Via nazionale a via dell'impero)," *L'illustrazione italiana*, October 28, 1934, p. 667. Letter, Giovanni Marinelli to Ercole, Ministro dell'educazione nazionale, July 14, 1934, *ACS*, PNF Direttorio, Ufficio Stralcio, busta 273. The Mostra had to close by October 1934 because the Second Quadriennale was scheduled to open in January 1935 in the Palazzo delle esposizioni.

63. "Il concorso nazionale per il palazzo del littorio e della mostra della rivoluzione fascista," *Le professioni e le arti* 4, no. 1 (January 1934): 32–33. For more on the "concorso per il Palazzo del Littorio," see Giuseppe Pagano, "Il concorso per il Palazzo del Littorio," *Casabella* 6, no. 82 (October 1934).

64. *Promemoria*, *ACS*, PNF Direttorio, Ufficio Stralcio, busta 273.

65. Letter, Ministero delle finanze to Ministero educazione nazionale, July 6, 1934, *ACS*, PNF Direttorio, Ufficio Stralcio, busta 273.

66. For a discussion of the intellectual formulations of "cultural autarchy," see Giuseppe Carlo Marino, *L'autarchia della cultura* (Rome: Riuniti, 1983), p. 3, "La disgregazione della cultura autarchica," especially sec. 2, "La bonifica della cultura."

67. Marcello Piacentini, *Il giornale di Italia*, July 15, 1938.

68. *Chi è?* (Rome: A. F. Formaggiani, 1936–1938), 6:587.

69. Telegraph dispatch, PCM Medici to Tutti i ministri gabinetto, September 21, 1937, *ACS*, PCM (1940–42), 14.1.156.

70. "La Mostra della rivoluzione sarà riaperta il 23 settembre—presente le alte cariche dello stato e le Gerarchie del Regime," *Il giornale d'Italia*, September 16, 1937.

71. "Il Duce inaugura oggi le Mostre imperiali," *Corriere della sera*, September 23, 1937.

72. "La Mostra della rivoluzione sarà riaperta il 23 settembre presente le alte cariche dello stato e le Gerarchie del Regime," *Il giornale d'Italia*, September 16, 1937.

73. "Il Duce inaugura oggi le Mostre imperiali."

74. Ibid.

75. *Mostra Augustea della romanità*, 4th ed., cat. exh. (Rome: C. Colombo, 1938).

76. The Mostra Augustea della romanità opened at ten o'clock and the Mostra della rivoluzione fascista at eleven.

77. "La fiamma sacra della rivoluzione," *Corriere della sera*, September 23, 1937.

78. Maria Cagnetta, "Il mito di Augusto e la 'rivoluzione' fascista," *Quaderni di storia* 2 (1976): 148.

79. "La Mostra della rivoluzione a Valle Giulia," *Corriere della sera*, September 22, 1937.

80. Letter, Ministero educazione nazionale to Starace, September 22, 1937, *ACS*, PNF Direttorio, Ufficio Stralcio, busta 273.

81. "La Mostra della rivoluzione a Valle Giulia."

82. *ACS*, PNF, MRF, Archivio Fotografico, catalogo negativi, ed. 1937. I thank Professor Borden Painter for bringing this information to my attention.

83. Memo, Generale Edmondo Rossi to Marinelli, September 29, 1939, *ACS*, PNF direttorio, Ufficio Stralcio, busta 272.

84. "Il Duce inaugura oggi le Mostre imperiali."

85. *Corriere della sera*, September 21, 1937. "Promemoria per il seg. amminstrativo

de PNF," July 5, 1939, *ACS*, MRF Appendixi 1, Altocommissario per le sanzioni contro il fascismo tit. XVII, vol. 2, no. 10, sottofascicolo 493; Alceo Valcini, "Venti anni di terrore in Russia," *L'illustrazione italiana*, November 14, 1937. Apparently Melchiori accompanied the Mostra della rivoluzione fascista materials to Berlin for the opening of the exhibition.

86. Letter, Marinelli to Paulucci di Calboli, Presidente Luce, February 27, 1939, *ACS*, PNF Direttorio, Ufficio Stralcio, busta 273.

87. "Appunto per il segretario del partito," February 6, 1939, *ACS*, PNF direttorio, Ufficio Stralcio, busta 273. Special emphasis was laid on sending material that stressed the "the contribution of Fascism to the anti-Bolshevik struggle."

88. Vincenzo Talarico, "La Mostra della rivoluzione fascista a Valle Giulia," *Capitolium* 13 (November 1937): 515.

89. Ibid., p. 517.

90. Ibid., p. 515.

91. "Il Duce inaugura oggi le Mostre imperiali."

92. Ibid.

93. Letter, Emilio di Mattia to Alfieri, November 24, 1937, *ACS*, PNF Direttorio, Ufficio Stralcio, busta 272.

94. *Promemoria per l'On. Marinelli*, *ACS*, PNF Direttorio, Ufficio Stralcio, busta 272.

95. "Ispezione delle MRF 26–27/12/39," *ACS*, PNF Direttorio, Ufficio Stralcio, busta 273.

96. "Rendiconto vendita biglietti ingresso dal 9/7/40 al 31/1/40," *ACS*, PNF Direttorio, Ufficio Stralcio, busta 272, sottofascicolo *Verbale di consegna*.

97. *Promemoria per il Capo dei servizi amministrativi del direttorio nazionale del PNF*, August 7, 1940, *ACS*, PNF Direttorio, Ufficio Stralcio, busta 272.

98. Memo, June 18, 1940, *ACS*, PNF Direttorio, Ufficio Stralcio, busta 272.

99. Memo, June 25, 1938, *ACS*, PNF Direttorio, Ufficio Stralcio, busta 272.

100. "Rendiconto vendita guide 10/7/1940–17/4/1942," *ACS*, PNF Direttorio, Ufficio Stralcio, sottofascicolo *Verbale di consegna*.

101. *ACS*, PNF, Ufficio Stralcio, Direttorio, busta 274. The exhibition organizers must have based their estimates on sales at the 1932 Mostra: 45,000 catalogs had been printed in Italian and apparently 28,468 sold before April 30, 1936 (and, hence, prior to the opening in Valle Giulia). As noted, only 148 sold afterward.

102. Ibid.

Chapter Eight
Conclusion

1. Giorgio Ciucci, *Gli architetti e il Fascismo* (Turin: Einaudi, 1989), p. 181.

2. On the Esposizione universale di Roma, see Maurizio Calvesi and Enrico Guidoni, eds., *E42, Utopia e scenario del regime*, vol. 1, *Ideologia e programma per l'Olimpiade delle civiltà* and vol. 2, *Urbanistica, architettura, arte e decorazione*, cat. exh. (Venice: Marsilio, 1987), G. Pagano, M. Piacentini, L. Piccinato, E. Rossi, and L. Vietti, "Il piano regolatore dell'Esposizione Universale di Roma, 1941–42," *Casabella* 10, no. 114 (June 1937).

3. Calvesi and Guidoni, *E42, Utopia e scenario del regime*, 1:104–39.

4. Ibid., 1:104. This figure does not include the various attractions, such as sound-and-light shows and aquatic parks.

5. Raymond Williams, "Theatre as a Political Forum," in *Visions and Blueprints: Avante-Garde Culture and Radical Politics in Early Twentieth-Century Europe*, ed. Edward Timms and Peter Collier (Manchester: Manchester University Press, 1988), p. 309.

▪ ▪ ▪ ▪ ▪ ▪ *BIBLIOGRAPHY*

Primary Sources

ARCHIVAL SOURCES

Archivio centrale dello stato (ACS), Rome

Altocommisione per le sanzioni contro il Fascismo
Ministero della cultura popolare (MCP)
Ministero dell'istruzione pubblica (MPI)
Partito Nazionale Fascista (PNF), Servizio Direttorio, Uffico Stralcio
Partito Nazionale Fascista, Mostra della rivoluzione fascista (PNF-MRF)
Presidenza consiglio dei ministri (PCM)
Segretario particolare del Duce

Archivio storico dell'arte contemporanea (ASAC), Venice

Archivio Documentario
Registre Vendite, 1928–42

Cinecittà, Istituto Luce, Rome

Registre dei cinegiornali, 1930–40

CONTEMPORARY NEWSPAPERS AND JOURNALS

Architettura
Le arti
Bibliografia fascista
Casabella
Capitolium
Corriere della sera
Corriere Padano
Critica fascista
Emporium
Europa Svegliata
Gazzetta del popolo
Gazzetta di Venezia
Il gazzettino
Gerarchia
L'illustrazione italiana
Italia
Maestrale
Il messaggero
Le mostre d'arte in Italia and, after January 1939, *L'arte nelle mostre italiane*
La nuova antologia

Il popolo d'Italia
Le professioni e le arti
Quadrivio
Rassegna dell'istruzione artistica
La rassegna italiana
Rivista illustrata del popolo d'Italia
Il Tevere
Vedetta di Italia
Vedetta fascista

PRINTED PRIMARY SOURCES

Alfieri, Dino. *Il libro d'Italia*. Milan: Istituto Fascista di Cultura, 1929.

Alfieri, Dino, and Luigi Freddi. *Traccia storico-politica per la Mostra del Fascismo*. Rome: Bozze di Stampa, Tipografia della Camera dei Deputati, 1932.

Andalo, Guelfo. *Sono venuto a vivere la rivoluzione fascista: Impressioni e confessioni di un rimpatriato*. Rome: Studio Editoriale Bussetto, 1934.

Aristarco, "Riflessioni e critiche sulla XXII Biennale." *Maestrale* 1, no. 2 (July 1940): 72–80.

Bardi, P. M. "Esposizioni." *Bibliografia fascista* 7, no. 11 (November 1932): 701.

———. "Il nuovo assetto del Sindacato belle arti in una intervista con Antonio Maraini." *Le professioni e le arti* 3, nos. 1–2 (January–February 1933): 34–37.

———. "Il cartellone." *Bibliografia fascista* 8, no. 11 (November 1933): 3–5.

Barone, Francesco. *Tappe d'ottobre*. Rome: Edizioni Luzzati, 1934.

Biadene, Giovanni. "La Mostra della rivoluzione (da Via nazionale a Via dell'impero)." *L'illustrazione italiana*, October 28, 1934, pp. 667–69.

———. "Aspetti e curiosità della mostra del tessile." *L'illustrazione italiana*, November 28, 1937, p. 1485.

Biagi, Bruno. "Il sindacato, l'arte ed i giovani." *Gerarchia* 11 (February 1933).

Biancale, Michele. "Panorama critico della XVIII Internazionale d'arte di Venezia." *Rassegna dell'istruzione artistica*, 15 (April 1932): 145–54.

Bocci, Mario. "Ordinamento sindacale fascista." *Bibliografia fascista* 8, no. 11 (November 1933): 886–92.

Bottai, Giuseppe. *Roma nella mostra della rivoluzione fascista*. Rome: L. Cappelini, 1934. Reprinted from *Roma* (January 1934).

———. "Discorso pronunziato da S. E. Bottai nella inaugurazione della XXI Biennale a Venezia." *Rassegna dell'istruzione artistica* (May–June 1938): 183–85.

———. "Per l'inaugurazione del Terzo Premio Bergamo." *Le arti* 4 (October–November 1941): 1–4.

Capo, Gian. "La mostra azzurra." *L'Illustrazione italiana*, June 24, 1934, p. 954.

Chi è?. Vols. 6–8. Rome: A. F. Formiggiani, 1936–38.

Cosera, F. *Le professioni e le arti nello stato fascista* Rome: Tipografia dello stato, 1941.

Costantini, Vincenzo. "Il Premio Cremona—Arte umana per il popolo." *L'illustrazione italiana*, May 20, 1939, 1159–60.

Di Marzio, Cornelio. "La Mostra del Fascismo." *Bibliografica fascista* 7, no. 5 (May 1932): 259–64.

Dinale, Ottavio. "Il Sacrario dei Martiri." *La rivista illustrata del popolo d'Italia* 11, no. 3 (March 1933).

————. "La Mostra della rivoluzione—Visioni d'arte." *La rivista illustrata del popolo d'Italia* 11 (June 1933): 40–44.

————. *La rivoluzione che vince.* Rome: Franco Campitelli, 1934.

Federici, Federico. "L'arte nello stato nazionalsocialista." *Gerarchia* 15 (September 1937): 630–38.

Gargano, Francesco. *Italiani e stranieri alla Mostra della rivoluzione fascista.* Rome: SAIE, 1935.

Giuliano, Balbino. "Commento alla Biennale di Venezia." *Bibliografia fascista* 9, no. 6 (June 1934): 435–37.

Guerrisi, Michele. "Sindacato e civiltà artistica." *Le professioni e le arti* 3, no. 5 (May 1933): 3–5.

————. "L'arte nella civiltà fascista." *Rassegna dell'istruzione artistica* 4 (October–December 1934): 333–38.

Guttuso, Renato. "La XXII Biennale." *Le arti* 2 (June–September 1940): 366.

Guzzi, Virgilio. "La XX Biennale di Venezia." *La nuova antologia* 71, no. 1543 (July 1, 1936): 65–73.

————. "La XXI Biennale Veneziana." *La nuova antologia* 73, no. 1588 (May 16, 1938): 431–42.

Interlandi, Telesio. "Arte e razza." *Quadrivio,* November 20, 1938, p. 1.

Lancellotti, Arturo. *L'inquadramento sindacale degli artisti e la disciplina delle mostre d'arte in Italia.* Rome: Instituto Nazionale per le Relazioni Culturali con l'Estero, 1940.

Lantini, Ferruccio. "Autarchia." *La rassegna italiana* 21, no. 1 (January 1938): 3–14.

Longo, Claudio. "Mostra autarchica del minerale italiano a Roma." *Architettura* 7, no. 4 (April 1939): 197–235.

Maccari, Mino. "Il carattere popolare della Mostra della rivoluzione fascista." *L'illustrazione italiana,* April 2, 1933, pp. 498–99.

Magi-Spineri, Carlo. "La prima mostra autarchica del minerale italiano." *Architettura* 7, no. 7 (July 1939): 209–20.

Maino, Gigi. "La Mostra della rivoluzione fascista." *La rassegna italiana* 16, no. 178 (March 1933): 203–11.

Maraini, Antonio. "Un anno di mostre sindacati regionali." *Dedalo* (1929–30): 679–720.

————. "Il nuovo assetto della Biennale Veneziana." *Rassegna dell'istruzione artistica* 12 (February 1930): 34–36.

————. "La XVIII Biennale di Venezia." *Le tre venezie* 7, no. 5 (May 1932): 246–51.

————. "L'inquadramento sindacale degli artisti." *Le professioni e le arti* 6, no. 8 (August 1936): 13–15.

————. "La XXI Biennale di Venezia." *Le tre venezie* 13, no. 6 (June 1938).

Marinetti, F. T. *Teoria e intervenzione futurista.* Edited by Luciano De Maria. Milan: Mondadori, 1968.

Martello, Carlo. "In cerca della rivoluzione alla XIX Biennale." *Europa Svegliata* 2, no. 6 (June 1934): 12–16.

Mazzucchelli, A. M. "Stile di una mostra." *Casabella* 7, no. 80 (August 1934): 6–8.

Melchiori, Alessandro. "La Mostra della rivoluzione fascista—una grande opera di fede." *L'illustrazione italiana,* April 2, 1933, pp. 512–14.

Melli, Domenico. "Il contributo dell'arte all'educazione del popolo." *Gerarchia* 20 (September 1940).

Mignosi, Pietro. *Pippo Rizzo e le nuove correnti della pittura siciliana.* Rome: Edizione d'Arte "Quadrivio," 1936.

Mulé, F. P. "La Mostra della rivoluzione fascista." *Capitolium* 9 (January 1933): 1–8.

Mussolini, Benito. "Agli artisti della Quadriennale." *Scritti e discorsi* 7 (Milan: Ulrico Hoepli, 1934).

Nebbia, Ugo. "L'arte italiana alla XX Biennale." *Rassegna dell'istruzione artistica* 19 (July–August 1936): 216–36.

Neppi, Alberto. "L'opera degli artisti alla Mostra della rivoluzione fascista." *Rassegna dell'istruzione artistica* 15 (November–December 1932): 335–43.

––––––. "La XX Biennale a Venezia e la VI Triennale a Milano." *La rassegna italiana* 19 (July 1936): 491–500.

Ojetti, Ugo. "Concorsi e rittrati," *Corriere della sera*, June 9, 1940.

Oppo, C. E. "L'arte e lo stato." *Le professioni e le arti* 2, no. 5 (May 1932): pp. 8–9.

Pacini, Renato. "Il valore educativo e patriottico della mostra." *Emporium* 77 (April 1933): 251–56.

Pagano, Giuseppe. "La mostra azzurra." *Casabella* 6, no. 80 (August 1934): 4–5.

––––––. "Il concorso per il Palazzo del Littorio." *Casabella* 6, no. 82 (October 1934).

––––––. "La Mostra delle colonie estive." *Casabella* 10, no. 116 (August 1937): 6–7.

Pagano, Giuseppe, M. Piacentini, L. Piccinato, E. Rossi, and L. Vietti. "Il piano regolatore dell'Esposizione universale di Roma, 1941–41." *Casabella* 10, no 114 (June 1937).

Papini, Roberto. "Arte della rivoluzione." *Emporium* 77 (April 1933): 195–98.

Pensabene, Giuseppe. "L'arte e i funzionari." *Quadrivio*, December 30, 1934, p. 1.

––––––. "Prime considerazioni sulla Quadriennale." *Quadrivio*, February 10, 1935, p. 1.

––––––. "Premi per le belle arti." *Quadrivio*, April 12, 1936, pp. 1–2.

––––––. "Meglio tardi che mai." *Il Tevere*, June 25–26, 1938, pp. 1–2.

Persico, Edoardo. "Mostra della rivoluzione fascista," *Casabella* 5, no. 59 (1932): 28–31.

Picenardi, G. Sommi. "Organizzazione, controllo, e disciplina dell'arte in Germania." *La vita italiana* 2 (May 1937): 573–83.

Piezza, Giuseppe. "Il critico sostituito in Germania dal resocontista d'arte." *Le professioni e le arti*, no. 11, year VI (November 1936): 13–14.

Pomba, Giuseppe, ed. *La civiltà fascista.* Turin: Unione Tipografica, 1928.

Reggiori, Ferdinando. "L'Esposizione dell'aeronautica italiana nel palazzo dell'arte di Milano." *Architettura* 2, no. 9 (September 1934): 532–40.

Rizzo, Pippo. "Un passo avanti? La XIX Biennale d'arte di Venezia." *Quadrivio*, May 20, 1934, p. 3.

––––––. "Primo sguardo al Padiglione Italiana." *Quadrivio*, June 28, 1942, p. 1.

Saliva, Carlo. *Ali italiane alla mostra di milano.* Milan: Vercelli, 1934.

Santangelo, Giulio. "Anno Decimo: La Mostra della rivoluzione fascista." *Bibliografia fascista* 7, (July 1932): 422–24.

Sapori, Francesco. "Alla XVII Biennale Veneziana: La pittura." *Rassegna dell'istruzione artistica* 12 (April 1930): 193–202.

––––––. "Alla XIX Biennale Veneziano." *Rassegna dell'istruzione artistica* 16 (April–May–June 1934): 83–90.

Sarfatti, Margarita. "L'arte e il fascismo." In *La civiltà fascista*, edited by Giuseppe L. Pomba, pp. 217–19. Turin: Unione Tipografica, 1928.

––––––. *Storia della pittura moderna.* Rome: Paolo Cremonese, 1930.

————. "Spiriti e forme nuove a Venezia." *Il popolo d'Italia*, May 4, 1930.

————. "Nel Decennale: Orientamenti e presagi." *Gerarchia* 12 (1932): 879–81.

————. "Architettura, arte e simbolo alla Mostra del Fascismo." *Architettura* 2, no. 12 (January 1933): 1–17.

————. "La diciottesima Biennale di Venezia" *La rivista illustrata del popolo d'italia*, 5 (June 1932).

Sironi, Mario. "L'architettura della rivoluzione." *Il popolo d'Italia*, November 8, 1932.

Stagi, Rina Maria. *Pellegrinaggio alla Mostra della rivoluzione*. Pisa: Nistri-Lischi Editori, 1934.

Talarico, Vincenzo. "La Mostra della rivoluzione fascista a Valle Giulia." *Capitolium* 13 (November 1937): 513–18.

Torriano, Piero. "La seconda mostra del sindacato fascista Lombardo e la biennale di Brera." *L'illustrazione italiana*, October 1930, p. 1062.

————. "Pittori italiani alla XX Biennale d'arte a Venezia." *L'illustrazione italiana*, August 2, 1936, pp. 210–11.

————. "Scultori italiani alla XX Biennale di Venezia." *L'illustrazione italiana*, September 13, 1936, pp. 445–47.

Usellini, Guglielmo. "La mostra." *Emporium* 77 (April 1933): 199–250.

Zorzi, Elio. "Inaugurazione della III Mostra internazionale del cinema." *L'illustrazione italiana*, August 18, 1935, pp. 345–47.

Contemporary Exhibition Catalogs

2a Mostra nazionale di plastica murale per l'edilizia fascista in Italia e in Africa. Cat. exh. Rome: Edizioni futuriste di 'poesia,' 1936.

III Mostra regionale del sindacato belle arti delle Marche. Cat. exh. Ancona, 1932.

III Mostra regionale sindacato fascista belle art: della Romagna-Emilia. Cat. exh. Ferrara, 1933.

3a Mostra Senese del sindacato fascista belle arti. Cat. exh. Siena, 1933.

IV Esposizione d'arte del sindacato regionale fascista belle arti della Venezia Giulia. Cat. exh. Trieste, 1930.

IV Esposizione regionale d'arte, sindacato fascista belle arti di Sicilia, 1933. Cat. exh. Palermo, 1933.

Va Mostra regionale d'arte—Udine. Cat. exh. Udine, 1931.

VI Esposizione sindacale d'arte del sindacato interprovinciale fascista belle arte Venezia Tridentina. Cat. exh. 1937.

VI Mostra del sindicato belle arti del Lazio. Cat. exh. Rome: Enzo Pinci, 1936.

Alfieri, Dino, and Freddi, Luigi, eds. *Mostra della rivoluzione fascista*. Cat. exh. Bergamo: Istituto Italiano Arti Grafiche, 1933.

La Biennale di Venezia. *XIII Esposizione internazionale d'arte della città di Venezia*. Cat. exh. Florence: Casa Editrice d'arte Bestetti e Tumminelli, 1922.

————. *XVI Esposizione internazionale d'arte della città di Venezia*. 3d ed. Cat. exh. Venice: Carlo Ferrari, 1928.

————. *XVII Esposizione biennale internazionale d'arte, 1930*. Cat. exh. Venice: Carlo Ferrari, 1930.

————. *XVIII Esposizione biennale internazionale d'arte, 1932*. Cat. exh. Venice: Carlo Ferrari, 1932.

La Biennale di Venezia. *XIX Esposizione biennale internazionale d'arte, 1934.* Cat. exh. Venice: Carlo Ferrari, 1934.

————. *XX Esposizione biennale internazionale d'arte, 1936.* Cat. exh. Venice: Carlo Ferrari, 1936.

————. *XXI Esposizione biennale internazionale d'arte, 1938.* Cat. exh. Venice: Carlo Ferrari, 1938.

————. *XXII Esposizione biennale internazionale d'arte, 1940.* Cat. exh. Venice: Carlo Ferrari, 1940.

————. *XXIII Esposizione biennale internazionale d'arte, 1942.* Cat. exh. Venice: Carlo Ferrari, 1942.

Comitato manifestazioni artistiche Cremona. *Premio Cremona.* Cat. exh. Cremona: Cremona Nuova, 1939.

Ente autonomo manifestazioni artistiche Cremona. *III Premio Cremona.* Cat. exh. Cremona, 1941.

Fiera di Milano. *Esposizione dell'aeronautica italiana.* Cat. exh. Milan: Edizioni d'arte Bestetti, 1934.

Freddi, Luigi. *Mostra della rivoluzione fascista.* Cat. exh. Florence: Vallecchi, 1933.

Ministero dell'educazione nazionale. *Istruzione tecnica alla Mostra autarchia del minerale italiano.* Cat. exh. Rome: Fratelli Palombi, 1939.

Mostra Augustea della romanità. 4th Cat. exh. Rome: C. Colombo, 1938.

Mostra autarchica del minerale italiano. Cat. exh. Rome: Circo Massimo, 1938.

Mostra del Dopolavoro. Cat. exh. Milan: Unione Tipograficia, 1938.

Partito Nazionale Fascista, *Mostra delle colonie estive e dell'assistenza all'infanzia: Guida del padiglione della scuola.* Cat. exh. Rome: Società Tipografica "Leonardo Da Vinci," 1937.

Premio Bergamo: Mostra nazionale del paesaggio Italiano. Cat. exh. Bergamo, 1939.

Prima mostra degli artisti italiani in armi. Cat. exh. Rome: Stato Maggiore R. Esercito: 1942.

Prima Mostra nazionale del Dopolavoro—Guida per stranieri. Cat. exh. Rome: Partito Nazionale Fascista, 1938.

Prima mostra nazionale di plastica murale per l'edilizia fascista. Cat. exh. Genoa: Palazzo Ducale, 1934.

Salocchi, Gino, ed. *Mostra nazionale delle colonie estive e dell'assistenza all'infanzia.* Cat. exh. Milan: Unione Tipografica, 1937.

Società amatori e cultori di belle arti. *XCIV Esposizione di belle arti. Societa amatori cultori di belle arti.* Cat. exh. Rome: Enzo Pinci, 1928.

Secondary Sources

BOOKS AND ARTICLES

Adamson, Walter. "Fascism and Culture: Avant-gardes and Secular Religion in the Italian Case." *Journal of Contemporary History* 94, no. 3 (July 1989): 411–35.

————. "Modernism and Fascism: The Politics of Culture in Italy, 1903–1922." *American Historical Review* 95, no. 2 (April 1990): 359–90.

————. *Avant-Garde Florence: From Modernism to Fascism.* Cambridge, Mass.: Harvard University Press, 1993.

Albertina, Vittoria. "Totalitarianismo ed intelletuali: L'istituto nazionale fascista di cultura dal 1925 al 1937." *Studi storici* 23 (October–December 1982): 897–918.

———. *Le riviste del duce: Politica e cultura del regime.* Turin: Guanda, 1983.

Allason, Barbara. *Memorie di un'antifascista, 1919–1940.* Milan: Edizione Avanti, 1961.

Alloway, Lawrence. *The Venice Biennale, 1895–1968.* London: Faber & Faber, 1969.

Andreotti, Libero. "The Aesthetics of War: The Exhibition of the Fascist Revolution." *Journal of Architectural Education* 45 (February 1992): 76–86.

Aquarone, Alberto. *L'organizzazione dello stato totalitario.* Turin: Einaudi, 1965.

Armellini, Guido. "Fascismo e pittura italiana: I. Carra, Sironi, Rosai." *Paragone*, no. 271 (1973): 50–68.

———. *Le immagine del Fascismo nelle arte figurative.* Milan: Fabbri, 1980.

Barocchi, Paola, ed. *Storia moderna dell'arte in Italia.* Turin: Einaudi, 1990.

Baudrillard, Jean. *Simulations.* New York: Semiotext(e), 1983.

Bazzoni, Romolo. *Sessant'anni della Biennale di Venezia.* Venice: Lombroso Editore, 1962.

Becker, Howard. *Art Worlds.* Berkeley: University of California Press, 1982.

Ben Ghiat, Ruth. "The Politics of Realism: *Corrente di vita giovanile* and the Youth Culture of the 1930's." *Stanford Italian Review* 8, nos. 1–2 (1990): 139–64.

———. "Fascism, Writing and Memory: The Realist Aesthetic in Italy, 1930–50." *Journal of Modern History* 67, no. 3 (1995): 627–65.

Benzi, Fabio. "Materiali inediti dall'archivio di Cipriano Efisio Oppo." *Bollettino d'arte*, nos. 37–38 (May–August 1986): 169–91.

Benzi, Fabio, and Andrea Sironi. *Sironi illustratore: Catologo ragionato.* Rome: De Luca Editore, 1988.

Berezin, Mabel. "The Organization of Political Ideology: Culture, State, and Theater in Fascist Italy." *American Sociological Review* 56 (October 1991): 643–46.

Bobbio, Norberto. "La cultura e il Fascismo." In *Fascismo e società italiana.* Turin: Einaudi, 1973.

———. "L'ideologia del Fascismo." In *Il fascismo: Antologia di scritti critici*, edited by Costanzo Casucci. Bologna: 1982.

Boime, Albert. *The Art of the Macchia and the Risorgimento.* Chicago: University of Chicago Press, 1993.

Bondanella, Peter. *Italian Cinema from Neo-Realism to the Present.* New York: Fredrick Ungar, 1983.

Bossaglia, Rossana. "Caratteri e sviluppi del Novecento." In *Mostra del novecento italiano*, edited by Rossana Bossaglia, pp. 19–32. Milan: Mazzotta, 1983.

———. "L'iconografia del novecento italiano nelle contesto europeo." *Journal of Decorative and Propaganda Arts* (Winter 1987).

———. ed. *Il Novecento italiano—Storia, documenti, iconografia.* Milan: Feltrinelli, 1979. Reprint, 1995.

Bourdieu, Pierre. *Distinction: A Social Critique of the Judgement of Taste.* Cambridge, Mass.: Harvard University Press, 1984.

———. *The Field of Cultural Production.* Edited by Randal Johnson. New York: Columbia University Press, 1993.

Bown, Matthew Cullerne, and Brandon Taylor, eds. *Art of the Soviets: Painting, Sculpture and Architecture in a One-Party State.* Manchester: Manchester University Press: 1993.

Boyer, M. Christine. "Cities for Sale." In *Variations on a Theme Park*, edited by Michael Sorkin, pp. 181–204. New York: Noonday Press, 1992.

Braun, Emily. "Illustrations of Propaganda—The Political Drawings of Mario Sironi." *Journal of Decorative and Propaganda Arts* 3 (Winter 1987): 84–107.

―――. "La scuola romana: Fact or Fiction." *Art in America*, no. 3 (March 1988): 128–37.

―――. "Mario Sironi and a Fascist Art." In *Italian Art in the Twentieth Century*, edited by Emily Braun, pp. 173–80. London and Munich: Royal Academy and Prestel Verlag, 1989.

―――. *Mario Sironi 1919–1945*: Art and Politics in Fascist Italy." Cambridge: Cambridge University Press, 1999.

Brenner, Hildegard. *La politica culturale del nazismo*. Bari: Laterza, 1965.

Brunetta, Gian Piero. *Cinema italiano tra le due guerre*. Milan: Mursia, 1975.

―――. *Storia del cinema italiano*. Rome: Riuniti, 1979.

Buck-Morss, Susan. *The Dialectics of Seeing*. Cambridge, Mass.: MIT Press, 1990.

Bussman, Georg. "Degenerate Art—A Look at a Useful Myth." In *German Art in the Twentieth Century: Painting and Sculpture, 1905–1985*, edited by Christos M. Joachimides, Norman Rosenthal, and Wieland Schmied. Munich: Prestel Verlag, 1985.

Cagnetta, Maria. "Il mito di Augusto e la 'rivoluzione' fascista." *Quaderni di storia* 2 (1976): 139–81.

―――. *Antichisti e impero fascista*. Laterza: Bari, 1979.

Canfora, Luciano. "Classicismo e Fascismo." *Quaderni di storia* 2 (1976): 15–48.

―――. "Classicismo e Fascismo." In *Matrici culturali del Fascismo*, edited by Luciano Canfora, pp. 85–112. Bari: Laterza, 1977.

Cannistraro, Philip V. *La fabbrica del consenso*. Rome-Bari: Laterza, 1975.

―――. "Fascism and Culture in Italy, 1919–1945." In *Italian Art in the Twentieth Century*, edited by Emily Braun, pp. 147–54. London and Munich: Royal Academy and Prestel Verlag, 1989.

―――, ed. *Historical Dictionary of Fascist Italy*. Westport, Conn.: Greenwood Press, 1982.

Cannistraro, Philip, and Brian Sullivan. *The Duce's Other Woman*. New York: William Morrow, 1993.

Caramel, Luciano. "Gli astratti." In *AnniTrenta: Arte e Cultura in Italia*, edited by Vittorio Fagone, pp. 151–74. Cat. exh. Milan: Mazzotta, 1980.

―――. "Abstract Art in the Thirties." In *Italian Art in the Twentieth Century*, edited by Emily Braun, pp. 187–92. London and Munich: The Royal Academy and Prestel Verlag, 1989.

Cinelli, Barbara. "Firenze 1861: Anomalie di una esposizione." *Ricerche di storia dell'arte* 8, no. 18 (1982): 21–26.

Ciucci, Giorgio. "L'autorappresentazione del Fascismo." *Rassegna* 4, no. 10 (June 1982): 48–55.

―――. "Linguaggi architettonici negli anni '30 in Europa e in America." Lecture, Istituto Gramsci di Bologna, April 10, 1987.

―――. *Gli architetti e il Fascismo*. Turin: Einaudi, 1989.

Clark, Martin. *Modern Italy, 1871–1982*. London: Longman, 1984.

Crane, Diane. *The Transformation of the Avant-Garde*. Chicago: University of Chicago Press, 1987.

Crispolti, Enrico. *Il mito della macchina e altri temi del futurismo.* Celebes: Trapani, 1969.

▬▬▬. *Storia e critica del futurismo.* Bari: Laterza, 1986.

▬▬▬. "Second Futurism." In *Italian Art in the Twentieth Century*, edited by Emily Braun, pp. 165–72. London and Munich: Royal Academy and Prestel Verlag, 1989.

Croce, Benedetto. *Trent'anni di storia italiana.* Turin, 1961.

da Costa Meyer, Esther. *The Work of Antonio Sant'Elia.* New Haven, Conn.: Yale University Press, 1995.

Danesi, Silvia, and Luciano Patteta, eds. *Il razionalismo e l'architettura in Italia durante il Fascismo.* Venice: Edizioni La Biennale di Venezia, 1976.

de Beauvoir, Simone. *La force de l'age.* Paris: Gallimard, 1960.

De Bord, Guy. *The Society of the Spectacle.* Detroit: Red & Black, 1977.

De Felice, Renzo. *Mussolini il rivoluzionario.* Turin: Einaudi, 1965.

▬▬▬. *Mussolini il fascista: La conquista del potere.* Turin: Einaudi, 1966.

▬▬▬. *Mussolini il fascista: L'organizzazione dello stato fascista.* Turin: Einaudi, 1968.

▬▬▬. *Le interpretazioni del Fascismo.* Roma-Bari: Laterza, 1969.

▬▬▬. *Storia degli ebrei sotto il Fascismo.* Turin: Einaudi, 1972.

▬▬▬. *Il Duce: Gli anni del consenso.* Turin: Einaudi, 1974.

▬▬▬. *Il Duce: Lo stato totalitario.* Turin: Einaudi, 1981.

▬▬▬. "Outlines for Further Study." *Stanford Italian Review* 7, nos. 1–2 (1990): 5–12.

▬▬▬. *Rosso e nero*, a cura di Pasquale Chessa. Milan: Baldini & Castoldi, 1995.

De Grada, Raffaelle. "La critica del novecento." In *Mostra del novecento italiano*, edited by Rossana Bossaglia, pp. 43–52. Cat. exh. Milan: Mazzota, 1983.

De Grand, Alexander. "Giuseppe Bottai e il fallimento del fascismo revisionista." *Storia Contemporanea* 6, no. 4 (December 1975) 697–731.

▬▬▬. *Bottai e la cultura fascista.* Bari: Laterza, 1978.

▬▬▬. *The Italian Nationalist Association and the Rise of Fascism in Italy.* Lincoln: University of Nebraska Press, 1978.

▬▬▬. *Italian Fascism.* 2d ed. Lincoln: University of Nebraska Press, 1982.

de Grazia, Victoria. *The Culture of Consent: The Mass Organization of Leisure.* Cambridge: Cambridge University Press, 1981.

▬▬▬. *How Fascism Ruled Women.* Berkeley: University of California Press, 1992.

De Luna, Giovanni, and Marco Revelli, eds. *Fascismo e anti-Fascismo.* Florence: La nuova italia, 1995.

De Seta, Cesare. *La cultura architettonica in Italia tra le due guerre.* Bari: Laterza, 1972.

Del Boca, Angelo, Massimo Legnani, and Mario Rossi, eds. *Il regime fascista: Storia e storiografia.* Rome-Bari: Laterza, 1995.

Del Buono, Oreste, ed. *Eia, Eia, Eia, Alala: La stampa italiana sotto il Fascismo.* Preface by Nicola Tranfaglia. Milan: Feltrinelli, 1971.

Delzell, Charles. *Mediterranean Fascism, 1919–45.* New York: Harper and Row, 1970.

Di Maggio, Paul. "Cultural Entrepreneurship in Nineteenth-Century Boston: The Creation of an Organizational Base for High Culture in America." In *Rethinking Popular Culture*, edited by Chandra Mukerji and Michael Schudson, pp. 374–97. Berkeley: University of California Press, 1991.

Doordan, Dennis. *Building Modern Italy.* New York: Princeton Architectural Press, 1988.

Ecksteins, Modris. *The Rite of Spring: The Great War and the Birth of the Modern Age.* Boston: Anchor Books, 1989.

Eco, Umberto. *Role of the Reader.* Bloomington: Indiana University Press, 1979.

————. *Travels in Hyperreality.* New York: Harcourt, Brace Jovanovich, 1983.

Etlin, Richard. *Modernism in Italian Architecture, 1890–1940.* Cambridge, Mass.: MIT Press, 1991.

Evans, Richard. *In Hitler's Shadow.* New York: Pantheon, 1989.

Fagiolo dell'Arco, Maurizio. *Futurism.* Rome: De Luca, 1984.

Fagone, Vittorio, ed. *Gli AnniTrenta: Arte e cultura in Italia.* Milan: Mazzotta, 1983.

Femia, Joseph V. *Gramsci's Political Thought.* Oxford: Clarendon Press, 1981.

Ferrario L., and D. Pastore. *Giuseppe Terragni: La casa del fascio.* Rome: Istituto Mides, 1982.

Fioravanti, Giovanna. *Archivio centrale dello stato: Partito nazionale fascista—Mostra della rivoluzione fascista.* Rome: Archivio di Stato, Ministero per i Beni Culturali e Ambientali, 1990.

Fish, Stanley. *Is There a Text in This Class?: The Authority of Interpretive Communities.* Cambridge, Mass.: Harvard University Press, 1988.

Forgacs, David. *Italian Culture in the Industrial Era.* Manchester: Manchester University Press, 1990.

Fornari, Harry D. "Roberto Farinacci." In *Uomini e volti del Fascismo,* edited by Fernando Cordova. Rome: Bulzoni, 1980.

Fossati, Paolo. *L'immagine sospesa—Pittura e scultura astratte in Italia, 1934–1940.* Turin: Einaudi, 1971.

Foster, Arnold, and Judith Blau, eds. *Art and Society: Readings in the Sociology of the Arts.* Albany: SUNY Press, 1989.

Fraquelli, Simonetta. *"La prima mostra del novecento italiano": The Interaction of Art and Politics.* M.A. thesis, Courtauld Institute of Art, 1986.

Friedberg, Anne. *Window Shopping.* Berkeley: University of California Press, 1993.

Galleria d'Arte Moderna. *Roma 1911.* Edited by Gianna Piantoni. Rome: De Luca, 1980.

Gentile, Emilio. *Le origine dell'ideologia fascista (1918–1925).* Bari: Laterza, 1975.

————. "Fascism as a Political Religion." *Journal of Contemporary History* 25, nos. 2–3 (1990): 229–51.

————. *Il culto del littorio.* Bari: Laterza, 1993.

Ghirardo, Diane. "Italian Architects and Fascist Politics: An Evaluation of the Rationalists Role in Regime Building." *Journal of the Society of Architectural Historians* 39, no. 2 (May 1980): 109–27.

————. *Building New Communities: New Deal America and Fascist Italy.* Princeton, N.J.: Princeton University Press, 1989.

————. "City and Theater: The Rhetoric of Fascist Architecture." *Stanford Italian Review* 8, nos. 1–2 (1990): 165–94.

Gitlin, Todd. *The Twilight of Common Dreams.* New York: Metropolitan Books, 1995.

Golsan, Richard. *Fascism, Aesthetics, and Culture.* Hanover, N.H.: University Press of New England, 1992.

Gramsci, Antonio. *Selections from the Prison Notebooks.* Edited and translated by Quinta Hoare and Geoffrey Nowell-Smith (London: Lawrence and Wishart, 1971).

Greenhalgh, Peter. *Ephemeral Vistas: The Expositions Universelles, the Great Exhibition and World's Fair, 1851–1939.* Manchester: Manchester University Press, 1988.

Grimaldi, U. Alfassio, and Gherardo Bozzetti. *Farinacci: Il più fascista.* Milan: Bompiani, 1972.

Grimaldi, U. Alfassio, and M. Addis Saba. *Cultura a passo romano*. Milan: Feltrinelli, 1983.

Guerri, Giordano Bruno. *Giuseppe Bottai: Un fascista critico*. Milano: Feltrinelli, 1976.

Hamilton, Alastair. *The Appeal of Fascism: A Study of Intellectuals and Fascism*. London: Macmillan, 1971.

Harris, Neil. *Humbug: The Art of P. T. Barnum*. Chicago: University of Chicago Press, 1973.

Harrison, Helen, ed. *Dawn of a New Day: The New York World's Fair, 1939/40*. New York: New York University Press, 1980.

Hay, James. *Popular Film Culture in Fascist Italy*. Bloomington: Indiana University Press, 1987.

Herf, Jeffrey. *Reactionary Modernism: Technology, Culture, and Politics in Weimar and the Third Reich*. New York: Cambridge University Press, 1984.

Hinz, Berthold. *Art in the Third Reich*. New York: Pantheon, 1979.

Hobsbawm, Eric, and Terence Ranger, eds. *The Invention of Tradition*. Cambridge: Cambridge University Press, 1983.

Hoelterhoff, Manuela. "Art of the Third Reich: Documents of Oppression." *Art Forum* 14, no. 4 (December 1975): 55–62.

Holt, Elizabeth Gilmore. *The Art of All Nations, 1850–1873*. Princeton, N.J.: Princeton University Press, 1982.

Isnenghi, Mario. *Intellettuali militanti e intellettuali funzionari: Appunti sulla cultura fascista*. Turin: Einaudi, 1979.

Jacobelli, Jader, ed. *Il Fascismo e gli storici oggi*. Bari: Saggi Tascabili Laterza, 1988.

Kalaidjian, Walter. *American Culture between the Wars*. New York: Columbia University Press, 1993.

Karp, Ivan, and Steven Lavine, eds. *Exhibiting Cultures*. Washington, D.C.: Smithsonian Institution Press, 1991.

Koon, Tracy H. *Believe, Obey, Fight: Political Socialization of Youth in Fascist Italy, 1922–43*. Chapel Hill: University of North Carolina Press, 1985.

Lamberti, Maria Mimita. "L'esposizione nazionale del 1880 a Torino." *Ricerche di storia dell'arte*, no. 18 (1982): 37–44.

Lanaro, Silvio. "Simbologia, immaginari di massa ed estetica della politica nell'Italia negli anni trenta." Lecture, Istituto Gramsci di Bologna, April 11, 1987.

Landini, Enrica Torelli. "Terragni e il completamento della Casa del Fascio a Como." In *Avanguardia, traduzione, ideologia: Itinerario attraverso un ventennio di dibattito sulla pittura e plastica murale*, edited by Simonetta Lux. (Rome: Bagatto Libri, 1990).

Landy, Marcia. *Fascism in Film*. Princeton, N.J.: Princeton University Press, 1986.

Lavagnino, Emilio. *L'arte moderna*. Vol. 2. Turin: Unione Tipografico Torinese, 1956.

Lebovics, Herman. *True France: Wars over Cultural Identity, 1900–1945*. Ithaca, N.Y.: Cornell University Press, 1992.

Lenman, Robin. "Painters, Patronage and the Art Market in Germany, 1850–1914." *Past and Present*, no. 123 (1989): 109–40.

Luke, Timothy. *Shows of Force: Power, Politics, and Ideology in Art Exhibitions*. Durham, N.C.: Duke University Press, 1992.

Lux, Simonetta, ed. *Avanguardia, traduzione, ideologia: Itinerario attraverso un ventennio di dibattito sulla pittura plastica murale*. Rome: Bagatto Libri, 1990.

Lyttleton, Adrian. *The Seizure of Power*. Princeton, N.J.: Princeton University Press, 1986.

MacCannell, Dean. *The Tourist Papers.* New York: Routledge, 1992.

Mainardi, Patricia. *Art and Politics of the Second Empire.* New Haven, Conn.: Yale University Press, 1989.

Maltese, Corrado. *Storia dell'arte italiana, 1785–1943.* Turin: Einaudi, 1960.

Malvano, Laura. *Fascismo e la politica dell'immagine.* Turin: Bollati Boringhieri, 1988.

Mancini, Elaine. *Struggles of the Italian Film Industry during Fascism, 1930–1935.* Ann Arbor, Mich.: UMI Research Press, 1985.

Mangoni, Luisa. *Interventismo della cultura.* Bari: Laterza, 1974.

Marchand, Roland. "The Designers Go to the Fair: Walter Dorwin Teague and the Professionalization of Corporate Industrial Exhibits, 1933–1940." *Design Issues* 8, no. 1, (Fall 1991): 5–17.

————."The Designers Go to the Fair II: Norman Bel Geddes, the General Motors 'Futurama,' and the Visit to the Factory Transformed." *Design Issues* 8, no. 2 (Spring 1992): 23–40.

Marciano, Ada Francesca. *Giuseppe Terragni: Opera completa, 1925–43.* Rome: Officina Edizioni, 1987.

Marino, Giuseppe Carlo. *L'autarchia della cultura.* Rome: Riuniti, 1983.

Masi, Alessandro. *Un'arte per lo stato.* Naples: Marotta and Marotta, 1991.

Mazzatosta, Teresa Maria. *Il regime fascista tra educazione e propaganda, 1935–43.* Bologna: Cappelli, 1978.

Mazzi, Maria Cecilia. "Modernità e tradizione: Temi della politica artistica del regime fascista." *Ricerche di storia dell'arte,* no. 12 (1980): 19–32.

Melosh, Barbara. *Engendering Culture,* Washington, D.C.: Smithsonian Institution Press, 1991.

Michaelis, Meir. *Mussolini and the Jews.* Oxford: Oxford University Press, 1978.

Miller, Daniel. *Material Culture and Mass Consumption.* Oxford: Basil Blackwell, 1987.

Millon, Henry, and Linda Nochlin, eds. "The Role of the History of Architecture in Fascist Italy." *Journal of the Society of Architectural Historians* 24 (1965): 49–53.

————. *Art and Architecture in the Service of Politics.* Cambridge, Mass.: MIT Press, 1978.

Moroni, I. *L'orientamento del gusto attraverso le Biennale.* Milan: Edizioni "Le Rete," 1957.

Mosse, George. *Nazi Culture.* New York: Schocken Books, 1966.

————. "The Poet and the Exercise of Political Power: Gabriele D'Annunzio." *Yearbook of Comparative and General Literature* 22 (1973): 32–43.

————. *The Nationalization of the Masses.* New York: Howard Fertig, 1975.

————. *Masses and Man.* New York: Howard Fertig, 1980.

————. "The Political Culture of Italian Futurism." *Journal of Contemporary History* 25, nos. 2–3 (1990): 253–68.

Ozouf, Mona. *Festivals and the French Revolution.* Cambridge, Mass.: Harvard University Press, 1988.

Papa, Emilio. *Storia di due manifesti.* Milan: Marsilio, 1958.

————. *Fascismo e cultura.* Venice: Marsilio Editori, 1974.

Painter, Borden, Jr. "Renzo De Felice and the Historiography of Italian Fascism." *American Historical Review* 95, no. 2, (April 1990): 359–402.

Passerini, Luisa. "L'immagine di Mussolini: Specchio dell'immaginario e promessa d'identità." *Rivista di storia contemporanea,* no. 3 (1986): 322–49.

————. *Fascism in Popular Memory.* London: Cambridge University Press, 1987.

Peukert, Detlev. *Inside Nazi Germany*. New Haven, Conn.: Yale University Press, 1985.

Pica, Agnolodomenico. *Storia della Triennale di Milano, 1918–1957*. Milan: Edizione del Milione, 1957.

Poggioli, Renato. *The Theory of the Avant-Garde*. Cambridge: Cambridge University Press, 1968.

Quilici, Vieri. *Adalberto Libera l'architettura come ideale*. Rome: Officina Edizioni, 1981.

Radaway, Janice. *Reading Romance: Women, Patriarchy and Popular Literature*. Chapel Hill: University of North Carolina Press, 1984.

Redi, Riccardo, ed. *Cinema italiano sotto il fascismo*. Venice: Marsilio, 1979.

Ricciotti, Lazzero. *Il partito nazionale fascista: Come era organizzata e funzionava il partito che mise l'Italia in camicia nera*. Milan: Rizzoli, 1985.

Richards, Thomas. *The Commodity Culture of Victorian England: Advertising and Spectacle, 1851–1914*. Stanford, Calif.: Stanford University Press, 1990.

Rizzi, Paolo, and Enzo di Martini, eds. *La Storia delle Biennale, 1895–1982*. Milan: Electa, 1982.

Romano, Sergio. *Giuseppe Volpi: Industria e finanza tra Giolitti e Mussolini*. Milan: Bompiani, 1979.

Ross, Andrew. *No Respect: Intellectuals and Popular Culture*. New York: Routledge, 1989.

Rubinstein, David. "The Mystification of Reality: Art under Italian Fascism." Ph.D dissertation, New York University, 1978.

Rydell, Robert. *All the World's a Fair*. Chicago: University of Chicago Press, 1984.
——————. *Worlds of Fairs*. Chicago: University of Chicago Press, 1993.

Saba, Maria Addis, and Ugoberto Alfassio Grimaldi. *Cultura a passo romano*. Milan: Feltrinelli, 1983.

Sachs, Harvey. *Music in Fascist Italy*. New York: Norton, 1988.

Salaris, Claudia. *Storia del futurismo*. Rome: Editore Riuniti, 1985.
——————. *F. T. Marinetti*. Florence: La Nuova Italia Editrice, 1988.
——————. *Marinetti editore*. Bologna: Il Mulino, 1990.

Santarelli, Enzo, *Storia del movimento e del regime fascista*. Rome: Feltrinelli, 1967.

Sarti, Roland. "Giuseppe Volpi." In *Uomini e volti del Fascismo*, edited by Fernando Cordova, pp. 523–46. Rome: Bulzoni, 1980.

Sauerlander, Willibald. "The Nazis' Theater of Seduction." *New York Review of Books* 41, no. 8 (April 1994): 16.

Scalia, Gianni. "Tre interpretazioni del Fascismo." In *Cinema italiano sotto il Fascismo*, edited by Riccardo Redi, pp. 19–28. Venice: Marsilio, 1979.

Schiavo, Alberto. *Futurismo e Fascismo*. Rome: Giovanni Volpe, 1981.

Schnapp, Jeffrey. "Forwarding Address." *Stanford Italian Review* 8, nos. 1–2 (1990): 53–80.

Schnapp, Jeffrey and Barbara Spackman, eds. "Selections from the Great Debate on Fascism and Culture: *Critica fascista* 1926–1927." *Stanford Italian Review* 8, nos. 1–2 (1990): 235–72.
——————. "Mafarka and Son: Marinetti's Homophobic Economics." *Modernism/Modernity* 1, no. 3 (September 1994): 89–108.

Schumacher, Thomas. *The Danteum*. New York: Princeton Architectural Press, 1985.
——————. *Surface and Symbol: Giuseppe Terragni and the Architecture of Italian Rationalism*. New York: Princeton Architectural Press, 1991.

Sellers, Susan. "Mechanical Brides: The Exhibition," *Design Issues* 10, no. 2 (Summer 1994).

Sherman, Daniel S. *Worthy Monuments*. Cambridge, Mass.: Harvard University Press, 1989.

Sherman, Daniel S., and Irit Rogoff, eds. *Museum Culture*. Minneapolis: University of Minnesota Press, 1994.

Silva, Umberto. *Ideologia e arte del Fascismo*. Milan: Mazzotta, 1973.

Silverman, Debora. "The 1899 Exhibition: The Crisis of Bourgeois Individualism." *Oppositions* 8 (Spring 1977): 77–91.

―――――. *Art Nouveau in Fin-de-Siécle France*. Berkeley: University of California Press, 1989.

Simeone, William E. "Fascists and Folklorists in Italy." *Journal of American Folklore* 91, no. 359: 443–558.

Sontag, Susan. "Fascinating Fascism." In *Under the Sign of Saturn*, pp. 73–105. New York: Vintage Books, 1980.

Steinweis, Alan E. *Art, Ideology and Economics in Nazi Germany*. Chapel Hill: University of North Carolina Press, 1993.

Sternhell, Zeev. *The Birth of Fascist Ideology*. Princeton, N.J.: Princeton University Press, 1994.

Stone, Marla. "Staging Fascism: The Show of the Fascist Revolution." *Journal of Contemporary History* 28, no. 2 (April 1993): 215–43.

Storey, John. *Cultural Theory and Popular Culture*. Athens: University of Georgia Press, 1993.

Tannenbaum, Edward. *The Fascist Experience: Italian Society and Culture, 1922–1945*. New York: Basic Books, 1972.

Taylor, Joshua C. *Futurism*. New York: Doubleday, 1961.

Tempesti, Fernando. *Arte dell'Italia fascista*. Milan: Feltrinelli, 1976.

Timms, Edward, and Peter Collier, eds. *Visions and Blueprints: Avant-garde Culture and Radical Politics in Twentieth-Century Europe*. Manchester: Manchester University Press, 1988.

Tranfaglia, Niccolo. *Dallo stato liberale al regime fascista*. Milan: Feltrinelli, 1973.

―――――. *Labirinto Italiano: Radici storiche e nuove contradizioni*. Turin: CELID, 1982.

Turi, Gabriele. *Il Fascismo e il consenso degli intellettuali*. Bologna: Il Mulino, 1980.

Visser, Romke. "Fascist Doctrine and the Cult of the *Romanità*." *Journal of Contemporary History* 27 (1992): 5–22.

von Geldern, James. *Bolshevik Festivals, 1917–1920*. Berkeley: University of California Press, 1993.

Walton, Whitney. *France at the Crystal Palace*. Berkeley: University of California Press, 1992.

Whitford, Frank. "The Triumph of the Banal: Art in Nazi Germany." In *Visions and Blueprints: Avant-Garde Culture and Radical Politics in Early Twentieth-Century Europe*, edited by Edward Timms and Peter Collier, pp. 252–69. Manchester: Manchester University Press, 1988.

Willet, John. *Art and Politics in the Weimar Period*. New York: Pantheon, 1978.

Williams, Raymond. "Theatre as a Political Forum." In *Visions and Blueprints: Avant-Garde Culture and Radical Politics in Early Twentieth-Century Europe*, edited by Edward Timms and Peter Collier, pp. 307–20. Manchester: Manchester University Press, 1988.

Williams, Rosalind. *Dream Worlds*. Berkeley: University of California Press, 1982.

Wilson, Michael. "Consuming History: The Nation, the Past and the Commodity at L'Exposition Universelle de 1900." *American Journal of Semiotics* 8, no. 4 (1991): 145.

Zangrandi, Ruggero. *Il lungo viaggio attraverso il Fascismo*. Milan: Feltrinelli, 1962.

Zuccotti, Susan. *Italy and the Holocaust*. New York: Basic Books, 1987.

Zunnino, Pier Giorgio. *L'ideologia del Fascismo*. Bologna: Il Mulino, 1985.

Modern Exhibition Catalogs

Ades, Dawn, Tim Benton, David Elliot, and Ian Boyd White, eds. *Art and Power: Europe under the Dictators, 1930–45*. Cat. exh. London: Hayward Gallery / South Bank Centre, 1995.

Barron, Stefanie, ed. *Degenerate Art: The Fate of the Avant-Garde in Nazi Germany*. Cat. exh. Los Angeles: Los Angeles County Museum of Art, 1991.

Bossaglia, Rossana, ed. *Mostra del novecento italiano*. Cat. exh. Milan: Mazzotta, 1983.

Bown, Matthew Cullerne. *Soviet Socialist Realist Painting*. Cat. exh. Oxford: Museum of Modern Art, 1992.

Braun, Emily, ed. *Italian Art in the Twentieth Century*. Cat. exh. London and Munich: Royal Academy and Prestel Verlag, 1989.

Calvesi, Maurizio, and Enrico Guidoni, eds. *E42: Utopia e scenario del regime*: Vol. 1, *Ideologia e programme per l'Olimpiade delle civiltà*, vol. 2, *Urbanistica, architelture, arte e decorazione*. Cat. exh. Venice: Marsilio, 1987.

Città di Prato. *Anni creativi al "Milione" 1932–1939*. Cat. exh. Milan: Silvana Editoriale, 1980.

Commune di Milano. *Mario Sironi*. Cat. exh. Milan: Electa, 1973.

Crispolti, Enrico, ed. *Riconstruzione futurista dell'universo*. Cat. exh. Turin: Museo Civico di Torino, 1980.

Fosso, Mario, and Enrico Mantero. *Giuseppe Terragni, 1904–43*. Cat. exh. Como: Comune di Como, 1982.

Futurismo e futurismi. Cat. exh. Milan: Pontus Hulten, 1986.

La menzogna della razza. Cat. exh. Bologna: Grafis Edizioni, 1994.

Mario Sironi 1885–1961. Cat. exh. Galleria nazionale di arte moderna. Rome: Electa, 1993.

Piatoni, Gianna, ed. *Roma 1911*. Cat. exh. Rome: Galleria d'arte moderna, 1980.

Pizzinato. Cat. exh. Milan: Rebellato, 1975.

Pizzinato: L'arte come bisogno di libertà. Cat. exh. Venice: Marsilio, 1981.

abstract art: artists attack against Italian
(1938–39), 192; *concretisti* artists of, 53–54;
state patronage of, 4

advertising: Bauhaus techniques, 158; in-
fluence in Circus Maximus designs,
235–36

Aeronautics Exhibition (Mostra aeronau-
tica): in Milan (1934), 129–30, 223–24,
253; as modernist political exhibition,
222–26; similarities of, to Exhibition of
the Fascist Revolution, 224

aeropittura style, 49–51

aesthetic, Fascist. *See* pluralism, aesthetic

aesthetics: Fascist interpretation of, 130–33,
159–60; and Italian nationalism (*roma-
nità* and *italianità*), 194; related to Ger-
man use of art, 194

aesthetics, Fascist: militarized and racial-
ized, 181

Alessandrini, Goffredo, 109

Alfieri, Dino, 82, 109; conception of Mos-
tra della rivoluzione fascista, 134–35; as
cultural impresario, 55, 58–60; inaugura-
tion of first Cremona Prize exhibition,
184

Allason, Barbara, 171

Alverà, Mario, 41

Amato, Orazio, 75

Andalo, Guelfo, 175

antipluralists: battle between pluralists
and, 179–81, 189; concessions to, 223;
criticism of Fascist arts policy, 78–79,
197; criticism of novecento art, 49; in
Fascist Party, 45–46; increased power
of, 210, 219; on social function of art,
88

anti-Semitism, Fascist, 180–81, 219

Archipenko, Alexander P., 35

architects: attack against rational (1938–
39), 193; commissioned by Exhibition
of the Fascist Revolution (1932), 5;
Gruppo, 7, 145; hired to work on Circus
Maximus exhibits, 236–27; support for
modernism of rational, 193

architecture: of exhibitions as point of
entry, 62; of functionalists in political

exhibitions (1930s), 130–33; rationalism
of new Venice Biennale facade, 61–64;
state support for rationalist and neo-
Roman, 4

Armellini, Guido, 12, 157

art: as cultural form in Italy, 29–30; exhib-
ited in first Cremona Prize competition
(1939), 182–83

art, Fascist: of Bottai, 186–88; corporatism
in, 25–26; demand of futurists for, 193;
in period of the Battle for Culture, 178

art, modern: battle of National Socialism
against, 190–91; Italian antipluralist at-
tack on (1937–38), 192

art, public: in countries outside Italy, 114;
in Italy, 113–20

art exhibitions: of Fascist regime, 30–31; in
nineteenth-century Italy, 29–30

artists: commissioned by Exhibition of the
Fascist Revolution (1932), 5; demands of
futurists, 193; under Fascist syndicalism,
26–28; of first Exhibition of the Fascist
Revolution, 140–41; hired to work on
Circus Maximus exhibits, 236–37; of the
novecento, 35; in partisan struggle
against Fascism, 189; response of, to al-
tered patronage style, 209; response of,
to Fascist patronage and aesthetic plu-
ralism, 78–86; syndicates offering sup-
port to, 26–28; winners in Venice Bien-
nale (1938), 201–3. *See also* syndicates of
Fascist artists

art market: government and party pur-
chases in, 71–73, 75–76, 215; Mussolini's
purchases, 77, 212–13; official purchases
at Biennale (1936), 212; pre-Fascist pri-
vate patron, 117; purchases from young
artists (1940s), 215–16; purchases of Nazi
officials, 76; Venice Biennales of (1938–
42), 119, 212–15

arts policy, Fascist: basis for, 78; criticism
of, 89–94

audiences: attendance incentives (1936–
39), 240; disinterest (1940s), 220; at Exhi-
bition of the Fascist Revolution (1932–
34), 171; political exhibitions targeting

About the Author

Marla Susan Stone is Assistant Professor of History at Occidental College. She is the editor, with Harold James, of *When the Wall Came Down: Reactions to German Reunification*, and the author of numerous articles on European cultural politics.